Digital Photography For Dummies, 3rd Edition

W9-BSG-324

Faker's Guide to Digital Photography Lingo

Stuck in a room full of digital photographers? Sprinkle your conversation with these terms to make it sound like you know more about the topic than you really do.

Term	What It Means
CCD, CMOS	Two types of computer chips used inside digital cameras; the component responsible for capturing the image
CompactFlash, SmartMedia	Two popular forms of removable memory for digital cameras
compression	A way of shrinking a large image file to a more manageable size
digicam	A hip way to say "digital camera"
dpi	Dots per inch; a measurement of how many dots of color a printer can create per inch
dye-sub	Short for dye-sublimation; a type of printer that creates excellent prints of digital images
jpegged	Pronounced *jay-pegged;* slang for an image that has been saved using JPEG compression
megapixel	One million pixels or more; used to describe a high-resolution camera
pixel	The tiny squares of color used to create digital images; like tiles in a mosaic
ppi	Pixels per inch; the higher the ppi, the better the image looks when printed
RGB	A color model in which colors are created by mixing red, green, and blue light; digital-camera images are RGB images
resample	To add more pixels to an image or throw away existing pixels
resolution	The number of pixels per linear inch (ppi); higher resolution equals better image quality
sharpening filter	An image-editing tool that creates the appearance of a more sharply focused picture

For Dummies®: Bestselling Book Series for Beginners

Digital Photography For Dummies, 3rd Edition

Cheat Sheet

File Format Guide

Rely on these popular file formats when saving digital images.

Format	Description
TIFF	Files saved in this format can be opened on both PC and Macintosh computers. The best choice for preserving all image data, but usually results in larger file sizes than other formats. Don't use for images going on a World Wide Web page.
JPEG	JPEG files can be opened on both PC and Macintosh computers. JPEG can compress images so that files are significantly smaller, but too much compression reduces image quality. One of two formats to use for Web images.
GIF	Use for Web images only. Offers a feature that enables you to make part of your image transparent so that the Web page background shows through the image. But all GIF images must be reduced to 256 colors, which can create a blotchy effect. Compatible with both Macintosh and PC computers.
BMP	Use only for images that will be used as Windows system resources, such as desktop wallpaper.
PICT	Use for images that will be used as Macintosh system resources, such as a desktop pattern.

Common Keyboard Shortcuts

Press these key combinations to perform basic operations in most image-editing programs, as well as in other computer programs.

Operation	Windows Shortcut	Macintosh Shortcut
Open an existing image	Ctrl+O	⌘+O
Create a new image	Ctrl+N	⌘+N
Save an image	Ctrl+S	⌘+S
Print an image	Ctrl+P	⌘+P
Cut a selection to the Clipboard	Ctrl+X	⌘+X
Copy a selection to the Clipboard	Ctrl+C	⌘+C
Paste the contents of the Clipboard into an image	Ctrl+V	⌘+V
Select the entire image	Ctrl+A	⌘+A
Undo the last thing you did	Ctrl+Z	⌘+Z
Quit the program	Ctrl+Q	⌘+Q

For Dummies®: Bestselling Book Series for Beginners

Digital Photography FOR DUMMIES® 3RD EDITION

by Julie Adair King

IDG Books Worldwide, Inc.
An International Data Group Company

Foster City, CA ◆ Chicago, IL ◆ Indianapolis, IN ◆ New York, NY

Digital Photography For Dummies®, 3rd Edition

Published by
IDG Books Worldwide, Inc.
An International Data Group Company
919 E. Hillsdale Blvd.
Suite 400
Foster City, CA 94404
www.idgbooks.com (IDG Books Worldwide Web site)
www.dummies.com (Dummies Press Web site)

Library of Congress Catalog Card No.: 99-66340

ISBN: 0-7645-0646-3

Printed in the United States of America

10 9 8 7 6 5 4 3

3B/QX/RS/ZZ/IN

Distributed in the United States by IDG Books Worldwide, Inc.

Distributed by CDG Books Canada Inc. for Canada; by Transworld Publishers Limited in the United Kingdom; by IDG Norge Books for Norway; by IDG Sweden Books for Sweden; by IDG Books Australia Publishing Corporation Pty. Ltd. for Australia and New Zealand; by TransQuest Publishers Pte Ltd. for Singapore, Malaysia, Thailand, Indonesia, and Hong Kong; by Gotop Information Inc. for Taiwan; by ICG Muse, Inc. for Japan; by Intersoft for South Africa; by Eyrolles for France; by International Thomson Publishing for Germany, Austria and Switzerland; by Distribuidora Cuspide for Argentina; by LR International for Brazil; by Galileo Libros for Chile; by Ediciones ZETA S.C.R. Ltda. for Peru; by WS Computer Publishing Corporation, Inc., for the Philippines; by Contemporanea de Ediciones for Venezuela; by Express Computer Distributors for the Caribbean and West Indies; by Micronesia Media Distributor, Inc. for Micronesia; by Chips Computadoras S.A. de C.V. for Mexico; by Editorial Norma de Panama S.A. for Panama; by American Bookshops for Finland.

For general information on IDG Books Worldwide's books in the U.S., please call our Consumer Customer Service department at 800-762-2974. For reseller information, including discounts and premium sales, please call our Reseller Customer Service department at 800-434-3422.

For information on where to purchase IDG Books Worldwide's books outside the U.S., please contact our International Sales department at 317-596-5530 or fax 317-596-5692.

For consumer information on foreign language translations, please contact our Customer Service department at 1-800-434-3422, fax 317-596-5692, or e-mail rights@idgbooks.com.

For information on licensing foreign or domestic rights, please phone +1-650-655-3109.

For sales inquiries and special prices for bulk quantities, please contact our Sales department at 650-655-3200 or write to the address above.

For information on using IDG Books Worldwide's books in the classroom or for ordering examination copies, please contact our Educational Sales department at 800-434-2086 or fax 317-596-5499.

For press review copies, author interviews, or other publicity information, please contact our Public Relations department at 650-655-3000 or fax 650-655-3299.

For authorization to photocopy items for corporate, personal, or educational use, please contact Copyright Clearance Center, 222 Rosewood Drive, Danvers, MA 01923, or fax 978-750-4470.

 is a registered trademark under exclusive license to IDG Books Worldwide, Inc. from International Data Group, Inc.

About the Author

Digital-photography expert **Julie Adair King** is the author of *Adobe PhotoDeluxe For Dummies* and *Microsoft PhotoDraw 2000 For Dummies.* She has contributed to many other books on digital imaging and computer graphics, including *Photoshop 4 For Dummies, CorelDRAW! 7 For Dummies, PageMaker 6 For Dummies,* and *Photoshop 4 Bible.* She is also the author of *WordPerfect Office 2000 For Dummies, WordPerfect Suite 8 For Dummies* and *WordPerfect Suite 7 For Dummies.*

ABOUT IDG BOOKS WORLDWIDE

Welcome to the world of IDG Books Worldwide.

IDG Books Worldwide, Inc., is a subsidiary of International Data Group, the world's largest publisher of computer-related information and the leading global provider of information services on information technology. IDG was founded more than 30 years ago by Patrick J. McGovern and now employs more than 9,000 people worldwide. IDG publishes more than 290 computer publications in over 75 countries. More than 90 million people read one or more IDG publications each month.

Launched in 1990, IDG Books Worldwide is today the #1 publisher of best-selling computer books in the United States. We are proud to have received eight awards from the Computer Press Association in recognition of editorial excellence and three from Computer Currents' First Annual Readers' Choice Awards. Our best-selling *...For Dummies®* series has more than 50 million copies in print with translations in 31 languages. IDG Books Worldwide, through a joint venture with IDG's Hi-Tech Beijing, became the first U.S. publisher to publish a computer book in the People's Republic of China. In record time, IDG Books Worldwide has become the first choice for millions of readers around the world who want to learn how to better manage their businesses.

Our mission is simple: Every one of our books is designed to bring extra value and skill-building instructions to the reader. Our books are written by experts who understand and care about our readers. The knowledge base of our editorial staff comes from years of experience in publishing, education, and journalism — experience we use to produce books to carry us into the new millennium. In short, we care about books, so we attract the best people. We devote special attention to details such as audience, interior design, use of icons, and illustrations. And because we use an efficient process of authoring, editing, and desktop publishing our books electronically, we can spend more time ensuring superior content and less time on the technicalities of making books.

You can count on our commitment to deliver high-quality books at competitive prices on topics you want to read about. At IDG Books Worldwide, we continue in the IDG tradition of delivering quality for more than 30 years. You'll find no better book on a subject than one from IDG Books Worldwide.

John Kilcullen
John Kilcullen
Chairman and CEO
IDG Books Worldwide, Inc.

Steven Berkowitz
Steven Berkowitz
President and Publisher
IDG Books Worldwide, Inc.

VIII WINNER
*Eighth Annual
Computer Press
Awards 1992*

IX WINNER
*Ninth Annual
Computer Press
Awards 1993*

X WINNER
*Tenth Annual
Computer Press
Awards 1994*

XI WINNER
*Eleventh Annual
Computer Press
Awards 1995*

IDG is the world's leading IT media, research and exposition company. Founded in 1964, IDG had 1997 revenues of $2.05 billion and has more than 9,000 employees worldwide. IDG offers the widest range of media options that reach IT buyers in 75 countries representing 95% of worldwide IT spending. IDG's diverse product and services portfolio spans six key areas including print publishing, online publishing, expositions and conferences, market research, education and training, and global marketing services. More than 90 million people read one or more of IDG's 290 magazines and newspapers, including IDG's leading global brands — Computerworld, PC World, Network World, Macworld and the Channel World family of publications. IDG Books Worldwide is one of the fastest-growing computer book publishers in the world, with more than 700 titles in 36 languages. The "...For Dummies®" series alone has more than 50 million copies in print. IDG offers online users the largest network of technology-specific Web sites around the world through IDG.net (http://www.idg.net), which comprises more than 225 targeted Web sites in 55 countries worldwide. International Data Corporation (IDC) is the world's largest provider of information technology data, analysis and consulting, with research centers in over 41 countries and more than 400 research analysts worldwide. IDG World Expo is a leading producer of more than 168 globally branded conferences and expositions in 35 countries including E3 (Electronic Entertainment Expo), Macworld Expo, ComNet, Windows World Expo, ICE (Internet Commerce Expo), Agenda, DEMO, and Spotlight. IDG's training subsidiary, ExecuTrain, is the world's largest computer training company, with more than 230 locations worldwide and 785 training courses. IDG Marketing Services helps industry-leading IT companies build international brand recognition by developing global integrated marketing programs via IDG's print, online and exposition products worldwide. Further information about the company can be found at www.idg.com. 1/24/99

Dedication

This book is dedicated to my family (you know who you are). Thank you for putting up with me, even on my looniest days. A special thanks to the young 'uns, Kristen, Matt, Adam, Brandon, and Laura, for brightening my world with your smiles and hugs.

Acknowledgments

Many, many thanks to all those people who provided me with the information and support necessary to create this book. I especially want to express my appreciation to the following folks for arranging equipment loans and providing technical guidance:

Joe Runde, Jay Kelbley, and Brian Fox, Eastman Kodak Company
Tara Poole and Jeremy Pepper, Shandwick USA
Michael Rubin, Nikon Inc.
Vincent Park and Melinda Battle, Roundhouse Public Relations
Kelly Lesson, Fuji Photo Film U.S.A., Inc.
Scott Gardiner, Edelman Public Relations Worldwide
Cheryl Balbach, Casio, Inc.
Epson America, Inc.
Jerry Hsu, Walt and Company
Marlene Hess and Colleen Clifford, Olympus America Inc.
Karen Thomas, Thomas Public Relations, Inc.
Maggie O'Neill, Mindstorm Communications
Sony Electronics Inc.
Hewlett-Packard
Alicia Swanson, Eastwick Communications
Katie Williams and Michelle Sibbitt, Copithorne and Bellows
Pam Leeds and Rose Guarino, Canon USA, Inc.
Bob Goligoski, SanDisk
Iomega Corporation
Steve Goodwin, Antec, Inc.
Pete Stoddart, KBGear Interactive
Steven Alessandrini, BSMG Worldwide

I also want to express my appreciation to my astute and extremely helpful technical editor, Alfred DeBat; to project editor Melba Hopper; to Maridee Ennis, Shelley Lea, and the rest of the IDG Books production team. Thanks also to Steve Hayes, Mike Kelly, and Diane Steele for presenting me with the opportunity to be involved in this project and to Heather Dismore, Megan Roney, and Carmen Krikorian for putting together the CD that accompanies this book.

And my heartfelt thanks to image-editing guru Deke McClelland for sharing his knowledge and introducing me to the fascinating world of pixels!

Publisher's Acknowledgments

We're proud of this book; please register your comments through our IDG Books Worldwide Online Registration Form located at http://my2cents.dummies.com.

Some of the people who helped bring this book to market include the following:

Acquisitions, Editorial, and Media Development

Project Editor: Melba D. Hopper

 (Previous Edition: Jennifer Ehrlich)

Acquisitions Editor: Steven H. Hayes

Copy Editor: Melba D. Hopper

Technical Editor: Alfred DeBat

Associate Media Development Editor: Megan Decraene

Associate Permissions Editor: Carmen Krikorian

Editorial Manager: Mary C. Corder

Media Development Manager: Heather Heath Dismore

Editorial Assistant: Beth Parlon

Production

Project Coordinator: Maridee V. Ennis

Layout and Graphics: Shelley Norris, Barry Offringa, Tracy Oliver, Jill Piscitelli, Jacque Schneider, Dan Whetstine

Proofreaders: Laura Albert, Marianne Santy, Rebecca Senninger, Toni Settle, Joel Showalter

Indexer: Sherry Massey

Special Help

 Constance Carlisle, Suzanne Thomas, The Sander's Group

General and Administrative

IDG Books Worldwide, Inc.: John Kilcullen, CEO; Steven Berkowitz, President and Publisher

IDG Books Technology Publishing Group: Richard Swadley, Senior Vice President and Publisher; Walter Bruce III, Vice President and Associate Publisher; Joseph Wikert, Associate Publisher; Mary Bednarek, Branded Product Development Director; Mary Corder, Editorial Director; Barry Pruett, Publishing Manager; Michelle Baxter, Publishing Manager

IDG Books Consumer Publishing Group: Roland Elgey, Senior Vice President and Publisher; Kathleen A. Welton, Vice President and Publisher; Kevin Thornton, Acquisitions Manager; Kristin A. Cocks, Editorial Director

IDG Books Internet Publishing Group: Brenda McLaughlin, Senior Vice President and Publisher; Diane Graves Steele, Vice President and Associate Publisher; Sofia Marchant, Online Marketing Manager

IDG Books Production for Dummies Press: Debbie Stailey, Associate Director of Production; Cindy L. Phipps, Manager of Project Coordination, Production Proofreading, and Indexing; Tony Augsburger, Manager of Prepress, Reprints, and Systems; Laura Carpenter, Production Control Manager; Shelley Lea, Supervisor of Graphics and Design; Debbie J. Gates, Production Systems Specialist; Robert Springer, Supervisor of Proofreading; Kathie Schutte, Production Supervisor

Dummies Packaging and Book Design: Patty Page, Manager, Promotions Marketing

◆

The publisher would like to give special thanks to Patrick J. McGovern, without whom this book would not have been possible.

◆

Contents at a Glance

Table of Contents

Introduction

In the 1840s, William Henry Fox Talbot combined light, paper, a few chemicals, and a wooden box to produce a photographic print, laying the foundation for modern film photography. Over the years, the process that Talbot introduced was refined, and people everywhere discovered the joy of photography. They started trading pictures of horses and babies. They began displaying their handiwork on desks, mantels, and walls. And they finally figured out what to do with those little plastic sleeves inside their wallets.

Today, nearly 160 years and countless *Star Trek* reruns after Talbot's discovery, we're entering a new photographic age. The era of the digital camera has arrived, and with it comes a new and exciting way of thinking about photography. In fact, the advent of digital photography has spawned an entirely new art form — one so compelling that major museums now host exhibitions featuring the work of digital photographers.

With a digital camera, a computer, and some image-editing software, you can explore unlimited creative opportunities. Even if you have minimal computer experience, you can easily bend and shape the image that comes out of your camera to suit your personal artistic vision. You can combine elements of several different pictures into a photographic collage, for example, and create special effects that are either impossible or extremely difficult to achieve with film.

On a more practical note, digital photography dramatically reduces the time required to touch up everyday images. With a few clicks of a mouse button, you can fix color-balance problems, crop away distracting background elements, and even create the appearance of sharper focus.

Digital photography also enables you to share visual information with people around the world instantaneously. Literally minutes after snapping a digital picture, you can put the image in the hands of friends, colleagues, or strangers across the globe by attaching it to an e-mail message or posting it on the World Wide Web.

Blending the art of photography with the science of the computer age, digital cameras serve as both an outlet for creative expression and a serious communication tool. Just as important, digital cameras are *fun*. When was the last time you could say *that* about a piece of computer equipment?

Why a Book for Dummies?

Digital cameras have been around for several years, but at a price tag that few people could afford. Now, stores like Wal-Mart sell entry-level cameras for less than $100, which moves the technology out of the realm of exotic toy and into the hands of ordinary mortals like you and me. Which brings me to the point of this book (finally, you say).

Like any new technology, digital cameras can be a bit intimidating. Browse the digital camera aisle in your favorite store, and you come face-to- face with a slew of technical terms and acronyms — *CCD, pixel, JPEG compression,* and the like. These high-tech buzzwords may make perfect sense to the high-tech folks who have been using digital cameras for a while. However, if you're an average consumer, hearing a camera salesperson utter a phrase like, "This model has a megapixel CCD and can store 60 images on an 8MB CompactFlash card using JPEG compression," is enough to make you run screaming back to the film counter.

Don't. Instead, arm yourself with *Digital Photography For Dummies,* 3rd Edition. This book explains everything you need to know to become a successful digital photographer, from choosing a camera to shooting, editing, and printing your pictures. And you don't need to be a computer or photography geek to understand what's going on. *Digital Photography For Dummies* speaks your language — plain English, that is — with a dash of humor thrown in to make things more enjoyable.

What's in This Book?

Digital Photography For Dummies covers all aspects of digital photography, from figuring out which camera and accessories you should buy to preparing your images for printing or for publishing on the World Wide Web. Some of the book is devoted to helping newcomers select the right equipment, but most chapters focus on helping people who already own digital cameras to turn out great pictures. In addition to general background information that gives you a better understanding of how to use your camera, you'll find instructions on how to perform certain image-editing jobs, such as adjusting image brightness and contrast and creating photographic collages.

For some editing tasks, I provide specific instructions for doing the job in one popular image-editing program, Adobe PhotoDeluxe, Home Edition 3.0. However, if you're not using this version of PhotoDeluxe, or if you use another program altogether, don't think that this book isn't for you. The basic editing tools that I discuss function similarly from program to program — a

crop tool in one program isn't all that different from a crop tool in another program, for example. And the general approach to editing is the same no matter what program you use. So you can refer to this book for the solid foundation you need to understand different editing functions and then easily adapt the specific steps to your own image editor.

Although this book is designed for beginning- and intermediate-level digital photographers, I do assume that you have a little bit of computer knowledge. For example, you should understand how to start programs, open and close files, and get around in the Windows or Macintosh environment, depending on which type of system you use. Knowing just the right spot to whack your computer if it misbehaves is also valuable. If you're brand-new to computers as well as to digital photography, you may want to get a copy of *Windows 95 For Dummies,* 2nd Edition, or *Windows 98 For Dummies,* both by Andy Rathbone (IDG Books Worldwide, Inc.), or *Macs For Dummies,* 6th Edition, by David Pogue (IDG Books Worldwide, Inc.), as an additional reference.

As a special note to my Macintosh friends, I want to emphasize that although the screen shots in this book were taken on a Windows computer, this book is for Mac as well as Windows users. Whenever applicable, I provide editing instructions for both Macintosh and Windows platforms.

Now that I've firmly established myself as neutral in the computer platform wars, here's a brief summary of the kind of information you can find in *Digital Photography For Dummies.*

Part I: Peering through the Digital Viewfinder

This part of the book gets you started on your digital photography adventure. The first two chapters help you understand what digital cameras can and can't do and how they perform their photographic magic. Chapter 3 helps you track down the best camera for the type of pictures you want to take, while Chapter 4 introduces you to some of the camera add-ons and other accessories that make digital photography better, easier, or just more fun.

Part II: Ready, Set, Shoot!

Are you photographically challenged? Are your pictures too dark, too light, too blurry, or just plain boring? Before you fling your camera across the room in frustration, check out this part of the book.

Chapter 5 reveals the secret to capturing perfectly exposed, perfectly focused photographs and also presents tips to help you compose more powerful, more exciting images. Chapter 6 explores technical questions that arise on a digital photography shoot, such as what resolution and compression settings to choose. In addition, you find out how to take pictures that you plan to incorporate into a photo collage, capture a series of photographs that you can stitch together into a panorama, and handle problems such as shooting in fluorescent lighting and taking action shots.

In other words, this part saves you from turning your digital camera into a broken pile of chips and wires.

Part III: From Camera to Computer and Beyond

After you fill up your camera with images, you need to get them off the camera and out into the world. The chapters in this part of the book show you how to do just that.

Chapter 7 explains the process of transferring image files to your computer and also discusses ways to store and catalog all those images. Chapter 8 gives you a thorough review of your printing options, including information on the different types of color printers. And Chapter 9 looks at ways to display and distribute images electronically — placing them on Web pages, attaching them to e-mail messages, and even creating a personalized desktop background for your computer monitor.

Part IV: Tricks of the Digital Trade

In this part of the book, you get an introduction to image editing. Chapter 10 discusses simple fixes for problem pictures. Of course, after reading the shooting tips in Chapters 5 and 6, you shouldn't wind up with many bad photos. But for the occasional stinker, Chapter 10 comes to the rescue by showing you how to adjust exposure and contrast, sharpen focus, and crop away unwanted portions of the image.

Chapter 11 explains how to select a portion of your image and then copy and paste the selection into another image. You also find out how to cover up flaws and unwanted image elements. Chapter 12 presents some more-advanced editing tricks, including painting on your image, building photo collages, and applying special effects.

Keep in mind that coverage of image editing in this book is intended just to spark your creative appetite and give you a solid background for exploring your image-editing program. If you want in-depth information about a specific program, IDG books publishes excellent ...*For Dummies* books about several top image editors, including Adobe PhotoDeluxe, Corel PHOTO-PAINT, and Adobe Photoshop. (In the interest of full disclosure, I should tell you that I wrote the PhotoDeluxe book and contributed to the other ones. But they're good books just the same — at least, that's what my grandma says, and I choose to believe her.)

Part V: The Part of Tens

Information in this part of the book is presented in easily digestible, bite-sized nuggets. Chapter 13 contains the top ten ways to improve your digital photographs; Chapter 14 offers ten ideas for using digital images; and Chapter 15 lists ten great online resources for times when you need help sorting out a technical problem or just want some creative inspiration. In other words, Part V is perfect for the reader who wants a quick, yet filling, mental snack.

Part VI: Appendixes

In most cases, the back of a book is reserved for unimportant stuff that wasn't useful enough to earn a position in earlier pages. But the back of *Digital Photography For Dummies* is every bit as helpful as the rest of the book.

Appendix A, for example, contains a glossary of hard-to-remember digital photography terms. And Appendix B provides a guide to all the stuff provided on the CD included with this book. (But if you want a sneak preview, the next section gives you one.)

What's on the CD?

The CD tucked inside the back cover of this book is loaded with goodies. For starters, you get Kodak Pictures Now, an easy-to-navigate program that you can use to open and print images in a snap. For even more digital photography fun, the CD includes MediaCenter, an interesting hybrid of Web browser and image-editing program, from PictureWorks Technology.

In addition, the CD contains trial versions of a host of other image-editing and cataloging software. I've also provided some sample images so that you can get your feet wet with digital editing if you haven't yet taken any of your own pictures. Last, but not least, the CD includes online reference materials from the Kodak Digital Learning Center as a supplement to the information provided in this book.

Icons Used in This Book

Like other books in the *...For Dummies* series, this book uses icons to flag especially important information. Here's a quick guide to the icons used in *Digital Photography For Dummies.*

This icon lets you know when a product or image that I'm describing is included on the CD at the back of the book. You can try out the program for yourself or open the image and experiment with the technique being discussed.

As mentioned earlier, I sometimes provide steps for accomplishing an image-editing goal using Adobe PhotoDeluxe, Home Edition 3.0. The PhotoDeluxe Tip icon marks information specifically related to that program. But if you're using another image editor, you can adapt the general editing approach to your own software, so don't automatically ignore paragraphs marked with the PhotoDeluxe Tip icon. And if you're using another version of PhotoDeluxe, you'll find that most of the tools I discuss work exactly the same in your copy of the program, especially in Version 2.0 and the Business Edition.

This icon marks stuff that you should commit to memory. Doing so will make your life easier and less stressful, believe me.

Text marked with this icon breaks technical gobbledygook down into plain English. In many cases, you really don't need to know this stuff, but boy, will you sound impressive if you do.

The Tip icon points you to shortcuts that help you avoid doing more work than necessary. This icon also highlights ideas for creating better pictures and working around common digital photography problems.

When you see this icon, pay attention — danger is on the horizon. Read the text next to a Warning icon to keep yourself out of trouble and to find out how to fix things if you leaped before you looked.

Conventions Used in This Book

In addition to icons, *Digital Photography For Dummies* follows a few other conventions. When I want you to choose a command from a menu, you see the menu name, an arrow, and then the command name. For example, if I want you to choose the Cut command from the Edit menu, I write it this way: "Choose Edit⇨Cut."

Sometimes, you can choose a command more quickly by pressing two or more keys on your keyboard than by clicking your way through menus. I present these keyboard shortcuts like so: "Press Ctrl+A," which simply means to press and hold down the Ctrl key, press the A key, and then let up on both keys. Usually, I provide the PC shortcut first, followed by the Mac shortcut, if it's different.

What Do I Read First?

The answer depends on you. You can start with Chapter 1 and read straight through to the Index, if you like. Or you can flip to whatever section of the book interests you most and start there.

Digital Photography For Dummies is designed so that if you want to read it cover to cover, you can, and you'll have a mighty fine time doing so. But information is also presented in such a way that you can grasp the content in one section without having to read anything that comes before or after it. So if you need information on a particular topic, you can get in and out quickly, without having to wade through page after page of unrelated details.

The one thing this book isn't designed to do, however, is to insert its contents magically into your head. You can't just put the book on your desk or under your pillow and expect to acquire the information inside by osmosis — you have to put eyes to page and do some actual reading.

With our hectic lives, finding the time and energy to read is always easier said than done. But I promise that if you spend just a few minutes a day with this book, you'll increase your digital photography skills tenfold. Heck, maybe even elevenfold or twelvefold. Suffice it to say that you'll discover a whole new way to communicate, whether you're shooting for business, for pleasure, or for both.

Digital cameras are the next Big Thing. And with *Digital Photography For Dummies,* you get all the information you need in order to take advantage of this powerful new tool — quickly, easily, and with a few laughs along the way.

Part I
Peering through the Digital Viewfinder

The 5th Wave By Rich Tennant

SQUAD
ROOM

WANTED
WANTED WANTED
WANTED
WANTED WANTED
WANTED
WANTED

"It's the break we've been waiting for, Lieutenant.
The theives accidentally snapped a digital picture of
themselves during the camera heist."

In this part . . .

When I was in high school, the science teachers insisted that the only way to learn about different creatures was to cut them open and poke about their innards. In my opinion, dissecting dead things never accomplished anything other than giving the boys a chance to gross out the girls by pretending to swallow formaldehyde-laced body parts.

But even though I'm firmly against dissecting our fellow earthly beings, I am wholly in favor of dissecting new technology. It's my experience that if you want to make a machine work for you, you have to know what makes that machine tick. Only then can you fully exploit its capabilities.

To that end, this part of the book dissects the machine known as the digital camera. Chapter 1 looks at some of the pros and cons of digital photography, while Chapter 2 pries open the lid of a digital camera so that you can get a better understanding of how the thing performs its magic. Chapter 3 puts the magnifying glass to specific camera features, giving you the background you need to select the right camera for your photography needs. Chapter 4 provides the same kind of close inspection of camera accessories and digital imaging software.

All right, put on your goggles and prepare to dissect your digital specimens. And boys, no flinging camera parts around the room or sticking cables up your noses, okay? Hey, that means you, mister!

Chapter 1

Filmless Fun, Facts, and Fiction

· ·

· ·

I love hanging out in computer stores. I'm not a major geek — not that there's anything *wrong* with that — I just enjoy seeing what new gadgets I may be able to justify as tax write-offs.

You can imagine my delight, then, when digital cameras began showing up on the store shelves at a price that even my meager equipment budget could handle. Here was a device that not only offered time and energy savings for my business but, at the same time, was a really cool new toy for entertaining friends, family, and any strangers I could corral on the street.

If you, too, have talked your accountant, manager, or significant other into investing in a digital camera, I'd like to offer a hearty "way to go!" — but also a little word of caution. Before you hand over your money, be sure that you understand how this new technology works — and don't rely on the salesperson in your local electronics or computer superstore to fill you in. From what I've observed, many salespeople don't fully understand digital photography. As a result, they may steer you toward a camera that would be perfect for someone else but doesn't come close to meeting your needs.

Nothing's worse than a new toy, er, *business investment* that doesn't live up to your expectations. Remember how you felt when the plastic action figure that flew around the room in the TV commercial just stood there doing nothing after you dug it out of the cereal box? To make sure that you don't experience the same letdown with a digital camera, this chapter sorts out the facts from the fiction, explaining the pros and cons of digital imagery in general and digital cameras in particular.

Film? We Don't Need No Stinkin' Film!

As shown in Figure 1-1, digital cameras come in all shapes and sizes. (You can see additional camera designs in Chapter 3.) But although features and capabilities differ from model to model, all digital cameras are created to accomplish the same goal: to simplify the process of creating digital images.

When I speak of a *digital image,* I'm referring to a picture that you can view and edit on a computer. Digital images, like anything else you see on your computer screen, are nothing more than bits of electronic data. Your computer analyzes that data and presents the image to you on-screen. (For a more detailed look at how digital images work, check out Chapter 2.)

Digital images are nothing new — people have been creating and editing digital pictures using programs such as Adobe Photoshop and Corel PHOTOPAINT for years. But until the advent of digital cameras, the process of getting a stunning sunset scene or an endearing baby picture into digital form required some time and effort. After shooting the picture with a film camera, you had to get the film developed and then have the photographic print or slide *digitized*

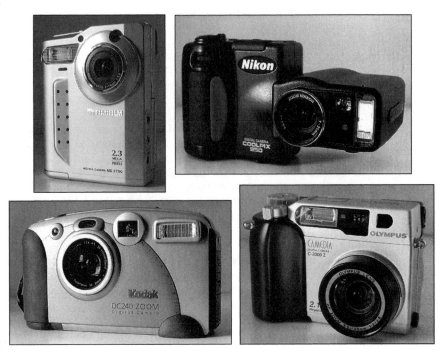

Figure 1-1: A sampling of digital cameras on the market today. Clockwise, from top left: Fuji MX-2700, Nikon Coolpix 950, Kodak DC240, and Olympus C-2000.

(that is, converted to a computer image) using a piece of equipment known as a *scanner.* Assuming that you weren't well-off enough to have a darkroom and a scanner in the east wing of your mansion, all this could take several days and involve several middlemen and associated middleman costs.

The film-and-scanner approach is still the most common way to create digital photographs. But digital cameras provide an easier, more convenient option. While traditional cameras capture images on film, digital cameras record what they see using computer chips and digital storage devices, creating images that can be immediately accessed by your computer. No film, film processing, or scanning is involved — you press the shutter button, and voilà: You have a digital image. To use the image, you simply transfer it from your camera to the computer, a process that can be accomplished in a variety of ways. With some cameras, you can send your pictures directly to a special photo printer — you don't even need a computer!

Fine, but Why Do I Want Digital Images?

Going digital opens up a world of artistic and practical possibilities that you simply don't enjoy with traditional photographic prints. Here are just a few advantages of working with digital images:

✔ You gain quality control over your pictures. With traditional photos, you have no input into an image after it leaves your camera. Everything rests in the hands of the photofinisher. But if you snap a digital photo, you can use image-editing software to touch up your pictures, if necessary. You can correct contrast and color-balance problems, improve a poorly focused shot, and crop out unwanted objects from the scene.

Figures 1-2 and 1-3 illustrate the point: The top image shows the original digital photo. In addition to being overexposed, the picture is poorly framed and contains some distracting background elements. Parts of another swimmer's leg and foot are visible near the top of the frame, and some other unidentified object juts into the picture on the left side of the frame.

I opened the picture in Adobe PhotoDeluxe, an entry-level image-editing program provided with many digital cameras, and after a few minutes of editing, took care of all these problems. I removed the intrusive background elements, adjusted the brightness and contrast, and then cropped the picture to eliminate some of the excess pool areas and frame the main subject better. You can see the much-improved picture in Figure 1-3.

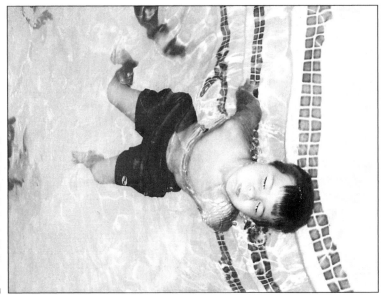

Figure 1-2: My original photo of this fledgling swimmer is over-exposed and poorly framed.

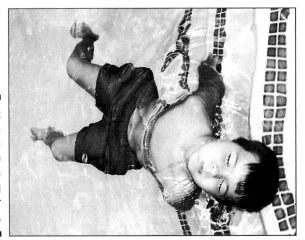

Figure 1-3: A little editing turns a so-so image into a compelling summer memory.

Some would say that I could have created the same image with a traditional camera, simply by paying attention to the background, exposure, and framing before I took the picture. But when you're photographing children and other fast-paced subjects, you have to shoot quickly. Had I

taken the time to make sure that everything was perfect before I recorded the image, I can guarantee you that my opportunity to capture this subject would have been long gone. I'm not saying that you shouldn't strive to shoot the best pictures possible, but if something goes awry, you often can rescue marginal images in the editing stage.

✔ You can send an image to friends, family members, and clients almost instantaneously by attaching it to an e-mail message. This capability is undoubtedly one of the biggest benefits of digital imagery. Journalists covering stories in far-off lands can get pictures to their editors moments after snapping the images. Salespeople can send pictures of products to prospective buyers while the sales lead is still red hot. Or, to pull an example from my own thrilling life, part-time antiques dealers can share finds with other dealers all over the world without so much as leaving their homes. When I needed some help identifying a Danish antique print, for example, I posted a message to an antiques newsgroup on the Internet. A gentleman in Denmark offered to help if I could send him a photograph of the print. No problem. I picked up a digital camera, took a picture of the print, sent the image off via e-mail, and had a response the next day. Is this a great age we live in, or what?

Again, you can achieve the same thing with print photographs and the postal service — and don't think we don't all love receiving the 5 x 7 glossy of your dog wearing the Santa hat every Christmas. But if you had a digital image of Sparky, you could get the picture to all interested parties in a matter of minutes, not days. Not only is electronic distribution of images quicker than regular mail or overnight delivery services, it's also more convenient. You don't have to address an envelope, find a stamp, or truck off to the post office or delivery drop box.

✔ You can include pictures of your products, your office headquarters, or just your pretty face on your company's site on the World Wide Web. One picture, as they say, is worth a thousand words, especially when you're trying to do business with people who live halfway across the planet. Chapter 9 explains everything you need to do to prepare your images for use on the Web.

✔ You can add sizzle to your multimedia presentations. Many presentation programs enable you to download pictures from digital cameras directly into an open presentation file. But you can display your photos to a large audience without ever launching a presentation program or even using a computer if you want. Most digital cameras on the market today offer a video connection so that you can play back your pictures on a TV and record them on a VCR. Some cameras offer a slide-show mode that displays all the pictures in the camera's memory, one by one, with just one press of a button. And a few cameras even enable you to record and play audio clips and text along with your pictures.

✔ You can include digital images in business databases. For example, if your company operates a telemarketing program, you can insert digital images of your products into the product order database so that when sales representatives pull up information about a certain product, they can see a picture of the product and describe it to customers. Or you may want to insert product shots into inventory spreadsheets, as I did in Figure 1-4.

✔ You can have a heck of a lot of fun exploring your artistic side. Using an image-editing program, you can apply wacky special effects, paint mustaches on your evil enemy, and otherwise distort reality. You can also combine several images into a photo montage, such as the one shown in Color Plates 12-3 and 12-4 and examined in Chapter 12.

✔ You can create your own personalized stationery, business cards, calendars, mugs, T-shirts, postcards, and other goodies, as shown in Figure 1-5. The figure offers a look at Adobe PhotoDeluxe, which is one of many consumer image-editing programs that provides templates for creating such materials. You just select the design you want to use and insert your own photos into the template. In the figure, I'm placing a picture of a house into a real-estate sales flier.

Figure 1-4:
You can insert digital images into spreadsheets to create a visual inventory record.

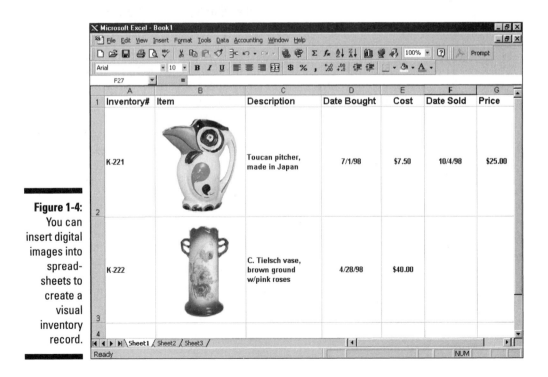

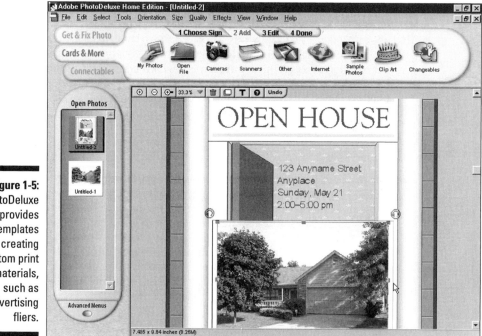

Figure 1-5:
PhotoDeluxe
provides
templates
for creating
custom print
materials,
such as
advertising
fliers.

After you place your photos into the templates, you can print your artwork on a color inkjet printer using specialized print media sold by Kodak, Epson, Hewlett-Packard, and other vendors. If you don't have access to a printer with this capability, you can get the job done at a local quick-copy shop or e-mail your image to one of the many vendors offering digital printing services via the Internet.

These advantages are just some of the reasons digital photography is catching on so quickly. For convenience, quality control, flexibility, and efficiency, digital does a slam dunk on film.

Now Tell Me the Downside

As wonderful as digital photography may be, the technology is not without its drawbacks. In the interest of fairness, the following list discusses some of the problems facing digital photographers:

✔ One problem with digital images is print quality. Manufacturers have accomplished great things in this regard over the past two years; for about $300, you can now buy photo printers that produce results startlingly close to traditional film prints. But to get that kind of quality, you need a high-resolution digital camera, which costs a minimum of $300. Lower-priced cameras deliver lower-resolution images, which just don't contain enough picture information to produce decent prints at anything but very small sizes — a maximum of about 3 inches wide by 2 ½ inches tall. (See Chapter 2 for a complete explanation of resolution and how it affects your print quality.) Low-res images are perfectly okay for on-screen display in a Web page or multimedia presentation, however.

✔ Images from lower-priced digital cameras often require a little touch-up work to correct problems with color balance, focus, and contrast. High-end cameras deliver better images — depending on the photographer's skills, of course — but also need a little help at times. Fortunately, today's image-editing programs make easy work of these types of corrections, and most digital cameras ship with image-editing software. You can read more about image editing in Chapters 10 through 12, and the CD accompanying this book provides demos and trial versions of some popular image-editing programs.

✔ After you press the shutter button on a digital camera, the camera requires a few seconds to store the image in its memory. During that time, you can't shoot another picture. With some cameras, you also experience a slight delay between the time you press the shutter button and the time the camera actually captures the image.

These pre- and post-exposure lag times can be a problem when you're trying to capture action-oriented events, such as a tennis match.

Generally speaking, the more current and more expensive the camera, the less lag time you encounter. With some of the new, top-flight models, lag time isn't much more than you experience with a point-and-shoot film camera using an automatic film advance.

Many digital cameras also offer a burst or continuous-capture mode that enables you to take a series of pictures with one press of the shutter button. This mode is helpful in some action scenarios, although you're typically restricted to capturing these sequential images at a low resolution or without a flash. Chapter 6 provides more information on this feature.

✔ Becoming a digital photographer does involve learning some new concepts and skills. If you're familiar with a computer, you shouldn't have much trouble getting up to speed with digital images. If you're a novice to both computers and digital cameras, expect to spend a fair amount of time making friends with your new machines. A digital camera may look

and feel like your old film camera on the surface, but underneath, it's a far cry from your father's Kodak Brownie. This book guides you through the process of becoming a digital photographer as painlessly as possible, but you do need to be willing to invest the time to read the information it contains.

As manufacturers continue to refine digital imaging technology, you can expect continued improvements in quality and image-capture functions. I'm less hopeful that anything involving a computer will become easier to learn in the near future; my computer still forces me to "learn" something new every day — usually, the hard way. Of course, becoming proficient with film cameras requires some effort as well.

Whether or not digital will completely replace film as the foremost photographic medium remains to be seen. In all likelihood, the two mediums will each secure their niche in the image world. So make a place for your new digital camera in your camera bag, but don't stick your film camera in the back of the closet just yet. Digital photography and film photography each offer unique advantages and disadvantages, and choosing one option to the exclusion of the other limits your creative flexibility.

Just Tell Me Where to Send the Check . . .

Digital photography equipment was once priced out of range of all but professional photographers and graphics studios. But over the past few years, prices of cameras, printers, and other necessary equipment have fallen dramatically, making this new art form available to ordinary folks like you and me.

Still, digital photography isn't cheap. If you're starting from scratch — that is, you don't even have a computer yet — you can expect to spend around $1,500 for a basic digital photography setup (computer, camera, monitor, and printer). Add several hundred more if you need a high-resolution camera or want a super-fast, high-powered computer.

But digital photography offers some money-saving benefits to offset the expenses. For example, with a digital camera, you can experiment without worrying about the cost of film and processing. You can snap a picture, and if you don't like the image you capture, you simply delete it. No harm, no foul. If you're a prolific photographer, this capability alone can add up to significant savings over time.

The following sections outline the various costs involved in going digital. Prices mentioned here are valid as of the time of printing — by the time you read this book, prices may have dropped even further. (Don't you wish *everything* would keep coming down in price the way computer technology does?)

Cameras

You no longer need a pot of gold to buy a digital camera. In fact, you can get a bare-bones model such as the JamCam, from KB Gear, for less than $100. But models in this price range produce very low-resolution images, suitable for Web pictures and other on-screen uses only. They also lack several convenience features, such as removable image storage and a monitor for reviewing pictures without downloading them to a computer.

Expect to spend anywhere from $300 to $900 for a camera that can generate quality prints and includes a flash, a good lens, monitor, removable storage, and other features that you'll want if you plan to use your camera on a regular basis. Cameras at the high end of the price spectrum offer features that professional photographers and advanced photo hobbyists enjoy, such as controls for manually selecting shutter speed and aperture. But if you don't need or want all the photographic bells and whistles, you'll be more than happy with a camera in the $300 to $600 price range.

Image-processing and printing equipment

On top of the camera itself, digital photography involves a slew of peripheral hardware and software, not the least of which is a fairly powerful computer for viewing, storing, editing, and printing your images. You need a machine with a robust processor, at least 32MB of RAM, and a big hard drive with lots of empty storage space.

Unless you have a better source than I do, the very least you can expect to spend on such a system is about $800. Some manufacturers and stores now offer you a "free" computer if you agree to pay for their Internet service for two or three years. These systems work out fine for some users; just be sure that the system offers the best set of features for the price.

Getting your images from computer to paper requires an additional investment. Color printers marketed to home and small-office users range in price from $100 to $500, but the lower-priced models typically don't do a hot job of printing digital images. The magic price point for good quality printers is currently about $300.

In addition, you need to factor in the cost of image-editing software, image storage and transfer devices, special paper for printing your photos, camera batteries — and digital cameras suck up battery life like you wouldn't believe — and other peripherals. If you're a real photography buff, you'll probably also want to buy special lenses, lights, a tripod, and some of the other bells and whistles. Chapter 4 gives you a rundown of the digital photography peripherals that are either essential, helpful, or just cool to own.

Nope, setting up a digital darkroom isn't cheap. Then again, neither is traditional film photography, if you're a serious photographer. And when you consider all the benefits of digital imagery, especially if you do business nationally or internationally, justifying the expense isn't all that difficult. Just in case you're getting queasy, however, look in Chapters 3 and 4 for more details on the various components involved in digital photography — plus some tips on how to cut budgetary corners when possible.

Chapter 2

Mr. Science Explains It All

● ●

In This Chapter

▶ Understanding how digital cameras record images

▶ Visualizing how your eyes — and digital cameras — see color

▶ Perusing a perfectly painless primer on pixels

▶ Exploring the murky waters of resolution

▶ Analyzing the undying relationship between resolution and image size

▶ Looking at f-stops, shutter speeds, and other aspects of image exposure

▶ Exposing color models

▶ Diving into bit depth

● ●

*I*f discussions of a technical or scientific nature make you nauseated, keep a supply of a stomach-soothing potion handy while you read this chapter. The following pages are chock-full of the kind of technical babble that makes science teachers and engineers drool but leaves us ordinary mortals feeling motion-sick.

Unfortunately, you can't be a successful digital photographer without getting acquainted with the science behind the art. But never fear: This chapter provides you with the ideal lab partner as you explore such important concepts as pixels, resolution, f-stops, bit depth, and more. Sorry, you don't dissect pond creatures or analyze the cell structure of your fingernails in this science class, but you do get to peel back the skin of a digital camera and examine the guts of a digital image. Neither exercise is for the faint of heart, but both are critical for understanding how to turn out quality images.

From Your Eyes to the Camera's Memory

A traditional camera creates an image by allowing light to pass through a lens onto film. The film is coated with light-sensitive chemicals, and wherever light hits the coating, a chemical reaction takes place, recording a latent image. During the film development stage, more chemicals transform the latent image into a printed photograph.

Digital cameras also use light to create images, but instead of film, digital cameras capture images using an *imaging array,* which is a fancy way of saying "light-sensitive computer chips." Currently, these chips come in two flavors: CCD, which stands for *charge-coupled device,* and CMOS, which is short for *complementary metal-oxide semiconductor.* (No, Billy, that information won't be on the test, so you can safely forget it right now.)

Although CCD and CMOS chips differ in some important ways, which you can read about in Chapter 3, both chips do essentially the same thing. When struck by light, they emit an electrical charge, which is analyzed and translated into digital image data by a processor inside the camera. The more light, the stronger the charge.

After the electrical impulses are converted to image data, the data is saved to the camera's memory, which may come in the form of an in-camera chip or a removable memory card or disk. To access the images that your camera records, you just transfer them from the memory to your computer. With some cameras, you can transfer images directly to a television monitor or printer, enabling you to view and print your photographs without ever turning on your computer.

Keep in mind that what you've just read is the basic explanation of how digital cameras record images. I could write an entire chapter on the different types of CCD designs, for example, but you would only wind up with a big headache. Besides, the only time you need to think about this stuff at all is when deciding which camera to buy. Chapters 3, 4, and 7 explain the important aspects of imaging chips, memory, and image transfer so that you can make a sensible purchase decision without filling up your head with unnecessary technobabble.

The Secret to Living Color

Like traditional film cameras, digital cameras create images by reading the amount of light and darkness in a scene. But how does the camera translate that brightness information into the colors you see in the final image? As it turns out, a digital camera does the job pretty much the same way as the human eye.

To understand how digital cameras — and your eyes — perceive color, you first need to know that light can be broken down into three primary colors: red, green, and blue. Inside your eyeball, you have three receptors corresponding to those colors. Each receptor measures the brightness of the light for its particular color. The red receptor senses the amount of red light, the green receptor senses the amount of green light, and the blue receptor senses the amount of blue light. Your brain combines the information from the three receptors into one multicolored image in your head.

Because most of us didn't grow up thinking about mixing red, green, and blue light to create color, this concept can be a little hard to grasp. Here's an analogy that may help.

Imagine that you're standing in a darkened room and have one flashlight that emits red light, one that emits green light, and one that emits blue light. If you point all the flashlights at one spot, you end up with white light. Remove all the lights, and you get black. And by turning the beam of each light up or down so that you produce a higher- or lower-intensity beam, you can create just about every color of the rainbow.

Just like your eyes, a digital camera captures the light intensity — sometimes referred to as the *brightness value* — of the red, green, and blue light. Then it records the brightness values for each color in separate portions of the image file. Digital imaging professionals refer to these vats of brightness information as *color channels*. After recording the brightness values, the camera mixes them together to create the full-color image.

Images created using these three primary colors of light are known as *RGB images* — for red, green, and blue. Computer monitors, television sets, and scanners also create images by combining red, green, and blue light, by the way.

In sophisticated image-editing programs such as Adobe Photoshop, you can view and edit each color channel independently of the others. Figure 2-1 and Color Plate 2-1 show a color image broken down into its red, green, and blue color channels. Notice that each color channel contains nothing more than a grayscale image. That's because the camera records only light — or the absence of it — for each color channel.

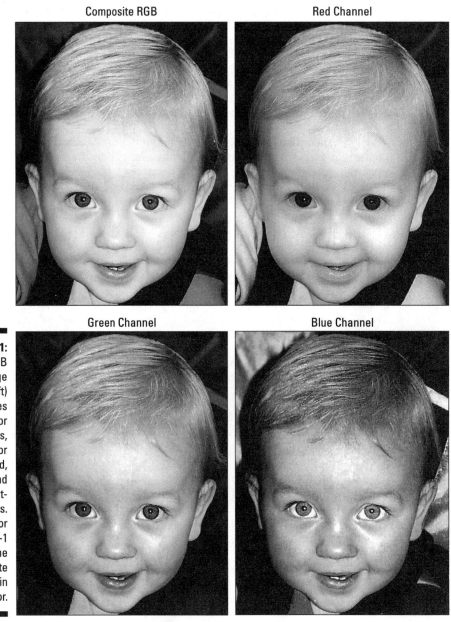

Figure 2-1: An RGB image (top left) comprises three color channels, one each for storing red, green, and blue brightness values. Color Plate 2-1 shows the composite image in full color.

At the risk of confusing the issue, I should point out that not all digital images contain three channels. If you convert an RGB image to a grayscale image inside an image editor, for example, the brightness values for all three color channels are merged together into one channel. And if you convert the image to the *CMYK color model* in preparation for professional printing, you end up with four color channels, one corresponding to each of the four primary colors of ink (cyan, magenta, yellow, and black). For more on this intriguing topic, see "RGB, CMYK, and Other Colorful Acronyms," later in this chapter.

Don't let this color channel stuff intimidate you — until you become a seasoned image editor, you probably will never need to think twice about channels. I bring them up only so that when you see the term *RGB* bandied about — and it's bandied about a lot — you have some idea what's going on.

Resolution Rules!

Without a doubt, the number one thing you can do to improve the quality of your digital images is to understand the concept of *resolution*. Unless you make the right choices about resolution, your images will be a disappointment, no matter how captivating the subject, how perfect the setting, or how ideal the lighting conditions.

In other words, don't skip this section!

Pixels: The building blocks of every image

Have you ever seen the painting "A Sunday Afternoon on the Island of La Grande Jatte," by the French artist Georges Seurat? Seurat was a master of a technique known as *pointillism,* in which scenes are composed of millions of tiny dots of paint, created by dabbing the canvas with the tip of a paintbrush. When you stand across the room from a pointillist painting, the dots blend together, forming a seamless image. Only when you get up close to the canvas can you distinguish the individual dots.

Digital images work something like pointillist paintings. Rather than being made up of dots of paint, however, digital images are composed of tiny squares of color known as *pixels.* The term *pixel* is short for *picture element.* Don't you wish you could get a job thinking up these clever computer words?

If you magnify an image on-screen, you can make out the individual pixels, as shown in Figure 2-2. Zoom out on the image, and the pixels seem to blend together, just as when you step back from a pointillist painting.

Figure 2-2: Zooming in on an image enables you to see the individual pixels.

Image resolution and image quality

Every digital image is born with a set number of pixels. Low-end digital cameras typically create images that are 640 pixels wide and 480 pixels tall, for example.

Some people use the term *pixel dimensions* to refer to the number of pixels in an image — number of pixels wide by number of pixels high. Others use the term *image size,* which can lead to confusion because that term is also used to refer to the physical dimensions of the image (inches wide by inches tall, for example). For the record, I use *pixel dimensions* to refer specifically to the pixel count and *image size* to mean the physical dimensions.

Resolution refers to the number of pixels per inch (ppi) in your image. Resolution has a major effect on the quality of your image, especially when printed. The more pixels per inch, the crisper the image, as illustrated by Figures 2-3 through 2-5. The first image has a resolution of 300 pixels per inch, or *ppi;* the second has a resolution of 150 ppi; and the third has a resolution of 75 ppi. For living-color examples of these three images, see Color Plate 2-2.

Figure 2-3:
A grayscale image with a resolution of 300 ppi looks crisp and terrific.

Figure 2-4:
When the resolution of the image in Figure 2-3 is reduced to 150 ppi, the image loses some sharpness and detail.

Figure 2-5:
Reducing the resolution of the image in Figure 2-4 to 75 ppi results in significant image degradation.

Note that resolution is measured in terms of pixels per *linear* inch, not square inch. So a resolution of 72 ppi means that you have 72 pixels horizontally and 72 pixels vertically, or 5184 pixels for each square inch of image.

Why does the 75-ppi image in Figure 2-5 look so much worse than its 150-ppi counterpart in Figure 2-4? For one thing, the pixels are bigger. After all, if you divide an inch into 75 squares, the squares are significantly larger than if you divide the inch into 150 squares. And the bigger the pixel, the easier it is for your eye to figure out that it's really just looking at a bunch of squares.

If you look closely at one particular element of the figures — the black border around the edges — you can get a clearer idea of how resolution affects pixel size. Each image sports a 2-pixel border. But the border in Figure 2-5 is twice as thick as the one in Figure 2-4, because a pixel at 75 ppi is twice as large as a pixel at 150 ppi. Similarly, the border around the 150-ppi image in Figure 2-4 is twice as wide as the border around the 300-ppi image in Figure 2-3.

But a change in pixel size isn't the only reason lower-resolution images look worse than high-resolution photos. You see, a pixel can be one color and one color only — you can't have a pixel that's light blue in one area and dark blue in another. With fewer pixels, you have fewer distinct blocks of color to represent your scene, which means that small image details get lost.

How many pixels are enough?

"Okay," you're thinking, "so if higher resolution means better-looking images, I want all my images to have lots and lots of pixels, right?" Well, sometimes yes, and sometimes no.

The number of pixels you need depends on how you want to use an image. For on-screen use, such as placing the image on a Web page, a resolution of 72 to 96 ppi is plenty, because most monitors aren't set up to display any more pixels per inch anyway. This fact is great news for digital photographers with low budgets, because even the most inexpensive digital camera captures enough pixels to cover a large expanse of on-screen real estate at 72 ppi. (Read "More mind-boggling resolution stuff," later in this chapter, for more information about screen display; also, refer to Chapter 9 for specifics on how to size your images for the screen.)

But if you plan on printing your image and you want the best output quality possible, you need an image resolution in the neighborhood of 300 ppi. This number can vary depending on the printer; sometimes you can get by with fewer pixels, and sometimes you need a little more than 300 ppi. Check your printer manual for precise resolution guidelines, and see Chapter 8 for additional printing information.

To determine the maximum size at which you can produce an image at a particular resolution, just divide the total number of image pixels across by the desired resolution. Or divide the total number of pixels down by the desired resolution. Say that your camera captures 1280 pixels across by 960 pixels wide. If your target resolution is 300 ppi, divide 1280 by 300 to get the maximum image width — in this case, about 4.25 inches. Or to find out the maximum height, divide 960 by 300, which equals about 3.25 inches. So you can print a 4.25 x 3.25 inch image at 300 pixels per inch. At 72 pixels per inch, that same image measures about 17.75 x 13.25 inches.

Because I've hammered home the point that more pixels means better print quality, you may think that if 300 ppi delivers good print quality, higher resolutions produce even better quality. But this isn't the case. In fact, exceeding that 300-ppi ceiling can degrade image quality. Printers are engineered to work with images set to a particular resolution, and when presented with an image file at a higher resolution, most printers simply eliminate the extra pixels. Printers don't always do a great job of slimming down the pixel population, and the result can be muddy or jagged photos. You get better results if you do the job yourself in your image editor, as discussed later, in "So how do I control pixels and resolution?"

Additionally, too many pixels means bloated file sizes, as explained next.

More pixels means bigger files

Each pixel in a digital image adds to the size of the image file. For a point of comparison, the top image in Color Plate 2-2 measures 853 pixels wide by 600 pixels tall, for a total pixel count of 511,800. This file consumes roughly 935K (kilobytes) of storage space.

By contrast, the bottom image measures 213 pixels wide by 150 pixels tall, for a total of 31,950 pixels. This low-resolution image consumes just 75K.

In addition to eating up storage space, large image files make big demands on the computer memory (RAM) when you edit them. Typically, the RAM requirement is roughly three times the file size. And when placed on a Web page, huge image files are a major annoyance. Every kilobyte of data increases the time required to download the file.

To avoid straining your computer — and the patience of Web site visitors — keep your images lean and mean. You want the appropriate number of pixels to suit your final output device (screen or printer), but no more. You can find out more details on preparing images for print in Chapter 8 and read about designing pictures for screen use in Chapter 9.

So how do I control pixels and resolution?

When you open an image from your digital camera, your image-editing software assigns a default image resolution, which is typically either 72 ppi or 300 ppi. If you want to raise or lower the resolution, you have two options: resampling or resizing your image.

Resampling: The dangerous way to change resolution

One way to increase or decrease image resolution — in other words, to change the number of pixels per inch — is to have your image-editing software add or delete pixels, a process known as *resampling.* Image-editing gurus refer to the process of adding pixels as *upsampling,* and deleting pixels as *downsampling.*

Upsampling sounds like a good idea — if you don't have enough pixels, you just go to the Pixel Mart and fill up your basket, right? The problem is that when you add pixels, the image-editing software simply makes its best guess as to what color, saturation, and brightness to make the new pixels. And even high-end image-editing programs using sophisticated calculations don't do a very good job of pulling pixels out of thin air, as illustrated by Figure 2-6.

Figure 2-6:
The result of
upsampling
the 75-ppi
image from
Figure 2-5 to
300 ppi.

To create this figure, I started with the 75-ppi image shown in Figure 2-5 and resampled the image to 300 ppi in Adobe Photoshop, one of the best image-editing programs available. Compare this new image with the 300-ppi version in Figure 2-3, and you can see just how poorly the computer does at adding pixels. With some images, you can get away with minimal upsampling — say, 10 to 15 percent — but with other images, you notice a quality loss with even slight pixel infusions. Images with large, flat areas of color tend to survive upsampling better than pictures with lots of intricate details.

If your image contains too many pixels, which is often the case for pictures that you want to use on the Web, you can safely delete pixels (downsample).

But keep in mind that every pixel you throw away contains image information, so too much pixel-dumping can degrade image quality. Try not to downsample by more than 25 percent, and always make a backup copy of your image in case you ever want those original pixels back.

For step-by-step instructions on how to alter your pixel count, see the section related to sizing images for on-screen display in Chapter 9.

Resizing: The better way to adjust resolution

A much better way — in fact, the only completely *safe* way — to change the image resolution is to resize the image *while maintaining the original pixel count*. If you reduce the size of the image, the pixels shrink and move closer together in order to fit into their new boundaries. If you enlarge the image, the pixels puff themselves up and spread out to fill in the expanded image area.

Say that you have a 4 x 3 image set to a resolution of 300 ppi. If you double the image size, to 8 x 6, the resolution is cut in half, to 150. Naturally, the lower resolution reduces your print quality, for reasons explained earlier in this chapter (see "Image resolution and image quality"). Conversely, if you reduce the image size by half, to 2 x 1.5, the resolution is doubled, to 600 ppi, and your print quality should improve.

Because reducing your image size is the only non-damaging way to increase image resolution, capture your digital pictures using the camera setting that results in a pixel count at or above what you need for your final output. If you wind up with extra pixels, you can delete them as necessary. But you can't rely on being able to add pixels after the fact with any degree of success.

For specific steps involved in adjusting resolution in this manner, see the Chapter 8 section on sizing photos for print.

Not all image-editing programs enable you to maintain your original pixel count when resizing images. Programs that don't provide this option typically automatically resample your image whenever you resize your photo, so be careful. Check your program's help system or manual to get details on your resizing and resolution controls. If you don't find any specific information, you can test the program by making a copy of a picture and then enlarging the copy. If the file size of the enlarged picture is bigger than the file size of the original, the program added pixels to your image.

More mind-boggling resolution stuff

As if sorting out all the pixel, resampling, and other image resolution stuff discussed in the preceding sections isn't challenging enough, you also need to be aware that *resolution* doesn't always refer to image resolution as just

described. The term is also used to describe the capabilities of digital cameras, monitors, scanners, and printers. So when you hear the word *resolution,* keep the following facts in mind:

✔ Digital camera manufacturers often use the term *resolution* to describe the number of pixels in the images produced by their cameras. A camera's stated resolution might be 640 x 480 pixels or 1.3 million pixels, for example. But those values refer to the pixel dimensions or total pixels a camera can produce, not the number of pixels per inch in the final image. *You* determine that value in your image-editing software. Of course, you can use the camera's pixel count to figure out the final resolution you can achieve from your images, as described earlier in "How many pixels are enough?"

Some vendors use the term *VGA resolution* to indicate a 640 x 480-pixel image, *XGA resolution* to indicate a 1024 x 768-pixel image, and *megapixel resolution* to indicate a total pixel count of 1 million or more.

✔ The same resolution distinction applies to computer monitors. Manufacturers use the word *resolution* to describe the number of pixels the monitor can display. Most monitors enable you to choose from display settings of 640 x 480 pixels (again, often referred to as VGA resolution), 800 x 600 pixels, or 1024 x 768 pixels (XGA). Some monitors can display even more pixels. The number of pixels per inch depends on the physical size of your screen and the display setting you choose.

Most Macintosh monitors leave the factory with a display setting that translates to 72 pixels per inch. PC monitors are usually set to display 96 pixels per inch. These values become important when you're sizing images for on-screen use; see Chapter 9 for details.

✔ Scanner vendors describe scanner capabilities in terms of resolution, too. In this case, resolution is usually stated in the same terms as image resolution, thankfully. A low-end scanner typically captures a maximum of 300 or 600 pixels per inch.

By the way, if you're scanner shopping, pay attention to *optical* resolution, which is a scanner's "real" resolution. Many scanner models make a big deal about offering a high *interpolated* or *enhanced* resolution, but that higher resolution is the result of upsampling from the model's optical (true) resolution. If the importance of that fact is lost on you, read the earlier section, "Resampling: The dangerous way to change resolution," earlier in this chapter. Or just remember this: The optical resolution value is the important measure of a scanner's capabilities.

✔ Printer manufacturers also refer to their machines' capabilities in terms of resolution. Printer resolution is measured in terms of *dots per inch,* or *dpi,* rather than pixels per inch. But the concept is similar: Printed images are made up of tiny dots of color, and dpi is a measurement of how many dots per inch the printer can produce.

In general, the higher the dpi, the smaller the dots, the better looking the printed image. But, as discussed in Chapter 8, gauging a printer solely by dpi can be misleading. Different printers use different printing technologies, some of which result in better images than others do. So some 300-dpi printers can actually deliver better results than some 600-dpi printers.

Some people (including some printer manufacturers and image-editing software companies) mistakenly interchange dpi and ppi, which leads many users to think that they should set their image resolution to match their printer resolution. *But a printer dot is not the same thing as an image pixel.* Most printers use multiple printer dots to reproduce one image pixel. Every printer is geared to handle a specific image resolution, so you need to check your computer manual for the right image resolution for your model. See Chapter 8 for more information on printing and different types of printers.

What all this resolution stuff means to you

Head starting to hurt? Mine, too. So to help you sort out all the information you accumulated by reading the preceding sections, here's a brief summary of resolution matters that matter most:

- Number of pixels across (or down) ÷ image width (or height) = image resolution (ppi). For example, 600 horizontal pixels divided by 2 inches equals 300 ppi.

- For good-quality prints, strive for a resolution of 300 ppi. Chapter 8 provides in-depth information on this topic.

- For on-screen display, 72 to 96 ppi is appropriate. However, when sizing images for the screen, you're better off thinking in terms of pixel dimensions than image resolution. See Chapter 9 for specifics.

- Enlarging a picture can reduce image quality. When you enlarge an image, one of two things has to happen — either the pixels expand to fit the new image boundaries, or the pixels stay the same size and the image-editing software adds pixels to fill in the gaps. Either way, your image quality can suffer.

- To safely raise the resolution of an existing image, reduce the image size. As I just stated, adding pixels to raise the image resolution rarely delivers good results. Instead, retain the existing number of pixels and reduce the physical dimensions of the image, if your image-editing program offers this option. Chapter 8 provides the complete scoop on resizing images in this manner.

- Set your camera to capture a pixel count at or above what you need for your final picture output. Most cameras enable you to capture images at several different pixel dimensions. Remember, you can safely toss away pixels if you want a lower image resolution later, but you can't add pixels

without risking damage to your image. Also, you may need a low-resolution image today — for example, if you want to display a picture on the Web — but you may decide later that you want to print the image at a larger size, in which case you're going to need those extra pixels. For more on this issue, see Chapter 6.

✔ More pixels means a bigger image file. And even if you have tons of file-storage space to hold all those huge images, bigger isn't always better. Large images require a ton of RAM to edit and increase the time your image-editing software needs to process your edits. On a Web page, large image files mean long download times, which aggravate visitors to your site. Finally, sending more pixels to the printer than are needed usually produces worse, not better, prints. If your image has a higher resolution than required by the output device (printer or monitor), see Chapter 9 for information on how to dump the excess pixels.

Lights, Camera, Exposure!

Whether you're working with a digital camera or a traditional film camera, the brightness or darkness of the image is dependent on *exposure* — the amount of light that hits the film or image-sensor array. The more light, the brighter the image. Too much light results in a washed-out, or *overexposed,* image; too little light, and the image is dark, or *underexposed.*

Many digital cameras, like many point-and-shoot film cameras, don't give you much control over exposure; everything is handled automatically for you. But some cameras offer a few different automatic exposure settings, and a few higher-end cameras even provide you with manual exposure control.

Regardless of whether you're shooting with an automatic model or one that offers manual controls, you should be aware of the different factors that affect exposure — including shutter speed, aperture, and ISO rating — so that you can understand the limitations and possibilities of your camera.

Aperture, f-stops, and shutter speeds: The traditional way

Before taking a look at how digital cameras control exposure, it helps to understand how a film camera does the job. Even though digital cameras don't function in quite the same way as a film camera, manufacturers describe their exposure control mechanisms using traditional film terms, hoping to make the transition from film to digital easier for experienced photographers.

Figure 2-7 shows a simplified illustration of a film camera. Although the specific component design varies depending on the type of camera, all film cameras include some sort of *shutter,* which is placed between the film and the lens. When the camera isn't in use, the shutter is closed, preventing light from reaching the film. When you take a picture, the shutter opens, and light hits the film. (Now you know why the little button you press to take a picture is called the *shutter button* and why people who take lots of pictures are called *shutterbugs.*)

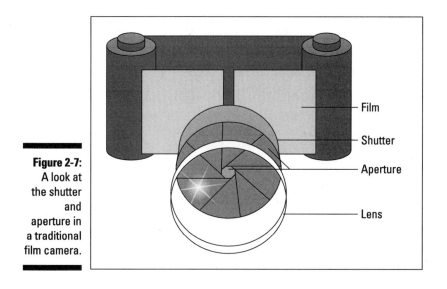

Figure 2-7:
A look at the shutter and aperture in a traditional film camera.

Film

Shutter

Aperture

Lens

You can control the amount of light that reaches the film in two ways: by adjusting the amount of time the shutter stays open (referred to as the *shutter speed*) and by changing the *aperture.* The aperture, labeled in Figure 2-7, is a hole in an adjustable diaphragm set between the lens and the shutter. Light coming through the lens is funneled through this hole to the shutter and then onto the film. So if you want more light to strike the film, you make the aperture bigger; if you want less light, you make the aperture smaller.

The size of the aperture opening is measured in *f-numbers,* more commonly referred to as *f-stops.* Standard aperture settings are f/1.4, f/2, f/2.8, f/4, f/5.6, f/8, f/11, f/16, and f/22.

Contrary to what you may expect, the larger the f-stop number, the smaller the aperture and the less light that enters the camera. Each f-stop setting lets in half as much light as the next smaller f-stop number. For example, the camera gets twice as much light at f/11 as it does at f/16. (And here you were complaining that computers were confusing!) See Figure 2-8 for an illustration that may help you get a grip on f-stops.

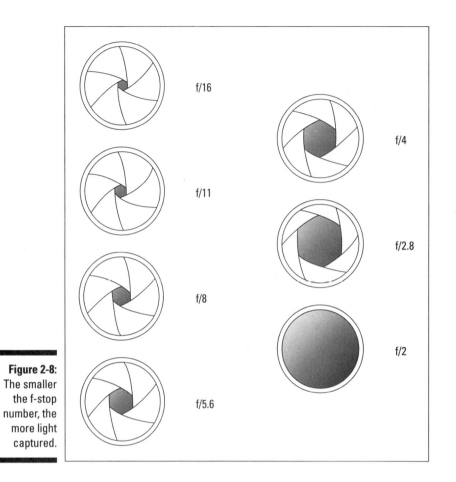

Shutter speeds, thankfully, are measured in more obvious terms: fractions of a second. A shutter speed of ⅛, for example, means that the shutter opens for ⅛ second. That may not sound like much time, but in camera years, ⅛ second is in fact a *very* long period. Try to capture a moving object at that speed and you wind up with a big blur. You need a shutter speedof about ½₀₀ to capture action clearly.

On cameras that offer aperture and shutter speed control, you manipulate the two settings in tandem to capture just the right amount of light. For example, if you are capturing fast action on a bright, sunny day, you can combine a fast shutter speed with a small aperture (high f-stop number). To shoot the same picture at twilight, you need a wide-open aperture (small f-stop number) in order to use the same fast shutter speed.

Aperture, shutter speed, and f-stops: The digital way

As with a film camera, the exposure of a picture shot with a digital camera depends on the amount of light that the camera captures. But some consumer-level digital cameras don't use a traditional shutter/aperture arrangement to control exposure. Instead, the chips in the image-sensor array simply turn on and off for different periods of time, thereby capturing more or less light. In some cameras, exposure is also varied — either automatically or by some control the user sets — by boosting or reducing the strength of the electrical charge that a chip emits in response to a certain amount of light.

Even on cameras that use this alternative approach to exposure control, however, the camera's capabilities are usually stated in traditional film-camera terms. For example, you may have a choice of two exposure settings, and those settings may be labeled with icons that look like the aperture openings shown in Figure 2-8. The settings are engineered to deliver the *equivalent* exposure that you would get with a film camera using the same f-stop.

So regardless of whether your camera uses the old-fashioned shutter/aperture setup or some fancy electrical footwork to arrive at exposure, you need to be familiar with the concepts of f-stops and shutter speeds. (So go back and read the preceding section, if you haven't done so yet.)

Aperture and shutter speeds aren't the only factors involved in image exposure, however. The sensitivity of the image-sensor array also plays a role, as explained next.

ISO ratings and chip sensitivity

Pick up a box of film, and you should see an ISO number; film geared to the consumer market typically offers ratings of ISO 100, 200, or 400. This number tells you how sensitive the film is to light. The ISO number is also referred to as the *film speed.* The higher the number, the more sensitive the film, or if you prefer photography lingo, the *faster* the film. And the faster the film, the less light you need to capture a decent image. The advantage of using a faster film is that you can use a faster shutter speed and shoot in dimmer lighting than you can with a low-speed film.

Most digital camera manufacturers also provide an ISO rating for their cameras. This number tells you the *equivalent* sensitivity of the chips on the image-sensor array. In other words, the value reflects the speed of film you'd be using if you were using a traditional camera rather than a digital camera. Typically, consumer-model digital cameras have an equivalency of ISO 100.

I bring all this up because it explains why digital cameras need so much light to produce a decent image. If you were really shooting with ISO 100 film, you would need a wide-open aperture or a slow shutter speed to capture an image in low lighting — assuming that you weren't aiming for the ghostly-shapes-in-a-dimly-lit-cave effect on purpose. The same is true of digital cameras.

A few new, higher-end consumer digital cameras enable you to choose from a few different ISO settings. Unfortunately, raising the ISO setting on most digital cameras doesn't give you the same shooting advantages that you get when selecting a faster film in a traditional camera. When you raise the ISO setting on your digital camera, the camera simply boosts the electronic signal that's produced when you snap a picture to increase the camera's reaction to light. Often, the extra signal power results in electronic "noise" that can create specks and other flaws in your image.

RGB, CMYK, and Other Colorful Acronyms

If you read "The Secret to Living Color" earlier in this chapter, you already know that cameras, scanners, monitors, and television sets are called *RGB devices* because they create images by mixing red, green, and blue light. When you edit images, you also mix red, green, and blue light to create the colors you apply with the image-editing program's painting tools.

But RGB is just one of many color-related acronyms and terms you may encounter on your image-editing adventures. So that you aren't confused when you encounter these buzzwords, the following list offers a brief explanation:

- ✔ **RGB:** Just to refresh your memory, RGB stands for *red, green,* and *blue.* RGB is the *color model* — that is, method for defining colors — used by digital images, as well as any device that transmits or filters light.

 Image-editing gurus also use the terms *color space* when discussing a color model, something they do with surprising frequency.

- ✔ **sRGB:** A variation of the RGB color model, sRGB offers a smaller *gamut,* or range of colors, than RGB. One reason this color model was designed was to improve color matching between on-screen and printed images. Because RGB devices can produce more colors than printer inks can reproduce, limiting the range of available RGB colors helps reduce the possibility that what you see on-screen isn't what you get on paper. The sRGB color model also aims to define standards for on-screen colors so that images on a Web page look the same on one viewer's monitor as they do on another. The sRGB color model is a topic of much debate right now. Many image-editing purists hate sRGB; others see it as a

necessary solution to the color-matching problem. For practical purposes, though, most users don't need to worry about the distinction between RGB and sRGB. If you're a high-end user working in Photoshop 5 or some other professional image editor, you can specify whether you want to edit your images in RGB or sRGB, but otherwise, the image-editing software makes the decision for you, behind the scenes.

✔ **CMYK:** While light-based devices mix red, green, and blue light to create images, printers mix primary colors of ink to emblazon a page with color. Instead of red, green, and blue, however, commercial printers use cyan, magenta, yellow, and black ink. Images created in this way are called CMYK images (the *K* is used to represent black because everyone figured B could be mistaken for blue, and commercial printers refer to the black printing plate as the Key plate). Four-color images printed at a commercial printer need to be converted to the CMYK color mode before printing. (See Chapter 8 for more information on CMYK printing.)

✔ **Bit depth:** You sometimes hear people discussing images in terms of bits, as in *24-bit images.* The number of bits in an image — also called the *bit depth* — indicates how much color information each image pixel can contain. In practical terms, a higher bit depth means more image colors.

Bit is short for *binary digit,* which is a fancy way of saying a value that can equal either 1 or 0. On a computer, each bit can represent two different colors. The more bits, the more colors you see. An 8-bit image has 256 colors (2^8=256), a 16-bit image has about 32,000 colors, and a 24-bit image has about 16 million colors. If you want the most vibrant, full-bodied images, naturally, you want the highest bit depth you can get. But the higher the bit depth, the larger the image file.

✔ **Indexed color:** Indexed color refers to images that have had some of their colors stripped away in order to reduce the image bit depth and, therefore, the file size (see the preceding item). Many people reduce images to 8-bit (256 color) images before posting them on a Web page; in fact, a popular file format for Web images, GIF, doesn't permit you to use any more than 256 colors. Where does the term *indexed* come from? Well, when you ask your image editor to reduce the number of colors in an image, the program consults a color table, called an *index,* to figure out how to change the colors of the image pixels. For more on this topic, see Chapter 9 and also take a look at Color Plate 9-1, which illustrates the difference between a 24-bit image and an 8-bit image.

✔ **Grayscale:** A grayscale image is comprised solely of shades of black and white. All the images on the regular pages of this book — that is, not on the color pages — are grayscale images. Some people (and some image-editing programs) refer to grayscale images as black-and-white images, but a true black-and-white image contains only black and white pixels, with no shades of gray in between. Graphics professionals often refer to black-and-white images as *line art.*

As photographers such as Ansel Adams have illustrated, grayscale images can be every bit as powerful as full-color images. Most digital cameras for the consumer market aren't capable of capturing grayscale or black-and-white images, but you can convert an RGB image to grayscale easily inside your image-editing program. Check out Chapter 12 for the how-to's on creating a grayscale image and then adding a sepia tone to create the appearance of a hundred-year-old photograph, as I did in Color Plate 12-4.

A few new camera models offer an option that converts your image to grayscale or sepia as the image is stored in the computer's memory. In a pinch, these options can come in handy, but you get more control over the look of your image if you do the job yourself in your image-editing program.

✔ **CIE Lab, HSB, and HSL:** These acronyms refer to three other color models for digital images. Until you become an advanced digital-imaging guru, you don't need to worry about them. But just for the record, CIE Lab defines colors using three color channels. One channel stores luminosity (brightness) values, and the other two channels each store a separate range of colors. (The *a* and *b* are arbitrary names assigned to these two color channels.) HSB and HSL define colors based on hue (color), saturation (purity or intensity of color), and brightness (in the case of HSB) or lightness (in HSL).

About the only time you're likely to run into these color options is when mixing paint colors in an image-editing program. Even then, the on-screen display in the color-mixing dialog boxes makes it easy to figure out how to create the color you want. Some programs also give you the option of opening images from certain Photo CD collections in the Lab color mode. But you can safely ignore that option for now.

Chapter 3

In Search of the Perfect Camera

• •

• •

*A*s soon as manufacturing engineers figured out a way to create digital cameras at a price range the mass market could swallow, the rush was on to jump on the digital bandwagon. Today, everyone from long-standing icons of the photography world, such as Kodak, Olympus, Nikon, and Fujifilm, to powerhouse players in the computer and electronics market, such as Hewlett-Packard, Casio, and Epson, offers some sort of digital photography product.

Having so many different fingers in the digicam pie is both good and bad. On the upside, more competition means better products, a wider array of choices, and lower prices for consumers. On the downside, you need to do a lot more research to figure out which camera is right for you. Different manufacturers take different approaches to winning the consumer's heart, and sorting through the various options takes some time and more than a little mental energy.

If you're the type who hates to make any decisions on your own, you may be hoping that I can simply tell you which camera to buy. Unfortunately, I can't. Buying a camera is a very personal decision, and no one camera suits every need and every user. The camera that fits snugly into one person's hand may feel awkward in another's. You may enjoy a camera that provides advanced photographic options, while the guy down the block may prefer a model

that's plain and simple, with few decisions required on the photographer's part. You may need a top-flight camera for producing large, high-quality prints while someone else may be drawn to entry-level models geared toward casual Internet use and family fun.

But even though I can't guide you to a specific model, I can help you determine which camera features you really need and which ones you can do without. I can also provide you with a list of questions to ask as you're evaluating different models. As you're about to find out, you need to consider a wide variety of factors before you plunk down your money.

Mac or Windows — Does It Matter?

Here's a relatively easy one. Most — not all, but most — digital cameras work on both Macintosh and Windows-based computers. The only differences lie in the cabling that hooks the camera to your computer and the software that you use to download and edit your pictures. Most cameras come with the appropriate cabling and software for both platforms, although you should verify this before making your final selection. Sometimes you do need to pay a few bucks to get the necessary cables and software if you use a Macintosh computer.

Nor do you need to worry that your Mac friends won't be able to open your images if you work on a PC, or vice versa. Several image file formats work on both platforms, and you can buy good image-editing programs for both PCs and Macs as well. Pay a visit to Chapter 7 if you want more details about file formats, and spend a minute or two with Chapter 4 for tips on choosing image-editing software.

A few cameras that operate on the Windows platform require computers with a Pentium II or MMX processor or better. And Windows 95 doesn't cooperate especially well with cameras that require a USB connection, even if you use the version of Windows 95 that's supposed to enable USB. So before buying a camera, check to see whether your computer matches the camera's system requirements. See Chapter 7 for more information about USB devices.

You Say You Want a Resolution

Chapter 2 explores the subject of image resolution in detail, but here's the short story: More pixels mean better-looking images. Different cameras can capture different numbers of pixels; generally, the more you pay, the more pixels you get.

How many pixels do you need? That depends on how you want to use your pictures.

✔ If all you want to do with your digital images is share them via e-mail, post them on a Web page, or use them in a multimedia presentation, you can get by with a camera at the low end of the price spectrum — $300 and under. In this price range, you're typically limited to 640 x 480 pixels, also known as *VGA resolution*. That's fine for most any on-screen image display. But as for print quality, you're going to be disappointed unless you keep the print size very small. Even at standard snapshot size, your pictures likely will be less than satisfactory.

✔ For a good balance between price and picture quality, move up to a *megapixel* camera, which delivers between 1 and 2 million total pixels. You can get great megapixel cameras for $300 to $700. You'll be able to print your pictures at a reasonable size (up to about 5 x 7 inches) and also use your pictures on the Web and in presentations.

✔ If you plan on making larger, high-quality prints, go for a camera that captures 2 megapixels or more. Currently, 2-megapixel models represent the top end of the consumer price spectrum, costing anywhere from $700 to $1,500.

Keep in mind that all those pixels not only increase the camera cost but also the amount of storage space you need to hold your picture files. (Check out Chapter 4 for a better understanding of storage issues.) Unless you really need every last pixel, you may want to stick with a middle-range camera and put your savings into a few photography accessories.

As you compare cameras, be aware that different models deliver the specified pixel count in different ways. And the route the camera takes to create image pixels can have an impact on your images. For this reason, you can't simply look at the pixel values on the camera box and make a wholesale judgment about image quality.

Say that a camera offers you a choice of two capture settings: 640 x 480 or 1024 x 768 pixels. On some cameras, the camera actually captures the number of pixels you select. But some cameras capture the image at the smaller size and *interpolate* — make up — the rest of the pixels. The camera's brain analyzes the color and brightness information of the existing pixels and adds additional pixels based on that information. But because interpolation is an imperfect science, images captured in this way usually don't look as good as those captured without interpolation. Then again, cameras that work this way are typically cheaper than those that don't.

The war between CCD and CMOS

Image-sensor chips — the chips that capture the image in digital cameras — fall into two main camps: *CCD,* or charge-coupled device, and *CMOS* (pronounced *see-moss*), which stands for complementary metal-oxide semiconductor.

The main argument in favor of CCD chips is that they're more sensitive than CMOS chips, so you can get better images in dim lighting. CCD chips also tend to deliver cleaner images than CMOS chips, which sometimes have a problem with *noise* — small defects in the image.

On the other hand, CMOS chips are less expensive to manufacture, and that cost savings translates into lower camera prices. In addition, CMOS chips are less power-hungry than CCD chips, so you can shoot for longer periods of time before replacing the camera's batteries.

CMOS chips also perform better than CCD chips when capturing highlights, such as the sparkle of jewelry or the glint of sunlight reflecting across a lake. CCD chips suffer from *blooming,* which means creating unwanted halos around very bright highlights, while CMOS sensors do not.

Currently, an overwhelming number of cameras use CCD technology. But camera manufacturers are working to refine CMOS technology, and when they do, you can expect to hear more about this type of camera.

Now add this information to the mix: Most cameras compress images in order to store them in the camera's memory. As discussed in the next section, to *compress* an image means to squish all the data together so that it takes up less room in the camera's memory. Being able to store more images in less space is an advantage, obviously. But compression typically eliminates some image data. So a highly compressed, high-resolution image may come out of the camera looking worse than an uncompressed image at a lower resolution.

The moral of the story is this: For top image quality, look for the camera capable of capturing the most *actual* (not interpolated) pixels with the least amount of compression. But because image quality is affected by many other factors, such as the quality of the lens and how sensitive the image sensor is to light, don't rely totally on these numbers. Instead, use your head — more specifically, use your eyes. Shoot test images on several different cameras and judge for yourself which unit offers the best image quality.

The Great Compression Scheme

As I said in the previous section, digital cameras often compress image files when saving them in the camera memory. To compress a file means to eliminate some data in order to reduce the size of the file. Several forms of compression are available, but most cameras use a type known as JPEG *(jay-peg)* compression.

JPEG stands for Joint Photographic Experts Group, the imaging-industry committee that developed JPEG. (I bet you can't wait to drop that sparkling nugget at your next neighborhood picnic.) You can read more about JPEG in Chapters 7 and 9.

Anyway, by compressing your images, the camera can store more pictures in each megabyte of memory. The more compression, the smaller the image file, and the more pictures you can store. The drawback is that JPEG compression often sacrifices some important image data as it shrinks the image file. The more the image is compressed, the more data you lose, and the more the image suffers.

Color Plate 3-1 shows an original, uncompressed image (top image) and the same image after it was saved at a low level of JPEG compression (middle image) and at a high level of compression (bottom image). At a low level of compression, the quality loss is barely distinguishable. But at a high level of compression, you can see a definite loss of detail. All three images have a resolution of 300 ppi.

Does that mean that you should steer away from cameras that compress images? Absolutely not. First of all, a little bit of compression doesn't do visible damage to most images, as illustrated in Color Plate 3-1. Second, for some projects, such as creating a household insurance inventory or sharing a picture over the Web, most people are happy to sacrifice a little image quality in exchange for smaller file sizes.

For the most flexibility, choose a camera that enables you to select from two or three different compression amounts so you can compress a little or a lot, depending on what sort of quality you need for a particular picture. If your photographic projects require the highest possible image quality, look for a camera that offers a no-compression or low-compression setting.

Typically, compression options are given vague names such as "Good," "Better," or "Best." On some cameras, though, these same types of names are given to settings that control the number of image pixels, so be sure that you know what option you're evaluating. Check the camera manual for this information.

Also keep in mind that every manufacturer handles compression a little differently. The low-level compression setting on one camera may be equivalent to a medium-level compression on another. To find out which of the models you're considering compresses images the least at its high-quality setting — important for projects that require top-notch images — find out how many pictures you can store in 1MB (megabyte) of memory at a particular resolution. If you're evaluating two cameras that both capture 640 x 480 images, for example, the camera that stores *fewer* images in that 1MB of memory is applying the least compression.

Memory Matters

Another specification to examine when you shop for digital cameras is what kind of memory the camera uses to store images. A few cameras have built-in memory (if you want to be hip, call it *on-board memory*). After you fill up the on-board memory, you can't take any more pictures until you transfer the images to your computer.

On-board storage used to be the norm. But most cameras now rely on removable media for image storage. You put a memory card or disk into a slot on the camera, just as you put a floppy disk into your computer. The camera then writes the image data to the removable media as you shoot. After you fill up the card or disk, you simply pop it out and put in another one. Figure 3-1 shows me in the process of inserting a memory card into a Canon digital camera.

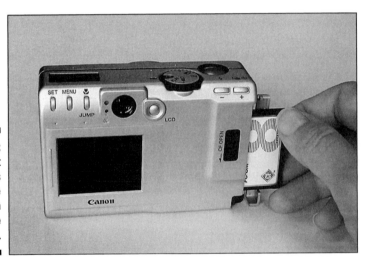

Figure 3-1: Most cameras now store images on removable media.

Removable camera media currently exists in the following forms:

✔ Most cameras use the matchbook-sized CompactFlash cards or SmartMedia cards. Figure 3-2 offers a look at both types of cards alongside a regular old floppy disk.

✔ A few older, consumer-level digital cameras and most professional digital cameras store pictures on credit-card-sized PCMCIA Cards (PC Cards, for short). These cards fit into the PC Card slots found on most laptop computers.

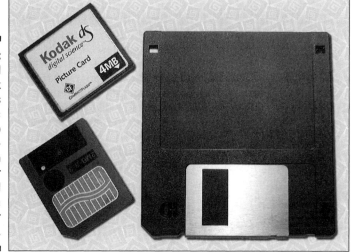

Figure 3-2:
A standard
floppy disk
(right) looks
gigantic
compared to
a Compact-
Flash
card (upper
left) and
SmartMedia
card (lower
left).

✔ Sony Digital Mavica cameras enable you to store images on regular floppy disks.

✔ Sony Cyber-shot cameras accept the Sony Memory Stick, which is about the size of a stick of gum. Memory Stick cards currently work only with certain Sony devices. You can get a look at a Memory Stick in Figure 3-7, later in this chapter.

Cameras that don't accept removable memory generally are less expensive than those that do. But personally, I don't find the savings adequate reason to do without removable memory, for two reasons:

✔ I don't like being forced to stop shooting to download pictures at regular intervals. I prefer to have abundant removable memory so that I can shoot as long as the photographic mood lasts. If you're not a prolific photographer, you may not be bothered by this limitation. But if you ever travel with your digital camera and you don't have access to a computer or other means of downloading images from the camera, you absolutely need the option of using removable memory.

✔ When you do download images to your computer, the transfer process is slow and inconvenient if your camera offers only on-board storage. First, you have to connect the camera and computer via cable, a step that usually involves crawling around the back of the computer looking for the right place to plug in the cable. More important, images take a long time to funnel through the cable, for reasons I won't explain for fear of boring you to death.

With cameras that store images on removable media, downloading is quick and painless. If you use a Sony camera that stores images on floppy disk, you just take the disk out of the camera and put it into your computer's floppy drive to download images. Similarly, you can buy special adapters and card readers that enable you to transfer images directly to a computer from a PC Card or CompactFlash, SmartMedia, or Memory Stick card. In addition to being more convenient, this method of data transfer results in much, much faster download speeds. (See Chapter 4 for details on adapters and card readers, if you're intrigued.)

If you do opt for a camera that accepts removable memory, the following additional nuggets of information may be of use:

✔ You can get CompactFlash cards with storage capacity ranging from 4MB to a whopping 128MB. SmartMedia cards come in sizes ranging from 4MB to 32MB, but not all cameras that accept SmartMedia cards can handle the largest-capacity cards.

✔ CompactFlash, SmartMedia, and Memory Stick memory costs about $3 to $6 per megabyte, depending on the card capacity (you save a little per megabyte by buying a large-capacity card). Standard PC cards cost slightly less per megabyte.

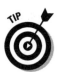

Keep in mind that you can reuse memory cards as many times as you like. And you can also use them to store data other than digital images. For example, I sometimes transfer files from my laptop computer to my desktop via a memory card. All you need are the proper card readers and/or adapters to make use of your memory cards in this fashion.

✔ Floppy disk memory, of course, costs much less — less than $1 per megabyte. But the floppy-disk setup presents some problems that you don't get with other types of removable memory. Because cameras that store images on floppies have built-in floppy disk drives, they consume more battery power and are bulkier than cameras using the two other memory options. In addition, you get less than 1.5MB of storage space per disk, which means that your images must either be low resolution, highly compressed, or both.

✔ Although I wouldn't advise you to buy a camera solely on the basis of what type of removable memory it uses, you may find one form of memory more convenient than another for your specific photographic and computing needs. The difference has nothing to do with memory cost or performance, but with the devices that you can use to download images. Some devices may fit your existing computing setup better than others. So before you make the final memory decision, check out the section in Chapter 4 that discusses card readers and adapters to be sure that you understand all your options.

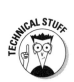

✔ If you want to explore the issue of removable memory from a technical viewpoint, pay a visit to the PCMCIA Web site, www.pcmcia.org. The site provides detailed specifications and all sorts of other in-depth information about a variety of memory devices.

One last word of wisdom regarding memory, whether on-board or removable: When you're comparing cameras, be sure to look closely at the manufacturer's "maximum storage capacity" claims — the maximum number of images you can store in the available memory. The maximum storage capacity reflects the number of images you can store if you set the camera to capture the fewest number of pixels or apply the highest level of compression, or both. So if Camera A can store more pictures than Camera B, and both cameras offer the same amount of memory, Camera A's images must either contain fewer pixels or be more highly compressed than Camera B's images. (See "The Great Compression Scheme," earlier in this chapter, for more information.)

To LCD or Not To LCD

Most cameras have an LCD *(liquid-crystal display)* screen. The LCD screen is like a miniature computer monitor, capable of displaying images stored in the camera. The LCD is also used to display menus that enable you to change the camera settings and delete images from the camera's memory. Figure 3-3 gives you a look at the LCD screen on a Casio digital camera.

Figure 3-3: Found on most cameras, the LCD monitor enables you to review images and select capture settings and other camera options.

The ability to review and delete images right on the camera is very helpful because you avoid the time and hassle of downloading unwanted images. If an image doesn't come out the way you wanted, you delete it and try again.

On most cameras, the LCD can also provide a preview of your shot. So if your camera has a traditional viewfinder and an LCD, you can frame your pictures using the LCD or the viewfinder. In fact, most cameras force you to use the LCD when shooting close-up pictures to avoid parallax errors (a phenomenon explained in Chapter 5).

A few cameras with LCDs lack traditional viewfinders, so you must compose *all* your pictures using the LCD. I find it difficult to shoot pictures using the LCD for framing because you have to hold the camera a few inches away from you in order to see what you're shooting. If your hands aren't that steady, taking a picture without moving the camera can be tricky. Using a tripod is especially important in this shooting scenario.

LCD monitors have a few other drawbacks, too. They add some weight to the camera, and they consume lots of battery juice. Additionally, when you're shooting in bright light, the LCD display tends to wash out, making it difficult to see your images. And of course, an LCD adds to the cost of the camera. Some manufacturers offer the LCD as an optional accessory, while others include it in the basic camera package.

That said, I personally couldn't do without *both* an LCD monitor and a viewfinder. Without the LCD, you can't review and delete your pictures on the camera. Without the viewfinder, picture taking is sometimes awkward — and, on a bright, sunny day, downright difficult.

Special Breeds for Special Needs

Digital cameras come in all shapes and sizes. Some are styled to look and feel like a 35mm point-and-shoot camera, while others look more like a video camera. There's no right or wrong here — all other things being equal, buy the camera that feels the most comfortable to you.

A few cameras, however, are designed to meet specific needs:

 ✔ **Desktop digital video cameras:** A few cameras, including the Kodak DVC-325 shown in Figure 3-4, are designed to perch atop your computer monitor or desk. These cameras have no viewfinder or LCD — you can see what you're shooting only while the camera is tethered to the computer.

Figure 3-4:
Desktop cameras like the Kodak DVC-325 are digital video cameras designed primarily for video-conferencing and Internet telephony.

Unlike the cameras that I discuss in the rest of this book, these cameras are digital video cameras, not still-image cameras. Although digital video cameras can capture still images, their primary purpose is to record live video. In fact, when you snap a still image, you're really freezing one video frame.

What's the point? Well, these cameras are designed primarily for video-conferencing and Internet telephony (making phone calls over the Internet). You sit in front of the camera, and the camera transmits your image to the monitor of the person on the other end of the telephone line — assuming that the other person also has the necessary hardware and software.

Although you find digital video cameras mixed in with all the other digital cameras in computer and electronics stores, they're really a different breed, designed for a narrow market. For that reason, and because capturing and editing digital video is an entirely different process from capturing and editing still digital images, these few paragraphs represent the extent to which I address the subject in this book.

✔ **Digital SLRs and camera backs:** I mention this category of camera just to make the serious camera buffs in the crowd drool. If you have the money and the inclination, you can buy an ultra-high-resolution digital SLR (single-lens reflex) camera or an adapter that enables you to take digital images with your existing SLR. Figure 3-5 shows the Kodak DCS 660, a digital SLR that merges a Nikon camera body with Kodak digital-imaging technology. This camera can capture a whopping 6 million pixels. At a list price of just under $30,000, though, the DCS 660 probably won't be among your stack of birthday gifts any time soon. Then again, it never hurts to ask, does it?

Figure 3-5:
Built for professional photographers, the Kodak DCS 660 merges a Nikon camera body with Kodak imaging components. This camera can capture 6 million pixels and has an equally impressive price tag of about $30,000.

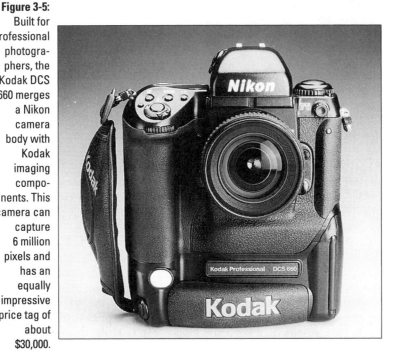

✔ **Teen-market cameras:** At the opposite end of the price list — and far more likely to make an appearance at that birthday party — cameras aimed at the teen market are currently making a big splash. For less than $100, you can pick up cameras like the KBGear JamCam and the Vivitar E-cam. The JamCam, shown in Figure 3-6, offers a maximum resolution of 640 x 480 pixels and 2MB of on-board memory, but no LCD monitor, flash, or removable memory. The E-cam offers similar features.

Although these cameras are marketed toward kids, adults with minimal digital photography needs may want to consider them as well. But be sure that you're willing to give up convenience features such as an LCD monitor in exchange for the low price. Also know that these "starter" cameras use less costly image sensors and lenses than higher-priced cameras offering the same image resolution. So even though you may get the same number of pixels with a $90 camera as you do from a $300 camera, your image quality won't be as good.

Figure 3-6:
Aimed at
teens, the
KBGear
JamCam
offers
minimal
features
and a
rock-bottom
price.

What? No Flash?

When you take pictures using film, a flash is a must for indoor photography and for shooting outdoors in dim lighting. You may be surprised to learn that the same isn't always true for digital cameras.

Some cameras take good indoor pictures without a flash. But not all cameras have the same capability, so before you consider a model that doesn't have a flash, snap some sample pictures in a variety of low-light situations. Also, remember that just as with film cameras, a flash can be very useful even when shooting outdoors, as examined in Chapter 5. You may want a flash to compensate for backlighting, for example, or to light up a subject standing in the shade or shadows.

Here are a few other flash facts to consider when you're shopping:

✔ For cameras that do offer a flash, find out how many flash settings you get. Usually, cameras with a built-in flash give you three settings: *automatic* (the flash fires only when the camera thinks the light is too low); *fill flash* (the flash fires no matter what); and *no flash*. If the camera has an automatic flash, you definitely want the other two modes as well so that you, and not the camera, ultimately control whether the flash fires.

✔ A few new cameras also enable you to raise or lower the intensity of the flash slightly, which can be helpful in tricky lighting situations. Give extra points to cameras offering this option.

✔ Some cameras also offer a *red-eye reduction mode,* which is designed to reduce the problem of a flash-induced red glint to subjects' eyes. I'm not too worried about this option because it usually doesn't work that well and you can always cover up red-eye problems in the image-editing stage. See Chapter 11 for the how-to's.

✔ Higher-end cameras sometimes offer two additional flash modes: a *slow sync mode,* for shooting in very low lighting, and an *external flash mode,* which enables you to attach a separate flash unit to the camera. These options are extremely attractive to professional photographers and advanced hobbyists, but everyday users can probably get by without them.

You can read more about using these flash options to improve your pictures and solve lighting problems in Chapter 5.

Through a Lens, Clearly

When shopping for a digital camera, many people get so caught up in the details of resolution, compression, and other digital options that they forget to think about some of the more basic, but just as essential, camera features. The lens is one of those basic camera components that is often overlooked — and shouldn't be.

Serving as your camera's "eye," the lens determines what your camera can see — and how well that view is transmitted to the CCD or CMOS chip for recording. The following sections explain some of the lens details that you should consider as you evaluate different cameras.

Fun facts about focal length

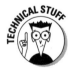

Different lenses have different *focal lengths.* On film cameras, focal length is a measurement of the distance between the center of the lens and the film. On a digital camera, focal length measures the distance between the lens and the image sensor (CCD or CMOS array). Focal length is measured in millimeters.

Don't get bogged down in all the scientific gobbledygook and mathematical lingo, though. Just focus — yuk, yuk — on the following focal length facts:

✔ Focal length determines the lens's angle of view and the size at which your subject appears in the frame. Shorter focal lengths produce wide-angle views, which means that you can fit more of the scene into the frame without moving back. A short focal-length lens has the visual effect of "pushing" the subject away from you and making it appear

smaller. Longer-than-normal focal-length lenses seem to bring the subject closer to you and increase the subject's size in the frame. Long focal-length lenses are called *telephotos*.

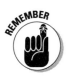

✔ On most point-and-shoot cameras, a lens focal length in the neighborhood of 35mm is considered a "normal" lens. This focal length is appropriate for the kinds of snapshots most people take.

✔ Cameras that offer a zoom lens enable you to vary focal length. As you zoom in, the focal length increases; as you zoom out, it decreases.

✔ A few cameras offer dual lenses, which usually provide a standard, snapshot-oriented focal length plus a telephoto focal length. In addition, some cameras have *macro* modes, which permit close-up photography. Dual-lens cameras are different from zoom lens cameras, which offer the ability to shoot at any focal length along the zoom range. For example, a 38–110mm zoom can be placed at any focal length between its maximum and minimum settings: 38mm, 50mm, 70mm, and so on. A dual lens 38mm/70mm camera has only the two focal-length settings.

✔ To get a visual perspective on focal length, turn to Color Plate 3-2. Here, you see the same scene captured by four different lenses. I captured the top-left image using a Nikon digital camera that offers a 38–115mm zoom lens; I zoomed all the way out to 38mm for this picture. I took the top-right image with an Olympus model that has a 36–100mm zoom; again I zoomed to the shortest focal length to shoot this picture. For the bottom-left shot, I picked up a Casio camera with a fixed focal length of 35mm. And for the bottom-right image, I used the Nikon again, but this time with an optional 24mm wide-angle adapter attached.

✔ Note that the focal lengths I just mentioned aren't the true numbers for these cameras. Rather, they indicate the equivalent focal length provided by a lens on a 35mm-format film camera. Because of the way digital cameras are designed, the actual focal lengths don't really provide any useful information for the photographer. So manufacturers indicate the capabilities of a lens by providing a "lens equivalency" number. Advertisements and spec sheets for cameras include lens statements such as "5mm lens, equivalent to 35mm lens on a 35mm-format camera."

This book takes the equivalency approach as well. So if I mention a lens focal length, I'm using the equivalent value.

Now that you understand what those little lens numbers mean on the digital camera boxes, you can choose a camera that offers a lens appropriate for the kind of shooting you plan to do. As mentioned earlier, a standard, 35mm (equivalent) lens is good for taking ordinary snapshots. If you want to do a lot of landscape shooting, you may want to look for a slightly shorter focal length because that will enable you to capture a larger field of view. A wide-angle lens is also helpful for shooting in small rooms; with a standard 35mm, you may not be able to get far enough away from your subject to fit it in the frame.

Zoom lenses are nice, but add to the cost of the camera — and of course, you can always zoom the old-fashioned way: Just move closer to your subject! If you want the greatest flexibility with regard to lenses, look for a model that can accept accessory wide-angle and telephoto lenses.

If a zoom lens is important to you, be sure that the camera you buy has an *optical zoom.* An optical zoom is a true zoom lens. Some cameras instead offer a *digital zoom,* which is nothing more than some in-camera image processing. When you use a digital zoom, the camera enlarges the center of the frame and trims away the outside edges of the picture. The result is the same as when you open an image in an image editor, crop away the edges of the picture, and then enlarge the remaining portion of the photo. Enlarging the "zoomed" area reduces the image resolution and the image quality. For a better understanding of resolution, see Chapter 2; for more information about digital and optical zooms, see Chapter 6.

Focusing aids

Some cameras have *fixed-focus* lenses, which means that the point of focus is unchangeable. Usually, this type of lens is engineered so that images appear in sharp focus from a few feet in front of the camera to infinity.

Many cameras have manual focus and permit users to adjust the focus point for three different distances. Among the settings are *macro mode* for extreme close-ups, *portrait mode* for subjects a dozen feet from the camera, and *landscape* mode for distant subjects. One of the great advantages of the extremely short focal lengths of digital-camera lenses is that they have extreme depth of field, which means that the zones of sharp focus (even with fixed-focus cameras) are far greater than that of typical film cameras.

Different cameras offer different focus ranges, which is probably most important in the area of close-up photography. Some cameras enable you to get extremely close to your subject, but other cameras are a bit limiting in this regard. If you want to do lots of close-up work, be sure to check the minimum subject-to-camera distance of a camera before you buy.

Cameras with *autofocus* automatically adjust the focus depending on the distance of the subject from the lens. Most cameras with autofocus abilities offer a very useful feature called *focus lock.* You can use this feature to specify exactly which object you want the camera to focus on, regardless of the object's position in the frame. Usually, you center the subject in the viewfinder, press the shutter button halfway down to lock the focus, and then reframe and snap the picture.

A few high-end cameras enable you to set the focus point a specific distance from the camera — 12 inches, 3 feet, and so on. This feature can come in handy at times because autofocusing mechanisms don't always do a dead-on focusing job when you're photographing a complex scene. If you're taking a picture of a tiger in a cage, for example, the autofocus may lock onto the cage instead of the tiger.

For more about different focusing options and how you might use them in your photography, see Chapter 5.

Lens gymnastics

Because of the way that digital cameras work, the lens doesn't have to remain in the standard front-and-center position. Taking advantage of this fact, a few digital cameras offer a rotating lens. Figure 3-7 gives you a look at one such camera, the Sony Cyber-shot DSC-F55.

Figure 3-7:
The Sony Cyber-shot DSC-F55 offers a rotating lens and stores images on Memory Stick, a new type of removable media produced for Sony products.

Being able to rotate the lens provides you with some useful shooting options. Suppose that you want to photograph an object that's sitting on the floor. You can place the camera on the floor, rotate the lens upward, and get a bug's-eye view that would be either impossible or, at the very least, very awkward with an immovable lens.

Some cameras, including several models from Minolta, have a lens that you can detach from the camera body. You can then hold the lens up in the air to shoot over a crowd or even mount the lens on an optional headband, creating a head-cam, as it were. Whether or not you'll find the ability to manipulate the lens in this fashion more fun than useful, I can't predict. But what's wrong with having a little fun, anyway?

Exposure Exposed

When you take a picture with a digital camera, the camera measures the light in the scene and then selects the aperture and shutter speed needed to properly "expose" the image. In this case, the image sensor, rather than film, gets exposed to light, but the concepts remain the same. (See Chapter 2 for a better understanding of apertures, shutter speed, and image exposure.)

Most digital cameras have programmed autoexposure modes, which means that the camera selects the proper aperture and shutter speed for you. Some cameras offer aperture-priority autoexposure, which means that you select the aperture and the camera sets the appropriate shutter speed to expose the picture at the chosen aperture. On low- and mid-price cameras, you typically get only two aperture settings: one for low-light shooting and another for bright light.

Higher-end cameras, such as the Olympus C-2000 and the Nikon Coolpix 950, enable you to select from a larger range of apertures when you shoot in aperture-priority mode. In addition, you can switch to shutter-priority mode to tackle the exposure issue from a different angle. You select the shutter speed, and the camera chooses the aperture.

In addition to autoexposure, mid-range and high-end cameras usually provide *EV compensation*. This control enables you to increase or decrease the exposure setting chosen by the automatic exposure mechanism. EV compensation comes in handy when you want to shoot in dim lighting without a flash, for example.

Yet another exposure-related factor to consider is the camera's *metering mode*. The metering mode determines how the camera evaluates the available light when determining the correct exposure. Three types of metering modes exist — *spot metering* sets the exposure based on the light at the center of the frame only; *center-weighted metering* reads the light in the entire frame but gives more importance to the light in the center quarter of the frame; and *matrix* or *multizone metering* reads the light throughout the entire frame and chooses an exposure that does the best job of capturing both the brightest and darkest regions of the picture. Lower-priced cameras typically provide only one metering mode, while more advanced cameras enable you to choose from all three, depending on the shooting situation.

For more information about all these exposure options and when you might find them useful, see Chapter 5.

Is That Blue? Or Cyan?

Just as different types of film see colors a little differently, different digital cameras have different interpretations of color. One camera may emphasize the blue tones in an image, whereas another may slightly overstate the red hues, for example. Color Plate 3-2 illustrates the color perspectives of cameras from three different manufacturers.

Note that the colors generated by a particular camera are not always a reflection of the camera's ability to record color accurately but rather an indication of the manufacturer's decision about what types of colors will please the majority of its customers. If a manufacturer finds that the target audience for a camera prefers highly saturated colors and deep blues, for example, the camera is geared to boost the saturation and the blues.

Bear in mind, too, that the colors in the Color Plate aren't exactly what came out of these cameras. For reasons discussed in Chapters 2 and 8, colors usually shift during the printing process. So consider the images in the Color Plate as simply a reminder that different cameras perceive colors differently.

In order to compare cameras on the basis of color output, you need to actually shoot and download some images — you can't really rely on a camera's LCD to give you an accurate impression of the colors in your images. Keep in mind, too, that your monitor throws its own color prejudices into the mix.

Accurately calibrating camera, monitor, and printer output isn't easy, and even with sophisticated color-management software, the best you can hope for is pretty-close color matching. So don't expect your interior decorator to be able to use a digital image to find a chair that perfectly matches the colors in your couch. If you need super-accurate color matching, you need a professional digital photographer with a professional color-calibration system.

Still More Features to Consider

The preceding sections in this chapter cover the major features to evaluate when you're camera shopping. Features discussed in the following sections, presented in no particular order, may also be important to you, depending upon the kind of photography you want to do.

Discount-store bargains — really a good buy?

You're cruising through the aisles of your neighborhood discount store. Just past the table of slightly imperfect waterbed sheets and the rack of 24-roll, megasaver toilet-paper packages, you spot a display of digital cameras. Wow! Digital cameras at deep discounts? Is this your lucky day? Or are you looking at a deal that's too good to be true? Maybe . . . maybe not.

Although you *can* get a good buy at deep-discount stores, you need to shop armed with plenty of data to be sure that you get a real bargain. Off-price stores and even major electronics chains often feature last year's cameras.

Although these cameras may be just fine from a quality and performance standpoint, they don't usually represent the best price/feature ratio, even when they're sold at a huge discount to the original retail prices.

Each year, manufacturers refine production processes to develop better, cheaper digital cameras. Most vendors also manufacture digital cameras in greater quantities now than in past years, which has lowered the per-unit cost even further. As a result, you may get more features for the same or less money if you opt for the manufacturer's newest model.

Now playing, on your big-screen TV

A number of cameras offer *video-out* capabilities. Translated into plain English, this means that you can connect your camera to your television and display your pictures on the TV screen or record the images on your VCR.

When might you use such a feature? One scenario is when you want to show your pictures to a group of people — such as at a seminar or family gathering. Let's face it, most people aren't going to put up with crowding around your 15-inch computer monitor for very long, no matter how terrific your images are.

Fortunately, video-out is one option that doesn't cost big bucks. Even a few low-priced cameras offer this feature.

You may sometimes hear video-out called *NTSC output.* NTSC, which stands for National Television Standards Committee, refers to the standard format used to generate TV pictures in North America. Europe and some other parts of the world go by a different standard, known as *PAL,* an acronym for *phase alteration line-rate.* You can't display NTSC images on a PAL system.

In addition to video input/output options, some cameras enable you to record audio clips along with your images. So when you play back your image, you can actually hear your subjects shouting "Cheese!" as their happy mugs appear on-screen.

Ready, set, run!

Many cameras offer a *self-timer* mechanism. Just in case you've never been to a large family gathering and haven't had experience with this particular option, a self-timer enables the photographer to be part of the picture. You press the shutter button, run into the camera's field of view, and after a few seconds, the picture is snapped automatically.

This feature is always good for a few laughs — everyone ends up with silly expectant grins on their faces, because you're never quite sure when that shutter release is going to fire. And the person who has to run into the frame inevitably trips over someone's foot or a table leg on the way from the camera into the scene. Still, a self-timer is the only way to include the photographer in the family portrait, so I give this feature a big thumbs-up.

Even if you hate group photos, a self-timer function can be extremely useful (and not just for shooting solo pictures of yourself, either). By using the self-timer, you can avoid the camera shake that sometimes occurs when clumsy or anxious fingers jab at the shutter button with too much force. You put the camera on a tripod or other steady surface, turn on the self-timer mechanism, press the shutter button, and move away from the camera. After a few seconds, the camera takes the picture automatically for you.

If you really want to impress people, you can get a camera like the Olympus C-2000, which takes the self-timer concept one step further. This camera has a remote control unit, shown in Figure 3-8. You can use the remote control not only to take pictures but also to display them on a monitor or TV.

Figure 3-8:
The remote control unit that comes with the Olympus C-2000 lets you trigger the camera's shutter release button from a distance.

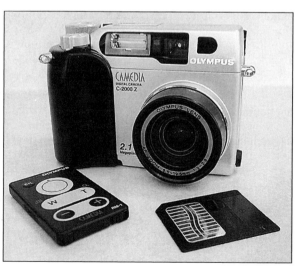

There's a computer in that camera!

All digital cameras include some computer-like components — chips that enable them to capture and store images, for example. But some of the newer and higher-priced models have bigger "brains" that enable them to perform some interesting functions that otherwise require a full-fledged computer. Here are some of the features you can find on such cameras, which some pundits have described as *cam-puters*.

✔ **Scripting:** High-end Kodak models, including the DC260 and DC220, are among cameras that can run mini-programs — *scripts* or *macros*. You can use scripts to automate certain aspects of your photography. For example, a script included on some Kodak cameras enables you to shoot the same image at several different exposure settings with one press of the shutter button. Scripting is fairly new, but expect to see more of this feature in the future.

If you want more information about scripting, check out the FlashPoint Technology Web site at www.flashpoint.com. FlashPoint developed Digita, a software language used to create scripts for many digital cameras. You can download free scripts from the site and then use them on compatible cameras.

✔ **Time-lapse photography:** Some cameras provide a time-lapse shooting option that tells the camera to take a picture automatically at specified intervals. The Kodak DC260 is one model that offers this feature; you can set the capture interval on this camera to a minimum of 60 seconds and a maximum of 1,550 minutes (that's 25 hours and 50 minutes, if you're attempting the math).

✔ **On-board image correction:** Many of the new digital cameras enable you to perform basic image correction without ever downloading images to your computer. You can apply sharpening and color correction, for example. Usually, you select the correction options before you snap the picture, and the corrections are applied as the image is saved to memory.

I'm not a big fan of this feature because you don't get the same kind of control over the correction as you do when fixing images yourself using even a basic image editor. But on-board editing can come in handy if you use a printer that can print directly from your camera or removable memory card. The on-board processing can improve print quality in this scenario.

✔ **Direct printing:** Several cameras enable you to output images directly to a printer. Cameras that offer this function typically also provide options for setting up the print job. For example, you can choose to print several copies of the same image on one sheet of paper and even add decorative backgrounds to your pictures. You don't get the same kind of control

over your pictures that you do when you manipulate pictures using your computer and image-editing software, but then again, you don't have to mess with manipulating your pictures using your computer and image-editing software.

If getting your pictures printed in the quickest way possible is a concern, look for a camera that offers this option. Of course, you'll also have to buy a printer that can connect to your camera or that can accept whatever removable media your camera may use. Chapter 8 discusses printing options in more detail.

✔ **GPS compatibility:** Want a gadget that will impress even your most techie friends? You now can get a digital camera that supports a GPS (global positioning satellite) attachment. So when you take a picture, the camera records your exact location on the planet along with the other image data. The Kodak DC265 is one model offering this option, which is especially useful to surveyors, scientific researchers, law-enforcement agencies, and others who need to keep track of geographical data. Kodak sells the camera and GPS unit in a bundled package for around $2,000.

Action-oriented options

Shooting action with digital cameras is difficult because the camera needs a few seconds between shots to process an image and store it in memory. To get around this limitation, a number of cameras now offer a *continuous-capture* option, often referred to as a *burst* option.

When the camera is set to this shooting mode, you can record a series of images with one press of the shutter button. The camera waits until after you release the shutter button to perform most of the image-processing and storage functions, so lag time is reduced.

Note that I said *reduced,* not *eliminated.* You can usually shoot a maximum of two or three frames per second. That's a fast capture rate, but it's still not quick enough to catch every moving target. See Chapter 6 (especially Figure 6-4) for examples of the pros and cons of continuous-capture shooting.

You should also know that most cameras default to a lower resolution — usually 640 x 480 — when set to the continuous-capture mode. The flash is sometimes also disabled because the camera can't recycle the flash quickly enough to keep up with the image capture rate.

As an alternative action-shot feature, some cameras, including the Sony Cyber-shot shown earlier in this chapter, enable you to record a "mini movie" in MPEG format. On the Sony camera, you can capture image and sound for a

maximum of 15 seconds. You can play the moving images back on your TV or on any computer that has software for opening and playing MPEG files (Active Movie Player is one such program).

Little things that mean a lot

When you're shopping for digital cameras, you can sometimes focus so much on the big picture (no pun intended) that you overlook the details. The following list presents some of the minor features that may not seem like a big deal in the store, but can really frustrate you after you get the camera home.

✔ **Batteries:** Thinking about batteries may seem like a trivial matter, but trust me, this issue becomes more and more important as you shoot more and more pictures. On some cameras, you can suck the life out of a set of batteries in less than an hour of shooting! On cameras with LCD screens (explained earlier in this chapter), the battery consumption is even higher.

Some cameras can accept AA lithium batteries, which have about three times the life of a standard AA alkaline battery — and cost twice as much. Other cameras use rechargeable NiCad or NiMH batteries or 3-volt lithium batteries, and others can accept only regular AA alkaline batteries. The new kid-oriented cameras, the JamCam and E-cam, typically run on a standard 9-volt battery.

Be sure to ask which types of batteries the camera can use and how many pictures you can expect to shoot on a set of batteries. Then factor that battery cost into the overall cost of camera ownership. Some cameras include a battery charger and rechargeable batteries in the camera box, which adds up to major savings over time.

✔ **AC adapters:** Many cameras offer an AC adapter that enables you to run the camera off AC power instead of batteries. Some manufacturers include the adapter as part of the standard camera package, whereas others charge extra for it. Either way, the adapter is something you definitely want. That way, you can run the camera on AC power while downloading images — which can take several minutes — and save your batteries for actual picture-taking.

✔ **Ease of use:** When you're looking at cameras, have the salesperson demonstrate how you operate the various controls, and then try working those controls yourself. How easy or how complicated is it to delete a picture, for example, or change the resolution or compression settings? Are the controls clearly labeled and easy to manipulate? After you take a picture or turn the camera off, do all the settings return to the default settings, or does the camera remember your last instructions? If the controls aren't easy to use, the camera may ultimately frustrate you.

✔ **Tripod mount:** As with a film camera, if you move a digital camera during the time the camera is capturing the image, you get a blurry picture. And holding a digital camera steady for the length of time the camera needs to capture the exposure can be difficult, especially when you're using the LCD as a viewfinder or when you're shooting in low light (the lower the light, the longer the exposure time). For that reason, using a tripod can greatly improve your pictures. Unless you have very steady hands, be sure to find out whether the camera you're considering can be screwed onto a tripod — not all cameras can.

✔ **Physical fit:** Don't forget to evaluate the personal side of the camera: Does it fit into your hands well? Can you reach the shutter button easily? Can you hold the camera steady as you press the shutter button? Do you find your fingers getting in the way of the lens, or does your nose bump up against the LCD when you look through the viewfinder? Is the viewfinder large enough that you can see through it easily? Don't just run out and buy whatever camera a friend or magazine reviewer recommends — make sure that the model you select is a good fit for *you*.

✔ **Durability:** Does the camera seem well-built, or is it a little flimsy? For example, when you open the battery compartment, does the little door or cover seem durable enough to withstand lots of opening and closing, or does it look like it might fall off after 50 or 60 uses?

✔ **Lag time:** How long does it take for the computer to store an image in memory? If you take lots of action-oriented photographs, you want the shortest lag time possible or a *continuous-capture* option that enables you to record a series of images with one press of the shutter button. (See the section "Action-oriented options," earlier in this chapter, for more information.) Note that with many cameras, you also experience a pre-exposure lag time — that is, a delay between the moment you press the shutter button and the time the camera captures the image. Typically, the pre-exposure lag time is very small and doesn't present a problem in ordinary picture-taking situations. But again, if action photography is a strong interest for you, pay attention to both pre- and post-exposure lag times.

✔ **Computer connection:** How does the camera connect to your computer? Some cameras connect via a serial port, others via a parallel port, others through a SCSI (pronounced *scuzzy)* port. A few newer models enable you to connect via a USB (Universal Serial Bus) port or IrDA (infrared) connection.

Find out which setup the camera uses, and then check out your computer. Do you have the right port or slot available? Or is it currently being used by other peripherals — your modem, printer, or mouse, for example? If so, remember that you need to unhook the current peripheral each time you want to connect your camera. Alternatively, you can get a switching device that lets you connect two peripherals into the same port and then switch from one to the other as needed.

Of course, if you're buying a camera with removable memory, the connection design isn't as important (see the section "Memory Matters," earlier in this chapter, to find out why). But just as a backup, you should make sure that you can hook the camera up to the computer "the old-fashioned way," if necessary.

As I stated earlier in this chapter, USB devices don't always work as they should on computers running Windows 95. Even if you install the Windows 95 upgrade that supposedly takes care of the USB problem, you may encounter problems. So if you plan to rely on USB and you use a PC, plan to upgrade to the more USB-friendly Windows 98.

Just for the record, most users have a difficult time getting IrDA connections to work, too. In fact, I recently sat in a meeting of digital imaging experts, and even with our collective experience and input from the camera manufacturer's own representatives, we couldn't get a camera-to-laptop computer IrDA transfer to work. Many manufacturers aren't even bothering to include IrDA components in their cameras anymore because the technology has proven so frustrating.

✔ **Software:** Every camera comes with software for downloading images. But many also come with image-editing software, such as Adobe PhotoDeluxe. Because the programs included with cameras typically retail for under $50, having an image editor included with the camera isn't a huge deal. Then again, 50 bucks is 50 bucks, so if all other things are equal, the included software is something to consider.

✔ **Warranty, restocking fee, exchange policy:** As you would with any major investment, find out about the camera's warranty and the return policy of the store. Be aware that some major electronics stores and mail-order companies charge a *restocking fee,* which means that unless the camera is defective, you're charged a fee for the privilege of returning or exchanging the camera. Some sellers charge restocking fees of 10 to 20 percent, which can mean a sizable sum out of your pocket.

Sources for More Shopping Guidance

If you read this chapter, you should have a solid understanding of the features you do and don't want in your digital camera. But I urge you to do some more in-depth research so that you can find out the details on specific makes and models.

First, look in magazines like *Shutterbug, PC Photo, Macworld,* and *PC World* for reviews on individual digital cameras and peripherals. Some of the reviews may be too high-tech for your taste or complete understanding, but if you first digest the information in this chapter as well as Chapter 2, you should be able to get the gist of the reviewer's comments.

If you have Internet access, log on to a digital photography or computer newsgroup and ask whether anyone has any personal experience with models you're considering. You can also find good information on several Web sites dedicated to digital photography. See Chapter 15 for suggestions on a few newsgroups and Web sites worth visiting.

Try Before You Buy!

Some camera stores offer digital camera rentals. If you can find a place to rent the model you want to buy, I *strongly* recommend that you do so before you make a purchase commitment. For about $30, you can spend a day testing out all the camera's bells and whistles. If you decide that the camera isn't right for you, you're out 30 bucks, but that's a heck of a lot better than spending several hundred dollars to buy the camera and finding out too late that you made a mistake.

To find a place that rents cameras, call your local camera, computer, and electronics stores. As digital cameras become more and more popular, more and more outlets may begin offering short-term camera rentals.

Chapter 4

Extra Goodies for Extra Fun

· ·

In This Chapter

▶ Buying and using removable media

▶ Transferring images to your computer the easy way

▶ Pushing the cursor around with a pen

▶ Choosing a digital closet (storage solutions)

▶ Showing off your work in high-tech style

▶ Seeking out the best imaging software

▶ Stabilizing and lighting your shots

▶ Protecting your camera from death and destruction

· ·

Do you remember your first Barbie doll or — if you're a guy who refuses to admit playing with a girl's toy — your first G.I. Joe? In and of themselves, the dolls were entertaining enough, especially if the adult who ruled your household didn't get too upset when you tried stuff like shaving Barbie's head and seeing whether G.I. Joe was tough enough to withstand a spin in the garbage disposal. But Barbie and Joe were even more fun if you could talk your mom, dad, or some other doting relative into buying you some of the many doll accessories on the toy-store shelves. With a few changes of clothing, a plastic convertible or tank, and loyal doll friends like Midge and Ken, Dollworld was a much more interesting place.

Similarly, you can enhance your digital photography experience by adding a few hardware and software accessories. Digital camera accessories don't bring quite the same rush as a Barbie penthouse or a G.I. Joe surface-to-air missile, but they greatly expand your creative options and make some aspects of digital photography easier.

This chapter introduces you to some of the best camera accessories, from adapters that speed the process of downloading images, to software that enables you to retouch and otherwise manipulate your photographs. If you begin buttering up your loved ones now, I just know that one of them will cave and buy you at least one of these goodies soon.

Extra Memory Cards

If your camera accepts removable storage media, you probably received one memory card with your camera. The Olympus C-2000 ships with an 8MB SmartMedia card, for example, which is fairly typical of cameras that offer megapixel resolution or better.

In the days of low-resolution cameras, 8MB was more storage space than most people needed on a regular basis. But because today's cameras can capture many more pixels than cameras even a few years old, 8MB now represents just a starting point for most digital photographers. As a frame of reference, you can fit just one picture on an 8MB card when you shoot at the highest picture quality available on the C-2000 (1600 x 1200 pixels and no image compression).

How much extra memory do you need? In my case, there is no such thing as too much memory. But I typically shoot at the highest quality settings, and I use cameras that generate large image files. On top of that, I'm often shooting away from my office, and I don't like lugging around a laptop computer just for the purpose of downloading pictures. So the more memory I can tuck in my camera bag, the better.

If you can get by with fewer pixels or you don't mind applying a high degree of compression to your photos, your memory needs are much smaller because the image files are smaller. And of course, if you usually have a computer close by, enabling you to download images when you fill up your existing memory, you may not need any additional memory at all. A few new temporary storage options, such as the Iomega Clik! drive, provide another alternative to carrying a large amount of removable memory. (See "Portable Storage," later in this chapter, for a look at the Clik! drive.)

After you decide on the storage space you need, look to the following sections for everything you need to know about buying and caring for removable memory.

Several options, one choice

Removable memory for digital cameras comes in several basic flavors. Your camera can use only one type, however, so check your manual to find out which of the following options works with your model.

✔ **Floppy disks:** At least one line of cameras, the Digital Mavica models from Sony, can store images on regular old floppy disks. If you own one of these models, purchasing additional memory is a no-brainer; floppy disks are cheap, so stock up. Remember that each floppy can hold less than 1.5MB of image data, so keep a bundle of disks handy.

✔ **PC Cards:** A few older models of consumer cameras, including the Kodak DC-50, accept PC Cards, formally known as PCMCIA Cards. About the size of a credit card, these memory cards are the same type used by most laptop computers. If your camera uses PC Cards, be sure to find out whether it uses Type I, II, or III before going shopping. Prices for PC Card memory range from about $2 to $6 per megabyte, depending on the type and capacity of the card.

✔ **CompactFlash:** Smaller versions of standard PC Cards, CompactFlash cards sport a hard-shell outer case and pin connectors at one end. CompactFlash cards are currently available in sizes from 4MB to 128MB, with even larger-capacity cards in the works. A 4MB card empties about $30 from your piggy bank; a 128MB card runs about $400. So your cost per megabyte is lower if you buy the larger-capacity cards. Kodak, Canon, and Nikon cameras are among those that accept CompactFlash memory.

✔ **SmartMedia:** These cards are smaller, thinner, and more flexible than CompactFlash cards; they feel sort of like the old 5.25-inch floppy disks that we used in the dark ages of computing (six or seven years ago). Fujifilm cameras use SmartMedia cards, as do some cameras from Minolta, Olympus, and Toshiba.

You sometimes see the initials *SSFDC* in conjunction with the SmartMedia moniker. SSFDC stands for Solid State Floppy Disk Card and refers to the technology used in the cards. But if you go into a store and ask for an SSFDC card, you're likely to be greeted by blank stares, so stick with SmartMedia instead.

Like CompactFlash cards, SmartMedia cards come in several different capacities, but the biggest-capacity card you can buy at present is 32MB. As with CompactFlash, you get a better per-megabyte price if you buy the larger-capacity cards. A 4MB card costs about $20, and a 32MB card runs about $100. (You can also buy 2MB SmartMedia cards, but these usually are about the same price as a 4MB card, so you may as well go for the larger capacity.)

SmartMedia cards are made in two different voltages, 3.3 volts and 5 volts, to accommodate different types of cameras. Check your camera's manual to find out which voltage you need. Also be aware that a few older digital cameras can't use the newer, highest capacity SmartMedia cards.

✔ **Sony Memory Stick:** This new memory option, shown later in this chapter, in Figure 4-10, works only with certain Sony digital cameras, computers, and other devices. Capacities range from 4MB, sold for about $40, to 32MB, retailing for $120.

Prices for all types of removable media vary quite a bit depending on where you buy and what brand you buy. So shop around — you likely can get even better prices than mentioned here if you watch the sale ads. Also, many stores offer extra memory as a bonus when you buy a particular camera, so keep an eye out for these promotions if you're camera shopping.

Care and feeding of miniature memory cards

CompactFlash, SmartMedia, and Memory Stick cards are fairly hardy, but you do need to take some precautions when using them. Follow these rules of the road to keep your removable media happy and also to ensure the safety of any images stored on the cards:

✔ When you insert a memory card into your camera for the first time, you may need to format the card so that it's prepared to accept your digital images. Your camera should have a format procedure, so check your manual.

✔ Never remove the card while the camera is still recording or accessing the data on the card. (Most cameras display a little light or indicator to let you know when the card is in use.)

✔ Don't turn off the power to your camera while the camera is accessing the card, either.

✔ Avoid touching the contact areas of the card.

 • On a SmartMedia card, the gold region at the top of the card is the no-touch zone.

 • On a CompactFlash or PC card, keep your mitts off the connector on the bottom of the card.

 • On a Memory Stick card, don't finger the gold terminal on the underside of the card. Don't let metal objects come into contact with the terminal, either.

✔ Don't bend a SmartMedia card. SmartMedia cards are flexible, so if you decide to carry them in your hip pocket, don't sit down.

✔ If your card gets dirty, wipe it clean with a soft, dry cloth. Dirt and grime can affect the performance of memory cards.

✔ Try not to expose memory cards to heat, humidity, static electricity, and strong electrical noise. You don't need to be overly paranoid, but use some common sense in this area.

✔ Ignore those rumors you hear about airport security scanners destroying data on memory cards. This rumor has become a hot one again with the installation of newer, stronger scanners in some airports. But according to manufacturers of storage cards, security scanners do no harm to the cards. So instead of worrying about your data being damaged when you put your camera bag through the scanner, keep an eye out for airport thieves who would like nothing more than to lift your camera off the scanner belt while you're not paying attention.

Download Devices

Most digital cameras come with a serial cable for connecting the camera to the computer. To download images, you plug the cable into both devices, fire up the image-transfer software that shipped with your camera . . . and hurry up and wait. This method of file transfer is usually very slow — if you're downloading a camera full of images, the process can easily take 20 minutes or more, depending on the type of computer you're using.

The introduction of USB-enabled cameras in the past year improved the download situation slightly. (In case you're unfamiliar with the term, USB stands for *Universal Serial Bus* and is simply another means of connecting two devices.)

With USB, images flow from camera to computer more quickly than via standard serial cable. But as you're aware if you've explored Chapter 3, USB presents two major problems: First, if your computer's a few years old, you may not be able to take advantage of USB connections because your machine may not have a USB port. And if you use Windows 95 as your computer's operating system, expect a hassle getting USB connections to work, even if you install the updated version of Windows 95 that supposedly corrects USB hang-ups.

The difficulties presented by direct camera-to-computer connections helped Sony Digital Mavica cameras, which store images on floppy disk, become a huge seller. Mavica owners don't have to mess with getting their camera and computer to shake hands through a cable. You just eject the floppy disk from the camera and push it into your computer's floppy disk drive to download images.

In the past two years, manufacturers have developed several devices that enable photographers whose cameras use other types of removable memory to enjoy the same download speed and convenience offered by the Mavica's floppy-disk setup. If you shoot digitally on a regular basis, you definitely should get one of these gadgets — you'll never regret the investment. Not only can you transfer images to your computer in a flash, you save yourself the annoyance of having to fiddle with cable connections between your computer and your camera every time you want to download some images.

Here's a look at your options:

✔ **SmartMedia floppy disk adapter:** Shown in Figure 4-1, these adapters, often sold under the trade name FlashPath, make SmartMedia cards readable by your floppy disk drive. Slip the card into the adapter and then put the adapter into your floppy drive. Then just drag and drop image files from the floppy drive to your hard drive as you would any file on a floppy disk. You can buy an adapter for about $60.

Figure 4-1: Here's a SmartMedia floppy disk adapter.

✔ **PC Card adapter:** These adapters enable CompactFlash, SmartMedia, and Memory Stick cards to masquerade as standard PC Cards. Figure 4-2 offers a glimpse of an adapter for a CompactFlash card. After putting the memory card in the adapter, you insert the whole shebang into your laptop computer's PC Card slot or into a PC Card reader (see the next bullet point). The PC Card shows up as a drive on your computer desktop, and you drag and drop image files from the PC Card to your hard drive.

Most CompactFlash manufacturers provide a free PC Card adapter when you buy a memory card, but the adapters are also available independently for about $10. PC Card adapters for SmartMedia and Memory Stick cards cost about $60.

Figure 4-2:
A PC Card adapter for a CompactFlash card.

✔ **Card reader:** Another download alternative is to buy a memory-card reader. You can buy an internal card reader that installs into an empty expansion slot on your computer or an external reader that cables to the computer, usually via a parallel port or USB port. After you install the reader's driver software, your computer "sees" the card reader as just another drive on the system, like your floppy drive or your hard drive. You insert your memory card into the reader and then drag and drop the files from the reader to your hard drive.

Some card readers, such as the Antec PhotoChute (about $100), accept standard PC Cards as well as CompactFlash and SmartMedia cards. But if you plan on using only one type of removable media, you can save a little cash and get a reader designed to accept a specific type of memory card. For example, the SanDisk ImageMate, shown in Figure 4-3, reads CompactFlash cards only but sells for $40.

If you buy a card reader that connects via the parallel port, look for a model that offers a *pass-through connection* for your printer. In plain English, that means that you connect the reader to the parallel port and then connect the printer to the reader. That way, the two devices can share the same parallel port, which is important because many computers have only one parallel port. But be advised that some printers aren't happy with this arrangement and may spit out garbage pages every now and then to voice their displeasure. Before buying a card reader (or any other device, for that matter) that provides a pass-through connection, pay a visit to the manufacturer's Web site and check for any potential hardware conflicts.

Figure 4-3:
The SanDisk
ImageMate
can read
CompactFlash
cards.

Investing in a card adapter or reader not only saves you time in terms of image downloading, it expands the usefulness of your memory cards. In addition to using the device to transfer image files, you can use it to transfer regular data files between a laptop and desktop computer. Because memory cards can hold more data than a standard floppy, you can copy more files at a time using the memory-card option. Don't you just love it when you find a new reason to justify an additional gadget expense?

Portable Storage

Adding to the array of options for digital-image storage, devices such as the Iomega Clik! drive provide an interesting alternative to buying tons of camera memory cards. The Clik! drive, shown in Figure 4-4, serves as a sort of way station where you can dump camera images from a CompactFlash or SmartMedia card until you can download them to a computer.

Here's how this gadget works: When not in use, the Clik! drive rests in a docking unit that you connect to your computer. You can see the drive in the docking unit on the left side of Figure 4-4. When you set out on a shooting expedition with your digital camera, you grab the drive from the docking unit and connect it to the card reader, which is that small gray doohickey shown on the right side of Figure 4-4.

After you fill up a CompactFlash or SmartMedia card, you slip the card into
the reader and put a Clik! disk, shown at the bottom of Figure 4-4, into the
drive. You press a button on the reader to copy the card contents to the Clik!
disk, which holds 40MB of data. You can then erase the images from the
CompactFlash or SmartMedia card and start taking more pictures. When you
return home, you disconnect the reader from the drive, put the drive back into
the docking unit, and transfer the images on the Clik! disk to your computer.
If you want to transfer images to a laptop computer instead of a desktop, you
can buy a version of the Clik! designed for connection via a PC Card slot.

The main advantage of the Clik! solution is the cost of the Clik! disks. Clik!
storage costs about 25 cents per megabyte, even less if you buy several disks
at a time. So your on-the-road storage is substantially cheaper than if you
keep all your pictures on CompactFlash or SmartMedia memory cards. Of
course, you have to factor in the cost of the drive — currently about $175 for
the desktop version and a little more for the version designed for use with a
notebook computer. But if you're a prolific photographer, your camera uses
SmartMedia or CompactFlash storage, and you need a portable picture-
storage option, you may find the Clik! an economical answer.

Floppies, Zips, and Other Storage Options

In the professional digital imaging world, the hot new topic is *digital asset management.* Digital asset management — which, incredibly, is often referred to by its initials — simply refers to the storing and cataloging of image files. (I bet you never thought of your photos as assets, did you?) Professional graphic artists and digital photographers accumulate huge collections of images and are always striving for better ways to save and inventory their assets.

Your image collection may not be as large as that of a professional photographer's, but at some point, you, too, need to think about where to keep all those photos you take. You may be at that point now if you shoot high-resolution pictures and are already cramped for storage space on your computer.

Additional storage options are plentiful — provided you have the cash, you can add as many digital closets and shoe boxes to your system as you want. The following list looks at a few of the most popular storage options; Chapter 7 introduces you to some cataloging programs that can help you keep track of all your images after you stow them away.

- ✔ The most common removable storage option is the floppy disk. Almost every computer today, with the exception of the iMac from Apple, has a floppy disk drive. The disks themselves are incredibly cheap: You can get a floppy for less than $1 if you watch the sale ads. The problem is that a floppy disk can hold less than 1.5MB of data, which means that it's suitable for storing small, low-resolution, or highly compressed images, but not large, high-resolution, uncompressed pictures.

- ✔ Several companies offer removable storage devices commonly known as *super floppies.* These drives save data on disks that are just a little larger than a floppy but that can hold much more data. The most popular option in this category is the Iomega Zip drive, which is now available in 100MB and 250MB versions. Many vendors now include Zip drives as standard equipment on desktop and even laptop computers. If you want to add a Zip drive to your system, save up about $100 for the smaller-capacity drive and $160 for the 250MB drive. A 100MB disk costs around $8; a 250MB disk sets you back about $16.

- ✔ Another contender in the super-floppy ring, the Imation SuperDisk LS-120 (about $100), accepts 120MB disks ($8 each) but can also read and write to regular floppy disks — a feature that the Zip drive doesn't offer. You can't read a SuperDisk disk on a regular floppy drive, however. Some computer vendors now offer SuperDisk drives as optional equipment on new systems, so this device may become more common in the future.

✔ If you care to spend more, you can get drives that accept removable cartridges that hold anywhere from 650MB to more than 4GB (gigabytes) of data. Many people use these drives as second hard drives. One popular choice in this category is the 2GB Iomega Jaz, which costs about $350. The drive accepts 1GB or 2GB cartridges, which sell for $100 and $125, respectively.

✔ You can have your images transferred to a CD at a digital-imaging lab (check your Yellow Pages for a lab in your area that offers this service). A typical CD can hold about 650MB of data. Cost per image varies. In my neck of the woods, transferring 1–150MB worth of images costs about $40.

✔ If you enjoy being on the cutting edge, you can buy a CD recorder and transfer images to CD yourself (hip people call this *burning a CD*). Several manufacturers now make CD recorders aimed at the consumer and small-business market. Figure 4-5 shows a Hewlett-Packard CD model. You can pick up a CD recorder for $200 to $300, and the CDs themselves cost from $2 to $12, depending on which type you buy. (See the upcoming sidebar "CD-R or CD-RW?" for more on different types of CDs and CD recorders.)

Just a few years ago, I would have told you to avoid this storage option because the recorders were a little too finicky and the recording software too complicated for anyone who didn't care to spend hours learning a slew of new technical language and sorting out hardware conflicts. But many of the problems previously associated with this technology have been resolved, making the process of burning your own CDs much easier and much more reliable. Most recorders ship with wizards that walk you through the process of copying your images to a CD, so you no longer have to be a technical guru to make things work. In fact, many new computers now ship with CD recorders already installed in place of a standard read-only CD drive.

That said, recording your own CDs is by no means as carefree a prospect as copying files to a floppy disk or Zip disk. First, some compatibility issues exist that make it impossible for some types of homemade CDs to be read by some older computers. Second, even with the software wizards to guide you, you still must deal with plenty of new and confusing technical terminology when choosing recording options. So if techno-babble intimidates you and the occasional unexplained glitch tempts you to put your fist through your computer monitor, you may want to hold off on a CD recorder. Or at the very least, ask your neighborhood computer guru to help you install and set up the recorder.

Figure 4-5:
Burning
your own
CDs offers
an inexpen-
sive means
of storing
and sharing
digital
photos.

As with any computer data, digital-image data will degrade over time. How soon you begin to lose data depends on the storage media you choose. If your storage device uses magnetic media, which includes Zip disks and flop-pies as well as your computer's hard drive, image deterioration starts to become noticeable after about ten years. In other words, don't rely on mag-netic media for long-term archiving of images.

To give your images the longest possible life, opt for CD-ROM storage, which gives you about 100 years before data loss becomes noticeable — roughly the same life span as a print photograph. However, to get this storage life, you need to select the right type of CD media. If you're having your images transferred to CD at a professional lab, request archival-quality CDs; if you're burning your own CDs, use CD-R, not CD-RW, discs in your CD recorder. CD-RW discs have an estimated life of just 30 years. (See the sidebar "CD-R or CD-RW?" for information on the difference between CD-R and CD-RW discs.)

When choosing a storage option, also remember that the various types of disks and cartridges aren't interchangeable. Jaz cartridges, for example, don't fit in a Zip drive. So if you want to be able to swap images regularly with friends, relatives, or coworkers, you need a storage option that's in wide-spread use. You probably know many people who have a Zip drive, for exam-ple, but you may not find anybody in your circle of acquaintances using a Jaz drive. Also, if you're going to send images to a service bureau or commercial printer on a regular basis, find out what types of media it can accept before making your purchase.

CD-R or CD-RW?

CD recorders enable you to *burn* your own CDs — that is, copy image files or other data onto a compact disc (CD). Two types of CD recording exist: CD-R and CD-RW. The *R* stands for *recordable; RW* stands for *rewriteable.*

With CD-R, you can record data until the disc is full. But you can't delete files to make room for new ones — after you fill the disc once, you're done. On the plus side, your images can never be accidentally erased. Additionally, CD-R discs have a life expectancy of approximately 100 years, making them ideal for long-term archiving of important images. CD-R discs are cheap, too, selling for $2 each or even less if you happen upon a special store promotion.

With CD-RW, your CD works just like any other storage medium. You can get rid of files you no longer want and store new files in their place. Although CD-RW discs cost more than CD-R discs — about $8 each — they can be less expensive over the long run because you can reuse them as you do a floppy disk or Zip disk. However, you shouldn't rely on CD-RW discs for archiving purposes. For one thing, you can accidentally overwrite or erase an important image file. For another, data on CD-RW discs starts to degrade after about 30 years.

One other important factor distinguishes CD-R from CD-RW: compatibility with existing CD-ROM drives. If you're creating CDs to share images with other people, you should know that those people need *multiread* CD drives to access files on a CD-RW disc. This type of CD drive is being implemented in many new computer systems, but most older systems do not have multiread drives. Older computers can usually read CD-R discs without problems, however. (Depending on the recording software you use, you may need to format and record the disc using special options that ensure compatibility with older CD drives.)

Industry experts predict that CD-RW devices will be standard equipment in all new computer systems within two years, so more people will be able to access CD-RW discs. For now, if you're shopping for a CD recorder, be aware that some recorders can write to CD-R discs only, while other recorders can write to both CD-R and CD-RW discs. The best bet is a machine that gives you the option of creating either CD-R or CD-RW discs. You can use the cheaper and more widely supported CD-R discs for archiving images and distributing your photos to others and use CD-RW discs for routine storage.

Software Solutions

Flashy and sleek, digital cameras are the natural stars of the digital-imaging world. But without the software that enables you to access and manipulate your images, your digital camera would be nothing more than an overpriced paperweight. Because I know that you have plenty of other had-to-have-it, never-use-it devices that can serve as paperweights, the following sections introduce you to some software products that help you get the most from your digital camera.

Be sure to investigate the CD at the back of this book, too. The CD includes demo versions of many popular digital-imaging programs so that you can test them out for yourself before you buy. You also find complete, working versions of two programs, Kodak Pictures Now and MediaCenter, from PictureWorks Technology.

Image-editing software

Image-editing software enables you to alter your images in just about any way you see fit. You can retouch photos, correcting problems with brightness, contrast, color balance, and the like. You can crop out excess background and get rid of unwanted image elements. You can also apply special effects, combine pictures into a photographic collage, and explore countless other artistic notions. Part IV of this book provides you with a brief introduction to image editing to get you started on your creative journey.

Today's computer stores and mail-order catalogs are stocked with an enormous array of image-editing products. But all of these programs can be loosely grouped into two categories: consumer and professional. The following sections help you determine which type of software fits your needs best.

Consumer image-editing programs

If you're like many digital photographers, you received a copy of one of the leading image editors for the consumer market, Adobe PhotoDeluxe, with your digital camera. PhotoDeluxe also ships with many color printers and scanners. Other popular choices in this category are PhotoExpress, from Ulead Systems, and Microsoft Picture It!, from you-know-who.

Geared to the image-editing novice, these programs provide plenty of on-screen hand-holding. Wizards walk you through basic editing tasks, and project templates simplify the process of adding your photo to a business card, calendar, e-mail postcard, or greeting card. In Figure 4-6, I'm using a PhotoDeluxe template to put a picture on a baby-shower invitation.

Within the consumer category, the range of editing and effects tools provided varies widely. For the record, I think that the aforementioned products provide a solid assortment of features for the money — around $50 — but the retouching controls in PhotoDeluxe and PhotoExpress are more sophisticated than those in Picture It! On the other hand, I like the program interface in Picture It! better.

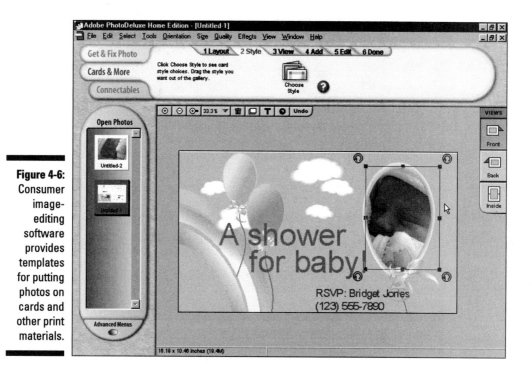

Figure 4-6:
Consumer image-editing software provides templates for putting photos on cards and other print materials.

What none of the consumer programs provide is the kind of power tools that professional graphics personnel need. You can't produce color separations for professional printing in a consumer program, for example. And although consumer programs provide enough tools to keep most casual users happy, people who edit pictures on a daily basis or just want the ultimate control over their images need to investigate professional programs, described next.

Professional image-editing programs

Designed for the serious photo editor — graphic designers, advanced photo hobbyists, and experienced computer artists — professional programs provide you with more flexible, more powerful, and, often, more convenient image-editing tools.

Here's just one example to illustrate the differences between professional and consumer packages. Say that you want to retouch an image that's overexposed. In a consumer program, you typically are limited to adjusting the exposure for all colors in the image. But in a professional program, you can adjust the highlights, shadows, and midtones independently — so that you can make a businessman's white shirt even whiter without also giving his dark brown hair a bleach job.

Additionally, you can adjust the brightness of each individual color channel independently (see Chapter 2 for an explanation of color channels). Using tools known as *dodge* and *burn tools,* you can "brush on" lightness and darkness as if you were painting with a paintbrush. And that's but a sampling of your many options — all just for adjusting image exposure.

Professional programs also include tools that enable power-users to accomplish complicated tasks more quickly. Some programs enable you to record a series of editing steps and then play the editing routine back to apply those same edits to a batch of images, for example.

The downside to professional programs is that they can be intimidating to new users and also require a high learning curve. You don't get much on-screen assistance or any of the templates and wizards provided in beginner-level programs. Expect to spend plenty of time with the program manual or a third-party book to become proficient at using the software tools.

Price is also a drawback, especially if you opt for one of the two premium players in the professional market, Adobe Photoshop (about $600) or Corel PHOTO-PAINT ($300). Although these programs represent the crème de la crème for professional photo-editing software, several good, less-expensive alternatives exist for users who don't need every possible bell and whistle. Jasc Paint Shop Pro ($90), Micrografx Picture Publisher ($110), Ulead PhotoImpact ($80), and Adobe Photoshop LE, a $95 "lite" version of Photoshop, are four programs to consider.

Before you invest in any imaging program, no matter how expensive, you're smart to give the program a whirl on your computer, using your images. The CD at the back of this book includes demo and trial versions of several image-editing programs, and you can find others at the Web sites of the software vendors.

Specialty software

In addition to programs designed specifically for photo editing, you can find some great niche programs geared to special digital photography needs and interests. Here's a sampling:

✔ Programs such as Kodak Pictures Now, shown in Figure 4-7 and provided on the CD at the back of the book, fall into a category that I call *photo-utility* software. These programs are designed for digital photographers who simply need a quick way to print their images or send them with an

e-mail message. Pictures Now, for example, simplifies the process of printing one or more images on the same sheet of paper, at various standard photo sizes (wallet size, 5 x 7 inches, and so on). Usually, this type of program features a simple, icon-based interface; you simply click the icon corresponding to the task you want to do. In some cases, you can do minor image corrections, such as cropping or rotating, but that's about it in terms of editing options.

Figure 4-7: Programs such as Kodak Pictures Now make quick work of getting your pictures onto paper.

✔ Image-cataloging programs assist you in keeping track of all your images. As mentioned earlier in this chapter, these programs are now referred to as digital asset management (DAM) tools by industry gurus. But you can just call them cataloging programs and get along fine with me. I don't think you want to walk into a computer store and ask to see all the DAM programs, anyway. At any rate, Chapter 7 provides more information about this kind of software, and the CD includes several cataloging programs for you to try.

✔ Stitching programs enable you to combine a series of images into a panoramic photo — similar to the kind you can take with some point-and-shoot film cameras. If you're in a stitching mood, Chapter 6 offers more information on the concept. And the CD at the back of the book includes a trial version of a leading stitching program, PhotoVista from Live Picture, Inc.

✔ Special-effects programs provide you with cool ways to distort your image, paint on your image, apply special effects, and otherwise explore the more artistic side of image editing. Most image-editing programs include at least a basic assortment of these artistic effects, but a few programs are devoted entirely to this aspect of image editing. Kai's SuperGoo, from MetaCreations, for example, enables you to become a digital Dr. Frankenstein of sorts, merging eyes, ears, noses, and other features from several faces into one, as I'm doing in Figure 4-8. You can also use Goo to stretch and bend photographic subjects, as though they were made of Silly Putty, and to add accessories such as hats and sunglasses. Keep in mind that although these programs can be fun, they're not designed for image retouching and other everyday image-editing tasks.

✔ Kid-oriented programs such as Looney Tunes Photo Print Studio, from MGI Software, are great for sharing digital photo fun with the younger members of the family. This program, which you can preview in Figure 4-9, includes templates for incorporating your photos into cards, banners, and other projects featuring Bugs Bunny and other Warner Brothers cartoon characters.

Figure 4-8:
Programs
such as
Kai's
SuperGoo
offer fun
special
effects but
no retouch-
ing tools.

TECHNICAL STUFF

I never metadata I didn't like

Many digital cameras, especially those at the higher end of the consumer price range, store *metadata* along with picture data when recording an image to memory. Metadata is a fancy name for information that gets stored in a special area of the image file. Digital cameras record such information as the aperture, shutter speed, exposure compensation, and other camera settings as metadata.

To capture and retain metadata, digital cameras typically store images using a variation of the JPEG file format known as EXIF, which stands for *exchangeable image format.* This flavor of JPEG is often stated in camera literature as JPEG (EXIF).

If your camera captures metadata using the EXIF format, you can view the metadata using an *extractor* program such as Picture Information Extractor, shown here. (A demo copy of the program is provided on the CD accompanying this book.)

By reviewing the metadata for each image, you can get a better grasp on how the various settings on your camera affect your images. It's like having a personal assistant trailing around after you, making a record of your photographic choices each time you press the shutter button — only you don't have to feed this assistant lunch or provide health insurance.

Picture Information Extractor 2.8 - Demo

File Edit View Extract Transform Help

Name	Date/Time	Shutter	Aperture	Flash	Quality	Zoom
DSCF0047.JPG	6/15/1999 12:37:05 AM	1/91 s	1:3.8	Yes	Normal	50mm...
DSCF0048.JPG	6/15/1999 12:37:35 AM	1/91 s	1:3.8	Yes	Normal	105m...
DSCF0049.JPG	6/15/1999 12:41:35 AM	1/91 s	1:3.8	Yes	Normal	105m...
DSCF0050.JPG	6/15/1999 12:42:29 AM	1/91 s	1:3.8	Yes	Normal	105m...
DSCF0051.JPG	6/15/1999 12:43:03 AM	1/91 s	1:3.8	Yes	Normal	105m...
DSCF0052.JPG	6/15/1999 12:50:37 AM	1/91 s	1:3.8	Yes	Normal	105m...
DSCF0053.JPG	6/15/1999 12:51:49 AM	1/14 s	1:3.8	No	Normal	50mm...
DSCF0054.JPG	6/15/1999 12:53:32 AM	1/91 s	1:3.8	Yes	Normal	105m...
DSCF0055.JPG	6/15/1999 12:53:53 AM	1/91 s	1:3.8	Yes	Normal	80mm...
DSCF0056.JPG	6/15/1999 1:02:29 AM	1/91 s	1:3.8	Yes	Normal	105m...
DSCF0057.JPG	6/15/1999 1:55:21 AM	1/416 s	1:7.6	No	Normal	35mm...
DSCF0058.JPG	6/15/1999 1:58:05 AM	1/416 s	1:7.6	No	Normal	50mm...
DSCF0059.JPG	6/15/1999 2:02:50 AM	1/724 s	1:7.6	No	Normal	35mm...
DSCF0060.JPG	6/15/1999 2:03:24 AM	1/588 s	1:7.6	No	Normal	35mm...
DSCF0061.JPG	6/15/1999 2:03:34 AM	1/724 s	1:7.6	No	Normal	35mm...
DSCF0062.JPG	6/15/1999 2:07:42 AM	1/362 s	1:7.6	No	Normal	50mm...
DSCF0063.JPG	6/15/1999 2:08:15 AM	1/338 s	1:7.6	No	Normal	80mm...
MoodyPyramid1.jpg	6/15/1999 12:23:23 AM	1/294 s	1:7.6	No	Normal	35mm...

My Computer
- 3½ Floppy (A:)
- (C:)
- Removable Disk (D:)
- (E:)
 - Casio
 - DigPix2ndEd
 - DigPix3
 - Fair98
 - FujiMX600Zoom
 - Houston
 - Roses
 - Sewing
 - KodakDC240
 - Nikon950
 - Nikoncoolpix

DSCF0057.JPG

Date: Tuesday, June 15, 1999
Time: 1:55:21 AM
Shutter: 1/416 sec Flash: No
Aperture: 1:7.6 Quality: Normal

Zoom: 35mm (1.0x)
Wide Tele

File Date: Tuesday, June 15, 1999
Time: 1:55:20 AM
Size: 323,105 Bytes

Dimension: 1280x1024 (24 Bit)
Image Type: JPEG file (*.JPG; *.JPEG; *.JFIF)

No Infofile 'picinfo.txt'. 25 files (18.0 MB)

Figure 4-9:
With Looney Tunes Photo Print Studio, kids can have a blast blending their digital photos with templates featuring popular cartoon characters.

Camera Accessories

So far, this chapter has focused on accessories to make your life easier and more fun after you shoot your digital pictures. But the three items in the following list are even more essential because they help you capture great pictures in the first place.

✔ **Special lens adapter and lenses:** If your camera can accept other lenses, you can expand your range of creativity by investing in a wide-angle, close-up, or telephoto lens (telephoto lenses are designed for shooting faraway objects). With some cameras, you can add supplementary wide-angle and telephoto elements that slip over the normal camera lens. You can also buy special lens filters, such as *polarizing filters,* which reduce glare and make blue skies and white clouds stand out better. The price range of these accessories varies depending on the quality and type — you can spend as little as $20 for a simple polarizing filter or as much as $100 for a super-wide-angle lens.

✔ **Tripod:** When you shoot with a digital camera, the image capture time is longer than with most film cameras, which means that you need to hold the camera steady for a longer period of time to avoid blurry images. If your images continually suffer from soft focus, camera shake is one possible cause — and using a tripod is a good cure. You can spend a

little or a lot on a tripod, with models available for anywhere from $20 to several hundred dollars. I can tell you that I've been quite happy with my $20 model, though. And at that price, I don't worry about tossing the thing into the trunk when I travel. Just be sure that the tripod you buy is sturdy enough to handle the weight of your camera. You may want to take your camera with you when you shop so that you can see how well the tripod works with your camera.

Alfred DeBat, technical editor for this book, suggests this method for testing a tripod's sturdiness: Set the tripod at its maximum height, push down on the top camera platform, and try turning the tripod head as though it were a doorknob. If the tripod twists easily, look for a different model.

- ✔ **Camera case:** Digital cameras are sensitive pieces of electronic equipment, and if you want them to perform well, you need to protect them from hazards of daily life. No camera is likely to take great pictures after being dropped on the sidewalk, being banged around inside a briefcase, or suffering other physical abuse on a regular basis. So whenever you're not using the camera, you should stow it in a well-padded camera case.

You can pick up a decent, padded carrying case for about $10 at a discount store. Or if you want to spend a little more, head for a camera store, where you can buy a full-fledged digital camera bag that has room for all your batteries and other gear. Some digital cameras do come with their own cases, but most of these cases are pretty flimsy and not up to the job of keeping your camera safe from harm. You're spending several hundred dollars on a camera, so do yourself a favor and invest a little more on a proper protective case.

Two More Cool Tools

To wrap up this chapter, I want to introduce you to two more accessories that don't seem to fit nicely into any of the other categories discussed so far.

The first, the Sony CyberFrame, falls into the "what to buy for someone who has everything" camp. Shown in Figure 4-10, the CyberFrame is a blend of computer monitor and picture frame (Sony calls it a "digital image stand"). You slip a Sony Memory Stick into a slot in the frame, and your pictures appear on the 5.5-inch, active-matrix LCD display.

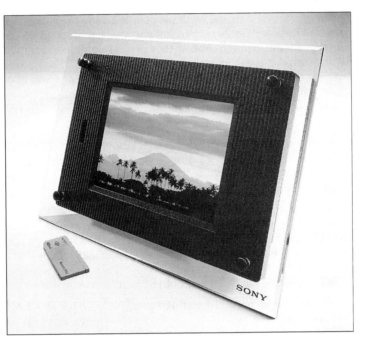

Figure 4-10:
The Sony
CyberFrame
offers table-
top display
of your
favorite digi-
tal images.

You can show MPEG mini-movies, display still shots, or play back multiple pictures in slide show mode. To up the cool factor even more, you can turn the thing on just by waving your hand in front of a sensor. Oh, and to make sure that the frame doesn't clash with your décor, it comes with interchange-able green and terra cotta frames. Pick up a CyberFrame for your favorite digital-imaging enthusiast, and you will outdo every other gift-giver in the family, no question about it. Of course, you may also wind up the gift-giver with the lightest wallet — the CyberFrame retails for $899. (Note to my friends and family: I don't have one of these yet!)

For a digital-imaging accessory that fits more easily into the annual equip-ment budget, I highly recommend a digital drawing tablet. A drawing tablet enables you to do your image-editing using a pen stylus instead of a mouse. If you do a good deal of intricate touch-up work on your pictures or you enjoy digital painting or drawing, you'll wonder what you ever did without a tablet after you try one.

To give yourself the most flexibility, look for a tablet with a connection that enables you to keep both the tablet and your regular mouse operational. For example, I use a Wacom Intuos tablet, which plugs into my PC's serial port. My mouse goes into a PS/2 mouse port, so I can switch back and forth

between mouse and pen whenever I want. Typically, I use the mouse for performing actions that call for large cursor movements — things like choosing menu commands and selecting words in my word processor. I pick up the pen stylus for doing detailed image-editing tasks, such as drawing a selection outline or cloning (see Part IV for more about image editing).

Professional drawing tablets run as high as $800, but you don't need to spend anywhere near that much for a decent tablet. The Wacom Intuos model shown in Figure 4-11, for example, costs about $165. The tablet has a 4 x 5 active drawing tablet and a feature that enables you to program "buttons" on the face of the tablet to access commands in some image-editing programs.

Frankly, though, you'll probably never miss programmable buttons and similar features that make the Intuos line from Wacom a favorite among graphics professionals. For people who just want the added control offered by a drawing tablet, Wacom and other manufacturers offer basic-feature tablets selling for $70 and under.

Figure 4-11:
Intricate editing tasks become easier when you set aside the mouse in favor of a drawing tablet and pen stylus like this Intuos model from Wacom.

Part II
Ready, Set, Shoot!

The 5th Wave By Rich Tennant

"...and now, a digital image of my dad trying to slip a $20 dollar bill to the police officer who pulled him over for speeding."

In this part . . .

Digital cameras for the consumer market are catego-
rized as "point-and-shoot" cameras. That is, you're
supposed to be able to simply point the camera at your
subject and shoot the picture.

But as is the case with point-and-shoot film cameras,
picture-taking with a digital camera isn't quite as auto-
matic as the camera manufacturers would like you to
believe. Before you aim that lens and press the shutter
button, you need to consider quite a few factors if you
want to come away with a good picture, as this part of the
book reveals.

Chapter 5 tells you everything you need to know about
composition, lighting, and focus — three primary compo-
nents of a great photograph. Chapter 6 covers issues
specific to digital photography, such as choosing the right
capture resolution and shooting pictures that you want to
place in a photo collage or stitch together into a panorama.

By abandoning the point-and-shoot approach and adopting
the think-point-and-shoot strategies outlined in this part,
you, too, can turn out impressive digital photographs. At
the very least, you will no longer wind up with pictures in
which the top of your subject's head is cut off or the focus
is so far gone that people ask why you took pictures on
such a foggy day.

Chapter 5

Take Your Best Shot

*A*fter you figure out the mechanics of your camera — how to load the batteries, how to turn on the LCD, and so on — taking a picture is a simple process. Just aim the camera and press the shutter button. Taking a *good* picture, however, isn't so easy. Sure, you can record an okay image of your subject without much effort. But if you want a crisp, clear, dynamic image, you need to consider a few factors before you point and shoot.

This chapter explores three basic elements that go into a superior image: composition, lighting, and focus. By mulling over the concepts presented in this chapter, you can begin to evolve from so-so picture-taker to creative, knock-their-socks-off photographer. Chapter 6 takes you one step further in your photographic development — sorry, bad pun — by exploring some issues specifically related to shooting with digital cameras.

One thing I can't do in this chapter is give you specifics on how to use your particular camera. So before you dig into this chapter, spend a little time with your camera's instruction manual. I know, reading manuals is a drag, but you can't exploit your camera's capabilities fully unless you take the time to find out how all those little buttons, knobs, and dials work.

Composition 101

Consider the image in Figure 5-1. As pictures go, it's not bad. The subject, a statue at the base of the Soldiers and Sailors Monument in downtown Indianapolis, is interesting enough. But overall, the picture is . . . well, a little boring.

Figure 5-1:
This image falls flat because of its uninspired framing and angle of view.

Now look at Figure 5-2, which shows two additional images of the same subject, but with more powerful results. What makes the difference? In a word, *composition*. Simply framing the statue differently, zooming in for a closer view, and changing the camera angle create much more captivating images.

Not everyone agrees on the "best" ways to compose an image — art being in the eye of the beholder and all that. For every composition rule, you can find an incredible image that proves the exception. That said, the following list offers some suggestions that can help you create images that rise above the ho-hum mark on the visual interest meter:

✔ Remember the rule of thirds. For maximum impact, don't place your subject smack in the center of the frame, as was done in Figure 5-1. Instead, mentally divide the image area into thirds, as illustrated in Figure 5-3. Then position the main subject elements at spots where the dividing lines intersect.

Figure 5-2:
Getting closer to the subject and shooting from less-obvious angles result in more interesting pictures.

Figure 5-3:
One rule of composition is to divide the frame into thirds and position the main subject at one of the intersection points.

✔ To add life to your images, compose the scene so that the viewer's eye is naturally drawn from one edge of the frame to the other, as in Figure 5-4. The figure in the image, also part of the Soldiers and Sailors Monument, appears ready to fly off into the big, blue yonder. You can almost feel the breeze blowing the torch's flame and the figure's cape.

Figure 5-4: To add life to your images, frame the scene so that the eye is naturally drawn from one edge of the image to the other.

✔ Avoid the plant-on-the-head syndrome. In other words, watch out for distracting background elements such as the flower and computer monitor in Figure 5-5. That's IDG editor extraordinaire, Jennifer Ehrlich, in the picture, by the way. Most editors do have telephones permanently affixed to their ears, but very few actually have big glowing monitors and flowers growing out of their heads, as this image makes it seem.

✔ Shoot your subject from unexpected angles. Again, refer to Figure 5-1. This image accurately represents the statue. But the picture is hardly as captivating as the images in Figure 5-2, which show the same subject from more unusual angles. Don't be afraid to climb up on a chair or lie on the ground to catch your subject from a unique point of view. Sure, people will point and stare, and you may occasionally get stepped on by some inattentive passerby, but that's the price that all great artists pay for making their creative mark.

Figure 5-5:
A classic example of a beautiful subject set against a horrendous background.

Here's a trick for shooting children: Photograph them while they're lying down on the floor and looking up at the camera, as in Figure 5-6. Maybe the children you photograph live in pristine surroundings, but in my family, rooms full of children are also full of Power Rangers toys, sippy cups, and other kid paraphernalia, which can make getting an uncluttered shot difficult. So I simply shove everything off to a small area of carpet and have the kids get down on the floor and pose. They think it's funny, so I always get good smiles in the picture.

Figure 5-6:
If you can't shoot kids without getting playroom clutter in the scene, have them lie down on an empty swatch of carpet.

Figure 5-7:
Getting down to eye level is another tactic for shooting good kid pics.

✔ Another good approach for shooting the wee ones is to hunker down so that you can shoot at eye level, as I did in Figure 5-7. If your knees are as bad as mine, this tactic isn't as easy as it sounds — the getting-down-to-eye-level part is easy enough, but the getting-back-up isn't! But the results are worth the effort and resulting ice pack.

✔ Get close to your subject. Often, the most interesting shot is the one that reveals the small details, such as the laugh lines in a grandfather's face or the raindrop on the rose petal. Don't be afraid to fill the frame with your subject, either. The old rule about "head room" — providing a nice margin of space above and to the sides of a subject's head — is a rule meant to be broken on occasion.

✔ Try to capture the subject's personality. The most boring people shots are those in which the subjects stand in front of the camera and say "cheese" on the photographer's cue. If you really want to reveal something about your subjects, catch them in the act of enjoying a favorite hobby or using the tools of their trade. This tactic is especially helpful with subjects who are camera-shy; focusing their attention on a familiar activity helps put them at ease and replace that stiff, I'd-rather-be-any-where-but-here look with a more natural expression.

A Parallax! A Parallax!

You compose your photo perfectly. The light is fine, the focus is fine, and all other photographic planets appear to be in alignment. But after you snap your picture and view the image on the camera monitor, you see something

different from what you saw through the viewfinder. The framing of the image is off, as though your subject repositioned itself while you weren't looking.

You're not the victim of some cruel digital hoax — just a photographic phenomenon known as a *parallax error*.

On most digital cameras, as on most point-and-shoot film cameras, the viewfinder looks out on the world through a separate window from the camera lens. Because the viewfinder is located an inch or so above or to the side of the lens, it sees your subject from a slightly different angle than the lens. But the image is captured from the point of view of the lens, not the viewfinder.

When you look through your viewfinder, you should see some little black lines near the corners of the frame. These lines indicate the boundaries of the "real" image — the edge of the frame as seen by the camera lens. If you don't pay attention to these framing cues as you shoot, you can wind up with subjects that appear to have been lopped off at the top, as with the poor pooch in Figure 5-8.

Figure 5-8:
My pal
Bernie loses
his ears as
the result of
a parallax
error.

The closer you are to your subject, the bigger the parallax problem becomes, whether you use a zoom lens or simply position the camera lens nearer to your subject. Some cameras provide a second set of framing marks in the viewfinder to indicate the framing boundaries that apply when you're shooting close-up shots. Check your camera manual to determine which framing marks mean what. (Some viewfinder markings have to do with focusing, not framing.)

If your camera has an LCD monitor, you have an additional aid for avoiding parallax problems. Because the monitor reflects the image as seen by the lens, you can simply use the monitor instead of the viewfinder to frame your image. On some cameras, the LCD monitor turns on automatically when you switch to macro mode for close-up shooting.

Let There Be Light

Digital cameras are extremely demanding when it comes to light. A typical digital camera has a light sensitivity equivalent to that of ISO 100 film (ISO film ratings and their implications are discussed in Chapter 2). As a result, image detail tends to get lost when objects are in the shadows. Too much light can also create problems. A ray of sunshine bouncing off a highly reflective surface can cause *hot spots* or *dropouts* — areas where all image detail is lost, resulting in a big white blob in your picture.

Color Plate 5-1 illustrates the problems that too much and too little light can create. In the lower-right corner of the image, where shadow falls over the scene, the detail and contrast suffer. On the other side of the coin, too much light in the upper-middle portion of the image causes a severe hot spot on the lemon. In this area, all image detail is lost. (The inset area provides a close-up view to give you a better look at this phenomenon.) In the upper-left corner of the image, where the light is neither too low nor too strong, the detail and contrast are excellent.

When you take digital pictures, capturing just the right amount of light involves not only deciding whether to use a flash or external photographic lights, but also figuring out the right exposure settings to choose. The following sections address everything you need to know to capture a well-lit, properly exposed image.

Keep in mind that you can correct minor lighting and exposure problems in the image-editing stage. Generally speaking, making a too-dark image brighter is easier than correcting an overexposed (too bright) image. So if you can't seem to get the exposure just right, opt for a slightly underexposed image rather than an overexposed one.

Locking in (auto) exposure

Exposure refers to the amount of light captured by the camera. (Read Chapter 2 for a complete discussion of exposure.) Most consumer-level digital cameras feature *autoexposure,* in which the camera reads the amount of light in the scene and then sets the exposure automatically for you.

In order for your camera's autoexposure mechanism to work correctly, you need to take this three-step approach to shooting your pictures:

1. **Frame your subject.**

2. **Press the shutter button halfway down and hold it there.**

 The camera analyzes the scene and sets the focus and exposure. (Upcoming sections discuss the focus side of the equation.) After the camera makes its decisions, it signals you in some fashion — usually with a blinking light near the viewfinder or with a beeping noise.

 If you don't want your subject to appear in the middle of the frame, you can recompose the image after locking in the exposure and focus. Just keep holding the shutter button halfway down as you reframe the image in your viewfinder. Don't move or reposition the subject before you shoot, or the exposure and focus may be out of whack.

3. **Press the shutter button the rest of the way down to capture the image.**

On lower-end cameras, you typically get a choice of two autoexposure settings — one appropriate for shooting in very bright light and another for average lighting. Many cameras display a warning light or refuse to capture the image if you've chosen an autoexposure setting that will result in a badly overexposed or underexposed picture. Higher-priced cameras give you more control over autoexposure, as discussed in the next few sections.

Choosing a metering mode

Some higher-priced digital cameras enable you to choose from several *metering modes.* (Check your manual to find out what buttons or menu commands to use to access the different modes.) In plain English, *metering mode* refers to the way in which the camera's autoexposure mechanism meters — measures — the light in the scene while calculating the proper exposure for your photograph. The typical options are as follows:

✔ Matrix metering, sometimes known as *multizone metering,* divides the frame into a grid (matrix) and analyzes the light at many different points on the grid. The camera then chooses an exposure that best captures both the shadowed and brightly lit portions of the scene. This mode is typically the default autoexposure mode and works just fine in most situations.

✔ Center-weighted metering measures the light in the entire frame but assigns a greater importance — weight — to the light in the center quarter of the frame. Use this mode when you're more concerned about how the stuff in the center of your picture looks than the stuff around the edges. (How's that for technical advice?)

✔ Spot metering measures the light only at the center of the frame. This mode is helpful when the background is much brighter than the subject — for example, when you're shooting backlit scenes (subjects that are in front of the sun or another light source). In matrix or center-weighted metering mode, your subject may be underexposed because the camera reduces the exposure to account for the brightness of the background, as illustrated by the top two examples in Figure 5-9. For the top-left shot, I used matrix metering; for the top-right image, I used center-weighted metering.

When using spot-metering mode, frame your image so that your main subject is in the center of the viewfinder and lock in the exposure and focus as explained in "Locking in (auto)exposure," earlier in this chapter. In the bottom example of Figure 5-9, I used this technique to properly expose the subject's face. See the section "Compensating for backlighting," later in this chapter, for other tricks for dealing with this shooting scenario.

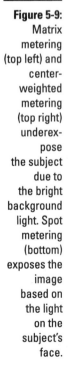

Figure 5-9: Matrix metering (top left) and center-weighted metering (top right) underexpose the subject due to the bright background light. Spot metering (bottom) exposes the image based on the light on the subject's face.

Applying exposure compensation

Exposure compensation, also referred to as EV (*exposure value*) adjustment, bumps the exposure up or down a few notches from what the camera delivers at the autoexposure setting. How you get to the exposure compensation settings varies from camera to camera. But you typically choose from settings such as +1, +2, 0, -1, and -2, with the 0 value representing the default autoexposure setting. A positive value increases the exposure, resulting in a brighter image. To decrease the exposure, choose a negative value.

Different cameras provide you with different ranges of exposure options, and the extent to which an increase or decrease in the exposure value affects your image also varies from camera to camera. Color Plate 5-2 shows you how a few exposure settings available on a Nikon digital camera affected an image I shot outdoors on a sunny day.

If your camera offers a choice of metering modes, you may want to experiment with changing the metering mode as well as using EV adjustment. For the shot in the color plate, I used the camera's matrix-metering mode, which sets autoexposure based on the entire image (see the preceding section for more information on metering modes). A few petals around the outer edge of the water lily were bright white, and the camera took that brightness information into account when figuring the correct exposure. An exposure that kept the white petals from being overexposed resulted in the rest of the flower being slightly underexposed. Switching to center-weighted or spot metering would likely have produced similar results to boosting the exposure to +1 in matrix-metering mode.

Using aperture- or shutter-priority mode

The newest cameras at the top of the consumer-model price tier enable you to switch from programmed autoexposure mode, where the camera sets both aperture and shutter speed, to *aperture-priority* autoexposure mode or *shutter-priority* autoexposure mode.

In aperture-priority mode, you gain control over the aperture. After setting the aperture, you frame your shot and then press the shutter button halfway down to set the focus and exposure, as you do when using programmed autoexposure mode. But this time, the camera checks to see what aperture you chose and then selects the shutter speed necessary to correctly expose the image at that aperture. Similarly, if you work in shutter-priority mode, you choose the shutter speed, and the camera selects the correct aperture. (If you're not sure what the terms *shutter speed* and *aperture* mean, check out Chapter 2.)

Theoretically, you should wind up with the same exposure no matter what aperture or shutter speed you choose, because as you adjust one value, the camera makes a corresponding change to the other value, right? Well, yes, sort of. Keep in mind that you're working with a limited range of shutter speeds and apertures (your camera manual provides information on available settings). So depending on the lighting conditions in the scene, the camera may not be able to properly compensate for the shutter speed or aperture that you choose.

Suppose that you're shooting outside on a bright, sunny day. You shoot your first picture at an aperture of f/11, and the picture looks great. Then you shoot a second picture, this time choosing an aperture of f/22. The camera may not be able to set the shutter speed high enough to accommodate the larger aperture, which means an overexposed picture.

Here's another example of how things can go wrong: Say that you're trying to catch a tennis player in the act of smashing a ball over the net on a gray, overcast day. You know that you need a high shutter speed to capture action, so you switch to shutter-priority mode and set the shutter speed to $\frac{1}{500}$ second. But given the lighting conditions, the camera can't capture enough light even if it selects the largest available aperture. So your picture turns out too dark.

As long as you keep the camera's shutter speed and aperture range in mind, however, switching to shutter-priority or aperture-priority mode can come in handy in the following scenarios:

- ✔ You can't get the camera to produce the exposure you want in programmed autoexposure mode.
- ✔ You're trying to capture an action scene, and the shutter speed the camera selects in programmed autoexposure mode is too slow to freeze the action.
- ✔ You purposefully want to use a too-slow shutter speed so that your picture looks a little blurry, creating a sense of motion.

If you're an experienced photographer, you probably know that with film cameras, adjusting the aperture also enables you to change the *depth of field* — the portion of the scene captured in sharp focus. But because of the way that digital cameras are engineered, you can't substantially alter depth of field by changing the aperture. You can, however, play with focus after the fact in your image-editing program. See Chapter 10 for more information.

Adjusting "ISO"

As you know if you explored Chapter 2, film is assigned an ISO number to indicate its sensitivity to light. The higher the number, the "faster" the film —

meaning that it reacts more quickly to light, enabling you to use a faster shutter speed or smaller aperture.

Some of the latest higher-end cameras enable you to select from a few different ISO settings. On the Olympus C-2000, for example, you can set the ISO to 100, 200, or 400, which correspond to most popular consumer film options. In general, though, when you switch from an ISO of 100 to 200 or 400, you don't get the same results that you do when using film. The camera simply makes some electronic adjustments when you shoot the picture, and those adjustments typically make your picture grainy or add other "noise."

I should point out that faster film also tends to produce grainier pictures than slower film, but the quality difference seems to be greater when you shoot digitally. Even the camera manuals make a point of warning you that images may not be as good when shot at a higher ISO.

Go ahead and experiment with ISO adjustment if your camera offers them, but my guess is that the results will convince you that this is one setting you can ignore.

Adding a flash of light

If an exposure adjustment doesn't deliver the results you want, you simply have to find a way to bring more light onto your subject. The obvious choice, of course, is to use a flash.

Most digital cameras, like point-and-shoot film cameras, provide a flash unit that operates in several different modes. You typically can choose from these options:

✔ **Auto flash:** In this mode, the camera gauges the available light and fires the flash if needed. This mode is usually the default mode.

✔ **Fill flash:** This mode triggers the flash regardless of the light in the scene. Fill-flash mode is especially helpful for outdoor shots, such as the one in Figure 5-10. I shot the image on the left using the auto-flash mode. Because this picture was taken on a bright, sunny day, the camera didn't see the need for a flash. But I did because the shadow from the hat obscured the subject's eyes. Turning on the fill-flash mode threw some additional light on her face, bringing her eyes into visible range.

✔ **No flash:** Choose this setting when you don't want to use the flash, no way, no how. With digital photography, you may find yourself using this mode more than you may expect. Especially when you're shooting highly reflective objects, such as a porcelain vase, a flash can cause hot spots (like the one in Color Plate 5-1). You usually get better results if you turn off the flash and use alternate light sources (as explained in the next section) or boost the exposure using your camera's manual exposure adjustments, if available.

But it looked good in the LCD!

If your camera has an LCD monitor, you can get a good idea of whether your image is properly exposed by reviewing it in the monitor. But don't rely entirely on the monitor, because it doesn't provide an absolutely accurate rendition of your image. Your actual image may be brighter or darker than it appears on the monitor, especially if your camera enables you to adjust the brightness of the monitor display.

I learned this lesson the hard way after I shot a batch of pictures with the monitor set to maximum brightness. I went home thinking that I had captured some terrific images, but when I transferred the photos to my computer, I found that every one was too dark. I managed to rescue a few pictures in my image-editing program, but most of them were lost causes.

To make sure that you wind up with at least one correctly exposed image of important subjects, *bracket* your shots if your camera offers exposure-adjustment controls. Bracketing simply means to record the same scene at several different exposure settings. Professional photographers always bracket their shots, and when capturing a good image is vital, so should you.

You may also want to turn off the flash simply because the quality of the existing light is part of what makes the scene compelling. The interplay of shadows and light in Figure 5-11, for example, is the interesting aspect of the photograph. You can almost feel the plant leaves straining to reach the late afternoon sun. Turn on the flash, and you have nothing more than a boring shot of your average plant on a stand.

Figure 5-10: An outdoor image shot without a flash (left) and with a flash (right).

Figure 5-11:
Turn off the flash to capture an interesting interplay of shadows and light.

When you turn off the flash, however, remember that the camera may increase the exposure time to partially compensate for the dim lighting. That means that you need to hold the camera steady for a longer period of time to avoid blurry images. Use a tripod or otherwise brace the camera for best results.

✔ **Flash with red-eye reduction:** Anyone who's taken people pictures with a point-and-shoot camera — digital or film — is familiar with the so-called red-eye problem. The flash reflects in the subject's eyes, and the result is a demonic red glint in the eye. Red-eye reduction mode aims to thwart this phenomenon by firing a low-power flash before the "real" flash goes off or by lighting a little lamp for a second or two prior to capturing the image. The idea is that the prelight, if you will, causes the iris of the eye to shut down a little, thereby lessening the chances of a reflection when the final flash goes off.

Unfortunately, red-eye reduction on digital cameras doesn't work much better than it does on film cameras. Often, you still wind up with fire in the eyes — hey, the manufacturer only promised to *reduce* red eye, not eliminate it, right? Worse, your subjects sometimes think the preflash or light is the real flash and start walking away just when the picture is actually being captured. So if you shoot with red-eye mode turned on, be sure to explain to your subjects what's going to happen.

The good news is that, because you're shooting digitally, you can edit out those red eyes in your image-editing software. Use the cloning or patching techniques discussed in Chapter 11 to make your red eyes blue (or black, gray, green, or brown, as the case may be).

✔ **Slow-sync flash:** A few higher-end cameras offer this variation on the auto-flash mode. Slow-sync flash increases the exposure time beyond what the camera normally sets for flash pictures. With a normal flash, your main subject may be illuminated by the flash, but background elements beyond the reach of the flash may be obscured by darkness. With slow-sync flash, the longer exposure time helps make those background elements brighter.

✔ **External flash:** Another high-end option enables you to use a separate flash unit with your digital camera, just as you can with a 35mm SLR and other high-end film cameras. In this mode, the camera's on-board flash is disabled, and you must set the correct exposure to work with your flash. This option is a great one for professional photographers and advanced photo hobbyists who have the expertise and equipment to use it; check your camera manual to find out what type of external flash works with your camera and how to connect the flash to your camera.

If your camera has a built-in flash but doesn't offer an accessory off-camera flash connection, you can get the benefits of an external flash by using so-called "slave" flash units. These small, self-contained, battery-operated flash units have built-in photo-eyes that trigger the supplemental flash when the camera's flash goes off. If you're trying to photograph an event in a room that's dimly lit, you can put several of these small slave units in different places. All the slave flash units will fire when you take a picture anywhere in the room.

Switching on additional light sources

Although your camera's flash offers one alternative for lighting your scene, flash photography isn't problem-free. When you're shooting your subject at close range, a flash can cause hot spots or leave some portions of the image looking overexposed, similar to the problems caused by the sun in Color Plate 5-1. A flash can also lead to red-eyed people, as discussed in the preceding section.

Some digital cameras can accept an auxiliary flash unit, which helps reduce hot spots and red eye because you can move the flash farther away from the subject. But if your camera doesn't offer this option, you usually get better results if you turn off the flash and use another light source to illuminate the scene.

If you're a well-equipped film photographer and you have studio lights, go dig them up. Or you may want to invest in some inexpensive photoflood lights — these are the same kind of lights used with video camcorders and are sometimes called "hot" lights because they "burn" continuously.

But you really don't need to go out and spend a fortune on lighting equipment. If you get creative, you can probably figure out a lighting solution using stuff you already have around the house. For example, when shooting small objects, I sometimes clear off a shelf on the white bookcase in my office. A nearby window offers a perfect natural light source.

For shots where I need a little more space, I sometimes use the setup shown in Figure 5-12. The white background is nothing more than a cardboard presentation easel purchased at an art and education supply store — teachers use these things to create classroom displays. I placed another white board on the table surface.

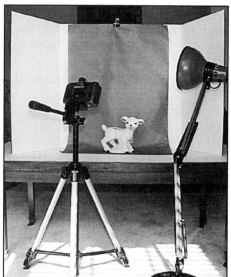

Figure 5-12: You can create a makeshift studio using nothing more than a sunny window, a few pieces of white cardboard, some tissue paper, a tripod, and an office lamp.

The easel and board brighten up the subject because they reflect light onto it. If I need still more light, I switch on a regular old desk lamp or a small clip-on shop light (the kind you buy in hardware stores). And if I want a colored background instead of a white one, I clip a piece of colored tissue paper, also bought at that education supply store, onto the easel. A solid-colored table-cloth or even a bedsheet works just as well as a background drape.

Okay, so professional photographers and serious amateurs will no doubt have a good laugh at these cheap little setups. But I say, whatever works, works. Besides, you've already spent a good sum of money on your camera, so why not save a few bucks where you can?

When using an artificial light source, whether it be a true-blue photography light or a makeshift solution like a desk lamp, you get better results if you don't aim the light directly at the object you're photographing. Instead, aim the light at the background and let the light bounce off that surface onto your subject. For example, when using a setup like the one in Figure 5-12, you might aim the light at one of the side panels. This kind of lighting is called *bounce lighting,* in case you're curious.

Because different light sources have different *color temperatures* (contain different amounts of red, green, and blue light), lighting a subject both with sun-light and an artificial light source, as shown in Figure 5-12, can confuse your camera. If your pictures exhibit an unwanted color cast, try changing your camera's white-balance setting to fix the problem. Alternatively, you can buy some daylight photo flood bulbs to get the color temperature of your artifi-cial lights more in sync with the daylight shining through the window. For more details about this issue, check out Chapter 6.

Compensating for backlighting

A *backlit* picture is one in which the sun or light source is behind the subject. With autoexposure cameras, strong backlighting often results in too-dark sub-jects because the camera adjusts the exposure based on the strength of the light in the overall scene, not just on the amount of light falling on the subject. The left image in Figure 5-13 is a classic example of a backlighting problem.

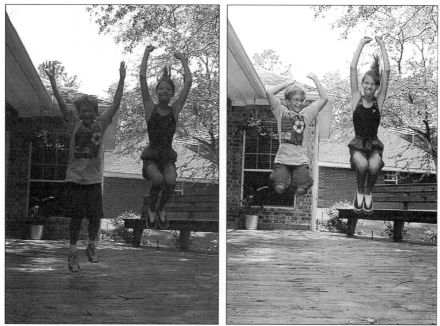

Figure 5-13: Backlighting can cause your subjects to appear lost in the shadows (left). Adjusting the exposure or using a flash can compensate for backlighting (right).

To remedy the situation, you have several options:

- ✔ Reposition the subject so that the sun is behind the camera instead of behind the subject.

- ✔ Reposition yourself so that you're shooting from a different angle.

- ✔ Use a flash. Most cameras offer a setting that fires the flash regardless of the amount of light in the scene — this setting is sometimes called *fill flash.* Adding the flash can light up your subjects and bring them out of the shadows. However, because the working range of the flash on most consumer digital cameras is relatively small, your subject must be fairly close to the camera for the flash to do any good. (See the section "Adding a flash of light," earlier in this chapter, for more information about flash options.)

- ✔ If the backlighting isn't terribly strong and your camera offers exposure compensation, try increasing the exposure, as explained in "Applying exposure compensation," earlier in this chapter. Check your camera's manual for information on using exposure compensation controls and other exposure options described elsewhere in this chapter.

Keep in mind that while increasing the exposure may brighten up your subjects, it may also cause the already bright portions of the scene to appear overexposed. You may even wind up with some flares or hot spots in areas.

✔ If your camera offers a choice of metering modes, switch to spot-metering or center-weighted metering. Center the subject in the middle of the frame, lock in the focus and exposure by pressing the shutter button halfway, reframe the picture, and then take the shot. Check out "Choosing a metering mode," earlier in this chapter, for information about metering modes.

✔ On cameras that don't offer spot- or center-weighted metering, meaning that the camera considers the light throughout the frame when setting the autoexposure, you can try to "fool" the autoexposure meter. Fill the frame with a dark object, press the shutter button halfway down to lock in the exposure, reframe the subject, and press the shutter button the rest of the way down to take the picture.

Because the focus is also set when you press the shutter button halfway, be sure that the dark object you're using to set the exposure is the same distance from the camera as your real subject. Otherwise, the focus of the picture will be off.

In the image on the right in Figure 5-13, I increased the exposure slightly and also used a flash. The image still isn't ideal — the subjects are still too dimly lit for my taste, and some regions border on being overexposed — but it's a vast improvement over the original. A little bit of additional brightness adjustment in an image editor could no doubt improve things even more. To fix this image, I would raise the brightness level of the foreground subjects only, leaving the sky untouched. For information on this kind of image correction, see Chapters 10 and 11.

Excuse me, can you turn down the sun?

Adding more light to a scene is considerably easier than reducing the light. If you're shooting outdoors, you can't exactly hit the dimmer switch on the sun. If the light is too strong, you really have only a few options. You can move the subject into the shade (in which case you can use a fill flash to light the subject), or on some cameras, you can reduce the exposure. Check your camera's manual for information about how to reduce the exposure on your model.

If you can't find a suitable shady backdrop, you can create one with a piece of cardboard or some other large, flat object. Just have a friend hold the cardboard between the sun and the subject. Voilà — instant shade. By moving the cardboard around, you can vary the amount of light that hits the subject.

Focus on Focus

Like point-and-shoot film cameras, digital cameras for the consumer market provide focusing aids to help you capture sharp images with ease. The following sections describe the different types of focusing schemes available and explain how to make the most of them.

Fixed focus

Fixed-focus cameras are just that — the focus is set at the factory and can't be changed. The camera is designed to capture sharply any subject within a certain distance from the camera lens. A subject outside that range appears blurry in the picture.

Fixed-focus cameras sometimes are called *focus-free* cameras because you're free of the chore of setting the focus before you shoot. But this term is a misnomer, because even though you can't adjust the focus, you have to remember to keep the subject within the camera's focusing range. There is no such thing as a (focus) free lunch. So be sure to check your camera manual to find out how much distance to put between your camera and your subject for proper focusing. With fixed-focus cameras, blurry images usually result from having your subject too close to the camera. (Most fixed-focus cameras are engineered to focus sharply from a few feet away from the camera to infinity, so you rarely get focus problems with faraway subjects.)

Autofocus

Most digital cameras now offer autofocusing, which means that the camera automatically adjusts the focus after measuring the distance between lens and subject. But "autofocusing" isn't totally automatic. For the autofocus feature to work, you need to "lock in" the focus before you shoot the picture, as follows:

1. **Frame the picture.**

2. **Press the shutter button halfway down and hold it there.**

 Your camera analyzes the picture and sets the focus. If your camera offers autoexposure — as most do — the exposure is set at the same time. After the exposure and focus are locked in, the camera lets you know that you can proceed with the picture. Usually, a little light blinks near the viewfinder or the camera makes a beeping noise.

3. **Press the shutter button the rest of the way down to capture the image.**

Although autofocusing is a great photography tool, you need to understand a few things about how your camera goes about its focusing work in order to take full advantage of this feature. Here's the condensed version of the auto-focusing manual:

✔ Different cameras use different autofocusing mechanisms. Some cameras read the distance of the element that's at the center of the frame in order to set the focus. This type of autofocus is called *single-spot* focus. Other cameras measure the distance at several spots around the frame and set the focus relative to the nearest object. This kind of autofocus is known as *multi-spot* focus. Some cameras enable you to choose which type of focusing you want to use for a particular shot.

You need to know how your camera adjusts focus so that when you lock in the focus (using the press-and-hold method just described), you place the subject within the area that the autofocus mechanism will read. If the camera uses single-spot focusing, for example, you should place your subject in the center of the frame when locking the focus.

✔ If your camera offers single-spot focus, you may see little framing marks in the viewfinder that indicate the focus point. Check your camera manual to see what the different viewfinder marks mean. On some cameras, the marks are provided to help you frame the picture rather than as a focusing indicator. (See the section on parallax problems earlier in this chapter for more information.)

✔ After you lock in the focus, you can reframe your picture if you want. As long as you keep the shutter button halfway down, the focus remains locked. Be careful that the distance between the camera and the subject doesn't change, or your focus will be off.

✔ Some cameras that offer autofocus also provide you with one or two manual-focus adjustments. Your camera may offer a *macro mode* for close-up shooting and an *infinity lock* or *landscape mode* for shooting subjects at a distance, for example. When you switch to these modes, autofocusing is turned off, so you need to make sure that your subject falls within the focusing range of the selected mode. Check your camera's manual to find out the exact camera-to-subject distance for sharp shooting.

Manual focus

On most consumer digital cameras, you get either no manual-focusing options or just one or two options in addition to any autofocusing options. You may be able to choose a special focus setting for close-up shooting and one for faraway subjects.

REMEMBER

Hold that thing still!

A blurry image isn't always the result of poor focusing; you can also get fuzzy shots if you move the camera during the time the image is being captured.

Holding the camera still is essential in any shooting situation, but it becomes especially important when the light is dim because a longer exposure time is needed. That means that you have to keep the camera steady for an even longer period of time than if you were shooting in bright light.

To help keep the camera still, try these tricks:

✔ Press your elbows against your sides as you snap the picture.

✔ Squeeze, don't jab, the shutter button. Use a soft touch to minimize the chance of moving the camera when you press the shutter button.

✔ Place the camera on a countertop, table, or other still surface. Better yet, use a tripod. You can pick up an inexpensive tripod for about $20 — a small price to pay for markedly better pictures.

✔ Use the self-timer feature. Sometimes, just the act of pressing the shutter button can jiggle the camera enough to cause a blurry photo.

If your camera offers a self-timer feature, you can opt for hands-free shooting to eliminate any possibility of camera shake. Place the camera on a tripod (or other still surface), set the camera to self-timer mode, and then press the shutter button (or do whatever your manual says to activate the self-timer mechanism). Then move away from the camera. After a few seconds, the camera snaps the picture for you automatically.

Of course, if you're lucky enough to own one of the new, high-end digital cameras that offers remote-control shooting, you can take advantage of that feature instead of the self-timer mode.

But a few high-end cameras offer you the option of setting the focus at a specific distance from the camera. On the Kodak DC260, for example, you can choose from distances ranging from 1.5 feet to infinity. On other cameras, the specific-distance focusing options are designed for close-up photography, and your focus settings are more limited — 8 inches to 20 inches, for example.

The ability to set the focus at a specific distance from the camera comes in handy when you want to shoot several pictures of one, nonmoving subject. By setting the focus manually, you don't have to go to the trouble of locking in the autofocus for each shot. Just be sure that you've accurately gauged the distance between camera and subject when setting the manual-focus distance.

If you're using manual focus for close-up shooting, get out a ruler and make sure that you have the correct camera-to-subject distance. You can't get a good idea of whether the focus is dead-on from the viewfinder or LCD, and being just an inch off in your focus judgment can mean a blurry picture.

Chapter 6

Digicam Dilemmas (And How to Solve Them)

Most of the tips and techniques in Chapter 5 apply not just to digital photography, but to film photography as well. This chapter is different.

Here, you find out how to tackle some of the challenges that are unique to digital photography. You also discover how to alter your shooting strategy to take advantage of the many new possibilities that are open to you now that you've gone digital.

In other words, it's time to look at photography from a pixel perspective.

Dialing In Your Capture Settings

Before you press the shutter button or even compose your image, you need to make a few decisions about how you want the camera to capture and store your images. Most digital cameras offer you a choice of image resolution and compression settings, and some cameras also enable you to store the image in one or two different file formats.

The following sections help you come to the right conclusions about your camera's resolution, compression, and file-format options.

Setting the capture resolution

Resolution, covered ad nauseam — emphasis on the *nauseam* — in Chapter 2, refers to the number of pixels in a digital image. On many digital cameras, you can select from two or more different resolution settings.

Note that I'm using the term *resolution* loosely in this case. Technically, image resolution means the number of pixels per linear inch (ppi), a value that you choose in your image editor. But many people, including camera manufacturers, use the term to refer to the total number of pixels in the image or the pixel dimensions (number of pixels wide by number of pixels high). Your camera manual likely uses the term in this fashion, so to avoid any confusion, I do the same in this section.

On some cameras, resolution values are specified in pixels — 640 x 480, for example — with the width value always given first. But on most cameras, the different resolution settings go by such vague names as Basic, Fine, Superfine, and so on.

Your camera manual should spell out exactly how you go about changing the resolution setting and how many pixels you get with each setting. You should also find information on how many images you can store per megabyte of camera memory at each setting.

When selecting a capture resolution, consider the final output of the image. For Web pictures, you can get by with 640 x 480 pixels or even 320 x 240 pixels. But if you want to print your picture, choose the capture setting that comes closest to giving you the final image resolution that your printer manual recommends.

For example, suppose that you camera offers the following resolution options: 640 x 480, 1024 x 768, and 1600 x 1200. Your printer manual tells you that the optimum image resolution for quality prints is 300 pixels per inch. If you capture the image at the lowest resolution, the print size at 300 ppi is around 2 inches wide by 1.6 inches tall. At 1024 x 768, you get a print size of about 3.4 x 2.5 inches; at 1600 x 1200, about 5 x 4. (These are just loose guidelines; you may be able to get good prints with fewer pixels per inch.)

Of course, the more pixels, the more memory your image consumes. So if your camera has limited memory and you're shooting at a location where you won't be able to download images, you may want to choose a lower resolution setting so that you can fit more pictures into the available memory. Alternatively, you can select a higher degree of image compression (discussed in the next section) to reduce file size.

On some cameras, the capture resolution is lowered automatically when you use certain camera features. For example, many cameras provide a burst or continuous-capture mode that enables you to record a series of images with one press of the shutter button (see "Catching a Moving Target," later in this chapter). When you use this mode, most cameras reduce the capture resolution to 640 x 480 pixels or lower.

Choosing a compression setting

Your camera probably provides a control for choosing the amount of *compression* that is applied to your images. You can read more about compression in Chapter 3, but in short, compression is simply a way of trimming some data out of an image file so that its file size is reduced.

Lossless compression removes only redundant image data so that any change in image quality is virtually undetectable. But because lossless compression often doesn't result in a significant shrinking of file size, most digital cameras use *lossy compression,* which is less discriminating when dumping data. Lossy compression is great at reducing file size, but you pay the price in reduced image quality. The more compression you apply, the more your image suffers. Color Plate 3-1 provides an example of how different compression amounts affect image quality.

Typically, compression settings are given the same vague monikers as resolution settings: Good/Better/Best or High/Normal/Basic, for example. Remember that these names refer not to the type or amount of compression being applied, but to the resulting image quality. If you set your camera to the Best setting, for example, the image is less compressed than if you choose the Good setting. Of course, the less you compress the image, the larger its file size, and the fewer images you can fit in the available camera memory.

Because all cameras provide different compression options, you need to consult your manual to find out what the options on your particular model do. Typically, you find a chart in the manual that indicates how many images you can fit into a certain amount of memory at different compression settings. But you need to experiment to find out exactly how each setting affects picture quality. Shoot the same image at several different compression settings to get an idea of how much damage you do to your pictures if you opt for a higher degree of compression. If your camera offers several capture resolution settings, do the "compression test" for each resolution setting.

As you choose your capture settings, remember that the pixel count and compression work in tandem to determine file size and image quality. Tons of pixels and minimum compression mean big files and maximum image quality. Fewer pixels and maximum compression mean tiny files and lesser image quality.

Selecting a file format

A few cameras enable you to select from a few different file formats — JPEG, FlashPix, and so on. (Chapter 7 explains these and other file formats in detail.) Some cameras also provide a proprietary format — that is, a format unique to the camera — along with the more standard formats.

Format decisions affect you in the following ways:

✔ Some file formats result in larger image files than others, either because of the structure of the data in the file or the amount of compression that's applied.

If that sounds sort of vague, well, it is. I suggest that you shoot the same image using the different file formats available on your camera. Then open each image in your image editor. First, compare the file size of each image. Now you know what format to use when you want to stuff the maximum number of images in your camera's available memory.

✔ The format you select may affect image quality. So give each of your test images a close-up inspection. Does one picture look sharper than the other? Is one a little jaggedy in areas where the other looks fine? When picture quality is a priority, choose the file format that gives you the best-looking images.

Keep in mind, though, that you pay for better picture quality with larger file sizes. For example, some cameras enable you to store images as TIFF files with no compression or as JPEG files with some compression. Although you undoubtedly get better image quality from the TIFF option, the number of pictures you can take before you fill up your available camera memory will be much lower than if you select JPEG as your storage format.

✔ All other things being equal, choose a standard file format, such as JPEG or TIFF, over a camera's proprietary image format. Why? Because most proprietary formats aren't supported by image-editing and image-cataloging programs. So before you can edit or catalog your pictures, you have to take the extra step of converting them to a standard file format using the software that came with your camera.

If you're transferring your images to your computer using a cable connection, you can often perform the format conversion at the same time you download (check your camera's software manual for format information and see Chapter 7 for more information on this process). But if you're transferring pictures via a floppy disk, floppy-disk adapter, or memory-card reader, storing your images in a standard format rather than the proprietary format means that you can open the files on your disk or memory card immediately, without doing any conversion.

A few cameras provide you with the option of storing images in the FlashPix file format. FlashPix has been around for a few years and once was touted as the ideal solution for digital images. Although the concept behind FlashPix is intriguing, the format seems to be withering on the vine today. As a result, few cataloging and image-editing programs can work with FlashPix files. Although I'm not ready to pronounce FlashPix officially dead, I'd shy away from this format unless your software welcomes FlashPix files with open arms.

Balancing Your Whites and Colors

Different light sources have varying *color temperatures,* which is a fancy way of saying that they contain different amounts of red, green, and blue light.

Color temperature is measured in Kelvin degrees, a fact that you don't really need to remember unless you want to dish with experienced film or video photographers, who sometimes toss the term into their conversations. The midday sun has a color temperature of about 5500 degrees Kelvin, which is often abbreviated as 5500°K — not to be confused with 5500 kilobytes, abbreviated as 5500K. When two worlds as full of technical lingo as photography and computers collide, havoc ensues. If you're ever unsure as to which *K* is being discussed, just nod your head thoughtfully and say, "Yes, I see your point."

Anyway, the color temperature of the light source affects how a camera — video, digital, or film — perceives the colors of the objects being photographed. If you've taken pictures in fluorescent lighting, you may have noticed a slight green tint to your photographs. The tint comes from the color of fluorescent light.

Film photographers use special films or lens filters designed to compensate for different light sources. But digital cameras, like video cameras, get around the color-temperature problem using a process known as *white balancing*. White balancing simply tells the camera what combination of red, green, and blue light it should perceive as pure white, given the current lighting conditions. With that information as a baseline, the camera can then accurately reproduce all the other colors in the scene.

On most digital cameras, white balancing is handled automatically. But many higher-end models provide manual white-balance controls as well. Why would you want to make manual white-balance adjustments? Because sometimes, automatic white balancing doesn't go quite far enough in removing unwanted color casts. If you notice that your whites aren't really white or that the image has an unnatural tint, you can sometimes correct the problem by choosing a different white-balance setting.

Typically, you can choose from the following manual settings:

- ✔ Daylight or Sunny, for shooting outdoors in bright light

- ✔ Cloudy, for shooting outdoors in overcast skies

- ✔ Fluorescent, for taking pictures in fluorescent lights, such as those found in office buildings

- ✔ Tungsten, for shooting under incandescent lights (standard household lights)

- ✔ Flash, for shooting with the camera's on-board flash

Color Plate 6-1 gives you an idea of how image colors are affected by the available white-balance settings on a Nikon digital camera. Normally, the automatic white-balance feature on this camera, as on other cameras, works pretty well. But this shooting location threw the camera a curve because the subject is actually lit by three different light sources. Like most office buildings, the one in which this picture was taken has fluorescent lights, which light the subject from above. To the subject's left (the right side of the picture), bright daylight was shining through a large picture window. And just to make things even more complicated, I switched on the camera's built-in flash.

The image has a slightly yellowish cast at the Automatic setting. That's because in the Automatic mode, the camera selects the Flash white-balance setting if the user turns on the flash (which is why the results of the Flash mode and the Automatic mode are the same in the Color Plate). But the Flash mode balances colors for the temperature of the flash only and doesn't account for the two other light sources hitting the subject. In my shooting scenario, the Fluorescent setting achieved the most accurate color balance, with the Sunny option coming in a close second.

If your camera doesn't offer white-balance adjustment or you just forget to think about this issue when you're shooting, you can sometimes remove unwanted color casts in the image-editing stage. Chapter 10 gives you information on how to fix unbalanced colors.

Composing for Compositing

For the most part, the rules of digital image composition are the same rules that film photographers have followed for years. But when you're creating digital images, you need to consider an additional factor as you set up your shots: how the image will be used. If you want to be able to lift part of your image out of its background — for example, in order to paste the subject into another image — pay special attention to the background and framing of the image.

Digital-imaging gurus refer to the process of combining two images as *compositing.*

Suppose that you're creating a product brochure. On the front cover, you want to put a photo montage that combines images of three or four products. To make your life easier in the image-editing stage, shoot each product against a plain background. That way, you can easily separate the product from the background when you're ready to cut and paste the product image into your montage.

As explained in Chapter 11, you must *select* an element before you can lift it out of its background and paste it into another picture. Selecting simply draws an outline around the element so that the computer knows which pixels to cut and paste into the other image. So why does shooting your subject against a plain background make the selection job easier? Because most image editors offer a special tool that enables you to click on a color in your image to automatically select surrounding areas that are similarly colored. If you place your subject against a red backdrop, for example, you can select the background simply by clicking on a red pixel in the background. You then can invert (reverse) the selection to easily select the subject.

If you shoot the object against a complex background, like the one in Figure 6-1, you lose this option. You have to draw your selection outline manually by tracing around it with your mouse. Selecting an image "by hand" is a fairly difficult proposition for most folks, especially when using consumer-level image-editing programs, which tend to have fairly awkward and unsophisticated selection tools.

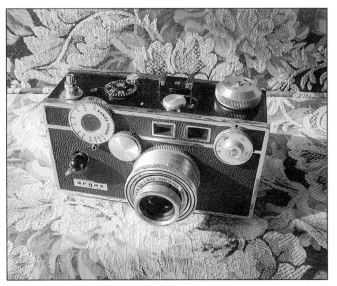

Figure 6-1:
Avoid busy
backgrounds
such as
this when
shooting
objects that
you plan to
use in a
collage.

All this selection stuff is explained more thoroughly in Chapter 11, but for now, just remember that if you want to separate an object from its background in the image-editing stage, shoot the object against a plain background, as in Figure 6-2. Make sure that the background color is distinct from the colors around the *perimeter* of the subject, not the interior, if you have a multicolor subject such as the camera in Figure 6-2. I shot the camera against a black background to provide the greatest contrast to the silver edges of the camera.

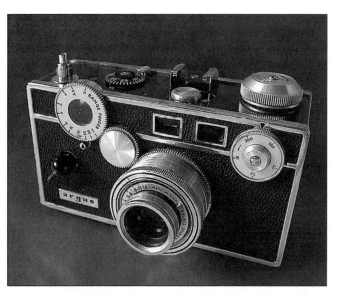

Figure 6-2: Shoot collage elements against a plain background and fill as much of the frame as possible.

See Color Plate 12-2 for another look at this concept. I knew that I wanted to be able to cut and paste each of the objects into a montage, so I chose appropriately contrasting backgrounds when shooting the pictures. (In many cases, a white background would actually work better than the colors I chose, but I didn't want to bore you with a page full of white backgrounds, especially when you're paying for living color.)

 Another important rule of shooting images for compositing is to fill as much of the frame as possible with your subject, as I did in Figure 6-2. That way, you devote the maximum number of pixels to your subject, rather than wasting them on a background that you're going to trim away. The more pixels you have, the better the image quality you can achieve. (See Chapter 2 for more information on this law of digital imaging.)

 While we're on the subject of creating photographic collages, make it a point on your next photographic expedition to look for surfaces that you can use as backgrounds in your composite images. For example, a close-up image of a nicely colored marble tile or a section of weathered barn siding can serve as an interesting background in a montage. Color Plate 11-2 gives you an example.

Zooming In without Losing Out

Many digital cameras offer zoom lenses that enable you to get a close-up perspective on your subject without going to the bother of actually moving toward the subject. Some cameras provide an *optical zoom,* which is a true zoom lens, just like the one you may have on your film camera. Other cameras offer a *digital zoom,* which isn't a zoom lens at all but a bit of pixel sleight of hand. The next two sections offer some guidelines for working with both types of zooms.

Shooting with an optical (real) zoom

If your camera has an optical zoom, keep these tips in mind before you trigger that zoom button or switch:

- ✔ The closer you get to your subject, the greater the chance of a parallax error. Chapter 5 explains this phenomenon fully, but in a nutshell, parallax errors cause the image you see in your viewfinder to be different from what your camera's lens sees and records. To make sure that you wind up with the picture you have in mind, frame your picture using the LCD monitor instead of the viewfinder. You can alternatively frame your subject using the framing marks in your viewfinder; check your camera's manual to find out which set of framing marks applies for close-up and zoom shooting.

- ✔ When you zoom in on a subject, you can fit less of the background into the frame than if you zoom out and get your close-up shot by moving nearer to the subject, as illustrated by Figure 6-3. In the case of this shot, zooming enabled me to fill the frame without including the less-than-attractive porch area behind the flowers.

- ✔ Zooming to a telephoto setting also tends to make the background blurrier than if you shoot close to the subject. This happens because the *depth of field* changes when you zoom. Depth of field simply refers to the zone of sharp focus in your photo. With a short depth of field — which is what you get when you're zoomed in — elements that are close to the camera are sharply focused, but distant background elements are not. When you zoom to a wide-angle lens setting, you have a greater depth of field, so faraway objects may be as sharply focused as your main subject. Notice that the bricks in the left portion of Figure 6-3 — the zoomed image — are less sharply focused than those in the right image. This effect would be even more pronounced if the flowers were situated farther from the bricks.

Figure 6-3: Zooming in on a subject (left) means less background in the frame than zooming out and moving closer to the subject (right).

Using a digital zoom

Some cameras put a new twist on zooming, providing a *digital zoom* rather than an optical zoom. With digital zoom, the camera enlarges the elements at the center of the frame to create the *appearance* that you've zoomed in on your subject. Say that you want to take a picture of a boat that's bobbing in the middle of a lake. You decide to zoom in on the boat and lose the watery surroundings. The camera crops out the lake pixels and magnifies the boat pixels to fill the frame. The end result is no different than if you had captured both boat and lake, cropped the lake away in your image editor, and then enlarged the remaining boat image.

TIP

Given that a digital zoom doesn't provide you with anything you couldn't achieve in your image editor, why would you want to use it? To wind up with smaller image files, which means that you can fit more images in your camera's memory before you have to download. Because the camera is cropping away the pixels around the edge of the frame, you don't have to store those pixels in memory — just the ones devoted to your main subject. If you know that you don't want those extra pixels, go ahead and use the digital zoom. Otherwise, just shoot your image normally and do your cropping in your image editor.

Catching a Moving Target

Capturing action with most digital cameras isn't an easy proposition. As you may recall if you read Chapter 2, digital cameras need plenty of light to produce good images. Unless you're shooting in a very brightly lit setting, the shutter speed required to properly expose the image may be too slow to "stop" action — that is, to record a non-blurry image of a moving target. Compounding the problem, the camera needs a few seconds to establish the autofocus and autoexposure settings before you shoot, plus a few seconds after you shoot to process and store the image in memory. If you're shooting with a flash, you also must give the flash a few seconds to recycle between pictures.

Some higher-end cameras now offer a rapid-fire option, usually known as *burst mode,* that enables you to shoot a series of images with one press of the shutter button. The camera takes pictures at timed intervals as long as you keep the shutter button pressed. This feature eliminates some of the lag time that occurs from the moment you press the shutter button until the time you can take another picture. I used the burst mode on a Kodak digital camera to record the series of images shown in Figure 6-4.

If your camera offers burst-mode shooting, check to find out whether you can adjust the settings to capture more or fewer images within a set period of time. To capture the images in Figure 6-4, for example, I set the camera to its fastest burst mode, three frames per second.

Keep in mind that most cameras can shoot only low-resolution pictures in burst mode (high-resolution pictures would require a longer storage time). And the flash is typically disabled for this capture mode. More importantly, though, timing the shots so that you catch the height of the action is difficult. Notice that in Figure 6-4, I didn't capture the most important moment in the swing — the point at which the club makes contact with the ball! If you're interested in recording just one particular moment, you may be better off using a regular shooting mode so that you have better control over when each picture is taken.

When you're shooting action shots "the normal way" — that is, without the help of burst mode — use these tricks to do a better job of stopping a moving subject in its tracks:

 ✔ Lock in focus and exposure in advance. Press the shutter button halfway down to initiate the autofocus and autoexposure process (if your camera offers these features) well ahead of the time when you want to capture the image. That way, when the action happens, you don't have to wait for the focus and exposure to be set. When locking in the focus and exposure, aim the camera at an object or person approximately the same distance away and in the same lighting conditions as your final subject will be. See Chapter 5 for more information about locking in focus and exposure.

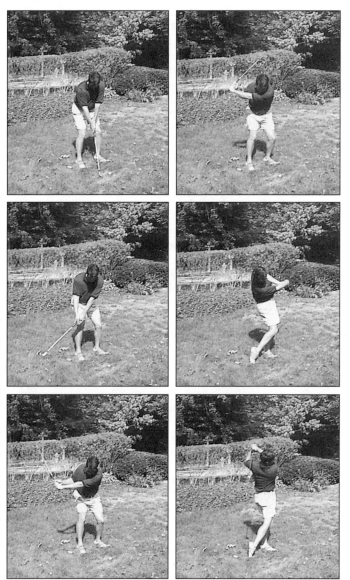

Figure 6-4: Burst mode enables you to shoot a moving target. Here, a capture setting of three frames per second broke a golfer's swing into six stages.

✔ Anticipate the shot. With just about any camera, there's a slight delay between the time you press the shutter button and the time the camera actually records the image. So the trick to catching action is to press the shutter button just a split second *before* the action occurs. Practice shooting with your camera until you have a feel for how far in advance you need to press that shutter button.

✔ Turn on the flash. Even if it's daylight, turning on the flash sometimes causes the camera to select a higher shutter speed, thereby freezing

action better. To make sure that the flash is activated, use the fill-flash mode, discussed in Chapter 5, rather than the auto-flash mode. Remember, though, that the flash may need time to recycle between shots. So for taking a series of action shots, you may want to turn the flash off.

✔ Switch to shutter-priority autoexposure mode (if available). Then select the highest shutter speed the camera provides and take a test shot. If the picture is too dark, lower the shutter speed a notch and retest. Remember, in shutter-priority mode, the camera reads the light in the scene and then sets the aperture as needed to properly expose the image at the shutter speed you select. So if the lighting isn't great, you may not be able to set the shutter speed high enough to stop action. For more about this issue, see Chapter 5.

✔ Use a lower capture resolution. The lower the capture resolution, the smaller the image file, and the less time the camera needs to record the image to memory. That means that you can take a second shot sooner than if you captured a high-resolution image.

✔ Make sure that your camera batteries are fresh. Weak batteries can sometimes make your camera behave even more sluggishly than it normally does.

✔ Keep the camera turned on. Because digital cameras suck up battery juice like nobody's business, the natural tendency is to turn off your camera between shots. But digital cameras take a few seconds to warm up after you turn them on — during which time, whatever it was that you were trying to record may have come and gone. Do turn the LCD monitor off, though, to conserve battery power as much as possible.

Shooting Pieces of a Panoramic Quilt

You're standing at the edge of the Grand Canyon, awestruck by the colors, light, and majestic rock formations. "If only I could capture all this in a photograph!" you think. But when you view the scene through your camera's viewfinder, you quickly realize that you can't possibly do justice to such a magnificent landscape with one ordinary picture.

Wait — don't put down that camera and head for the souvenir shack just yet. When you're shooting digitally, you don't have to try to squeeze the entire canyon — or whatever other subject inspires you — into one frame. You can shoot several frames, each featuring a different part of the scene, and then stitch them together just as you would sew together pieces of a patchwork quilt. Only this time, you don't have to worry about pricking your finger with a sharp needle. Figure 6-5 shows two images of a historic farmhouse that I stitched together into the panorama shown in Figure 6-6.

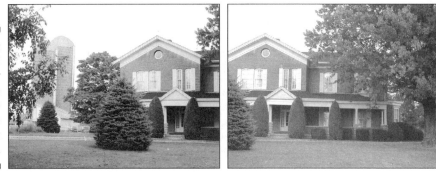

Figure 6-5:
I stitched together these two images to create the panorama in Figure 6-6.

Figure 6-6:
The resulting panorama provides a larger perspective on the farmhouse scene.

Although you could conceivably combine photos into a panorama using a regular image editor, using a dedicated stitching program such as Spin Panorama (PictureWorks Technology), shown in Figure 6-7, makes the job easier. You simply pull up the images you want to join, and the program assists you in stitching the digital "seam." You can create flat panoramas like the one in the figure or create a 360-degree panorama that can be viewed as a QuickTime VR movie.

The stitching part of the process is easy if you shoot the original images correctly. If you don't, you wind up with something that looks more like a crazy quilt than a seamless photographic panorama. Here's what you need to know:

- You must capture each picture using the same camera-to-subject distance and camera height. If you're shooting a wide building, don't get closer to the building at one end than you do at another, for example, or raise the camera for one shot in the series.

- Each shot should overlap the previous shot by at least 30 percent. Say that you're shooting a line of ten cars. If image one includes the first three cars in the line, image two should include the third car as well as

cars four and five. Some cameras provide a panorama mode that displays a portion of the previous shot in the monitor so that you can see where to align the next shot in the series. If your camera doesn't offer this feature, you need to make a mental note of where each picture ends so that you know where the next picture should begin.

✔ As you pan the camera to capture the different shots in the panorama, imagine that the camera is perched atop a short flagpole and rotate the camera around the flagpole. If you don't keep the same axis of rotation throughout your shots, you can't successfully join the images later. For best results, use a tripod.

✔ Keeping the camera level is equally important. Some tripods include little bubble levels that help you keep the camera on an even keel. If you don't have this kind of tripod, you may want to buy a little stick-on level at the hardware store and put it on top of your camera.

✔ Be sure to use a consistent focusing approach. If you lock the focus on the foreground in one shot, don't focus on the background in the next shot.

✔ Check your camera manual to find out whether your camera offers an exposure lock function. This feature retains a consistent exposure throughout the series of panorama shots, which is important for seamless image stitching.

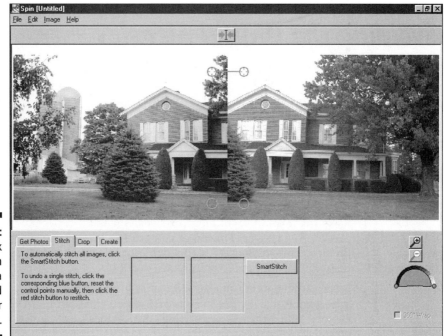

Figure 6-7:
A look
at Spin
Panorama, a
specialized
program for
stitching.

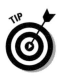

If your camera doesn't provide a way to override autoexposure, you may need to fool the camera into using a consistent exposure. Say that one half of a scene is in the shadows and the other is in the sunlight. With autoexposure enabled, the camera increases the exposure for the shadowed area and decreases the exposure for the sunny area. That sounds like a good thing, but what it really does is create a noticeable color shift between the two halves of the picture. To prevent this problem, lock in the focus and exposure on the same point for each shot. Choose a point of medium brightness for best results.

✔ Be aware of people, cars, and other objects that may be moving in the background, and try to avoid including them in your shots. If a person is walking across the landscape you're trying to shoot, you wind up with the same strolling figure in each frame of the panorama!

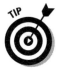

To be honest, capturing a series of shots that can be perfectly sewn up into a panorama isn't all that easy. That's why I tend to use the panorama approach more to capture still-life subjects than landscapes or cityscapes. Say that you want to take a picture of a Christmas decoration that spreads across your fireplace mantel. You can take several pictures at close range and then stitch them together. That way, you end up with more pixels devoted to each portion of the scene, enabling you to print the image at a larger size than you could if you had captured the entire mantle in one shot. (See Chapter 2 for more on the topics of pixels and print size.)

Avoiding the Digital Measles

Are your images coming out of your camera looking a little blotchy or dotted with colored speckles? Do some parts of the image have a jagged appearance? If so, the following remedies can cure your pictures:

✔ **Use a lower compression setting.** Jaggedy or blotchy images are often the result of too much compression. Check your camera manual to find out how to choose a lower compression setting. You can't fit as many images into the camera's memory with a lower compression setting because the image files are bigger. But the pictures you can store will be better looking.

✔ **Raise the resolution.** Too few pixels can mean blocky-looking — or pixelated — images. The larger you print or view the image, the worse the problem becomes. (See Chapter 2 for information on why low resolution translates to poor image quality.)

✔ **Increase the lighting.** Images shot in very low light often take on a grainy appearance, like the one in Figure 6-8. If you can't put more light on the subject, adjust the exposure using your camera's exposure compensation option, if available.

✔ Lower the camera's ISO setting (if possible). A few of the new, high-end cameras enable you to select from several ISO settings — 100, 200, 400, and so on. Typically, the higher the ISO, the grainier the image. For more on this issue, check out Chapter 5.

Figure 6-8:
Low lighting
can result
in grainy
images.

Dealing with Annoying "Features"

You know that saying, "One man's trash is another man's treasure"? Well, with digital cameras, what one person considers a helpful feature may drive another person nuts. I haven't found ways around every annoying camera feature, but I can offer a few tips for dealing with some of them.

✔ **On-board image processing:** Some cameras automatically apply certain image-correction functions, such as *sharpening* (boosting contrast to create the illusion of sharper focus). Personally, I prefer to make all my image corrections in my image editor, where I can control the extent of the corrections. Thankfully, most cameras provide a menu that enables you to turn off automatic processing; check your camera manual for information. You may want to leave the processing options turned on, however, if you plan on printing directly from the camera, as you can with some camera/printer combinations.

✔ **Automatic defaults at power up:** Many cameras that enable you to make adjustments to exposure, compression, and so forth, revert to the default settings when you turn off the camera. So if you shoot a picture

using a certain combination of settings and then turn the camera off for a few minutes, you have to start from square one to reset all the controls when you turn the camera back on.

I don't have a workaround to solve this annoyance, unfortunately. Check your camera manual to find out which settings, if any, are retained when you power down the camera so that you know which options you have to reset and which ones are still in force the next time you take a picture.

✔ **Auto shutdown (power saver):** Because digital cameras drain batteries so rapidly, most cameras shut off automatically if you don't take a picture or perform some other function within a certain period of time. Usually, that allowable downtime is very short — 30 seconds or so.

Auto shutdown may be a good idea for the forgetful crowd, but it can be a major pain when you're trying to carefully compose a picture. Just as you're rearranging the subject to your liking or working on other compositional details, the camera powers down. And when you turn the camera back on, you may have to go through the process of resetting all the manual controls! Aaaghh!

A few cameras enable you to disable the automatic-shutoff feature or at least to set the function to a longer wait time. If your camera doesn't, you have to remember to do something to make the camera think that it's in use to prevent the automatic shutdown. If your camera has a zoom, you can just zoom in and out a bit. Or press the shutter button halfway to activate the autofocus/autoexposure mechanism.

✔ **Washed-out LCD monitors:** The first time you take a picture in a bright, sunny setting using your LCD monitor to frame the image, you discover the drawback to an otherwise very cool feature. Bright light washes out the image on the LCD so much that you can't see what you're shooting.

If you're using a tripod, you can shade the LCD with your free hand (the other hand needs to be free to press the shutter button). But for a hands-free solution, try buying a polarizing filter for a 35mm camera lens and then taping the filter over the LCD. Another trick is to cut a business card in half and tape it to the camera to create a little sunshade or awning, if you will, above the LCD.

Newer digital cameras often offer a control for adjusting the brightness of the monitor. Although raising the brightness can make images easier to see in the LCD, it can also give you a false impression of your image exposure. So before you leave your shooting location, be sure to review your pictures in a setting where you can return the monitor to its default brightness level. See Chapter 5 for more tips about exposure.

Part III
From Camera to Computer and Beyond

The 5th Wave By Rich Tennant

"SOFTWARE SUPPORT SAYS WHATEVER WE DO, DON'T ANYONE START TO RUN."

In this part . . .

One major advantage of digital photography is how quickly you can go from camera to final output. In minutes, you can print or electronically distribute your images, while your film-based friends are cooling their heels, waiting for their pictures to be developed at the one-hour photo lab.

The chapters in this part of the book contain everything you need to know to get your pictures out of your camera and into the hands of friends, relatives, clients, or anyone else. Chapter 7 explains the process of transferring images to your computer and also discusses various ways to store image files. Chapter 8 describes all your printing options and provides suggestions for which types of printers work best for different printing needs. And Chapter 9 explores electronic distribution of images — placing them on the World Wide Web, sharing them via e-mail, and the like — and offers ideas for additional on-screen uses for your images.

In other words, you find out how to coax all the pretty pixels inside your camera to come out of hiding and reveal your photographic genius to the world.

Chapter 7

Building Your Image Warehouse

*M*aybe you're a highly organized photographer. As soon as you bring home a packet of prints from the photofinisher, you sort them according to date or subject matter, slip them between the pages of a photo album, and neatly record the date the picture was shot, the negative number, and the location where the negative is stored.

Then again, maybe you're like the rest of us — full of good intentions about organizing your life, but never quite finding the time to do it. I, for one, currently have no fewer than ten packets of pictures strewn about my house, all waiting patiently for their turn to make it into an album. Were you to ask me for a reprint of one of those pictures, you'd no doubt go to your grave waiting for me to deliver, because the odds that I'd be able to find the matching negative are absolutely zilch.

If you and I are soul mates on this issue, I have some unfortunate news for you: Digital photography demands that you devote some time to organizing and cataloging images after you download them to your computer. If you don't, you're going to have a tough time finding specific images when you need them. With digital images, you can't flip through a stack of prints to find a particular shot — you have to use an image editor or viewer to look at each image. Trust me, unless you set up some sort of orderly cataloging system, you waste a *lot* of time opening and closing images before you find the picture you want.

Before you can catalog your images, of course, you have to move them from the camera to the computer. This chapter gives you a look at the image-downloading process, explains the various file formats you can use when

saving your images, and introduces you to image-cataloging software. By the end of this chapter, you'll be so organized that you may even be motivated to tackle that disaster of a closet in your bedroom.

Downloading Your Images

You've got a camera full of images. Now what? You transfer them to your computer, that's what.

Some digital photography aficionados refer to the process of moving images from the camera to the computer as *downloading,* by the way. Other folks use the term *uploading.* I guess it's a matter of local computer dialect — sort of like how some people call the center of the city *downtown* and others call it *uptown.*

At any rate, the following sections introduce you to several methods of sending pictures from your camera to your computer.

A trio of downloading options

Digital camera manufacturers have developed several ways for users to transfer pictures from the camera to the computer. You may or may not be able to use all these options, depending on your camera. The following list outlines the various transfer methods, beginning with the fastest and easiest choice.

✔ **Card-to-computer transfer:** If your camera stores images on a floppy disk, just pop the disk out of your camera and insert it into your computer's floppy disk drive. Then copy the images to your hard drive as you do regular data files on a floppy disk.

If your camera uses CompactFlash, SmartMedia, or Memory Stick removable media, you can also enjoy the convenience of card-to-computer transfer, provided you have a card reader, floppy disk adapter, or device such as the Iomega Clik! drive. See Chapter 4 for more information on these gadgets.

In case you weren't paying attention three paragraphs ago, this option provides the fastest and easiest way to download images — and I'm not speaking of just a minor difference from other download methods, either. If you do much digital photography at all, do yourself a favor and invest in the equipment you need to take advantage of card-to-computer downloading. I guarantee that you'll enjoy working with your camera a great deal more if you do.

✔ **Infrared transfer:** A few cameras have an IrDA port that enables you to transfer files via infrared light beams, similar to the way your TV remote control transfers your channel-surfing commands to your TV set. In order to use this feature, your computer must have an IrDA port.

In case you're curious, IrDA stands for Infrared Data Association, an organization of electronics manufacturers that sets technical standards for devices that use infrared transfer. These standards ensure that the IrDA port on one vendor's equipment can talk to the IrDA port on another vendor's equipment.

Having tried IrDA transfer, I can tell you that getting the communication settings just right can be a bit of a challenge. I had the help of two tech support people (one for my laptop and one for the camera I was using), and between the three of us, getting the system working took well over an hour — basically, we just kept playing with different options until we stumbled across the right combinations. Maybe you'll have better luck with your setup.

If you do manage to get your camera and computer to communicate via IrDA, you simply place your camera close to your computer and start the camera's transfer program. Your image-transfer speed depends on the capabilities of your computer's IrDA port. With my laptop, the transfer rate was no faster than using the standard serial-cable connection (see the next bullet point).

But IrDA does enable traveling digital photographers to leave one cable out of their baggage. Different IrDA devices work differently, so consult your camera and computer manuals to find out how to take advantage of this option.

✔ **Cable transfer:** If you don't have the luxury of using either of the preceding transfer options, you're stuck with the "old-fashioned" method, which is to connect your computer and camera using the cable that came in your camera box. In most cases, the connection is via a serial cable, which transfers data at a speed roughly equivalent to a turtle pulling a 2-ton pickup. Okay, so maybe the speed isn't quite that slow — it just seems that way. Many newer cameras also can connect to the computer via a USB port, which makes the transfer process faster, but still not as fast as direct card-to-computer downloading.

The steps in the next section explain the transfer process, whether you use serial or USB cabling. Note that if you're a Macintosh user, you may need to order a cable for your system, because some cameras are equipped with PC cables only. *Quell discrimination!*

If all you want to do is print your images, you may not need to download them to your computer at all. Several new photo printers can print directly from digital cameras or removable media; see Chapter 8 for more information.

Regardless of which transfer method you use, don't forget to install the image-transfer software that came with your camera. If you're using direct card-to-computer transfer and your camera saves images in a standard file format (such as TIFF or JPEG), you may not need the software; you can open your images directly from the card in your image-editing program. But many cameras store images in a proprietary format that can be read only by the camera's transfer software. Before you can open the images in an image-editing program, you have to convert them to another file format using the camera transfer software. (See "File Format Free-for-All," later in this chapter, for an explanation of file formats.)

Cable transfer how-to's

Transferring images via a camera-to-computer connection works pretty much the same way from model to model. Because transfer software differs substantially from camera to camera, I can't give you specific commands for accessing your images; check your camera's manual for that information. But in general, the process works as outlined in the following steps:

1. **Turn off your computer and camera.**

 This step is *essential;* most cameras don't support *hot swapping* — connecting while the devices are turned on. If you connect the camera to the computer while either machine is powered up, you risk damaging the camera. (That's one more reason why direct card-to-computer transfer is so much more convenient than cable transfer.)

 If you're connecting via USB, you *may* not have to shut down your computer before hooking up the camera. But please, check your camera and computer manuals to be certain.

2. **Connect the camera to your computer.**

 Plug one end of the connection cable into your camera and the other into your computer. If you're going the serial-cable route and you use a Macintosh computer, you typically plug the camera cable into the printer or modem port, as shown in the top half of Figure 7-1. On a PC, the serial cable usually connects to a COM port (often used for connecting external modems to the computer), as shown in the bottom half of Figure 7-1.

 The setup is the same for cameras that come with a USB cable. Plug one end of the cable into the camera and the other into your computer's USB port. Note that if you use Windows 95, your computer may refuse to recognize the presence of the camera, even if you install the Windows 95 update that is supposed to enable USB. I've also experienced other problems after trying to download via USB on my Windows 95

computer — unexplained crashes and the so-called "blue screen of death" that Windows displays when it gets really annoyed. So if you want to avoid hassles, either upgrade to Windows 98 or use some method of image transfer other than USB.

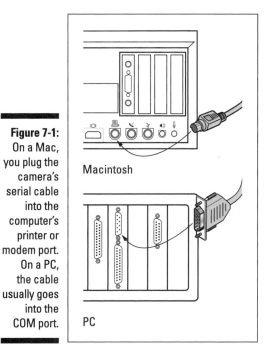

Figure 7-1:
On a Mac, you plug the camera's serial cable into the computer's printer or modem port. On a PC, the cable usually goes into the COM port.

Macintosh

PC

3. **Turn the computer and camera back on.**

4. **Set the camera to the appropriate mode for image transfer.**

 On some cameras, you put the camera in playback mode; other cameras have a PC setting. Check your manual to find out the right setting for your model.

5. **Start the image-transfer software.**

 You have to install the software before you can use it, of course. Your manual should tell you how.

6. **Download away.**

 From here on out, the commands and steps needed to get those pictures from your camera onto your computer vary, depending on the camera and transfer software.

Take the bullet TWAIN

Chances are good that your camera comes with a CD or floppy disk that enables you to install something called a *TWAIN driver* on your computer. TWAIN is a special *protocol* (language) than enables your image-editing or catalog program to communicate directly with a digital camera or scanner. Rumor has it that TWAIN stands for Technology Without An Interesting Name. Those wacky computer people!

After you install the TWAIN driver, you can access your camera's images through your image-editing or cataloging program, as though the camera were just another hard drive on your computer. Of course, your camera still needs to be cabled to the computer. And your image-editing or cataloging program must be *TWAIN compliant,* meaning that it understands the TWAIN language.

The command you use to open camera images varies from program to program. Typically, the command is found in the File menu and is named something like Acquire⇨TWAIN. (In some programs, you first have to select the *TWAIN source* — that is, specify which piece of hardware you want to access. This command is also usually found in the File menu and is named something like File⇨Select TWAIN Source.)

In Adobe PhotoDeluxe, an image editor supplied with many brands of digital cameras, you choose File⇨Open Special⇨Get Digital Photo. You're then presented with a list of devices for which you've installed TWAIN drivers. Click on the device you want to access and then click OK. PhotoDeluxe launches your camera's image-transfer program, and you can then select the images you want to open.

Tips for delightful downloads

For whatever reason, the download process is one of the more complicated aspects of digital photography. The introduction of direct card-to-computer transfer has made things much easier, but not all users have access to this method. If you're transferring images via a serial cable, USB, or IrDA, don't feel badly if you run into problems — I do this stuff on a daily basis, and I still sometimes have trouble getting the download process to run smoothly when I work with a new camera. The problem isn't helped by camera manuals that provide little, if any, assistance on how to get your camera to talk to your computer.

Here are some troubleshooting tips I've picked up during my struggles with image transfer:

✔ If you get a message saying that the software can't communicate with the camera, check to make sure that the camera is turned on and set to the right mode (playback, PC mode, and so on).

✔ On a Macintosh, you may need to turn off AppleTalk, Express Modem, and/or GlobalFax, which can conflict with the transfer software. Check the camera manual for possible problem areas.

✔ On a PC, check the COM port setting in the transfer software if you have trouble getting the camera and computer to talk to each other. Make sure that the port selected in the download program is the one into which you plugged the camera.

✔ If you're connecting via a USB port, make sure that the USB port is enabled in your system. Some manufacturers ship their computers with the port disabled. To find out how to turn the thing on, check your computer manual. Also see my earlier comments about USB and Windows 95, in the section "Cable transfer how-to's."

✔ Check your camera manufacturer's Web site for troubleshooting information. Manufacturers often post updated software drivers on their Web sites to address downloading problems. Log on to the Web sites for your brand of computer and image software, too, because problems may be related to that end of the download process rather than to your camera.

✔ Some transfer programs give you the option of choosing an image file format and compression setting for your transferred images. Unless you want to lose some image data — which results in lower image quality — choose the no-compression setting or use a lossless-compression scheme, such as LZW for TIFF images. (If that last sentence sounded like complete gibberish, you can find a translation in the section "File Format Free-for-All," later in this chapter. Also check out the section on file compression in Chapter 3.)

✔ In most cases, the transfer software assigns your image files meaningless names such as DCS008.jpg and DCS009.jpg (for PC files) or Image 1, Image 2, and the like (for Mac files). If you previously downloaded images and haven't renamed them, files by the same names as the ones you're downloading may already exist on your hard drive.

The transfer software should alert you to this fact and ask whether you want to replace the existing images with the new images, but just in case, you may want to create a new folder to hold the new batch of images before you download. That way, there's no chance that any existing images will be overwritten.

✔ If your camera has an AC adapter, use it when downloading images. The process can take quite a while, and you need to conserve all the battery power you can for your photography outings.

✔ When you initiate the transfer process, you may be able to select an option that automatically deletes all images from the camera's memory after downloading. At the risk of sounding paranoid, I *never* select this option. After you transfer images, always review them on-screen *before* you delete any images from your camera. Glitches can happen, so make sure that you really have that image on your computer before you wipe it off your camera. As an extra precaution, make a backup copy of the image on a removable disk (floppy, Zip, or the like).

Now Playing on Channel 3

Many cameras come with a *video-out* jack and video connection cable. Translated into English, that means that you can display your images on a regular old TV set if you like. You can even connect the camera to a VCR and record your images on videotape.

Why would you want to display your images on a TV? For one thing, you can show your pictures to a group of people in your living room or office conference room, rather than having them all huddle around your computer monitor. Viewing your images on TV also enables you to review your images more closely than you can on your camera's LCD monitor. Small defects that may not be noticeable on the camera monitor become readily apparent when viewed on a 27-inch television screen.

As with connecting the camera to a computer, consult your camera's manual for specific instructions on how to hook your camera to a TV or VCR. Typically, you plug one end of an AV cable (supplied with the camera) into the camera's video- or AV-out jack and then plug the other end into your TV or VCR's video-in jack, as shown in Figure 7-2. If your camera has audio-recording capabilities, as does the camera shown in the figure, the cable has a separate AV plug for the audio signal. That plug goes into the audio-in jack, as in the figure. If your TV or VCR supports stereo sound, you typically plug the camera's audio plug into the mono-input jack.

To display your pictures on the TV, you generally use the same procedure as when reviewing your pictures on the camera's LCD monitor, but again, check your manual. To record the images on videotape, just put the VCR in record mode, turn on the camera, and display each image for the length of time you want to record it. You may need to select a different input source for the VCR or TV — for example, to switch the VCR from its standard antenna or cable input setting to its auxiliary input setting.

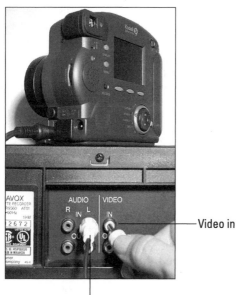

Video in

Audio in

Most digital cameras sold in North America output video in NTSC format, which is the format used by televisions in North America. You can't display NTSC images on televisions in Europe and other countries that use the PAL format instead of NTSC. So if you're an international business mogul needing to display your images abroad, you may not be able to do it using your camera's video-out feature. Some newer cameras do provide you with the choice of NTSC or PAL formats

File Format Free-for-All

You may also be asked to choose a file format when you transfer images from your camera to your computer or when you set up the camera itself — many new cameras can store images in two or more different file formats. You also need to specify a file format in order to save your image after editing in your image-editing software. (See Chapter 10 for more information on editing and saving files.)

The term *file format* simply refers to a way of storing computer data. Many different image formats exist, and each one takes a unique approach to data storage. Some formats are *proprietary,* which means that they're used only by the camera you're using to capture the image. (Proprietary formats are some-times also referred to as *native* formats.) If you want to edit images stored in

a proprietary format, you must use the software provided with the camera. Typically, you can use that software to convert the image files to a format that can be opened by other image-editing programs.

Many software programs also have a proprietary format. PhotoDeluxe, for example, uses the PDD format, which is geared to support all the PhotoDeluxe editing features and to speed editing inside the program. If you want to open the image file in some other program that doesn't support the PDD format, you can save the file in any of several other formats inside PhotoDeluxe.

Some formats are used only on the Mac, and some formats are for PCs only. A few formats are so obscure that almost no one uses them anymore, while others have become so popular that almost every program on both platforms supports them. The following list details the most common file formats for storing images, along with the pros and cons of each format:

✔ **JPEG:** Say it *jay-peg.* The acronym stands for Joint Photographic Experts Group, which was the organization that developed this format. JPEG is one of the most widely used formats today, and almost every program, on both Macintosh and Windows systems, can save and open JPEG images. JPEG is also one of the two main file formats used for images on the World Wide Web. Most digital cameras also store images in this format.

One of the main advantages of JPEG is that it can compress image data, which results in smaller image files. Smaller image files consume less space on disk and take less time to download on the Web.

The catch is that JPEG uses a *lossy compression scheme,* which means that some image data is sacrificed during the compression process. For initial storage of images in camera memory, you don't lose too much data if you select a capture option that applies minimal or even a medium amount of compression. But each time you open, edit, and resave your image in your image editor, the image is recompressed, and more damage is done.

When you save to the JPEG format, you're usually presented with a dialog box similar to the one in Figure 7-3, where you can specify the amount of compression you want to use. (The dialog boxes shown in Figures 7-3 and 7-4 are from Adobe PhotoDeluxe.)

To keep data loss to a minimum and ensure the best-printed images, choose the highest-quality setting (which results in the least amount of compression). For Web images, you can get away with a medium-quality, medium-compression setting. See Color Plate 3-1 for a look at how a large amount of JPEG compression affects an image, and read Chapter 3 for more on this subject.

The Format Options shown in Figure 7-3 are related to saving images for the Web. For more on this topic, see Chapter 9.

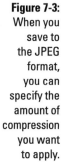

Figure 7-3:
When you
save to
the JPEG
format,
you can
specify the
amount of
compression
you want
to apply.

While you're working on an image, save it in your image-editing program's native format or the TIFF format (explained shortly), which retains all critical image data. Save to JPEG when you're completely finished editing the image. That way, you keep data loss to a minimum.

✓ **EXIF:** EXIF, which stands for *Exchangeable Image Format,* is one of many variants of the JPEG format. Many digital cameras store images using EXIF, sometimes referred to as JPEG (EXIF), to take advantage of the opportunity to store *metadata* — extra data — with the image file. In the case of digital cameras, information such as the shutter speed, aperture, and other capture settings gets recorded as metadata.

If your camera records metadata, you don't need to do anything different while capturing images, but you do need to use a special EXIF *extractor* program if you want to view the metadata after you download the pictures. Some cameras ship with proprietary software for viewing the metadata; you can also buy inexpensive programs to take a look. See the sidebar "I never metadata I didn't like," in Chapter 4, for more information.

✓ **TIFF:** TIFF stands for *Tagged Image File Format,* in case you care, which you really shouldn't. TIFF — say it *tiff,* as in little spat — ranks right up there with JPEG on the popularity scale except for use on the World Wide Web. Like JPEG images, TIFF images can be opened by most Macintosh and Windows programs.

When you save an image to the TIFF format, you're usually asked to specify a *byte order,* as shown in Figure 7-4. If you want to use the image on a Mac, choose the Macintosh option; otherwise, use the PC option. You also usually get the choice of applying LZW compression. LZW is a *lossless compression scheme,* which means that only redundant image data is abandoned when the image is compressed so that there is no loss in image quality. Unfortunately, compressing an image in this way doesn't reduce the image file size as much as using JPEG compression, which is why TIFF isn't a good option for Web images.

Figure 7-4:
TIFF files
can be
compressed
using the
lossless
LZW
compression
scheme.

TIFF Options

Byte Order
- ○ IBM PC
- ○ Macintosh

OK

Cancel

☑ LZW Compression

Most, but not all, programs support LZW-compressed TIFF images. If you have trouble opening a TIFF image, compression may be the problem. Try opening and resaving the image in another program, this time turning compression off.

✔ **Photo CD and Pro Photo CD:** Developed by Eastman Kodak, Photo CD is a format used expressly for transferring slides and film negatives onto a CD-ROM. Image-editing and cataloging programs can open Photo CD images. But no consumer software enables you to save to this format; if you want to store pictures as Photo CD images, you must enlist the help of a commercial imaging lab.

The Photo CD format stores the same image at five different sizes, from 128 x 192 pixels all the way up to 2048 x 3072 pixels. The Pro Photo CD format, geared to those professionals who need ultra-high-resolution images, saves one additional size: 4096 x 6144 pixels.

When you open a Photo CD image, you can select which image size you want to use. Choose the size that corresponds to the number of pixels you need for your final output. For images that you plan to print, you generally want to select the largest size available. Remember that the more pixels in the image, the higher the image resolution and the better your printed output. If your computer complains that it doesn't have enough memory to open the image, try the next smaller size. For Web images, you can go with one of the smaller image sizes. (To read more about image size and resolution, see Chapter 2.)

✔ **FlashPix:** FlashPix is a new format developed by several different companies, including Kodak, Hewlett-Packard, and Microsoft. The goal of this format is to speed up the image-editing process and to enable consumers to edit large images on computers that don't have gargantuan amounts of RAM.

FlashPix is similar to Photo CD in that your image is stored at several different sizes in the same file. The different image versions are stacked in a pyramid structure, with the largest version of the image at the bottom of the file. When you edit the image, most commands are carried

out on the smaller versions of the image, which reduces the amount of time and RAM your computer needs to perform the edit. Only a few editing functions require the software to dig down to the largest version of the image.

FlashPix was the hot new format on the imaging scene a few years ago, but it's lost some luster lately. Not all image-editing or cataloging programs support FlashPix, and some hardware and software makers who formerly included FlashPix support in their products have stopped doing so. So I don't recommend using this format unless you want to work expressly in an image-editing program that supports FlashPix, and you don't plan on sharing your images with anyone who uses a different program. In addition to not being fully supported by many programs, FlashPix files are larger than files stored in most other formats, including TIFF.

✔ **GIF:** This format (say it *gif,* with a hard *g,* not *jif,* like the peanut butter) was developed to facilitate transmission of images on CompuServe bulletin-board services. Today, GIF *(Graphics Interchange Format)* and JPEG are the two most widely accepted formats for World Wide Web use. One variety of GIF, thoughtfully named GIF89a, enables you to make areas of your image transparent, so that your Web page background is visible through the image.

GIF is similar to TIFF in that it uses LZW compression, which creates smaller file sizes without dumping any important image data. The drawback is that GIF is limited to saving 8-bit images (256 colors or less). To see the difference this limitation can mean to your image, look at Color Plate 9-1. The top image is a 24-bit image, while the bottom image is an 8-bit image. The 8-bit image has a rough, blotchy appearance because there aren't enough different colors available to express all the original shades in the fruit. One shade of yellow must be used to represent several different shades of yellow, for example. For information on converting your image to 256 colors and creating a transparent GIF image, see Chapter 9.

✔ **PNG:** PNG, which stands for *Portable Network Graphics* format and is pronounced *ping,* is a relatively new format designed for Web graphics. Unlike GIF, PNG isn't limited to 256 colors, and unlike JPEG, PNG doesn't use lossy compression. The upside is that you get better image quality; the downside is that your file sizes are larger, which means longer download times for Web surfers wanting to view your images.

Like FlashPix, PNG is still in its infancy and so doesn't have widespread support among Web-page creation and browser programs. For now, GIF and JPEG are better options for your Web images.

✔ **BMP:** Pronounce this by just saying the letters . . . B-M-P. A popular format in the past, BMP *(Windows Bitmap)* is used today primarily for images that will be used as wallpaper on PCs running Windows.

Programmers sometimes also use BMP for images that will appear in Help systems. (Some people refer to BMP images simply as *bitmap images,* but this term can cause confusion because pixel-based images in general are also known as bitmap images.)

BMP offers a lossless compression scheme known as RLE (Run-Length Encoding), which is a fine option except when you're creating a wallpaper image file. Windows sometimes has trouble recognizing files saved with RLE when searching for wallpaper images, so you may need to turn RLE off for this use. To find out how to use one of your digital images as wallpaper, see Chapter 9.

✔ **PICT:** When talking about this format, say *pict,* as in *Peter Piper PICT a peck of pixels.* PICT is based on the Apple QuickDraw screen language and is the native graphics format for Macintosh computers. If QuickTime is installed on your Mac, you can apply JPEG compression to PICT images. But be aware that QuickTime's version of JPEG compression does slightly more damage to your image than what you get when you save an image as a regular JPEG file. Because of this, saving your file to JPEG is a better option than PICT in most cases. About the only reason to use PICT is to enable someone who doesn't have image-editing software to see your images. You can open PICT files inside SimpleText, Microsoft Word, and other word processors.

✔ **EPS:** EPS (*Encapsulated PostScript,* pronounced *E-P-S*) is a format used mostly for high-end desktop publishing and graphics production work. If your desktop publishing program or commercial service bureau requires EPS, go ahead and use it. Otherwise, choose TIFF or JPEG. EPS files take up much more room on disk than TIFF and JPEG files.

Electronic Photo Albums

After you get all those images onto your hard drive, Zip disk, or other image warehouse, you need to organize them so that you can easily find a particular image.

If you're a no-frills type of person, you can simply organize your images into folders, as you do your word-processing files, spreadsheets, and other documents. You may keep all images shot during a particular year or month in one folder, with images segregated into subfolders by subject. For example, your main folder may be named 1998, and your subfolders may be named Family, Sunsets, Holidays, Work, and so on.

Many image editors include a utility that enables you to browse through your image folders and view thumbnails of each image. These utilities make it easy to track down a particular image if you can't quite remember what you named the thing. Figure 7-5 shows the EasyPhoto browser utility included with Adobe PhotoDeluxe, for example.

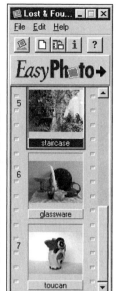

Figure 7-5:
Using image browsers like EasyPhoto, you can scroll through thumbnail views of your images.

You can also buy stand-alone viewer utilities, such as ThumbsPlus, a shareware program from Cerious Software. This particular viewer enables you to see your images in several different layouts, including one that mimics the Windows Explorer format, as shown in Figure 7-6. To organize images, you can drag and drop them from one folder to another. You can also perform some limited image editing in this program. (If you want to try this program out, install the trial version on the CD-ROM included with this book.)

If you want a fancier setup, several programs enable you to organize and view your images using an old-fashioned photo-album motif. Figure 7-7 offers a look at one such program, Presto! PhotoAlbum, from NewSoft. You drag images from a browser onto album pages, where you can then label the images and record information, such as the date and place the image was shot. You can also place your images inside frames and add other special on-screen touches.

You can find trial versions of Presto! PhotoAlbum, as well as another program that uses the photo-album approach, PhotoRecall Deluxe, on the CD-ROM accompanying this book.

Figure 7-6:
ThumbsPlus is a shareware program that enables you to view your images using a Windows Explorer-style interface.

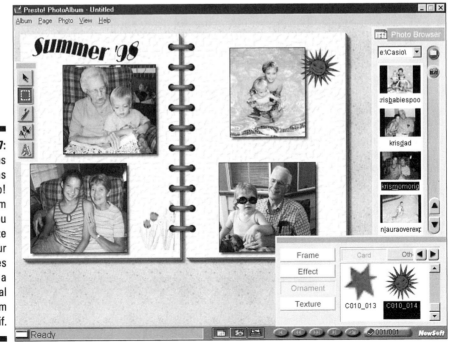

Figure 7-7:
Programs such as Presto! PhotoAlbum enable you to organize your pictures using a traditional photo-album motif.

Photo-album programs are great for those times when you want to leisurely review your images or show them to others, much as you would enjoy a traditional photo album. And creating a digital photo album can be a fun project to enjoy with your kids — they'll love picking out frames for images and adding other special effects. For simply tracking down a specific image or organizing images into folders, however, I prefer the folder-type approach like the one used by ThumbsPlus. I find that interface quicker and easier to use than flipping through the pages of a digital photo album.

If your image collection is large, you may want to look for a catalog program that enables you to store reference data with each image, such as a category, description, and the date the picture was taken. Some programs also enable you to list a few keywords with each image that can make hunting down the image easier in the future. For example, if you have an image of a Labrador retriever, you might enter the keywords "dog," "retriever," and "pet." When you later run the search portion of the browser, entering any of those keywords as a search criteria brings up the image. These kinds of tools can be extremely helpful when you start to accumulate large quantities of images. ThumbsPlus and PhotoRecall Deluxe are among the programs offering this feature.

Chapter 8

Can I Get a Hard Copy, Please?

These days, getting a roll of film turned into printed photographs is a no-brainer. You check a few boxes on the photofinishing lab's order form, hand over the order form and film canister, and skip off to your next errand. Film processing technology is so refined that you're virtually guaranteed good-looking pictures, even if the teenager who's printing your pictures doesn't know an f-stop from a shortstop.

When you take the leap into the digital frontier, however, things aren't so simple. (I bet you knew that's where I was headed, didn't you?) Taking your images from computer to paper involves several decisions, not the least of which is choosing the right printer for the job. You also need to think about things like image resolution, color matching, and paper stock.

This chapter helps you sort through the various issues involved in printing your images, whether you want to do the job yourself or have a commercial printer do the honors. In addition to discussing the pros and cons of different types of printers, the pages to come offer tips and techniques to help you get the best possible output from any printer.

If you're just dying to print a dozen copies of that picture of your boss looking foolish at the company picnic, skip ahead to "Sending Your Image to the Dance," later in this chapter, for instructions. In cases like this, image quality isn't as important as timeliness, especially with your annual review just around the corner. But promise to come back later and read the first part of the chapter to find out how to make those images look better the next time around.

Cruising the Printer Aisle

As the number of consumers embracing digital imaging has exploded, so too has the number of home- and small-office printers. Everybody from Hewlett-Packard to Xerox to Olympus is trying to capture the printing side of the digital-imaging market. And just as with digital cameras, the wide variety of options can make shopping for a printer an exercise in confusion.

 If you're in the market for a new printer, I urge you *not* to head for the store without reading the following sections, which explain different types of printers and provide some comparison-shopping tips. If your experience is like mine, you'll encounter salespeople who, although well-meaning, often provide printer information that's a little off the mark — and sometimes, so far off the mark that you wonder if the salesperson has any idea where the mark *is*.

Printer primer

When they aren't in high-level conferences thinking up acronyms like CMOS and PCMCIA, the engineers in the world's computer labs are busy trying to devise the perfect technology for printing digital images. In the commercial printing arena, the technology for delivering superb prints is already in place. (See "Letting the Pros Do It," later in this chapter, for more information about commercial printing.)

On the consumer front, several vendors, including Hewlett-Packard, Epson, and Casio, sell color printers specially designed for printing digital images. The marketing folks use terms such as *photo-realistic, near-photographic quality,* and even *photo quality* when describing printers in this category. The suggestion is that your images come out of the printer looking like traditional photographic prints. Although some printers come very close to delivering true photographic output, others don't live up to the marketing hype.

Different manufacturers have adopted different printing technologies, each of which offers advantages and disadvantages. The technology you should choose depends on your budget, your printing needs, and your print-quality expectations. To help you make sense of your options, the following sections discuss the main categories of consumer and small-office printers.

Color inkjet

Inkjet printers work by forcing little drops of ink through nozzles onto the paper. Inkjet printers designed for the home office or small business cost anywhere from $100 to $500. Typically, print quality peaks as you reach the $300 price range, though. Higher-priced inkjets offer speedier printing and a few extra convenience features, such as dual paper trays, than the lower-priced models, but don't necessarily give you better-looking output.

Most inkjet printers enable you to output pictures on plain paper or thicker, glossy, photographic-type stock. From a cost standpoint, that flexibility is great because you can print rough drafts and everyday work on inexpensive, plain paper and use the more costly photographic stock for final prints and important projects only. Keep in mind that when you use more expensive paper, your ink costs normally rise, too, because inkjet prints usually pump out more ink when set to print on glossy stock than on plain paper.

Although all inkjets employ a similar technology to put ink on paper, different models are geared toward different types of printing. General-purpose models do a decent job on both text and pictures. So-called *photocentric* printers, however, put the emphasis on printing photos. Photocentric printers produce better-quality photographic output than all-purpose printers, but you don't want to use them to print text because the print speed is very slow.

That's not to say that you should expect lightning-fast prints from a general-purpose inkjet, though. Even on the fastest consumer inkjet printer, outputting a color image can take several minutes if you use the highest-quality print settings. And with some printers, you can't perform any other functions on your printer until the print job is complete (see the section "Comparison shopping," later in this chapter).

 Another downside to inkjet printers is that your pictures sometimes look a little fuzzy because the ink droplets tend to spread out when they hit the paper, causing colors to bleed into each other. Professionals call this phenomenon *dot gain* and often tweak their images or printer software to account for it. Some consumer printers now include dot-gain compensation controls, too.

In addition, the wet ink can cause the paper to warp slightly, and the ink can smear easily until the paper dries. (Remember when you were a kid and painted with watercolors in a coloring book? The effect is similar with inkjets, although not as pronounced.) You can lessen all of these problems by using specially coated inkjet paper (see "Thumbing through Paper Options," later in this chapter).

Despite these flaws, however, inkjets remain a good, economical solution for many users. Newer inkjet models incorporate refined inkjet technology that produces much higher quality, less color bleeding, and less page warping than models in years past. Images printed on glossy photo stock approach true photographic quality — in fact, from a few inches away, most people can't distinguish an inkjet print from the "real thing." For the record, I've been especially impressed with output from Hewlett-Packard and Epson models that I've tested.

Color laser

Laser printers use a technology similar to that used in photocopiers. I doubt that you want or need to know the details, so let me just say that the process involves a laser beam, which produces electric charges on a drum, which rolls toner — the ink, if you will — onto the paper. Heat is applied to the page to permanently affix the toner to the page (which is why pages come out of a laser printer warm).

Color lasers can produce near-photographic quality images as well as excellent text. They're faster than inkjets, and you don't need to use any special paper (although you get better results if you use a high-grade laser paper as opposed to cheap copier paper).

The downside to color lasers? Price. Although they've become much more affordable over the past two years, color lasers still run $1,000 and up. And these printers tend to be big in stature as well as price — this isn't a machine that you want to use in a small home office that's tucked into a corner of your kitchen.

However, if you have the need for high-volume color output, a color laser printer can make sense. Although you pay more up front than you do for an inkjet, you should save money over time because the price of *consumables* (toner or ink, plus paper) is usually lower for laser printing than inkjet printing. Many color lasers also offer networked printing, making them attractive to offices where several people share the same printer.

Dye-sub (thermal dye)

Dye-sub is short for *dye-sublimation,* which is worth remembering only for the purpose of one-upping the former science-fair winner who lives down the street. Dye-sub printers transfer images to paper using a plastic film or ribbon that's coated with colored dyes. During the printing process, heating elements move across the film, causing the dye to fuse to the paper.

Dye-sub printers are also called *thermal-dye* printers — heated (thermal) dye . . . get it?

To my eyes — and to most eyes, I believe — dye-sub printers come closest to delivering true photographic quality, although the newer photocentric inkjet models run a very close second. Dye-sub printers manufactured for the consumer market cost about the same as a good inkjet, but they present a few disadvantages that may make them less appropriate for your home or office than an inkjet.

First, most dye-sub printers manufactured for the consumer market can produce only snapshot-size prints. So you can't use these printers to output letters, invoices, and other full-page text documents. A few printers, including models from Alps Electric, enable you to print in dye-sub mode or another,

everyday print mode, however. These dual-purpose printers do permit printing on letter-size pages. (See the following section "Micro Dry" for more information about printers from Alps Electric.)

The other disadvantage to dye-sub printing, no matter what size pictures you want to output, is that you can't print on plain, inexpensive paper. You have to use special stock designed to work expressly with dye-sub printers. Factoring in both the paper cost and the dye film/ribbon cartridges, your cost per print typically runs about $1, which is about the same as printing on premium glossy stock on an inkjet or laser printer.

In addition, the printing process is slow. On most dye-sub models, the dye film or ribbon contains four primary colors, and each color is applied individually. For each picture you print, the paper passes through the printer four times, a process that takes several minutes.

Micro Dry

Printers from Alps Electric use a printing technology known as Micro Dry. Like thermal-dye printers, these printers use heat to transfer color to the page. In this case, however, the color comes from ribbons coated with resin-based ink. The printers can print on plain paper as well as on glossy photographic stock.

Micro Dry printers do a good job outputting text documents as well as graphics, even on plain paper. Because the ink is dry when it hits the page, you don't get the color bleeding and page warping that sometimes occurs with inkjet printers. And the print cost per page is about the same as for inkjet printing. However, print speed is fairly slow — about the same as for a photocentric inkjet.

Some people who use this type of printer also complain about slight color banding appearing in light areas of an image. For example, if you have a picture that includes an eggshell-colored background, you can sometimes distinguish tiny bands of cyan, magenta, and blue where you should see only eggshell. For users who demand absolute color purity from their images, this phenomenon is a problem; for others, it's not a major issue.

If you want the benefits of Micro Dry printing and the option to produce dye-sub prints for special photos, several Alps Electric models offer dual printing modes. You can swap the four ink ribbons used for Micro Dry printing with four dye-sub ribbons for top-notch photo output.

Thermo-Autochrome

A handful of printers use Thermo-Autochrome technology. With these printers, you don't have any ink cartridges, sticks of wax, or ribbons of dye. Instead, the image is created using light-sensitive paper — the technology is similar to that found in fax machines that print on thermal paper.

You can find Thermo-Autochrome printers within the same general price range as consumer inkjet printers, and the cost per print runs about the same as with a dye-sub printer or inkjet printer using glossy photo stock. The special photographic paper used in Thermo-Autochrome printers has the look and feel of a traditional print, too.

Like most consumer dye-sub printers, however, most consumer Thermo-Autochrome printers can output snapshot-size prints only and can't print on plain paper. More important, examples that I've seen from consumer printers that employ this technology don't match dye-sub or even good inkjet output, although I will say that the latest crop of Thermo-Autochrome printers does a much better job than earlier models.

So which type of printer should you buy?

The answer to that question depends on your printing needs and your printing budget. Here's my take on which of the printing technologies discussed in the preceding section works best for which situation:

- If you want the closest thing to traditional photographic prints and you don't mind the slightly higher per-print cost, go for a dye-sub model. Just remember that you can't print on plain paper, and you can't use a dye-sub printer to print letters, memos, and other text documents (well, I guess you *can*, if you have a money tree growing in your backyard and loads of time to wait for your text pages to come creeping out of the printer).

- If you can afford only one printer and need to print both dye-sub quality photos and occasional text, printers that enable you to switch between dye-sub mode and a less expensive print mode (such as Micro Dry ink, in printers from Alps Electric), are a good solution. Text output is typically slower than on an inkjet or laser printer, however.

- If you're buying a printer for use in an office and you want a machine that can handle high-volume printing, check into color lasers.

- For home or small-office printing of both text and photos, opt for a Micro Dry or inkjet model. You can produce good-looking color and grayscale images, although you need to use high-grade paper and the printer's highest quality settings to get the best results. With both types of printers, you can print on glossy photographic paper as well. If you print more photos than text and print speed isn't an issue, look for a photocentric printer.

- Want to produce prints larger than the 8.5 x 11-inch maximum size produced by standard printers? Check into one of the new photocentric inkjet printers designed for large-format printing. For about $500, you can bring home a printer capable of outputting pages as large as 17 inches by 22 inches.

Keep in mind that to print a good-quality photo at a size of 17 inches by 22 inches, you need more pixels than even the top-of-the-line consumer digital camera can capture. If your printer manual suggests an image resolution of 300 ppi, for example, you need 5100 horizontal pixels and 6600 vertical pixels (17 multiplied by 300 equals 5100; 22 multiplied by 300 equals 6600). So for home-office or small-business purposes, these large-format printers are useful for printing documents that feature several digital images (or a single image and other text and art) rather than for outputting a single, 17 x 22-inch photo.

✔ Keep in mind that none of the color printers discussed here are engineered with text printing as the primary goal, so your text may not look as sharp as it would on a low-cost black-and-white laser or inkjet printer. Also, your text printing costs may be higher than on a black-and-white printer because of ink costs.

✔ I feel compelled also to offer a brief warning about inkjets. Some of the inkjets I've tried have been so slow and had such page-warping problems that I would never consider using them on a daily basis. Others do a really good job, delivering sharp, clean images in a reasonable amount of time, with little evidence of the problems normally associated with this printing technology. The point is, all inkjets are not created equal, so shop carefully.

✔ Multipurpose printers — those that combine a color printer, fax machine, and scanner in one machine — don't produce the kind of output that will satisfy most photo enthusiasts. Typically, you sacrifice print quality and/or speed in exchange for the convenience of the all-in-one design. However, as I write this, several top printer manufacturers are about to release new all-in-one models that incorporate better photo-printing technology. So if your budget is tight, you may want to take a look at these new machines to see whether the photo-printing improvements are enough to satisfy your needs.

Comparison shopping

After you determine which type of printer is best for your needs, you can get down to the nitty-gritty and compare models and brands. Print quality and other features can vary widely from model to model, so do plenty of research.

Unfortunately, the information you see on the printer boxes or marketing brochures can be a little misleading. So here's a translation of the most critical printer data to study when you're shopping:

✔ **Dpi:** Dpi stands for *dots per inch* and refers to the number of dots of color the printer can print per linear inch. You can find consumer-level color printers with resolutions of anywhere from 300 dpi up to more than 1400 dpi.

A higher dpi means a smaller printer dot, and the smaller the dot, the harder it is for the human eye to notice that the image is made up of dots. So in theory, a higher dpi should mean better-looking images. But because different types of printers create images differently, an image output at 300 dpi on one printer may look considerably better than an image output at the same or even higher dpi on another printer. For example, a 300-dpi dye-sub printer may produce prints that look better than those from a 600-dpi inkjet. So although printer manufacturers make a big deal about their printers' resolutions, dpi isn't always a reliable measure of print quality. For more information about resolution and dpi, take a cab to Chapter 2.

✔ **Quality options:** Many printers give you the option of printing at several different quality settings. You can choose a lower quality for printing rough drafts of your images and then bump up the quality for final output. Typically, the higher the quality setting, the longer the print time and, on inkjet printers, the more ink required.

Ask to see a sample image printed at each of the printer's quality settings and determine whether those settings will work for your needs. For example, is the draft quality so poor that you would need to use the highest quality setting even for printing proofs? If so, you may want to choose another printer if you print a lot of drafts.

Also, if you need to print many grayscale images as well as color images, find out whether you're limited to the printer's lowest-quality setting for grayscale printing. Some printers offer different options for color and grayscale images.

✔ **Inkjet colors:** Most inkjets print using four colors: cyan, magenta, yellow, and black. This ink combination is known as CMYK (see the sidebar "The separate world of CMYK," later in this chapter) and is the professional printing standard. Some lower-end inkjets eliminate the black ink and just combine cyan, magenta, and yellow to approximate black. "Approximate" is the key word — you don't get good, solid blacks without that black ink, so for best color quality, avoid three-color printers.

✔ **Print speed:** If you use your printer for business purposes and you print a lot of images, be sure that the printer you pick can output images at a decent speed. And be sure to find out the per-page print speed for printing at the printer's *highest* quality setting. Most manufacturers list print speeds for the lowest-quality or draft-mode printing. When you see claims like "Prints at speeds *up to . . . ,*" you know you're seeing the speed for the lowest-quality print setting.

✔ **Cost per print:** To understand the true cost of a printer, you need to think about how much you'll pay for consumables each time you print a picture. The paper part is easy: Just find out what kind of paper the manufacturer recommends and then go to any computer store or office-supply outlet and check prices for that paper. (Or if you don't feel like getting dressed, see "Thumbing through Paper Options," later in this chapter, for a rough approximation of prices.)

If you're considering a Thermo-Autochrome printer, your only cost lies in paper because all the chemicals that produce the print are contained in the paper. But for other types of printers, you need to add the cost of ink, toner, or dye to the paper cost.

Manufacturers usually include this data in their brochures or on their Web sites. You usually see costs stated in terms of x percentage of coverage per page — for example, "three cents per page at 15 percent coverage." In other words, if your image covers 15 percent of an 8.5 x 11-inch sheet of paper, you spend three cents on toner, ink, or dye. The problem is that no single standard for calculating this data exists, so you really can't compare apples to apples. One manufacturer may specify per-print costs based on one size image and one print-quality setting, while another uses an entirely different print scenario.

My advice? Don't discount cost-per-print data entirely, but don't take it as gospel, either. This information is most useful for deciding between different print technologies — inkjet, laser, and so on. But when you compare models within a category, don't drive yourself nuts trying to find the model that claims to shave a percentage of a penny off your print costs. Remember, the numbers you see are approximations at best and are calculated in a fashion designed to make the use costs appear as low as possible. As they say in the car ads, your actual mileage may vary.

That said, if you're buying an inkjet printer, you *can* lower your ink costs somewhat by choosing a printer that uses a separate ink cartridge for each ink color (typically, cyan, magenta, yellow, and black) or at least uses a separate cartridge for the black ink. On models that have just one cartridge for all inks, you usually end up throwing away some ink because one color will be depleted before the others. This is especially true if you print lots of grayscale images or text, thereby printing exclusively with black ink on many occasions.

Also remember that some printers require special cartridges for printing in photographic-quality mode. In some cases, these cartridges lay down a clear overcoat over the printed image. The overcoat gives the image a glossy appearance when printed on plain paper and also helps protect the ink from smearing and fading. In other cases, you put in a cartridge that enables you to print with more colors than usual — for example, if

the printer usually prints using four inks, you may insert a special photo cartridge that enables you to print using two additional inks. These special photographic inks and overlay cartridges are normally more expensive than standard inks. So when you compare output from different printers, find out whether the images were printed with the standard ink setup or with more expensive photographic inks.

✔ **Host-based printing:** With a *host-based printer,* all the data computation necessary to turn pixels into prints is done on your computer, not on the printer. In some cases, the process can tie up your computer entirely — you can't do anything else until the image is finished printing. In other cases, you can work on other things while the image prints, but your computer runs more slowly because the printer is consuming a large chunk of the computer's resources.

If you print relatively few images during the course of a day or week, having your computer unavailable for a few minutes each time you print an image may not be a bother. And host-based printers are generally cheaper than those that do the image processing themselves. But if you print images on a daily basis, you're going to be frustrated by a printer that ties up your system in this fashion. On the other hand, if you buy a printer that does its own image processing, be sure that the standard memory that ships with the printer will be adequate. You may need to buy additional memory to print large images at the printer's highest resolution, for example.

✔ **Camera or memory card input:** Several manufacturers now offer printers that offer direct connections to digital cameras. You can plug your camera right into the printer and generate prints without having to download images to the computer and then send them from the computer to the printer. Typically, you can use this feature only with a camera from the same manufacturer as the printer — for example, you can hook a Canon camera to a Canon photo printer. But you usually can hook the printer to a computer for normal printing if you use some other brand of camera.

If you want to take advantage of direct printing but don't want to be tied to a particular camera brand, look for a printer that can output from a floppy disk or SmartMedia, CompactFlash, or Memory Stick card. You just pop the disk or card out of the camera and into the printer to output your images. The Canon dye-sub model shown in Figure 8-1 is one printer that offers this option.

Although having the option to print in this fashion adds extra flexibility to your digital photography setup, I personally wouldn't pay more for the privilege because I almost always do some tweaking to my pictures before I print. But I can see this feature being very useful to anybody who gives priority to print immediacy over image perfection. For example, a real-estate agent taking a client for a site visit can shoot

pictures of the house and then output prints in a flash so that the client can take pictures home that day.

✔ **PostScript printing:** If you want to be able to print illustrations created in illustration programs such as Adobe Illustrator and saved in the EPS (Encapsulated PostScript) file format, you need a printer that offers PostScript printing functions. Some photo-editing programs enable you to save in EPS as well. Some printers have PostScript support built in, while others can be made PostScript-compatible with add-on software.

Although the preceding specifications should give you a better idea of which printer you want, be sure to also go to the library and search through computer and photography magazines for reviews of any printer you're seriously considering. In addition, you can get customer feedback on different models by logging onto one of the digital photography or printing newsgroups on the Internet. See Chapter 15 for leads on two newsgroups as well as a list of other sources for finding the information you need.

Just as with any other major purchase, you should also investigate the printer's warranty — one year is typical, but some printers offer longer warranties. And be sure to find out whether the retail or mail-order company selling the printer charges a *restocking fee* if you return the printer. Many sellers charge as much as 15 percent of the purchase price in restocking fees. (In my city, all the major computer stores charge restocking fees, but the office supply stores don't — yet.)

Figure 8-1:
This Canon dye-sub printer is one of several models that can print directly from a Compact Flash card or Canon digital camera.

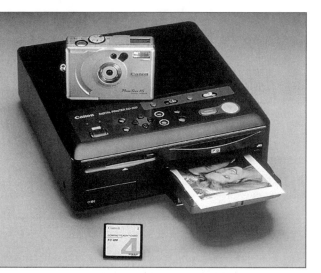

The separate world of CMYK

As you know if you read Chapter 2, on-screen images are *RGB* images. RGB images are created by combining red, green, and blue light. Professional printing presses and most, but not all, consumer printers create images by mixing four colors of ink — cyan, magenta, yellow, and black. Pictures created using these four colors are called *CMYK* images. (The *K* is used instead of *B* because the people who created this acronym were afraid someone might think that *B* meant blue instead of black. Also, black is called the *key* color in CMYK printing.)

You may be wondering why four primary colors are needed to produce colors in a printed image, while only three are needed for RGB images. (Okay, I know you're probably not wondering that at all, but indulge me. After all, you never know when this question is going to come up on *Jeopardy!* or *Win Ben Stein's Money.*) The answer is that unlike light, inks are impure. Black is needed to help ensure that black portions of an image are truly black, not some muddy gray, as well as to account for slight color variations between inks produced by different vendors.

Aside from looking smart on a game show, what does all this CMYK stuff mean to you? First, if you're shopping for an inkjet printer, be aware that some models print using only three inks, leaving out the black. Color rendition is usually worse on models that omit the black ink.

Second, if you're sending your image to a service bureau or commercial printer for four-color printing, you need to convert your image to the CMYK color mode and create *color separations.* If you read "The Secret to Living Color" in Chapter 2, you may recall that CMYK images comprise four color channels — one each for the cyan, magenta, yellow, and black image information. Color separations are nothing more than grayscale printouts of each color channel. During the printing process, your printer combines the separations to create the full-color image. If you're not comfortable doing the CMYK conversion and color separations yourself or your image-editing software doesn't offer this capability, your service bureau or printer can do the job for you.

Don't convert your images to CMYK for printing on your own printer, because consumer printers are engineered to work with RGB image data. And no matter whether you're printing your own images or having them commercially reproduced, remember that CMYK has a smaller *gamut* than RGB, which is a fancy way of saying that you can't reproduce with inks all the colors you can create with RGB. CMYK can't handle the really vibrant, neon colors you see on your computer monitor, for example, which is why images tend to look a little duller after conversion to CMYK and why your printed images don't always match your on-screen images.

For more information about RGB and CMYK, hightail it back to Chapter 2.

I resent the heck out of restocking fees, especially when it comes to costly equipment like printers, and I never buy at outfits that charge these fees. Yes, I understand that after you open the ink cartridges and try out the printer, the store can't sell that printer as new (at least, not without putting in replacement ink cartridges). But no matter how many reviews you read or

how many questions you ask, you simply can't tell for certain that a particular printer can do the job you need it to do without taking the printer home and testing it with your computer and with your own images.

Few stores have printers hooked up to computers, so you can't test-print your own images in the store. Some printers can output samples using the manufacturer's own images, but those images are carefully designed to show the printer at its best and mask any problem areas. So either find a store where you can do your own pre-purchase testing, or make sure that you're not going to pay a hefty fee for the privilege of returning the printer.

Thumbing through Paper Options

With paper, as with most things in life, you get what you pay for. The more you're willing to pay for your paper, the more your images will look like traditional print photographs. In fact, if you want to upgrade the quality of your images, simply changing the paper stock can do wonders, as illustrated by Color Plate 8-1, which features the famous Love sculpture, by artist Robert Indiana, on the grounds of the Indianapolis Museum of Art. I printed the same image on plain copier paper, photo-quality inkjet paper, and photo-quality glossy paper. All three images were printed on the same inkjet printer, using the same image resolution. Although the image colors are about the same in all three prints, the image appears noticeably sharper on the higher-grade papers.

For more examples of how paper quality affects print quality, just compare the images you see on the color pages of this book, printed on high-end glossy stock, with images on the black-and-white pages, which are printed on much less expensive paper. Take a look at the difference between the lily images in Color Plate 2-2, for example, with their black-and-white counterparts in Figures 2-3, 2-4, and 2-5. The photos on the glossy stock are much sharper than those on the black-and-white pages.

Table 8-1 shows some sample prices of commonly used paper stocks, with the least expensive stocks listed first. If your printer can accept different stocks, print drafts of your images on the cheaper stocks, and reserve the stocks at the end of the table for final output. Note that prices in the table reflect what you can expect to pay in discount office supply or computer stores. The paper size in all cases is 8.5 x 11 inches. You can buy photographic stock in smaller sizes, however, to use with some printers.

Don't limit yourself to printing images on paper, though. You can buy special paper kits that enable you to put images on calendars, stickers, greeting cards, transparencies (for use in overhead projectors), and all sorts of other stuff. Some printers even offer accessory kits for printing your photos on coffee mugs and T-shirts.

Table 8-1	Paper Types and Costs	
Type	*Description*	*Cost per Sheet*
Multipurpose	Lightweight, cheap paper designed for everyday use in printers, copiers, and fax machines. Similar to the stuff you put in your photocopier and typewriter for years.	$.01 to .02
Inkjet	Designed specifically to accept inkjet inks. At higher end of price range, paper is heavier and treated with special coating that enables ink to dry more quickly, reducing ink smearing, color bleeding, and page curl.	$.01 to .10
Laser	Engineered to work with the toners used in laser printers. So-called "premium" laser papers are heavier, brighter, smoother, and more expensive. The smooth surface makes images appear sharper; the whiter color gives the appearance of higher contrast.	$.01 to .04
Photo-realistic	Thick, glossy stock; creates closest cousin to traditional film print. Sometimes called simply *photo paper* or *glossy photo paper*.	$.50 to $3
Dye-sub	Glossy paper specially treated for use with dye-sub printers only	$1

Letting the Pros Do It

As you've no doubt deduced if you've read the meaty paragraphs prior to this one — as well as the less meaty, but still nutritious ones — churning out photographic-quality prints of your digital images can be a pricey proposition. When you consider the cost of special photographic paper along with special inks or coatings that your printer may require, you can easily spend $1 or more for each print. When you want high-quality prints, you may find it easier and even more economical to let the professional printers handle your output needs. Here are a few options to consider:

✔ Many neighborhood photo labs now offer digital printing services, and you can also find companies offering digital printing via the Internet. Both Kodak (www.kodak.com) and Fujifilm (www.fujifilm.net) offer this option, for example. You transmit your images to the company over the Internet and receive your printed images in the mail. These services are great for times when you want just a few high-quality prints of an image.

✔ If you don't like doing your business online, many retail photo-processing outlets and digital-imaging labs offer printing of digital files. You can get your picture printed on traditional silver-halide photographic paper or request dye-sub output on a variety of media. I've also had digital images enlarged and printed with amazing results at my local imaging lab.

✔ If you need many (50 or more) copies of an image or you want to print on a special stock — say, for example, a glossy, colored stock — call upon the services of a commercial printer or service bureau. You can then have your images reproduced using traditional four-color printing. The cost per printed image will depend on the number of images you need (typically, the more you print, the lower the per-print cost) and the type of stock you use.

Sending Your Image to the Dance

Assuming that you decide to print your image yourself, getting the picture on paper involves several steps and a few thoughtful decisions. Here's the drill:

1. **Open your image.**

 Sadly, you can't just slap your computer and make the image walk itself to the printer. To get the print process rolling, you first need to fire up your image editor and open the image.

2. **Set the image size and resolution.**

 This important and sometimes tricky process is outlined in depth in the next section.

3. **Choose the Print command.**

 In almost every program on the planet, the Print command resides in the File menu. Choosing the command results in a dialog box through which you can change the print settings, including the printer resolution or print quality and the number of copies you want to print. You can also specify whether you want to print in *portrait mode,* which prints your image in its normal, upright position, or *landscape mode,* which prints your image sideways on the page.

You don't have to go to all the trouble of clicking on File and then on Print, though. You can choose the Print command more quickly by pressing Ctrl+P in Windows or ⌘+P on a Mac. (Some programs bypass the Print dialog box and send your image directly to the printer when you use these keyboard shortcuts, however. So if you need to adjust any printing settings, as in the next few steps, you need to use the File⇨Print approach.)

4. Specify the print options you want to use.

The available options — and the manner in which you access those options — vary widely depending on the type of printer you're using and whether you're working on a PC or a Mac. In some cases, you can access settings via the Print dialog box; in other cases, you may need to go to the Page Setup dialog box, which opens like magic when you choose the Page Setup command, generally found in the File menu, not too far from the Print command. (You can sometimes access the Page Setup dialog box by clicking on a Setup button inside the Print dialog box, too.)

I'd love to explain and illustrate all kazillion variations of Print and Page Setup dialog box options, but I have neither the time, space, nor psychotherapy budget that task would require. So please read your printer's manual for information on what settings to use in what scenarios, and, for heaven's sake, follow the instructions. Otherwise, you aren't going to get the best possible images your printer can deliver.

Also, if you have more than one printer — you rich thing, you — make sure that you have the right printer selected before you go setting all the printer options.

5. Send that puppy to the printer.

Look in the dialog box for an OK or Print button and click the button to send your image scurrying for the printer.

With that broad overview under your belt — and with your own printer manual close at hand — you're ready for some more specific tips about making hard copies of your images. The following section tells all.

How to adjust size and resolution

Because print size and resolution have a major impact on print quality, you need to take care when setting these two values prior to printing. If you haven't read Chapter 2 yet, I suggest that you explore the sections on resolution before you continue on with this chapter, because the words of wisdom I'm about to impart will make more sense. But if your fingers are just too tired to turn backward in the book, here's a brief recap of the relevant concepts:

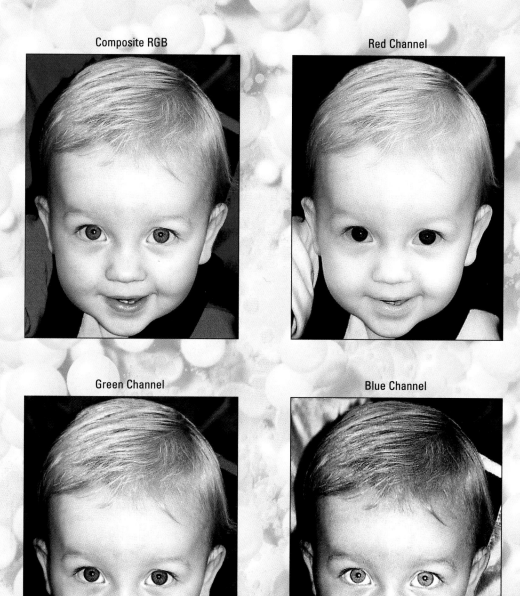

Composite RGB

Red Channel

Green Channel

Blue Channel

Color Plate 2-1:
An RGB image (top left) can be separated into three color channels, as shown here. Each channel contains a grayscale image, which is a representation of the brightness values for the red, green, or blue components of the image.

300 ppi

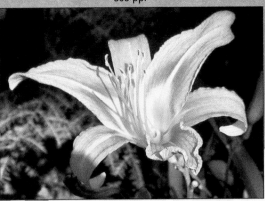

150 ppi

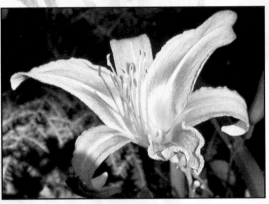

75 ppi

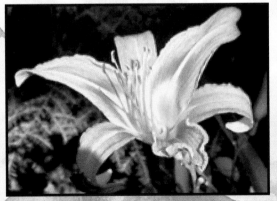

Color Plate 2-2:
Resolution plays a major role in the appearance of printed images. The top photo has a resolution of 300 ppi (pixels per inch); the middle image, 150 ppi; and the bottom image, a meager 75 ppi. Lower resolution means bigger pixels, a fact you can spot easily by looking at the black border around each image. The border is 2 pixels thick in all cases, but at 75 ppi, the border is twice the size of that around the 150 ppi image, and the 150 ppi border is twice the size of the 300 ppi border.

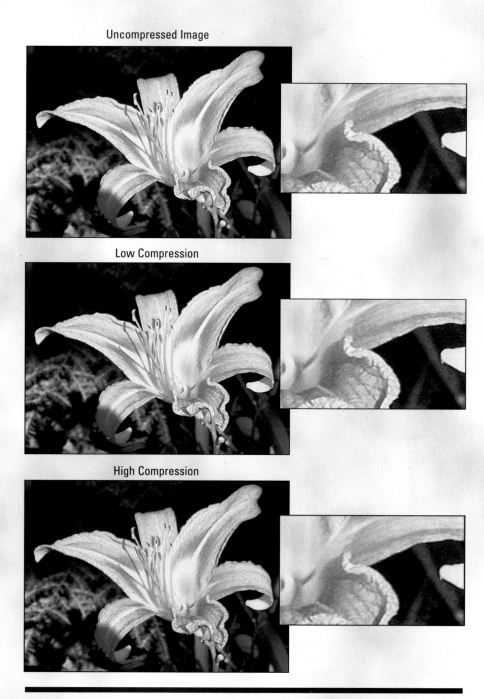

Color Plate 3-1:
When you save an image using JPEG compression, you sacrifice some image data. The top image is the original, uncompressed image. At a low compression setting (middle image), the data loss is barely noticeable. But at a high compression setting, fine details get lost (bottom image). The quality difference becomes more noticeable as you enlarge the image.

Nikon, 38mm

Olympus, 36mm

Casio, 35mm

Nikon, 24mm adapter

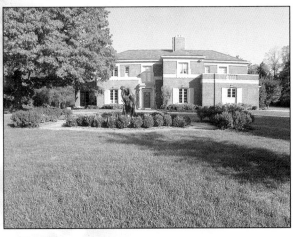

Color Plate 3-2:
The same scene as captured by four different digital cameras, each of which has a slightly different take on color. Each camera also captures a slightly different image area due to different lens focal lengths. The Olympus and Nikon models have zoom lenses; for the top two images, I set each camera to its shortest focal length. For the bottom-right image, I attached a wide-angle adapter to the Nikon lens.

Color Plate 5-1:
This classic fruit-in-a-bowl scene illustrates the problems of too much and too little light. On the top of the lemon, too much light created a hot spot where all image detail was lost (see the inset area for a closer view). In the bottom portion of the image, the light is too low, reducing contrast and clarity. Compare the amount of detail you can see in this area with that in the upper-left corner of the image, where the light is just about perfect.

Color Plate 5-2:
Many digital cameras offer exposure compensation controls that boost or reduce the exposure chosen by the camera's autoexposure feature. When exposure compensation is set to 0, the camera makes no adjustment to the exposure. A positive exposure value (EV) brightens the scene; a negative value creates darker pictures. Here, you see the results of four EV settings on the same image.

EV -1.0 EV 0.0

EV +1.0 EV +2.0

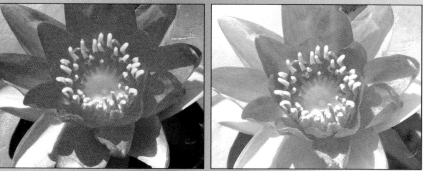

Auto

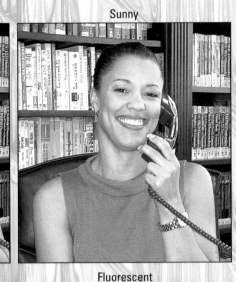

Sunny

Incandescent

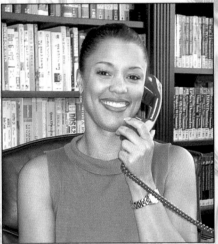

Fluorescent

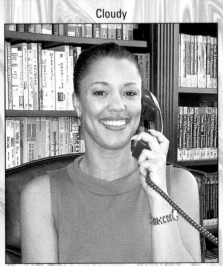

Flash

Cloudy

Color Plate 6-1:
To compensate for the varying color temperatures of different light sources, many cameras provide both automatic and manual white balance controls. This picture, taken with a Nikon digital camera, presented a special challenge because the subject was lit using a combination of fluorescent lighting (from above), bright daylight (from a window to the left of the subject, out of the frame), and the on-board flash. The Auto and Flash white-balance options on this particular camera deliver the same results because in Auto mode, the camera switches to Flash mode when the flash is turned on. The Fluorescent and Sunny white-balance options resulted in the most-accurate skin tones.

Color Plate 8-1:
Using a higher grade paper improves print quality noticeably. Here, I printed the same image on plain paper (top), photo-quality inkjet paper (middle), and photo-quality glossy paper (bottom). The famous sculpture in the picture is by artist Robert Indiana and is located at the Indianapolis Museum of Art.

Color Plate 9-1:
Zooming in on a bowl of fruit reveals what can happen when you convert a 24-bit image (top) to an 8-bit (256 color) GIF image (bottom). Without a broad variety of shades to represent the fruit, the bananas, lime, and apple look blotchy.

Color Plate 10-1:
Colors in my original butterfly picture (left) seemed a little drab; boosting the saturation value slightly produced deeper hues that more closely matched what I saw through the camera viewfinder.

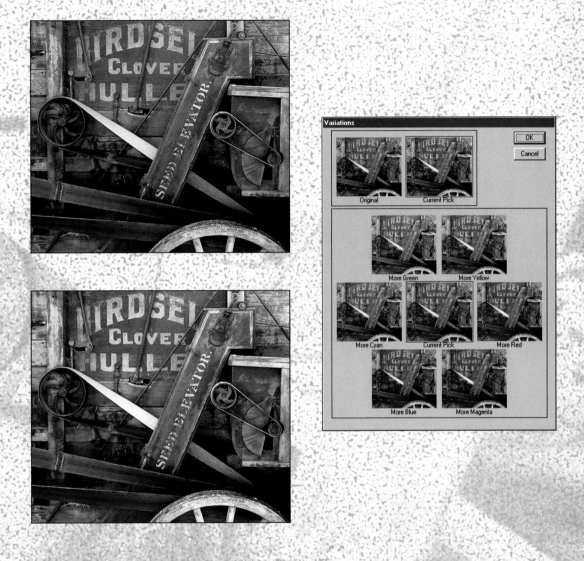

Color Plate 10-2:
I shot this photo, which provides a close up view of the mechanics of an old clover huller, using a digital camera that tends to emphasize blue tones. The original image (upper left) had a blue cast that wasn't terribly bothersome from an artistic standpoint, but didn't reflect the real colors of the huller. To fix the problem, I went into the PhotoDeluxe Variations dialog box, shown at right. By clicking once on the More Yellow box and once on the More Red box, I removed the blue cast and brought out the warm, faded reds and yellows of the old paint (lower left).

Original

Sharpen

Color Plate 10-3:
Sharpening creates the illusion of sharper focus by adding dark and light halos along the borders between differently colored pixels. Here, you see the results of the three automatic sharpening filters found in PhotoDeluxe and Photoshop.

Sharpen More

Sharpen Edges

Color Plate 10-4:
Unsharp masking enables you to control the intensity and scope of the sharpening halos. For this image, I applied the Unsharp Mask filter on the original image from Color Plate 10-3 using two different Amount and Radius values. I kept the Threshold value at 0 for all four examples.

Amount, 100%

Amount, 200%

Radius, 1.0

Radius, 2.0

Sharpen

Sharpen More

Sharpen Edges

Unsharp Mask

Color Plate 10-5:
A slightly out-of-focus image (center) receives four sharpening treatments. Sharpen and Sharpen Edges didn't sharpen enough, while Sharpen More sharpened too much, lending a grainy look to the photo. Applying Unsharp Mask three times with an Amount value of 50, Radius value of 2, and Threshold value of 3 achieved just the right effect.

Tolerance, 10 Tolerance, 32

Color Plate 11-1:
Most image editors provide a tool similar to the PhotoDeluxe Color Wand, which selects areas of contiguous color. In this example, I clicked at the same spot in the rose with the Color Wand set to four different Tolerance values. The yellow-tinted areas and dotted lines indicate the scope of the resulting selection. As you can see, low Tolerance values select only pixels that are very similar in color to the pixel you click. Higher values make the tool less discriminating. (See the left image in Color Plate 11-2 to see the rose without the selection markings.)

Tolerance, 64 Tolerance, 100

Color Plate 11-2:
After selecting the rose in the left image, I copied it and pasted it into the middle image, which is simply a close-up of some weathered wood siding. Then I lowered the opacity of the rose to 50 percent to create the image on the right.

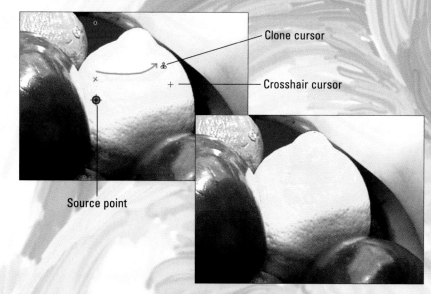

Clone cursor

Crosshair cursor

Source point

Color Plate 11-3:
Using the Clone tool, I painted a good portion of the lemon rind over the hot spot at the top of the fruit (top image). I cloned pixels that lie between the source point cursor and crosshair cursor onto the hot spot. The red X and arrow show the starting point and direction of my initial drag. I reset the source point and cloned from several different areas, using varying tool opacity settings to create a natural-looking, nearly perfect lemon (bottom).

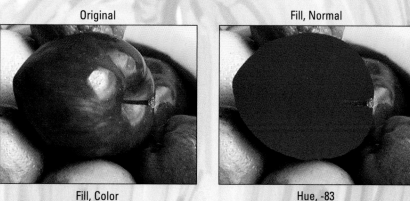

Original

Fill, Normal

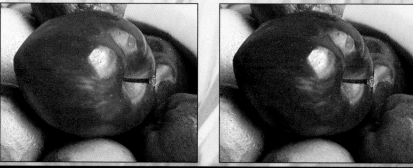

Fill, Color

Hue, -83

Color Plate 12-1:
To create a new species of apple, I first selected the apple but not the stem. Filling the selection using the PhotoDeluxe Selection Fill command resulted in a solid blob of color when the blend mode was set to Normal (top right). Using the Color blend mode turned the apple purple while retaining the original shadows and highlights (bottom left). In the bottom-right picture, I didn't fill the selection at all but instead used the Hue/Saturation command to change the apple color. Lowering the Hue value to -83 turned the red parts of the apple purple while making yellowish areas pink.

Color Plate 12-2:
These eight images served as the basis for the collage in Color Plate 12-3. I selected the subject of each of the top seven images and then copied and pasted them on top of the brick image, using the stacking order shown here.

Color Plate 12-3:
By placing each of the images in Color Plate 12-2 on a separate layer, I created this collage of objects from yesteryear.

Color Plate 12-4:
To create this antique photograph effect, I converted the color version of Color Plate 12-3 to grayscale. Then I created a new layer, filled the layer with dark gold, set the layer blend mode to Color, and set the layer opacity to 50 percent.

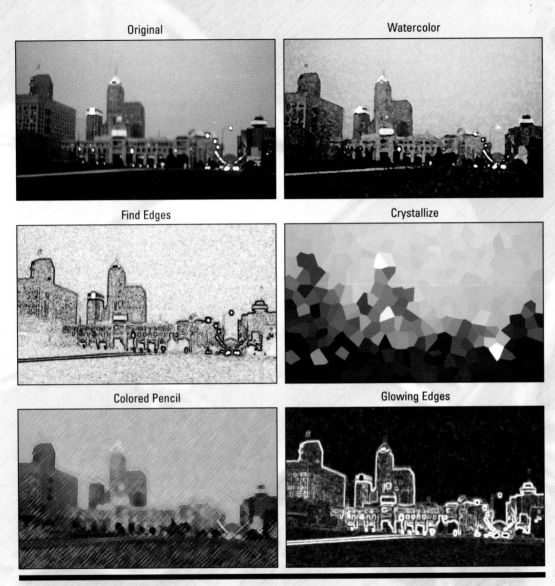

Color Plate 12-5:
With the help of special effects filters, you can sometimes create art out of a crummy picture. Here, I applied five different filters found in Adobe PhotoDeluxe and Photoshop to a dark, grainy, skyline scene, creating a variety of interesting color compositions.

- Image resolution is measured in *ppi* — pixels per inch. For most consumer printers, 300 ppi is the ideal image resolution for printing, but you should check your printer manual just to be sure. If you're having your image professionally printed, talk to the printer about the appropriate image resolution.

- Printer resolution is measured in *dpi* — dots per inch. Printer dots and image pixels are *not* the same. I repeat, *not the same.* So don't assume that you should set your image resolution to match your printer's resolution. On some printers, you do want a one-to-one ratio of image pixels to printer dots. But other printers use multiple ink dots to represent each image pixel. So check your printer manual for the optimum image resolution.

- Image size (number of pixels) and print size are irrevocably linked. When you enlarge an image, one of two things happens: The resolution goes down and the pixel size increases, or the image-editing software adds new pixels to fill the enlarged image area (a process called *upsampling*). Both options can result in a loss of image quality.

- Similarly, you have two options when you reduce the image size. You can retain the current pixel count, in which case the resolution goes up and the pixel size shrinks. Or you can retain the current resolution, in which case the image-editing software *downsamples* the image (dumps excess pixels). Because dumping too many pixels can also harm your image, avoid downsampling by more than 25 percent.

- To figure out the maximum size at which you can print your image at a desired resolution, divide the horizontal pixel count (the number of pixels across) by the desired resolution. The result gives you the maximum width of the image. To determine the maximum print height, divide the vertical pixel count by the desired resolution.

- What if you don't have enough pixels to get both the image size and resolution you want? Well, you have to choose which is more important. If you absolutely need a certain image size, you just have to sacrifice some image quality and accept a lower resolution. And if you absolutely need a certain resolution, you have to live with a smaller image. Hey, life's full of compromises, right?

With these points in mind, you're ready to specify your resolution and image size. The following steps explain how to resize your image *without* resampling in Adobe PhotoDeluxe:

1. Choose Size⇨Photo Size.

The Photo Size dialog box, shown in Figure 8-2, appears.

Photo Size

Current Size: 1.92M

Width: 2.43 inches
Height: 3.06 inches
Resolution: 300 pixels/inch

OK
Cancel

New Size: 1.92M

Width: 2.43 inches
Height: 3.06 inches
Resolution: 300 pixels/inch

Constrain: ☑ Proportions ☑ File Size

Figure 8-2:
To safely
resize your
images in
PhotoDeluxe,
select the File
Size check
box.

2. **Select the File Size check box.**

 This option controls whether PhotoDeluxe can add or delete pixels as you change the image dimensions. When the option is turned on, the number of pixels can't be altered.

 In order to access the File Size check box, you must also select the Proportions check box. This option ensures that the original proportions of your image are maintained.

3. **Enter the new image dimensions in the Width and Height option boxes.**

 As you change the image dimensions, the Resolution value changes automatically.

4. **Click OK.**

 If you did things correctly — that is, selected the File Size check box in Step 2 — you shouldn't see any change in your image on-screen, because you still have the same number of pixels to display. However, if you choose View⇨Show Rulers, which displays rulers along the top and left side of your image, you can see that the image will, in fact, print at the dimensions you specified.

If you want to resample the image in order to achieve a certain print resolution, deselect the File Size check box. Then set your desired Width, Height, and Resolution values. (But don't say I didn't warn you when your print quality is less than wonderful.)

If you're using another image editor, be sure to consult the program's help system or manual for information on resizing options available to you. Most professional programs, including Adobe Photoshop and Corel PHOTO-PAINT, offer you the option of controlling resolution as you resize, as does PhotoDeluxe. But many consumer image-editing programs don't offer this kind of resolution and resizing control. Some programs automatically resample the image any time you resize it, so be careful.

How can you tell if a program is resampling images upon resizing? Check the "before" and "after" size of the image file. If the file size changes when you resize the image, the program is resampling the photo. (Adding or deleting pixels increases or reduces the file size.)

These colors don't match!

You may notice a significant color shift between your on-screen and printed images. This color shift is due in part to the fact that you simply can't reproduce all RGB colors using printer inks, a problem explained in the sidebar "The separate world of CMYK," earlier in this chapter. In addition, the brightness of the paper, the purity of the ink, and the lighting conditions in which the image is viewed can all lead to colors that look different on paper than they do on-screen.

Although perfect color matching is impossible, you can take a few steps to bring your printer and monitor colors closer together, as follows:

✔ Changing your paper stock sometimes affects color rendition. In my experience, the better the paper, the truer the color matching.

✔ The software provided with most color printers includes color-matching controls that are designed to get your screen and image colors to jibe. Check your printer manual for information on how to access these controls.

✔ If playing with the color-matching options doesn't work, the printer software may offer controls that enable you to adjust the image's color balance. When you adjust the color balance using the printer software, you don't make any permanent changes to your image. Again, you need to consult your printer manual for information on specific controls and how to access and use them.

✔ Don't convert your images to the CMYK color model for printing on a consumer printer. These printers are designed to work with RGB images, so you get better color matching if you work in the RGB mode.

✔ Many image-editing programs also include utilities that are designed to assist in the color-matching process as well. In PhotoDeluxe 3, for example, the File➪Adjust Color Printing command invokes such a utility.

✔ If your job or personal level of fussiness demands more accurate color-matching controls than your printer software delivers, you can invest in professional color-matching software. This software enables you to calibrate all the different components of your image-processing system — scanner, monitor, and printer — so that colors stay true from machine to machine. Professional image-editing programs such as Adobe Photoshop and Corel PHOTO-PAINT often include this level of calibration software.

However, remember that even the best color-matching system can't deliver 100-percent accuracy. Also, expect to spend some time tweaking the software's color profiles (files that tell your computer how to adjust colors to account for different types of scanners, monitors, and printers). The default profiles usually don't deliver maximum results.

These same comments apply to the color-management systems that may be included free with your operating-system software, such as ColorSync.

✔ If your monitor enables you to adjust the screen display, try this procedure to get your printer and monitor more in synch. Print a color image and then hold the image up next to the monitor. Compare the printed picture with the one on-screen and then adjust the monitor settings until the two fall more in line. But remember that this process is a little backwards in that it calibrates the monitor to the printer rather than the other way around. So if you print your image on another printer, your colors may shift dramatically from what you see on the monitor.

✔ Finally, remember that the colors you see both on-screen and on paper vary depending on the light in which you view them.

More words of printing wisdom

In parting — well, at least for this chapter — let me offer these last few final tidbits of printing advice:

✔ The type of paper you use greatly affects image quality. For those special pictures, invest in glossy photographic stock or some other high-grade option. See "Thumbing through Paper Options," earlier in this chapter, for more paper news.

✔ Do a test print using different printer-resolution or print-quality settings to determine which settings work best for which types of images and which types of paper. The default settings selected by the printer's software may not be the best choices for the types of images you print. Be sure to note the appropriate settings so that you can refer to them later. Also, some printer software enables you to save custom settings so that you don't have to reset all the controls each time you print. Check your printer manual to find out whether your printer offers this option.

✔ If your image looks great on-screen but prints too dark, your printer software may offer brightness/contrast controls that enable you to temporarily lighten the image. You may get better results, though, if you do the job using your image editor's levels or brightness/contrast controls. In any case, if you want to make permanent changes to brightness levels, you need to use your image editor, not your printer software. See Chapter 10 for details.

✔ Speaking of printer software — known in geek collectives as a _driver_ — don't forget to install it on your computer. Follow the installation instructions closely so that the driver is installed in the right folder in your system. Otherwise, your computer can't communicate with your printer.

✔ If your printer didn't ship with a cable to connect the printer and computer, make sure that you buy the right kind of cable. Most new printers require bidirectional, IEEE 1284–compliant cables. Don't worry about what that means — just look for the words on the cable package. And don't cheap out and buy less-expensive cables that don't meet these specifications, or you won't get optimum performance from your system.

✔ Some printers don't perform well when connected to the computer through a pass-through device. For example, if you have a CD recorder connected to your computer's printer port and then plug your printer into a printer port on the CD recorder, you may experience printing hang-ups. Do a test print after connecting your printer to any new pass-through devices.

✔ Don't ignore your printer manual's instructions regarding routine printer maintenance. Print heads can become dirty, inkjet nozzles can become clogged, and all sorts of other gremlins can gunk up the works. When testing an inkjet model for this book, for example, I almost wrote the printer off as a piece of junk because I was getting horrendous printouts. Then I followed the troubleshooting advice in the manual and cleaned the print heads. The difference was like night and day. Suddenly, I was getting beautiful, rich images, just like the printer's advertisements promised.

✔ Images printed using ink, dye, toner, and wax fade when exposed to sunlight. (Micro Dry inks don't fade because the ink is comprised of a plastic resin.) So if you're printing an image for framing, you may want to invest in special UV-protected glass to give your image extra life. Also try to hang the picture in a place where it won't be exposed to strong sunlight on a daily basis. And keep a backup copy of that image on disk so that when the image starts to fade, you can print a new copy.

✔ If you're printing on glossy, photographic paper, try not to touch the image side of the print because you can leave fingerprints on the image.

Chapter 9

On-Screen, Mr. Sulu!

. .

In This Chapter

▶ Creating images for screen display

▶ Preparing images for use on a Web page

▶ Trimming your file size for faster image downloading

▶ Choosing between the two Web file formats — GIF and JPEG

▶ Making part of your Web image transparent

▶ Attaching an image to an e-mail message

▶ Using an image as a desktop background

. .

Digital cameras are ideal for creating images for on-screen display. Even the most inexpensive, entry-level cameras are capable of creating good pictures for the screen, where resolution demands are minimal.

This chapter explores a variety of on-screen uses for digital images, from adding pictures to Web pages to creating a custom background for your computer monitor. Among other things, you find out how to prepare an image for use on the Web, which image file formats work best for different on-screen uses, and how to send a picture along with an e-mail message.

Step into the Screening Room

With a printed picture, your display options are fairly limited. You can pop the thing into a frame or photo album. You can stick it to a refrigerator with one of those annoyingly cute refrigerator magnets. Or you can slip it into your wallet so that you're prepared when an acquaintance inquires after you and yours.

In their digital state, however, images can be displayed in all sorts of new and creative ways, including the following:

✔ Add pictures to your company's site on the World Wide Web —
assuming that your company is progressive enough to operate a site.
Many folks these days even have personal Web pages devoted not to
selling products but to sharing information about themselves. See
"Nothing but Net: Images on the Web," later in this chapter, for details on
preparing an image for use on a Web page.

✔ E-mail an image to friends, clients, or relatives, who then can view the
image on their computer screens, save the image to disk, and even edit
and print the image if they like. Check out "Drop Me a Picture Sometime,
Won't You?" later in this chapter for information on how to attach an
image to your next e-mail missive.

✔ Import the image into a multimedia presentation program such as
Microsoft PowerPoint or Corel Presentations. The right images, dis-
played at the right time, can add excitement and emotional impact to
your presentations and also clarify your ideas. Check your presentation
program's manual for specifics on how to import an image into your
next really big show.

✔ Use your favorite image as desktop wallpaper — the image that rests
behind all the icons, windows, and other elements of your computer's
operating environment. Turn to "Redecorate Your Computer's Living
Room," later in this chapter, for how-to's.

✔ Create a personalized screen saver featuring your favorite images. Most
consumer image-editing programs include a wizard or utility that makes
creating such a screen saver easy.

In Adobe PhotoDeluxe 3.0, for example, just click the Cards & More
button, click the Save and Send icon, and then select the Screen Saver
option from the resulting menu. Then follow the on-screen prompts to
add images to the screen saver.

✔ With many digital cameras, you can download images to your TV set or
VCR. You can then show your pictures to a living room full of captive
guests and even record your images to tape. Load up the camera with
close-up pictures of your navel, cable the camera to your TV, and you've
got an evening that's every bit as effective as an old-time slide show for
convincing pesky neighbors that they should never set foot in your
house again. For information on this intriguing possibility, see Chapter 7.

That's About the Size of It

Preparing pictures for on-screen display requires a different approach than
you use to get them ready for the printer. The following sections tell all.

Understanding on-screen display

As you prepare images for on-screen use, remember that monitors display images using one screen pixel for every image pixel. (The exception is when you're working in an image-editing program or other application that enables you to zoom in on an image, thereby devoting several screen pixels to each image pixel.) So to size your screen image, you simply figure out the pixel dimensions of your screen — how many pixels wide by how many pixels tall — and then determine how much of that screen real estate you want your image to consume. (If you need a primer on pixels, by the way, flip back to Chapter 2.)

Most monitors can be set to a choice of displays: 640 x 480 pixels, 800 x 600 pixels, 1024 x 768, and 1280 x 1024, for example. So if your image is 640 x 480 pixels, it consumes the entire screen on a monitor running at the 640 x 480 setting. On a monitor set up to display a higher number of pixels, the image no longer fills the whole screen.

Figures 9-1 and 9-2 show two shots of my 17-inch screen. In Figure 9-1, I displayed a 640 x 480 image with the screen display set at 640 x 480 pixels. The image fills the entire screen (a portion of the image is hidden by the Windows taskbar at the bottom of the frame). In Figure 9-2, I displayed the same 640 x 480 image but switched the screen display to 1280 x 1024 pixels. The image now eats up about one-fourth of the screen.

Figure 9-1:
When the monitor is set to the standard 640 x 480-pixel display, a 640 x 480-pixel image consumes the entire screen.

Figure 9-2:
When the monitor display is switched to 1280 x 1024 pixels, a 640 x 480-pixel image consumes roughly one-quarter of the screen.

Unfortunately, you often don't have any way to know or control what monitor setting will be in force when your audience views your pictures. Someone viewing your Web page in one part of the world may be working on a 21-inch monitor set at 1280 x 1024 pixels, while another someone may be working on a 13-inch monitor set at 640 x 480 pixels. So you just have to strike some sort of compromise.

For Web images, I recommend sizing your image assuming a 640 x 480 display — the least common denominator, if you will. If you create an image larger than 640 x 480, viewers with 640 x 480 monitors have to scroll the display back and forth to see the entire image. Of course, if you're preparing images for a multimedia presentation and you know what size monitor you'll be using, work with that monitor's display in mind.

Sizing your image for its screen debut

To resize your image for screen display, follow the same procedures you use to size images for print, but choose pixels as your unit of measurement. The exact steps vary depending on your image editor.

Here's how to do the job in PhotoDeluxe:

1. **Save a backup copy of your image.**

 In all likelihood, you're going to trim pixels from your image for on-screen display. You may want those original pixels back someday, so save a copy of the image under a different name before you go any farther.

2. **Choose Size⇨Photo Size to display the Photo Size dialog box.**

 The dialog box appears in Figure 9-3.

Figure 9-3:
To size your images for screen use in PhotoDeluxe, first deselect the File Save check box.

Photo Size
Current Size: 225K
Width: 320 pixels
Height: 240 pixels
Resolution: 300 pixels/inch
OK
Cancel
New Size: 225K
Width: 320 pixels
Height: 240 pixels
Resolution: 300 pixels/inch
Constrain: ☑ Proportions ☐ File Size

3. **Deselect the File Size check box.**

 With the check box turned off, you can adjust the pixel dimensions of your image (add or delete pixels).

 Pixel dimensions is just a fancy way of saying "the number of pixels across by the number of pixels down." See Chapter 2 for other pertinent pixel ponderings.

4. **Choose pixels as your unit of measurement for the Width and Height values.**

5. **Enter the pixel dimensions for the screen image.**

 Remember that if you increase the Width or Height values, the software has to make up — *interpolate* — the new pixels, and your image quality can suffer. Check out the information on resampling and resolution in Chapter 2 for more details on this subject.

 Also remember that the more pixels you have, the larger the image file. If you're preparing images for the Web, file size is a special consideration because larger files take longer to download than smaller files. See "Nothing but Net: Images on the Web" for more information about preparing images for use on Web pages.

6. **Click OK or press Enter.**

Sizing screen images in inches

Newcomers to the digital-image world often have trouble sizing images in terms of pixels and prefer to rely on inches as the unit of measurement. And some image editors don't offer pixels as a unit of measurement in their image-size dialog boxes. If you can't resize your image using pixels as the unit of measurement or you prefer to work in inches, set the image width and height as usual and then set the image resolution to somewhere between 72 and 96 ppi. (In PhotoDeluxe, you must deselect the File Size check box to set the image size and resolution values separately.)

Where does that 72 to 96 ppi figure come from? It's based on the default monitor display settings on Macintosh and PC monitors. Mac monitors usually leave the factory with a display setting that results in an effective screen resolution of 72 ppi, while PC monitors are geared to the 96 ppi resolution.

Note that unless you know the exact resolution of your screen, your images may not appear at precisely the width and height you specify, because all the monitor really cares about is the number of pixels in the image, not the image resolution that you specify in your image-editing program. But on most monitors, a resolution of 72 to 96 ppi should produce an image that's approximately the same width and height you choose when sizing your image. For precise on-screen sizing, the method described in the preceding section is the way to go.

Nothing but Net: Images on the Web

If your company operates a World Wide Web site or if you maintain a personal Web site, you can easily place images from your digital camera onto your Web pages.

Because I don't know which Web-page creation program you're using, I can't give you specifics on the commands and tools you use to place images on your pages. But I can offer some advice on a general artistic and technical level, which is just what happens in the next few sections.

Some basic Web rules

If you want your Web site to be one that people love to visit, take care when adding images (and other graphics, for that matter). Too many images or images that are too big quickly turn off viewers, especially impatient viewers with slow modems. Every second that people have to wait for a picture to download brings them a second closer to giving up and moving on from your site.

Would you like that picture all at once, or bit by bit?

Both JPEG and GIF enable you to specify whether your images display gradually or all at once. If you create an *interlaced* GIF or *progressive* JPEG image, a faint representation of your image appears as soon as the initial image data makes its way through the viewer's modem. As more and more image data is received, the picture details are filled in bit by bit. With noninterlaced or nonprogressive images, no part of your image appears until all image data is received.

As with most things in life, this option involves a trade-off. Interlaced/progressive images create the *perception* that the image is being loaded faster because the viewer has something to

look at sooner. But in reality, interlaced and progressive images take a little longer to download.

When I'm browsing the Web, I prefer interlaced images because I can find out more quickly whether the image is one I want to see. If not, I can click the browser's Stop button to interrupt the download and move on to something else. And if I do want to see the image, at least I have something to entertain me while I wait. Although I really would appreciate your creating Web pages with my personal preferences in mind, I do recognize that other people feel differently about the subject, and I'll try to understand if you opt for noninterlaced/nonprogressive images.

To make sure that you attract, not irritate, visitors to your Web site, follow these ground rules:

- ✔ Keep image size to a minimum — no more than 20K per picture and a total of 50K per page is optimal. If the image is too big, resize it following the guidelines discussed in "Sizing your image for its screen debut," earlier in this chapter. Or if you're saving the image as a JPEG file, as discussed in the upcoming "JPEG: The photographer's friend," use a higher compression setting.

- ✔ If you're using Adobe PhotoDeluxe as your image editor, note that the Current Size value in the Photo Size dialog box (the one you use to resize images) does not reflect the actual file size of the image. Instead, the value reflects the amount of memory the image consumes when open for editing. To check the actual file size, choose File➪Open and click the name of the image file in the Open dialog box. The file size appears at the bottom of the dialog box.

- ✔ Save your images in either the JPEG or GIF file format. These formats are the only ones widely supported by different Web browsers. Two other formats, PNG (pronounced *ping*) and FlashPix, are in development, but not fully supported by either browsers or Web-page creation programs yet. You can read more about JPEG and GIF in the next three sections and more about file formats in general in Chapter 7.

✔ Make sure that every image you add is *necessary*. Don't junk up your page with lots of pretty pictures that do nothing to convey the message of your Web page — in other words, images that are pure decoration. These kinds of images waste the viewer's time and cause people to click away from your site in frustration.

✔ If you use an image as a hyperlink — that is, if people click the image to travel to another page — also provide a text-based link. Why? Because many people (including me) set their browsers so that images are not automatically downloaded. Images appear as tiny icons that the viewer can click to display the entire image. It's not that I'm not interested in seeing important images — it's just that so many pages are littered with irrelevant pictures. When I use the Internet, I'm typically seeking information, not just cruising around looking at pretty pages. And I don't have time to download a bunch of meaningless images.

If you want to appeal to antsy folks like me, as well as to anyone who has a limited amount of time for Web browsing, set up your page so that people can navigate your site without downloading images if they prefer. My favorite sites are those that provide descriptive text with the image icon — for example, "Product shot" next to a picture of a manufacturer's hot new toy. This kind of labeling enables me to decide which pictures I want to download and which ones will be of no help to me. At the very least, I expect navigational links to be available as text-based links somewhere on the page.

✔ To accommodate the widest range of viewers, size your images with respect to a screen display of 640 x 480 pixels. For more on this topic, see "Understanding on-screen display," earlier in this chapter.

✔ Remember, too, that the file size is determined by the total number of pixels in the image, not the image resolution. A 640 x 480-pixel image consumes as much disk space at 72 ppi as it does at 300 ppi. Check out Chapter 2 for a more detailed explanation of all this file-size, pixel-count, and resolution stuff.

✔ Many image-editing programs offer a utility that shows you how long an image will take to download given a particular modem speed. If your image editor provides this tool, select the slowest modem speed when checking the download time. Again, design your Web site with the lowest-common equipment denominator in mind. Sure, some lucky corporate Web surfers have lightning-fast Internet connections, but most ordinary folks don't.

✔ Finally, a word of caution: Remember that anyone who visits your page can download, save, edit, print, and distribute your image. So if you want to control the use of your picture, don't post it on your Web page.

Decisions, decisions: JPEG or GIF?

As discussed in the preceding section, JPEG and GIF are the two mainstream formats for saving images that you want to put on a Web page. Both formats have their advantages and drawbacks.

JPEG is a better choice than GIF when you want the best possible image reproduction. JPEG supports 24-bit color, which means that your images can contain 16 million colors. GIF, on the other hand, can save only 8-bit images, which restricts you to a maximum of 256 colors. To see the difference this color limitation makes, take a look at Color Plate 9-1. In the Color Plate, I zoomed way in on a bowl of fruit. Those yellowish-green objects in the upper-right corner of the image are bananas, the big green blob is a lime, and the red thing is the edge of an apple. The top image is a 24-bit image; the bottom image has been converted to an 8-bit, 256-color image.

The color loss is most noticeable in the bananas. In the 24-bit image, the subtle color changes in the bananas are realistically represented. But when the color palette is limited to 256 colors, the range of available yellow shades is seriously reduced, so one shade of yellow must represent many similar shades. The resulting bananas have a blotchy, unappetizing appearance.

For this reason, JPEG is better than GIF for saving *continuous-tone* images — images like photographs, in which the color changes from pixel to pixel are very subtle. GIF is best reserved for grayscale images, which have only 256 colors or fewer to begin with, and for non-photographic images, such as line art and solid-color graphics.

However, JPEG does have its downside, file size being one of the major disadvantages. With more color information to store, a JPEG version of an image usually is much larger than a GIF version. Both JPEG and GIF compress image data in order to reduce file size, but JPEG uses *lossy* compression, while GIF uses *lossless* compression. Lossy compression dumps some image data, resulting in a loss of image detail. Lossless compression, on the other hand, eliminates only redundant image data so that any change in image quality is virtually undetectable. So although you can reduce a JPEG file to the same size as a GIF file, doing so typically requires a high degree of lossy compression, which can damage your image just as much as converting it from a 24-bit image to a 256-color GIF file. For a look at how various compression amounts affect an image, see Color Plate 3-1.

Choosing between JPEG and GIF sometimes becomes a question of the lesser of two evils. Experiment with both formats to see which one results in the best-looking image at the file size you need. In some cases, you may discover that shifting the image to 256 colors really doesn't have that much of an impact — if your image has large expanses of flat color, for example.

Similarly, you may not notice a huge loss of quality on some images even when applying the maximum amount of JPEG compression, while other images may look like garbage with the same compression.

Also keep in mind that the problems created by both GIF and JPEG compression are less noticeable when the image is displayed at small sizes. To illustrate the color loss that resulted from converting the image in Color Plate 9-1 to GIF, I had to zoom way in on the image. When viewed at a smaller size, the damage was less noticeable.

GIF does offer one additional feature that JPEG does not: the ability to make a portion of your image transparent, allowing the underlying Web-page background to show through. For more information on creating transparent GIFs, see the next section.

GIF: *256 colors or bust*

The GIF format can support only 8-bit (256-color) images. This color limitation results in small file sizes that make for shorter download times, but it can also make your images look a little pixel-y and rough. (See Color Plate 9-1 for an illustration.)

However, the quality loss that results from converting to 256 colors may not be too noticeable with some images. And GIF does offer a feature that enables you to make a portion of your image transparent.

GIF comes in two flavors: 87a and 89a. My, those are user-friendly names, aren't they? Anyway, 89a is the one that enables you to create a partially transparent image. With 87a, all your pixels are fully opaque. (Don't worry about remembering the numeric labels, though; most people just refer to the two types as transparent GIF and nontransparent GIF.)

Why would you want to make a portion of your image transparent? Well, suppose that you have an image of your company's latest product — a new tennis shoe, maybe. The shoe was shot against a red background. If you make the background transparent, only the shoe portion of the image shows up on the Web page — it looks as though you took some scissors and clipped away the background. If you save the image as a regular GIF image, viewers see both shoe and background. Neither approach is right or wrong; GIF transparency just gives you an additional creative option.

The following two sections explain how to create both regular and transparent GIF images in Adobe PhotoDeluxe. If you use another image editor that supports the GIF format, you should find the process much the same in your program. But check your help system or manual just to be sure.

Most image-editing programs can save to the GIF format, but not all can create transparent GIF images. In some programs, you must strip the image down to its 256-color bare bones — called *indexing* the colors — before the GIF format becomes available as a format choice when saving files. Other programs handle the color conversion for you automatically as part of the save process.

Creating a standard GIF image

The following steps explain how to save your image as a standard GIF file — without taking advantage of transparency — in PhotoDeluxe. If you're using another image editor and the program can save to GIF, you should find similar options available when you select the GIF format during the save process.

Remember that saving your image to GIF in PhotoDeluxe reduces the image to 256 colors. Be sure to make a backup copy of your image before you save it to GIF in case you ever want the original image colors back.

1. **Choose File➪Export➪GIF89a Export.**

 The dialog box shown in Figure 9-4 appears. (Note that although the command and dialog box name indicate GIF89A — transparent GIF — you use these options for saving nontransparent GIF images as well.)

Figure 9-4:
The first step to saving an image as a GIF file.

2. **Click Advanced.**

 Now you see the more complex dialog box shown in Figure 9-5. But don't worry: For your purposes, you need only consider the Interlaced check box. To create an interlaced GIF image — one that appears gradually as the image data is downloaded — select the check box. To create an image that does not display until all data is received by the viewer, deselect the check box. See the sidebar "Would you like that picture all at once, or bit by bit?" earlier in this chapter for more information on interlacing.

 And for future reference, if you don't care a whit about whether your images are interlaced or not, you can skip straight from Step 1 to Step 4.

3. **Click OK to return to the first GIF89a Export Options dialog box.**

Figure 9-5:
The
Interlaced
option
creates
images that
fade
gradually
into view as
image data
is down-
loaded.

GIF89a Export Options

Transparency From Mask

(Default)
Transparency Index Color

OK

Cancel

Preview

Palette: Adaptive

Colors: 255

☑ Interlaced
☐ Use Best Match
☐ Export Caption

4. Click OK.

PhotoDeluxe converts your image to an 8-bit image and displays the GIF89a Export dialog box, which looks like a run-of-the-mill Save dialog box except for the name.

5. Enter the filename and specify where you want to save the image.

The GIF format is already selected for you automatically as the file type.

6. Click Save.

Creating a GIF image with transparency

To use the GIF transparency option, point and click your way through these not-quite-as-easy-as-pie-but-still-not-brain-surgery steps instead. Again, these steps are specific to PhotoDeluxe, but the process works similarly in most other image editors as well.

After you strip your image down to 256 colors to save it to GIF, you can't get those colors back. So be sure to make a backup copy of your image before converting it to a GIF file. Also, editing in 256 colors can be difficult, so be sure that your image is just how you want it before you save to the GIF format.

With that crucial legal disclaimer out of the way, here's the path to transparency in PhotoDeluxe:

1. Choose File⇨Export⇨GIF89a Export.

The dialog box shown back in Figure 9-4 appears, just as before.

2. Click the Advanced button.

You see the GIF89a Export Options dialog box shown back in Figure 9-5. Do not — I repeat — do *not* touch the Palette and Colors options. Leave them set at Adaptive and 255, respectively.

3. **Set the transparency preview color.**

The color swatch in the Transparency From Mask area of the dialog box shows you what color will be used to represent the transparent pixels in your image when you view the image inside PhotoDeluxe. The default color is the gray that once was the standard background color for Web pages. If your image contains lots of gray, you may want to change the preview color so that you can more easily see which pixels are transparent and which ones are opaque. Click the color swatch to display the Color Picker dialog box and select a color just as you do when picking your paint colors. (See Chapter 12 if you need help.) Click OK to exit the Color Picker and return to the GIF89a Export Options dialog box.

4. **Click Preview.**

A big, black limo arrives and whisks you to the Select Transparent Colors dialog box shown in Figure 9-6. This dialog box is the meat of the GIF89a transparency option. Here, you choose the colors that you want to be transparent.

To make a color transparent, click the eyedropper icon and click on the color inside the image preview. Or click one of the color swatches at the bottom of the dialog box. You can select as many colors as you want. The swatches for selected colors are surrounded by a thick outline. If you change your mind and decide you don't want a particular color to appear transparent, Ctrl+click the color swatch with the eyedropper.

Figure 9-6:
To assign transparency to a color, click the color in the image preview or in the row of swatches at the bottom of the dialog box.

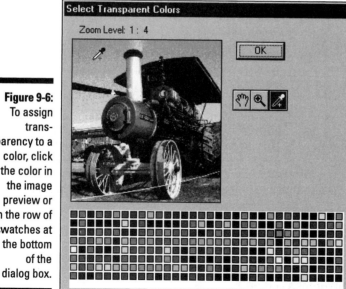

If you need to zoom in on the preview, click the magnifying glass icon and then click inside the preview. Alt+click to zoom out. To scroll the preview so that you can see another portion of your image, click the hand icon and then drag inside the preview.

After you select your colors, click OK to go back to the dialog box shown back in Figure 9-5.

5. Turn the Interlaced option on . . . or off.

As discussed in the sidebar "Would you like that picture all at once, or bit by bit?" this option determines how your image appears when a viewer downloads your page. Select the check box to turn interlacing on; deselect it to create a noninterlaced image.

6. Click OK.

Off you go to the Export GIF89a dialog box, which is your standard-issue Save/Export dialog box with a fancy name. Enter a name for your image, specify the folder and drive where you want to store the image, and click Save. The appropriate file type (GIF) is selected for you automatically.

JPEG: The photographer's friend

JPEG, which can save 24-bit images (16 million colors), is the format of choice for the best representation of continuous-tone images, including photographs. For more on the advantages and drawbacks of JPEG, see "Decisions, decisions: JPEG or GIF?" a few sections ago.

To save an image in the JPEG format in PhotoDeluxe, take the following exciting steps. If you're using another image editor, check the help system for the exact commands to use to save to JPEG. The available JPEG options should be much the same as described here.

In order to create smaller files, JPEG applies lossy compression, which dumps some image data. Before you save an image using JPEG with a high degree of compression, be sure to save a backup copy using a file format that doesn't use lossy compression — TIFF, for example, or the native PhotoDeluxe format (PDD). After you apply JPEG compression, you can't get back the image data that gets eliminated during the compression process. For more about compression, see Chapter 3 and Color Plate 3-1.

1. Choose File⇨Export⇨File Format.

(If you're not using PhotoDeluxe, the appropriate command may instead be named File⇨Save As or File⇨Export; check your manual or online help system for information.)

The Export dialog box, which is a variation of the standard Save dialog box, appears. Name your image, specify the drive and folder where you want the image to be saved, and choose JPEG as the file type. Then click Save to display the dialog box shown in Figure 9-7.

Figure 9-7:
Click the
Options
button to
control how
your JPEG
file is saved.

2. Click Options.

You get the JPEG Options dialog box, shown in Figure 9-8.

Figure 9-8:
Choose a
Quality
setting to
specify how
much you
want to
compress
your image.

3. Set the compression amount.

Using the Quality option box, the neighboring drop-down list, or the slider bar, you choose the amount of compression, thereby determining the image quality and file size. The higher the Quality value, the less compression applied, and the larger the file size.

The pop-up menu offers you four general settings, Maximum, High, Medium, and Low, with Maximum providing the best quality/least compression and Low providing the least quality/most compression. The slider bar and option box enable you to be a little more specific. You can choose from ten settings, with 0 giving you the lowest image quality

(maximum compression) and 10 the best image quality (least amount of compression). For Web images, you can usually get by with the Medium quality setting. Either choose the setting from the pop-up menu or enter 4 or 5 in the Quality option box. Alternatively, you can drag the slider bar until those values appear in the option boxes.

4. **Select a format option.**

 If you want to create a progressive JPEG file, select the Progressive option in the Format Options section of the dialog box. As discussed in the earlier sidebar "Would you like that picture all at once, or bit by bit?," a progressive image is displayed gradually when a viewer downloads your Web page. At first, viewers see a low-quality version of your image, and then the image gradually improves as more and more image data is received. The Scans value determines how many intermediate images the viewer sees before the image is displayed in full. You don't have much latitude here — you can specify 3, 4, or 5 scans. You'll be fine if you leave the option set to its default of 3.

 For a nonprogressive Web image — that is, one that doesn't appear until all image data is downloaded — choose the Baseline Optimized option. The other option, Baseline ("Standard"), is the right choice for images that will be printed rather than distributed over the Web.

5. **Ignore the Save Paths option.**

 This option is related to an image-editing function available in Adobe Photoshop, but not little brother PhotoDeluxe. The JPEG Options dialog box, like many in PhotoDeluxe, is lifted from Photoshop, which is why the option is included.

6. **Click OK.**

 The file is saved without further ado.

Progressive JPEGs demand more RAM to view and are not supported by some older Web browsers. In most cases, neither issue is a major concern. But if people complain that they're having trouble accessing or viewing the images on your Web site, try exchanging the images with nonprogressive versions.

Drop Me a Picture Sometime, Won't You?

Being able to send digital photos to friends and family around the world via e-mail is one of the most enjoyable aspects of owning a digital camera. With a few clicks of your mouse, you can send an image to anyone who has an e-mail account. That person can then view your image on-screen, save it to disk, and even edit and print it.

Of course, this capability comes in handy for business purposes as well. As a part-time antique dealer, for example, I often exchange images with other dealers and antique enthusiasts around the country. When I need help identifying or pricing a recent find, I e-mail my contacts and get their feedback. Someone in the group usually can provide the information I'm seeking.

Although attaching an image to an e-mail message is really simple, the process sometimes breaks down due to differences in e-mail programs and how files are handled on the Mac versus the PC. Also, newcomers to the world of electronic mail often get confused about how to view and send images — which isn't surprising, given that e-mail software often makes the process less than intuitive.

One way to help make sure that your image arrives intact is to prepare it properly before sending. First, size your image according to the guidelines discussed in this chapter, in "That's About the Size of It."

Also, save your image in the JPEG format, as explained in the preceding section. Use the Baseline Optimized setting and a Medium or High Quality setting. Some e-mail programs can accept GIF images, but not all can, so use JPEG for safety's sake. The exception is when sending images to CompuServe users, whose browsers often work with GIF but not JPEG. (In other words, if the recipient has trouble with the image in one format, try resending the picture in the other format.)

Note that these instructions don't apply to images that you're sending to someone who needs the image for some professional graphics purpose — for example, if you created an image for a client who plans to put it in a company newsletter. In that case, save the image file in whatever format the client needs, and use the image resolution appropriate for the final output, as explained in Chapter 2. With large image files, expect long download times. As a matter of fact, unless you're on a tight deadline, putting the image on a Zip disk, CD, or some other removable storage medium and sending it off via overnight mail may be a better option than e-mail transmission.

That said, the following steps explain how to attach an image file to an e-mail message in Netscape Communicator 4.0. If you use another program to send and receive e-mail, the process is probably very similar, but check your program's online help system for specific instructions.

1. **Connect to the Internet and fire up Communicator.**

2. **Choose Communicator⇨Messenger Mailbox (or click the little mail icon at the bottom of the program window).**

3. **Choose File⇨New⇨Message or click the New Msg button on the toolbar.**

 You're presented with a blank mail window.

4. **Enter the recipient's name, e-mail address, and subject information as you normally do.**

5. **Choose File⇨Attach⇨File or click the Attach button on the toolbar and then select File from the drop-down menu.**

Most programs provide such a toolbar button — look for a button that has a paper clip icon on it. The paper clip has become the standard icon to represent the attachment feature.

After you select the File option, you see a dialog box that looks much like the one you normally use to locate and open a file. Track down the image file that you want to attach, select it, and click Open. You're then returned to the message composition window.

If you want to attach more images to the same message, repeat Step 5.

6. **Choose File⇨Send Now or click the Send toolbar button to launch that image into cyberspace.**

If everything goes right, your e-mail recipient should receive the image in no time. In Netscape Navigator, the image either appears as an *inline graphic* — that is, it is displayed right in the e-mail window — as in Figure 9-9, or as a text link that the user clicks to display the image.

But as mentioned earlier, several technical issues can throw a monkey wrench into the process. If the image doesn't arrive as expected or can't be viewed, the first thing to do is call the tech support line for the recipient's e-mail program or service. Find out whether you need to follow any special procedures when sending images and verify that the recipient's software is set up correctly. If everything seems okay on that end, contact your own e-mail provider or software tech support. Chances are, some e-mail setting needs to be tweaked, and the tech support personnel should be able to help you resolve the problem quickly.

For special images, you may want to send an e-mail "postcard" instead of attaching your file to a standard e-mail message. With a postcard, your recipient sees your message and image laid out in a design that resembles a traditional postcard. In some cases, you can even add an audio message. Kodak offers a free postcard service at its Web site (click the Picture This Postcards link on the home page, www.kodak.com); you upload your picture to the site, add a message, and enter the recipient's e-mail address. The recipient then goes to the Kodak site to view the postcard.

You can also buy postcard software programs, such as NetCard from PictureWorks Technology (www.pictureworks.com), to design your own post-cards. With these programs, you attach your postcard file to an e-mail mes-sage along with a viewer that enables the recipient to view your handiwork. Or you can convert the postcard to a standard JPEG file so that no viewer is needed. Figure 9-10 shows the front and back sides of a postcard being created in NetCard.

Figure 9-9:
You can attach images to e-mail messages as shown here.

Figure 9-10:
Programs such as NetCard enable you to create and send e-mail postcards.

Redecorate Your Computer's Living Room

Tired of that plain old background that you see behind your program windows? You can turn one of your images into a customized background, as I did in Figure 9-11.

Somewhere along the line, the people who sit around dreaming up names for computer stuff decided that background screens should be referred to as *wallpaper.* Fortunately, hanging up new computer wallpaper isn't nearly as problematic as repapering a real room.

If you work on a Windows computer, PhotoDeluxe provides a command that automatically converts your image to wallpaper. Just choose File➪Export➪ Windows Wallpaper. Each time you choose the command, the current wallpaper image is deleted and replaced with the new image.

Just in case you're not using PhotoDeluxe or you want to create several different wallpaper images, the following sections explain how to create wallpaper using Windows 95 or 98, Macintosh System 7.5, and Mac OS 8.

Figure 9-11: My sunset image creates a far more soothing desktop environment than the standard-issue Windows wallpaper.

If you want the image to fill the entire screen, size the image to match the screen resolution. If your monitor is set to display 640 x 480 pixels, for example, make your image 640 x 480 pixels.

Creating Windows wallpaper

If you're using Windows 95 or 98, follow these steps to splatter your favorite image across your desktop:

1. **Save your image in the BMP format.**

 This is the format required by the Windows system software. If you need help with the saving process, flip to "Save Now! Save Often!" in Chapter 10.

2. **Right-click anywhere on the Windows desktop and choose Properties from the resulting pop-up menu.**

 The dialog box shown in Figure 9-12 appears. (The dialog box shown here is from Windows 95; this dialog box looks a little different in Windows 98. Also, your dialog box may have slightly different panels, depending on the video card your system uses.)

3. **Click the Background tab.**

4. **Click the Browse button.**

 In the resulting dialog box, track down the BMP file you just created. Click it and click OK.

5. **Choose the Tile or Center option.**

 In Windows 95, click the radio button for the option you want; in Windows 98, choose the option from the Display drop-down list.

 If you choose Center, the image is centered in the desktop area. If you choose Tile, the image is repeated across the screen, as many times as necessary to fill the entire desktop.

6. **Click OK.**

That's all there is to it. If you ever want to select a different wallpaper, repeat Steps 1 through 3, select a different wallpaper file from the Wallpaper scrolling list, and click OK.

Figure 9-12:
Replace
your
desktop
wallpaper
with a
custom
image
via this
dialog box.

Creating Macintosh wallpaper

Macintosh users can also replace their system wallpaper with an image. If you're using OS 8, you can fill your entire screen with an image, but if you're using System 7.5, you're limited to a 128 x 128-pixel image that repeats across the screen.

Here's how to create a customized background pattern when using System 7.5:

1. **Create a 128 x 128-pixel image.**

 If you need help resizing your image, see "Sizing your image for its screen debut," earlier in this chapter.

2. **Press ⌘+A to select the entire image.**

3. **Press ⌘+C to copy the image to the Clipboard.**

4. **Open the Desktop Patterns program.**

 The program should be located in the Control Panels folder. The Desktop Patterns dialog box appears.

5. **Press ⌘+V to paste your image into the dialog box.**

6. **Click the Set Desktop Pattern button.**

 Your pattern fills the screen, making you the envy of all your less-clever Mac enthusiasts.

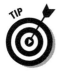

Note that you may need to increase the amount of memory available to the Desktop Pattern program in order to create a customized pattern. To do so, exit out of the program, switch to the Finder, and click the Desktop Pattern program icon. Press ⌘+I to open the Info dialog box for the program and raise the value in the Preferred Size option box.

For those of you who have made the move to OS 8, things are a little different. You can use any PICT or JPEG image as your wallpaper. Just follow these incredibly easy steps:

1. **Choose Control Panels⇨Desktop Patterns from the Apple menu.**

 The dialog box shown in Figure 9-13 appears.

2. **Click the Picture button.**

3. **Click Remove Picture.**

Display options menu Picture preview

Figure 9-13: In OS 8, head for this dialog box to use a custom image as your desktop wallpaper.

This step removes the current desktop picture and changes the Remove Picture button into the Select Picture button.

4. **Click Select Picture.**

Choose your image file from the dialog box that appears when you click the button. Click Open to select the file and return to the Desktop Pictures dialog box.

5. **Choose a display option from the drop-down menu.**

(The menu is labeled in Figure 9-13.) You have five options: Fill Screen fills the screen with your image, oddly enough. Scale to Screen enlarges or reduces your image so that it fits on the screen. Center on Screen puts your image smack dab in the middle of the screen, while Tile on Screen repeats the image as many times as necessary to fill the screen. Position Automatically scales or fills the screen with the picture, depending on the image size.

6. **Click the Set Desktop button.**

Your image is plastered to your screen.

Another way to change your desktop wallpaper is to simply drag the image file to the picture preview in the Desktop Pictures dialog box (refer to Figure 9-13). You can drag a whole folder of images to the preview to make the system display a group of images randomly.

Part IV
Tricks of the Digital Trade

The 5th Wave By Rich Tennant

Dwayne attempts to override his computer's cut and paste function.

In this part . . .

If you watch many spy movies, you may have noticed that image editing has worked its way into just about every plot line lately. Typically, the story goes like this: A Mel Gibson-type hero snags a photograph of the bad guys. But the photograph is taken from too far away to clearly identify the villains. So Mel takes the picture to a buddy who works as a digital imaging specialist in a top-secret government lab. Miraculously, the buddy is able to enhance the picture enough to give Mel a crystal-clear image of his prey, and soon all is well for Earth's citizens. Except for the buddy, that is, who invariably gets killed by the villains just moments after Mel leaves the lab.

I'm sorry to say that, in real life, image editing doesn't work that way. Maybe top-secret government-types have software that can perform the tricks you see in movies — hey, for all I know, our agents really have ray guns and secret decoder rings, too. But the image editors available to you and me simply can't create photographic details out of nothing.

That doesn't mean that you can't perform some pretty amazing feats, though, as this part of the book illustrates. Chapter 10 shows you how to do minor touch-up work, such as cropping your image and correcting color balance. Chapter 11 explains how to apply edits to just part of your image by creating selections, cut and paste two or more images together, and cover up minor image flaws and unwanted background elements. Chapter 12 gives you a taste of some advanced editing techniques, such as painting on your image, creating photographic montages, and applying special-effects filters.

Although real-world image editing isn't nearly as dramatic as Hollywood implies, it's still way, way cool, not to mention a lot safer. Real-life image editors hardly ever get whacked by villains — although, if you doctor an image to show your boss or some other nemesis in an unflattering light, you may want to stay out of dimly lit alleys for a while.

Chapter 10

Making Your Image Look Presentable

*O*ne of the great things about digital photography is that you're never limited to the image that comes out of the camera, as you are with traditional photography. With film, a lousy picture stays a lousy picture forever. Sure, you can get one of those little pens to cover up red-eye problems, and if you're really good with scissors, you can crop out unwanted portions of the picture. But that's about the extent of the corrections you can do without a full-blown film lab at your disposal.

With a digital image and a basic image-editing program, however, you can do amazing things to your pictures — with surprisingly little effort. In addition to cropping, color balancing, and adjusting brightness and contrast, you can cover up distracting background elements, bring back washed-out colors, paste two or more images together, and apply all sorts of creative effects.

Chapter 11 explains how to cover up image blemishes and how to cut and paste two photos together, while Chapter 12 explores painting tools, special-effects filters, and other advanced image-editing techniques. This chapter explains the basics: simple image-editing tricks you can use to correct minor defects in your image.

A Word about Image Editors

In this chapter, and in others that describe specific image-editing commands, I show you how to get the job done using Adobe PhotoDeluxe. I chose this software because it's included with many brands of digital cameras, which means that many readers have the program. Furthermore, PhotoDeluxe offers many of the same features found in the more sophisticated (and more expensive) Adobe Photoshop, the leading professional-level image editor.

This book isn't intended to be a thorough discussion of PhotoDeluxe, however. I touch on just a few key commands and tools, and I assume that you are already somewhat familiar with the program. If you want more guidance, get a copy of — warning, shameless plug about to arrive! — *Adobe PhotoDeluxe For Dummies,* written by yours truly and published by IDG Books Worldwide, Inc. That book covers Version 2 and Version 3, as well as the Business Edition of PhotoDeluxe, while this book features Version 3, Home Edition, exclusively. If you're using the new version of PhotoDeluxe, Version 4.0, grab a copy of the corresponding *Adobe PhotoDeluxe 4 For Dummies,* which should be available sometime in Spring 2000.

Text that is marked with a PhotoDeluxe margin icon relates specifically to PhotoDeluxe. But if you use an image editor other than PhotoDeluxe, please be assured that nearly all the PhotoDeluxe information provided in this book can be adapted easily to your software. Most image-editing programs provide similar tools and commands to the ones discussed here, although the exact tool names and command implementation may be slightly different. And the basic editing concepts and photographic ideas presented here are the same no matter what image editor you prefer.

So use this book as a guide for understanding the basic approach you should take when editing your digital pictures, and consult your software's manual or online help system for the specifics of applying certain techniques.

If you don't have any image-editing software or you're shopping for a new program, you can find demo versions of several image editors on the CD accompanying this book. I've also included some sample images on the CD, in case you don't yet have any at your disposal.

How to Open Images

Before you can edit an image, you have to open it inside your image editor. In just about every editing program on the planet, you can use the following techniques to crack open an image:

- Choose the Open command from the File menu.

- For speedier file access, use the universal Open command shortcut: Press Ctrl+O on a PC and ⌘+O on a Mac.

- If you want to create an entirely new image, starting from scratch instead of editing an existing photo, choose New from the File menu or press Ctrl+N (⌘+N). Most image-editing programs then display a dialog box in which you can specify the name, size, and resolution of the image.

Here are a few other scandalous bits of gossip related to opening images:

- Image editing requires a substantial amount of free RAM (system memory). If your image editor balks when you try to open an image, try shutting down all programs, restarting your computer, and then starting your image editor only. (Be sure to disable any startup routines that launch programs automatically in the background when you fire up your system.) Now you're working with the maximum RAM. If your image editor continues to complain about a memory shortage, consider adding more memory — memory prices are relatively cheap right now, fortunately.

- Some image editors, including PhotoDeluxe and Photoshop, use hard disk space as well as RAM when processing images. When you apply an edit, the programs copy whatever data is currently being stored in memory to the hard disk. Typically, you must have the same amount of free disk space as you have RAM. If your system has 96MB of RAM, for example, you need 96MB of free disk space.

 In PhotoDeluxe and Photoshop, you see a message saying that your *scratch disk* is full whenever you run out of the requisite amount of disk space. Other programs may use different terminology. In any case, you can solve the problem by deleting some unneeded files to free up some room on the hard disk.

- Most image editors can't read the proprietary file formats that some digital cameras use to store images. If your image editor refuses to open a file because of format, check your camera manual for information about the image-downloading software provided with your camera. You should be able to use the software to convert your images to a standard file format. (See Chapter 7 for a rundown of file formats.)

- Some programs, on the other hand, can open images directly from digital cameras. Again, check the program manual and the camera manual to find out how to make your software and hardware talk to each other. Look for information about something called TWAIN access. Chapter 7 provides additional enlightenment about this interesting acronym.

And finally, a few additional insights related specifically to PhotoDeluxe:

✔ When you open an image in PhotoDeluxe, the program analyzes the file to determine the file format. If the file format is something other than the native PhotoDeluxe format (PDD), the program opens a copy of the image and converts the copy to the PDD format. As long as you don't save the edited image using the same name and format as the original, you can always return to the original if you muck things up during editing. (See the upcoming section "Editing Safety Nets" for information on other ways to undo your editing mistakes, and see the next section for instructions on saving images.)

Why does PhotoDeluxe force you to work in the PDD format? Because programs can process images in their native format more quickly than images saved in other formats. Perhaps more importantly, though, the PDD format is geared to support the program's tools and features. For example, PDD is one of only two formats available in PhotoDeluxe that supports (can handle) image layers. Layers come into play when you're combining images, as discussed in Chapter 12. The other format that supports layers is the PSD format, which is the native format for Adobe Photoshop, the older sibling of PhotoDeluxe.

✔ If your image opens up on its side, choose Orientation⇨Rotate Right or Orientation⇨Rotate Left to turn things around in PhotoDeluxe. To flip the image horizontally or stand it on its head, choose Flip Horizontal or Flip Vertical from the Orientation menu.

Save Now! Save Often!

Actually, a more appropriate name for this section would be "Saving Your Sanity." Unless you get in the habit of saving your images on a frequent basis, you can easily lose your mind.

Until you save your image, all your work is vulnerable. If your system crashes, the power goes out, or some other cruel twist of fate occurs, everything you've done in the current editing session is lost forever. And don't think it can't happen to you because you popped for that state-of-the-art computer last month. Large digital images can choke even the most pumped-up system. I work on a souped-up computer with gobs of RAM, and I still get the occasional "This program has performed an illegal operation and will be shut down" message when working on large images.

To protect yourself, commit the following image-safety rules to memory:

✔ Stop, drop, and roll! Oops, no, that's fire safety, not image safety. Neither stopping, dropping, nor rolling will prevent your image from going up in digital flames should you ignore my advice on saving. Then again, when you tell your boss or client that you just lost a day's worth of edits, the

stop-drop-roll maneuver is good for dodging heavy objects that may be hurled in your direction.

✔ To save an image for the first time, apply the universal save command: Choose the Save command from the File menu or press Ctrl+S on a PC and ⌘+S on the Mac. Your program should then present a dialog box in which you can enter a name for your image and choose a storage location on disk, just as you do when saving any other type of document.

✔ While you're working on an image, store it on your hard drive, rather than on a floppy disk or some other removable media. Your computer can work with files on your hard drive faster than images stored on removable media. But always save a backup copy on whatever removable storage media you use, too, to protect yourself in the event of a system crash. See Chapter 4 for information about different types of removable media.

✔ After you first save an image, resave it after every few edits. You can usually simply press Ctrl+S (⌘+S on the Mac) to resave the image without messing with a dialog box. If you want to save the image under a different name, you typically choose the Save As command from the File menu.

✔ In most programs, you can specify which file format you want to use when you choose the Save As or Save command. But in PhotoDeluxe, both commands restrict you to saving only in the native PhotoDeluxe format, PDD. If you need to save the image in any other format — TIFF, JPEG, GIF, or whatever — choose File⇨Send To⇨File Format. (In other programs, this command may be File⇨Export.)

PhotoDeluxe then displays a dialog box just like the one you get when you choose the standard Save command, except that it offers a choice of file formats. For more information on the various file formats and options that appear when you save to them, see Chapter 7.

If your PhotoDeluxe image contains layers, don't save to a format other than PDD or the Adobe Photoshop format, PSD. Those are the only two formats available in PhotoDeluxe that retain layers. Other formats smush all your layers together. See Chapter 12 for more details about this layer stuff.

Note that when you save your image to another format in PhotoDeluxe, the program simply makes a *copy* of the on-screen image and stores that copy on disk. The command is designed to be used after you finish editing an image and want to export it (open it in some other program), not as a routine save option. The working image — the one on the screen — isn't saved or protected in any way. For this reason, save your image to the PhotoDeluxe (PDD) format until you're finished editing and then export it to the desired format. That way, you can easily resave your image as you work by pressing Ctrl+S (or ⌘+S on the Mac), as explained a few paragraphs ago.

Editing Safety Nets

As you make your way through the merry land of image editing, you're bound to take a wrong turn every now and then. Perhaps you clicked when you should have dragged. Or cut when you meant to copy. Or painted a mustache on your boss's face when all you really intended to do was cover up a little hot spot.

Fortunately, most mistakes can be easily undone by using the following options:

- ✔ Most programs provide an Undo command, usually accessed via Edit⇨Undo. The Undo command takes you one step back in time, undoing your last editing action. If you painted a line on your image, for example, Undo removes the line.

 In many programs, you can choose Undo quickly by pressing Ctrl+Z on a PC or ⌘+Z on a Mac.

- ✔ File⇨Revert to Last Saved — found in Photoshop as well as Photo-Deluxe — restores your image to the way it appeared the last time you saved it. This command is helpful when you totally make a mess of your image and you just want to get back to square one. However, the command works only after you save your image for the first time. In PhotoDeluxe, you must save to the PDD format. (See "Save Now! Save Often!" earlier in this chapter for information on saving images.)

The Revert to Last Saved command is pretty straightforward. Basically, using this command is the same as closing your image without saving it and then reopening the image. You simply save a few clicks getting the job done.

Undo is easy to use, too, but I need to pass along a bit more information on this command:

- ✔ Undo can't take care of all problems. For example, if you forget to save an image before you close it, Undo can't help you. Nor can Undo reverse the Save command.

- ✔ In most programs, you can choose the Print command without interfering with the option to use Undo. So you can make an edit, print your image, and then use Undo if you don't like the way your image looks.

- ✔ Some programs offer *multiple Undo,* which enables you to undo a whole series of edits rather than just one. Say that you crop your image, resize it, add some text, and then apply a border. Later, you can think more about that text, go back to the point at which you added the text, and reverse your decision. In most programs, any edits applied after the one you undo are also eliminated. If you undo that text step, your border step is also wiped out, for example. PhotoDeluxe doesn't offer this feature, unfortunately; Photoshop 5 and later, as well as most other professional-level image editors, do give you multiple Undo.

✔ If your image editor does not offer multiple Undo, choose Undo *immediately* after you perform the edit you want to reverse. If you use another tool or choose another command, you lose your opportunity to undo.

✔ Change your mind about that undo? Look for a Redo command (usually, the command is found on the Edit menu or in the same location as the Undo command). Redo puts things back to the way they were before you chose Undo. As with Undo, some programs enable you to redo a whole series of Undo actions, while others can reverse only the most recent application of the Undo command. Check your software manual or help system to find out how much Undo/Redo flexibility you have.

Editing Rules for All Seasons

Before you jump whole hog into editing, you need to review a few basic rules of success:

✔ Before you begin editing, always make a backup copy of your image. That way, you can experiment freely, safe in the knowledge that if you completely ruin your image, you can return to the original version at any time.

✔ Save your image at regular intervals in the editing process so that if your system crashes, you don't lose the entire day's work. Saving also provides you with extra editing flexibility. After you complete a particular editing task to your satisfaction, save the image before you move on to the next phase of the project. If you screw up in that next phase or just decide you liked the image better before you applied the latest edits, you can simply return to the saved version.

✔ If your image editor offers layers, as does PhotoDeluxe, copy your entire image to a new layer before tackling a significant edit. Then apply the edit to the copied layer. Don't like what you see? Just delete the layer and start over. (Chapter 12 explains what I mean by "layer," in case you're not familiar with this term.)

✔ Most image editors enable you to *select* a portion of your image and apply your edits to just the selected area. For example, if the sky in your image is very bright but the landscape is very dark, you can select the landscape and then increase the brightness of just that area. To find out more about this very useful technique, read Chapter 11.

✔ As you explore the menus and buttons in your image editor, you can no doubt find some "instant fix" filters. PhotoDeluxe, for example, offers a filter that promises to correct any problems with contrast, exposure, saturation, and focus with one click of your mouse. Feel free to go ahead and experiment with these tools — who am I to discourage you from seeking instant gratification? But understand that these automatic correction filters typically produce less-than-satisfactory results, either under- or

overcompensating for problems. For this reason, most programs also include "manual" correction tools that enable you to control the type and amount of correction applied to your image.

Correcting your image may take a few more seconds using these manual controls, but your images will thank you for your efforts. In this book, I concentrate on manual correction tools, although I introduce you to some of the more popular automatic filters as well.

✔ Don't forget that if you don't like the results of your edits, you can usually reverse them by choosing Edit➪Undo. See the section "Editing Safety Nets," earlier in this chapter, for details.

Cream of the Crop

Take a look at the image in Figure 10-1. Great subject, lousy composition — my lovely nieces almost get lost in all that pool water. The older one encouraged me to walk into the pool for a tighter shot, but somehow that didn't seem like a good idea with an $800 camera in hand!

Handle

Crop marquee

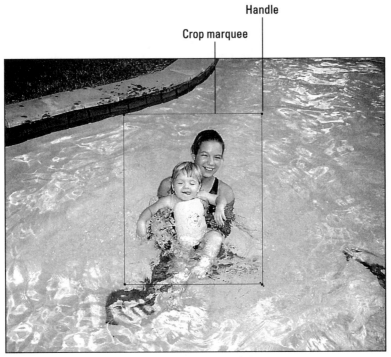

Figure 10-1:
Suffering from an excess of boring background, this image begs for some cropping.

Were this a film photograph, I'd have to live with the results or find myself a sharp pair of scissors. But because this isn't a film photograph and because PhotoDeluxe (and virtually every other image editor) offers a crop tool, I can simply clip away some of the pool, resulting in the much more pleasing image in Figure 10-2.

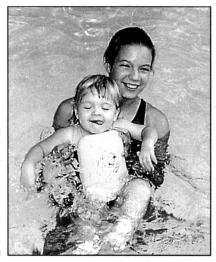

Figure 10-2:
A tight cropping job restores emphasis to the image subject.

The following steps explain how to give your image a haircut using a crop tool:

1. **Pick up the crop tool.**

 In PhotoDeluxe, choose Size⇨Trim to activate the tool.

2. **Drag to create a crop outline around the area you want to keep.**

 To create the outline, drag from one corner of the area you want to keep to the other corner. The outline appears on your image, as shown in Figure 10-1. Anything outside the outline is earmarked for a trip to the digital dumpster.

 After you release the mouse button, one of two things happens. In some entry-level image editors, the image is cropped immediately. If you don't like the results, choose the Undo command and try again.

 In PhotoDeluxe and most professional image-editing programs, you see a solid outline with a little box at each corner, as in Figure 10-1. You can use the boxes to adjust the crop outline if necessary, as explained in the next step.

 People who edit images for a living call crop outlines *marquees* and refer to those little boxes around the outline as *handles*. *Outlines* and *boxes* could be too easily understood by outsiders, you know.

3. **Drag the marquee handles to adjust the crop marquee.**

In PhotoDeluxe, you can also drag anywhere inside the outline to move the entire marquee.

4. **Apply the crop.**

In PhotoDeluxe, click outside the marquee to crop the image for good. In other image editors, you may need to click a Crop button or double-click to apply the crop; check the program's help system for details.

If you don't like what you see, choose that Undo command and go back to square one.

Readers who are really paying attention will notice that the subjects in Figure 10-2 are larger than they appear in Figure 10-1. To create the second image, I enlarged the photo, which had the side effect of lowering the image resolution slightly. The image originally has a resolution of 266 ppi; the enlarged image, just 200 ppi. Remember that when you reduce the resolution, your print quality can go down as well. In this case, 200 ppi produced an acceptable image for black-and-white printing, although the photo isn't quite as sharp as the original. For a refresher course on resolution, resizing images, and print quality, hop a plane to Chapter 2 and then to Chapter 8.

A special function of the crop tool in PhotoDeluxe, Photoshop, and some other image-editing programs enables you to rotate and crop an image in one fell swoop. Using this technique, you can straighten out images that look off-kilter, like the left image in Figure 10-3.

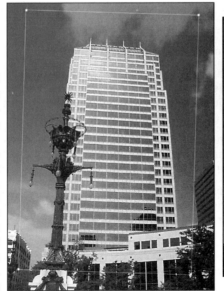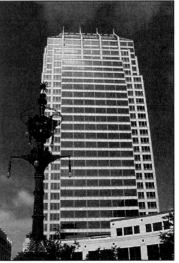

Figure 10-3: Some crop tools provide a rotate function that can turn a crooked subject (left) into an upright citizen (right).

To take advantage of this feature in PhotoDeluxe, draw your crop marquee as usual. Then press and hold the Alt key as you drag a marquee handle. While Alt is down, you can rotate the marquee. After you click to initiate the crop, PhotoDeluxe rotates and crops the image in one step, as shown in the second image in Figure 10-3.

Use this technique sparingly. Each time you rotate the image, the software reshuffles all the pixels to come up with the new image. If you rotate the same image area several times, you may begin to notice some image degradation.

Bring Your Image Out of the Shadows

At first glance, the underexposed picture on the left side of Figure 10-4 appears to be a throwaway. But don't give up on images like this, because with some creative editing, you may be able to rescue that too-dark image, as I did in the right image in Figure 10-4. The next two sections tell all.

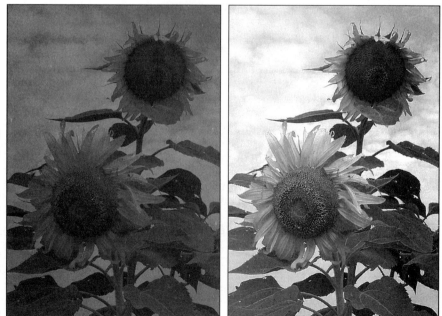

Figure 10-4:
An under-exposed image (left) sees new light, thanks to some brightness and contrast tweaking (right).

Basic brightness/contrast controls

Many image-editing programs offer one-shot brightness/contrast filters that adjust your image automatically. As mentioned earlier, these automatic correction tools tend to do too much or too little and depending on the image, can even alter image colors dramatically. Fortunately, most programs also provide manual correction controls that enable you to specify the extent of the correction. These controls are very easy to use and almost always produce better results than the automatic variety.

In PhotoDeluxe, you take the brightness/contrast helm by choosing the Quality⇨Brightness/Contrast command, which displays the dialog box shown in Figure 10-5. Drag the brightness slider to the right to lighten up your image; drag left to darken the scene. Alternatively, you can enter values between 100 and –100 in the corresponding option box.

Figure 10-5:
The
PhotoDeluxe
brightness
and
contrast
controls.

The PhotoDeluxe brightness control, like those in most other consumer-level image editors, isn't as sophisticated as you find in professional image editors such as Photoshop. In professional programs, you can adjust the brightness of the highlights, shadows, and midtones of the image individually (see the next section for more information). With the PhotoDeluxe brightness control, you lighten or darken all pixels simultaneously.

That's fine as long as your entire image is dark. But if a portion of your image is already bright, you're in a bit of a pickle. If you lighten the image enough to make the dark areas visible, the light areas get *too* bright. In cases like this, you need to select the dark areas of the image and apply the brightening only to the selection. (Creating selections is explained in Chapter 11.)

In Figure 10-4, I applied the brightness correction to the entire image, but you could arguably get a nicer picture if you took the time to deselect the sky before lightening the image. That way, you'd get better separation between the sunflowers and the sky. In color, the sunflowers are much more distinct from the background because the sky is a vivid blue, but in grayscale the flowers sort of blend into the sky in some spots.

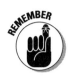

After you brighten an image, the colors may look a bit washed out. To bring some life back into your image, use your image editor's saturation adjustment, as explained in the upcoming section "Give Your Colors More Oomph." You may also need to tweak the contrast a bit, as I did for the right image in Figure 10-4. In PhotoDeluxe, use the Contrast control in the Brightness/Contrast dialog box. Drag the slider right to increase contrast; drag left to decrease contrast.

Brightness adjustments at higher Levels

Professional image-editing programs provide something called a Levels command, which provides a more sophisticated means of adjusting image brightness. If your image editor offers a Levels command — PhotoDeluxe doesn't — take the time to learn how to use it, because this tool produces much better results than the simple brightness/contrast commands discussed in the preceding section. (Note that the Levels tool may go by another name in your software; check the manual or online help system to find out whether you have a Levels-like function.)

Levels dialog boxes are usually a little intimidating, full of strange-sounding options, graphs, and such. Figure 10-6 shows the Levels dialog box from Adobe Photoshop 5.

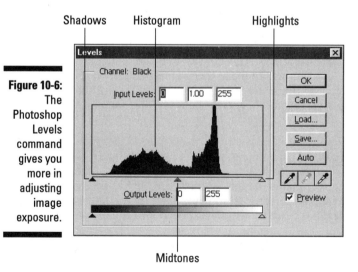

Figure 10-6: The Photoshop Levels command gives you more in adjusting image exposure.

The chart-like thing in the middle of the dialog box is called a *histogram*. A histogram maps out all the brightness values in the image, with the darkest pixels plotted on the left side of the graph and the brightest pixels on the right. For a good, properly exposed image, the range of brightness values should stretch clear across the histogram.

Being able to read a histogram is a fun parlor game, but the real goal is to adjust those brightness values to obtain a better-looking image. Here's what you need to know to get the job done:

- Levels dialog boxes generally offer three important controls, often labeled Input Levels. In Photoshop, you can adjust the Input Levels values by entering a number in the option boxes above the histogram or dragging the sliders beneath the histogram.

 - In Photoshop, the leftmost Input Levels option box and the left-most slider both control the shadows in the image. Drag the slider to the right or raise the option box value to darken your image shadows. Some programs refer to this control as the *Low Point control*.

 - The middle slider and option box affect the medium-brightness pixels, which most people refer to as *midtones*. Typically, you need to brighten up midtones, especially for printing. In Photoshop, drag the slider to the left or raise the option box value to brighten the midtones; drag right or lower the value to darken them. This control sometimes goes by the name *gamma control* or *Midpoint control*.

 - The rightmost option box and slider adjust the brightest pixels in the image. You can use this control to make teeth and eyes look whiter, for example. To make the brightest pixels in the image brighter, drag the slider to the left or lower the option box value. In some image editors, this control goes by the name of *High Point control*.

- Levels dialog boxes also may contain Output Levels options. Using these options, you can set the maximum and minimum brightness values in your image. In other words, you can make your darkest pixels lighter and your brightest pixels darker — which usually has the unwanted effect of decreasing the contrast in your image. Sometimes, you can bring an image that's extremely overexposed into the printable range by setting a slightly lower maximum brightness value, however. In Photoshop, nudge the right-hand Output Levels slider to the left to reduce the maximum brightness value.

If you use a professional image editor, you likely have several additional tools to wield against under- or overexposed images. Many programs offer tools that enable you to "paint" lightness or darkness onto your image by dragging over it with your mouse, for example (check your help system or manual for information about these tools, often named *dodge* and *burn* tools). And in some programs, including Photoshop, you can adjust the brightness and contrast of the red, green, and blue channels of the image independently. Check your manual for information about brightening an image to see what kinds of controls are available to you and where they're found.

Give Your Colors More Oomph

Images looking dull and lifeless? Toss them in the image-editing machine with a cupful of Saturation, the easy way to turn tired, faded colors into rich, vivid hues.

Now that you understand the kind of dangers of watching too many "daytime dramas" — you start sounding like a laundry-soap commercial without even knowing it — let me point your attention to Color Plate 10-1. The image on the left looks like it's been through the washing machine too many times — Oops, there I go again. Anyway, the colors in the image just aren't as brilliant as they were in "real life."

All that's needed to give the image a more colorful outlook is the Saturation command, found in PhotoDeluxe and many other image-editing programs. The image on the right in Color Plate 10-1 shows the effects of boosting the saturation. The butterfly regains its original yellow splendor, and the flowers and leaves also benefit from an infusion of color.

To access the saturation knob in PhotoDeluxe, choose Quality⇨Hue/Saturation. The dialog box shown in Figure 10-7 leaps to the screen, offering three controls, Hue, Saturation, and Lightness, which work as follows:

✔ Drag the Saturation slider to the right to increase color intensity; drag left to suck color out of your image.

✔ The Hue control shifts pixels around the *color wheel,* which is a circular graph that scientists and artists use to plot out all the colors of the rainbow (and other colored stuff). For more on the Hue control, see Chapter 12.

✔ As for that Lightness control, don't get it mixed up with the brightness adjustment discussed in the preceding section. And don't use it to lighten your images; this command does bad things to contrast. The only time to use Lightness is when you want to give your image a faded or washed-out appearance.

Figure 10-7:
To make
colors more
vivid,
increase the
Saturation
value.

Hue/Saturation				☒
Hue:		△	0	OK
Saturation:		△	0	Cancel
Lightness:		△	0	☑ Preview

Help for Unbalanced Colors

Both scanned images and images from digital cameras often have *color bal-ance* problems. In other words, the images look too blue, too red, or too green, or exhibit some other color sickness. The top image in Color Plate 10-2 is a case in point. I shot the picture with a camera that tends to emphasize blue tones. That's okay for pictures that feature expanses of sky or water — who doesn't enjoy a bluer sky or sea? But in the case of this photo, which shows a portion of an antique clover huller, the tendency to favor blue cre-ates an unwanted color cast. Notice how the belts and the top of the wooden wheel (lower-right corner) look almost navy blue? Trust me, navy belts and wheels are not authentic aspects of antique farm machinery.

PhotoDeluxe offers you two solutions to color-balance problems: the Color Balance command and the Variations command. The next two sections explain how to use these commands. Other image editors provide similar tools; check your software manual to find out more. The overall concepts of color balancing are the same no matter what program you're using, so keep reading even if you're not a PhotoDeluxe user.

Color balancing by the numbers

Color-balancing tools come in two forms. The first type works like the one in Figure 10-8, which shows the PhotoDeluxe Color Balance dialog box.

To display the dialog box, choose Quality⇨Color Balance. The Color Balance dialog box offers three slider bars. You drag the slider triangles to adjust the color mix in your image. To increase green, for example, drag the slider toward Green (duh!); to reduce the amount of green, drag the slider toward Magenta, which lives directly opposite green on the color wheel.

As you move the sliders, the values in the corresponding option boxes at the top of the dialog box reflect your changes. If you prefer, you can double-click an option box and enter the value you want to use from the keyboard. Maximum values are 100 and –100, but for best results, limit your moves to 30 or –30.

Otherwise, you can create unnatural, blotchy colors. When you're satisfied with your image, click OK.

In most image editors, you can preview the effects of your changes in the image window. But in PhotoDeluxe, Photoshop, and many other editors, you first must select the Preview check box in the Color Balance dialog box.

Remember, too, that your changes affect the entire image unless you select a portion of the photograph before choosing the Color Balance command. For more about selecting, take a giant step toward Chapter 11.

Figure 10-8:
Drag the
three sliders
in the Color
Balance
dialog box
to adjust the
colors in
your image.

Color Balance
Color Levels: -10 12 -8
Cyan — Red
Magenta — Green
Yellow — Blue
OK Cancel ☑ Preview

Variations on a color scheme

For another means of color correction, check out the right half of Color Plate 10-2 and Figure 10-9, both of which show the Variations dialog box found in PhotoDeluxe. The Variations command provides a more visual approach to balancing colors. Many image-editing programs provide a similar color-correction function.

To access the Variations dialog box in PhotoDeluxe, choose either Quality⟶ Variations or Effects⟶Adjust⟶Variations. I vote for the first option, which involves one less mouse click.

As you can see in Figure 10-9, the Variations dialog box includes thumbnail views of your image. To shift colors around, click the thumbnail corresponding to the color you want to boost. For example, click the More Yellow thumbnail to add more yellow to your image. If you add too much of one color, click the thumbnail on the opposite side of the dialog box. If you add too much yellow, click the More Blue thumbnail, for example. To remove the blue cast in the upper-left image in Color Plate 10-2, I clicked once on the More Yellow thumbnail and once on the More Red thumbnail. You can see the result in the lower-left image. Now the belts and wheel look gray, as they should. The color-balancing act also brings out the faded red and yellow paint of the clover huller.

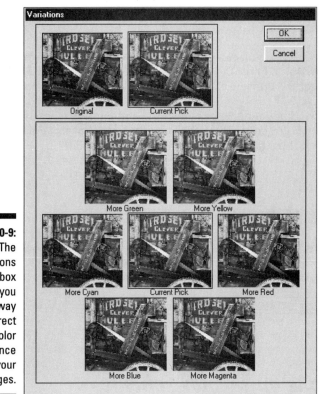

Each time you click a More thumbnail, the thumbnails labeled Current Pick update to show you how your image will appear if you go ahead and apply the color corrections. The Original thumbnail shows you . . . I know you can figure that one out for yourself.

In PhotoDeluxe — as in most other consumer image-editing programs — each click adds color in preset increments; you can't adjust the amount like you can in the Color Balance dialog box. Additionally, you can't preview the effects of your corrections in the image window. So for precise color balancing, you may prefer the Color Balance control to Variations when editing in PhotoDeluxe.

In Photoshop and other professional programs, this type of color-correction tool is more capable. You can usually specify whether you want to make large-scale changes with each click or just subtle adjustments. (In Photoshop, drag the slider at the top of the dialog box toward Coarse for maximum color-correction impact and drag toward Fine for less-noticeable changes.) You can also change the color balance of the image shadows, high-lights, and midtones independently. Whether you can preview your changes in the image window depends on the program; the Photoshop Variations dialog box lacks this option, but other image editors do provide the previews.

Focus Adjustments (Sharpen and Blur)

Digital images are notorious for being "soft" — that is, appearing to be slightly out of focus. Although no image editor can make a terribly unfocused image appear completely sharp, you can usually improve things quite a bit by using *sharpening tools*. The following sections explain how to sharpen your image and also how to blur the background of an image, which has the effect of making the foreground subject appear more focused.

Sharpening 101

Before I show you how to sharpen your images, I want to make sure that you understand what sharpening really does. Sharpening creates the *illusion* of sharper focus by adding small halos along the borders between light and dark areas of the image. The dark side of the border gets a dark halo, and the light side of the border gets a light halo.

To see what I mean, sharpen your focus on Figure 10-10. The top-left image shows you four bands of color before any sharpening is applied. Now look at the top-right image, which I sharpened slightly. Along the borders between each band of color, you see a dark stripe on one side and a light stripe on the other. Those stripes are the sharpening halos. To see the effect in color, flip to the color plate section and track down Color Plate 10-3.

Different sharpening filters apply the halos in different ways, creating different sharpening effects. The next few sections explain some of the common sharpening filters.

Automatic sharpening filters

Sharpening tools, like other image-correction tools discussed in this chapter, come in both automatic and manual flavors. With automatic sharpening filters, the program applies a preset amount of sharpening to the image.

In PhotoDeluxe, as in Photoshop, you're provided with three automatic sharpening filters: Sharpen, Sharpen More, and Sharpen Edges. To try out the filters, choose Effects⇨Sharpen. (In Photoshop, choose Filters⇨Sharpen.) Then click the name of the sharpening filter you want to apply.

The following list explains how each of these automatic filters does its stuff. To see the filters in action, see Figure 10-10 and Color Plates 10-3 and 10-5.

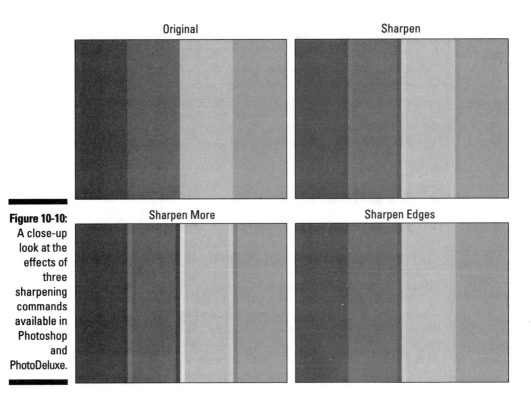

Figure 10-10:
A close-up look at the effects of three sharpening commands available in Photoshop and PhotoDeluxe.

✔ The plain old Sharpen command sharpens your entire image. If your image isn't too bad off, Sharpen may do the trick. But more often than not, Sharpen doesn't sharpen the image enough. In Color Plate 10-5, for example, a single application of the Sharpen filter barely made a dent in the picture's focusing problems (see the top-left example).

✔ Sharpen More does the same thing as Sharpen, only more strenuously. I feel safe in saying that this command will rarely be the answer to your problems. It simply oversharpens, in most cases. The top-right image in Color Plate 10-5 shows an example. See how that navy-bluish building on the left side of the image has a grainy appearance? And how the sky looks a little less smooth than in the other images? Both effects are due to oversharpening.

✔ Sharpen Edges looks for areas where significant color changes occur and adds the sharpening halos in those areas only. In Figure 10-10, for example, the sharpening halos appear between the two middle color bars, where there is a significant change in contrast. But no halos are applied between those two bars and the outer bars. The intensity of the halos is the same as with Sharpen, which is why this command also failed to do a good job with the image in Color Plate 10-5 (see the bottom-left image). I suspect that Sharpen Edges won't do much better

on your images, but you can give it a try if you like. When you discover that I'm telling the truth, head for the Unsharp Mask filter, explained in the next section.

Depending on your image editor, you may find automatic sharpening filters similar to the ones just discussed. But the extent to which each filter alters your image varies from program to program, so do some experimenting. For the best sharpening results, I suggest that you ignore the automatic sharpening filters altogether and rely on your program's manual sharpening controls, if available.

Manual sharpening adjustments

Some consumer-level programs provide you with just a fairly crude manual sharpening tool. You drag a slider one way to increase sharpening, drag it another to decrease sharpening.

PhotoDeluxe, like Photoshop and other more advanced image-editing programs, provides you with the mother of all sharpening tools, which goes by the curious name of Unsharp Mask.

The Unsharp Mask filter is named after a focusing technique used in traditional film photography. In the darkroom, unsharp masking has something to do with merging a blurred film negative — hence, the *unsharp* portion of the name — with the original film positive in order to highlight the edges (areas of contrast) in an image. And if you can figure that one out, you're a sharper marble than I.

Despite its odd name, Unsharp Mask gives you the best of all sharpening worlds. You can sharpen either your entire image or just the edges, and you get precise control over how much sharpening is done.

To use the Unsharp Mask filter in PhotoDeluxe, choose Effects⇨Sharpen⇨ Unsharp Mask. The dialog box shown in Figure 10-11 appears.

Figure 10-11:
The Unsharp Mask filter provides precise sharpening control.

Unsharp Mask	☒
Amount: 50 %	OK
Radius: 2.0 pixels	Cancel
Threshold: 3 levels	☑ Preview

The PhotoDeluxe Unsharp Mask dialog box contains three sharpening controls: Amount, Radius, and Threshold. You find these same options in most Unsharp Mask dialog boxes, although the option names may vary from program to program. Here's how to adjust the controls to apply just the right amount of sharpening:

✔ The Amount value determines the intensity of the sharpening halos. Higher values mean more intense sharpening. In Figure 10-12, I sharpened the original image from Figure 10-10 using two different Amount values in conjunction with two different Radius values and a Threshold value of 0. To see the same figure in color, check out Color Plate 10-4.

For best results, apply the Unsharp Mask filter with a low Amount value — between 50 and 100. If your image is too soft, reapply the filter using the same or lower Amount value. This technique usually gives you smoother results than applying the filter once with a high Amount value.

✔ The Radius value controls how many pixels neighboring an edge are affected by the sharpening. With a small Radius value, the haloing effect is concentrated in a narrow region, as in the top two images in Figure 10-12 and Color Plate 10-4. If you set a higher Radius value, the halos spread across a wider area and fade out gradually from the edge.

Generally, stick with Radius values in the 0.5 to 2 range. Use values in the low end of that range for images that will be displayed on-screen; values at the high end work better for printed images.

✔ The Threshold value determines how different two pixels must be before they're considered an edge and, thus, sharpened. By default, the value is 0, which means that the slightest difference between pixels results in a kiss from the sharpening fairy. As you raise the value, fewer pixels are affected; high-contrast areas are sharpened, while the rest of the image is not (just as when using Sharpen Edges, discussed in the preceding section).

When sharpening photos of people, experiment with Threshold settings in the 1 to 7 range, which can help keep the subject's skin looking smooth and natural. If your image suffers from graininess or noise, raising the Threshold value can enable you to sharpen your image without making the noise even more apparent.

But because Threshold values higher than 0 can sometimes create abrupt, obvious transitions between sharpened and unsharpened areas, you should usually leave this value at the default setting or at least keep it under 3.

The Unsharp Mask filter takes a little getting used to, but after you acquaint yourself with the controls, you can see for yourself why I recommend that you forget about the preset sharpening filters and use Unsharp Mask exclusively. Yes, this filter requires a bit more effort to use than the others, but the results make that effort worthwhile.

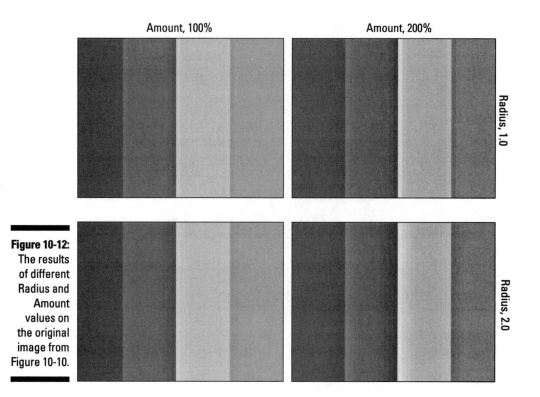

Amount, 100% Amount, 200%

Radius, 1.0

Figure 10-12:
The results of different Radius and Amount values on the original image from Figure 10-10.

Radius, 2.0

For proof, compare all the images in Color Plate 10-5. The automatic sharpening filters — Sharpen, Sharpen More, and Sharpen Edges — either didn't go far enough or oversharpened. With Unsharp Mask, I was able to add just the right amount of crispness to the image edges without bringing out that graininess that plagues the Sharpen More example. I applied the filter three times using an Amount value of 50, Radius value of 2, and Threshold value of 3.

Another way to control the extent of your sharpening is to use *selections*. You can then sharpen just one part of your image while leaving the rest untouched. For more on the subject of selections, see the next chapter.

Blur to sharpen?

If your main subject is slightly out of focus and using the sharpening tools explained in the preceding section doesn't totally correct the problem, try this: Select everything but the main subject (and other areas that you want to appear in sharpest focus). Then apply a blur filter, found in most image-editing programs, to the rest of the image. Often, blurring the background in this way makes the foreground image appear sharper, as illustrated in Figure 10-13.

Figure 10-13: Applying a slight blur to everything behind the car makes the car appear more in focus and also helps de-emphasize the distracting background.

In this figure, I selected everything behind the car and applied a slight blur. I then reversed the selection so that the car and foreground were selected and applied just a wee bit of sharpening. As a result, the car not only looks much crisper than before, but the distracting background elements become much less intrusive on the main subject.

PhotoDeluxe gives you five blur filters, all accessed by choosing Effects⇨Blur. Two of the five filters, Circular Blur and Motion Blur, are for creating special effects only. For more "normal" blurring, turn to Blur, Blur More, and Soften.

Blur and Blur More blur your image in preset amounts. Try Blur for subtle blurring; if the effect isn't strong enough, choose Blur More or apply Blur repeatedly until you get the amount of softening you're after. If you want to specify the amount of blurring, choose Soften. PhotoDeluxe then displays a dialog box with a single slider bar. Drag the slider to the right to increase the blur, and drag left to reduce the blur.

If you're not using PhotoDeluxe, your image editor likely offers at least one blur filter; check the manual or help system to find out how to access the filter. Most blur filters are either one-shot filters like Blur and Blur More or provide you with a means of specifying the amount of blur, as does Soften.

Out, Out, Darned Spots!

Sit around a coffee shop with a group of digital photographers, and the conversation often turns to a discussion of *jaggies*. This term refers to a type of defect in digital images, not the nervous condition that results from consuming all that coffee-shop brew.

Jaggies comes from *jagged,* which is how digital images appear if they've been overly compressed or enlarged too much. Instead of appearing smooth and seamless, pictures have a blocky — jaggedy — look. Some folks, wanting to sound more educated than their counterparts, use the term *aliasing* instead of jaggies. These are the same people who order nonfat decaf latte with just a *soupçon* of freshly ground cinnamon.

Closely related to aliasing (where's that latte I ordered?), *noise* gives your image a grainy, speckled look. Noise usually results from inadequate light on the subject, but sometimes it's caused by a blip in the electrical signals that your camera produces when recording an image. Figure 10-14 shows an image with a bad case of the jaggies. For a look at noise, see the top-left image in Color Plate 12-5. If your image exhibits either of these embarrassing properties, try applying a slight blur to the photo, using your image editor's Blur command. If you can, apply the blur just to the area where the defects are the worst so that you don't lose image detail in the rest of the image.

After applying the blur, you may need to apply a sharpening filter to restore lost focus. The problem is, sharpening can make those defects visible again. If your image editor offers an Unsharp Mask filter, you can avoid this vicious cycle by raising the Threshold value above the default setting, 0. I usually set the Threshold value between 1 and 3 when I find myself faced with a picture full of noise or jaggies.

Figure 10-14:
Too much
compression
and too few
pixels led to
a case of
the jaggies.

Many image editors provide a Despeckle or Remove Noise filter, which is specially designed to eliminate noise. All these filters do is apply a slight blur to the image, just like a blur filter. If your blur filter enables you to control the extent of the blur, forget about the Despeckle/Remove Noise and use the blur filter. If your blur filter is a one-shot filter (totally automatic), try applying both blur and Despeckle/Remove Noise, and see which one does a better job on the image. One filter may blur more than the other.

Some people use the term *artifacts* when referring to noise, jaggies, and other image defects. In the archaeological world, artifacts are treasures, remnants of a lost civilization. Digital artifacts are remnants of some processing or image-capture glitch and are definitely not considered treasures.

Chapter 11

Cut, Paste, and Cover Up

● ●

In This Chapter

▶ Making edits to specific parts of your image

▶ Using different types of selection tools

▶ Refining your selections

▶ Moving, copying, and pasting selections

▶ Creating a patch to cover up hot spots and other flaws

▶ Cloning over unwanted elements

● ●

*R*emember the O.J. Simpson trial (how could you *not*)? At one point in the trial, the defense claimed that a photograph had been digitally altered to make it appear as though the defendant wore a specific type of shoe. That kind of claim, together with the development of image-editing software that makes digital deception entirely doable, has led many people to question whether we now live in an age when the photograph simply can't be trusted to provide a truthful record of an event.

I can't remember the outcome of the shoe debate, but I can tell you that a photograph can just as easily speak a thousand lies as a thousand words. Of course, photographers have always been able to alter the public's perception of a subject simply by changing camera angle, backdrop, or other compositional elements of a picture. But with image-editing software, opportunities for putting our own spin on a photograph are greatly expanded.

This chapter introduces some basic methods that you can use to manipulate the content of your pictures. I want to emphasize that you should use these techniques solely in the name of creative expression, not for the purpose of deceiving your audience. Combining elements from four or five pictures to make a collage of your vacation memories is one thing; altering a photo of a house to cover up a big crater in the driveway before you place a for-sale ad in the real-estate section is quite another.

That said, this chapter shows you how to merge several pictures into one, move a subject from one spot in a photo to another, and cover up image flaws. Along the way, you get an introduction to *selections,* which enable you to perform all the aforementioned editing tricks, and more.

Why (And When) Do I Select Stuff?

If your computer were a smarter being, you could simply give it verbal instructions for how you wanted your image changed. You could simply say, "Computer, take my head and put it on Madonna's body," and the computer would do your bidding while you went to catch a special edition of *Jenny Jones* or *Jerry Springer* or something equally enlightening.

Computers can do that sort of thing on *Star Trek* and in spy movies. But in real life, computers aren't that clever (at least, not the ones that you and I get to use). If you want your computer to do something to a portion of your image, you have to draw the machine a picture — well, not a picture, exactly, but a *selection outline.*

By outlining the area of the image you want to edit, you tell your image editor which pixels to change and which pixels to leave alone. For example, if you want to blur the background of an image but leave the foreground as it is, you select the background and then apply the Blur command (for an example of this, see Figure 10-13 in Chapter 10). If you don't select anything, the entire image gets the blur.

Selections don't just limit the impact of special effects and image-correction commands, though. They also protect you from yourself. Say that you have an image of a red flower on a green background. You decide that you want to paint a purple stripe over the flower petals . . . oh, I don't *know* why, Johnny, maybe it's just been that kind of day. Anyway, if you have a steady hand, you may be able to get the paint just on the petals and avoid brushing any purple on the background. But people whose hands are that steady are usually busy wielding scalpels, not image-editing tools. Most people tackling the paint job get at least a few stray dabs of purple on the background.

If you select the petals before you paint, however, you can be as messy as you like. No matter where you move your paintbrush, the paint can't go anywhere but on those selected petals. The process is much the same as putting tape over your baseboards before you paint your walls. Areas underneath the tape are protected, just like pixels outside the selection outline.

So as you can see, selections are an invaluable tool. Unfortunately, creating precise selections requires a bit of practice and time. And precise selections are a major key to editing that looks natural and subtle, instead of editing that looks like a bull ran through the digital china shop. The first few times you try the techniques in this chapter, you may find yourself struggling to select the areas you want. But don't give up, because the more you work with your selection tools, the more you'll get the hang of things.

On-screen, selection outlines are usually indicated by a dotted outline known in image-editing cults as a selection *marquee.* Some people are so fond of this term that they also use it as a verb, as in "I'm gonna marquee that flower, okay?" And while we're on the subject of image-editing terminology, you should also know that many people refer to selections as *masks.* The deselected area is said to be *masked.*

Strap on your selection tool belt

Most image-editing programs provide you with an assortment of selection tools. Some tools are special-occasion devices, while others come in handy almost every day. The following sections discuss how to use common selection tools as well as how to use the different tools in conjunction with each other to create expert selections.

Throughout this section, I provide you with some specific instructions related to selecting in Adobe PhotoDeluxe. But selection tools in other image editors work similarly — a rectangular marquee tool is a rectangular marquee tool, no matter what program you're using. So don't skip this section if you don't use PhotoDeluxe, because much of the information applies to your program, too. (However, if you're working with a very basic entry-level program, you may get only one or two of the tools discussed here.)

Where do you find the selection tools? Depends on your image editor. Usually, the tools are accessible from a toolbar or tool palette. In PhotoDeluxe, you can choose the available selection tools from the Select➪ Selection Tools menu. But a better move is to choose View➪Show Selections to display the Selections palette, shown in Figure 11-1. The palette puts all your selection tools and options close at hand. If needed, you can move the palette to another place on the screen by dragging the title bar (the dark bar at the top of the palette). To activate a selection tool, choose its name from the drop-down list at the top of the palette.

Figure 11-1:
The
PhotoDeluxe
Selections
palette.

Selections	✕
Rectangle Tool	⬇

New Add Reduce Move

All None Invert

Note that one tool on the Selections palette list, the Object Selection tool, isn't really a standard selection tool; you use this tool to move or rotate your entire image or a layer. You can find out more about this tool later in this chapter, in the section "Cut, Copy, Paste: The old reliables."

Selecting regular shapes

The simplest selection tools enable you to draw regularly shaped selection outlines. In PhotoDeluxe, you get four geometric selection tools: Rectangle, Square, Oval, and Circle. Other image editors typically provide a rectangle and oval selection tool at the very least.

To use these geometric selection tools, you simply drag from one side of the area you want to select to the other, as illustrated in Figure 11-2.

Figure 11-2: To select a rectangular area, drag from one corner to another.

You really don't need to ever pick up the Square or Circle selection tools in PhotoDeluxe, though. If you want to draw a square selection outline, just press and hold the Shift key as you drag with the Rectangle tool. To draw a circular selection outline, press Shift as you drag with the Oval tool. These same techniques also work in Adobe Photoshop.

Selecting by color

One of my favorite selection weapons ropes off pixels based on color. PhotoDeluxe calls its color-based selection tool the Color Wand, while other programs call it the Magic Wand, Color Selector, or something similar. Regardless of its name, this tool selects contiguous areas of similarly colored pixels.

Okay, once more, this time in non-geek-speak. Suppose that you have an image like the one in Color Plate 11-1 (the color version of the rose shown in Figure 11-2). You can use the Color Wand to quickly select the pink pixels in the rose or the green pixels in the petals. When you click with the Color Wand, you select all pixels that are similar in color to the pixel you click. So to select the rose, you click a pixel in the rose.

However, similarly colored pixels are *not* selected if any pixels of another color lie between them and the pixel you click. For example, if you click the right-most green leaf in Color Plate 11-1, that leaf is selected, as is the neighboring leaf. But the leaves to the left are not selected because areas of brown (in the rose stem) and black (the background) lie between the two regions of leaves.

In most programs, you can specify how discriminating you want the tool to be when searching for similar colors. You can set the tool so that it selects only pixels that are very close in color to the pixel you click, or you can tell the program to select a broad range of similar shades. If you're not using PhotoDeluxe, check your help system to find out how to make this adjustment, usually referred to as setting the tool *tolerance*.

In PhotoDeluxe, choose File⇨Preferences⇨Cursors to display the Cursors dialog box shown in Figure 11-3. If you want the Color Wand to be very picky when selecting pixels, enter a low Tolerance value in the upper-right corner of the dialog box. To make the Color Wand select more pixels, enter a higher value.

Color Plate 11-1 shows the results of using four different Tolerance values: 10, 32, 64, and 100. The little *x* in each rose indicates the position of the Color Wand when I clicked; the yellowish tint indicates the regions that PhotoDeluxe included in the resulting selection.

Figure 11-3:
To adjust the perform-ance of the Color Wand, change the Tolerance value.

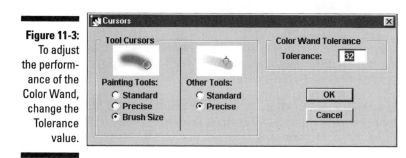

In PhotoDeluxe, you can enter a Tolerance value as high as 255, but anything above 100 or so tends to make the Color Wand *too* casual in its pixel roundup. For the image in Color Plate 11-1, for example, raising the value beyond 100 selected some pixels outside the boundaries of the rose petals. A value of 255

selects the entire image, which is pretty pointless; if you want to select the entire image, most programs provide a Select All command or something similar that does the job more quickly.

As you can see in Color Plate 11-1, a value of 100 selected most of the rose pixels, leaving just a few dark petal areas unselected. I can easily add those spots to the selection using the techniques described in "Refining your selection outline," later in this chapter.

Note that the effects of changing a tool's tolerance vary from program to program. The ones referenced here apply to PhotoDeluxe, so if you use another editor, experiment to get familiar with your color selection tool.

Drawing freehand selections

Another popular type of selection tool enables you to select irregular areas of an image simply by tracing around them with your mouse. Well, I say "simply," but frankly, you need a pretty steady hand to draw precise selection outlines. Some people can do it; I can't. So I normally use these tools to select a general area of the image and then use other tools to select the exact pixels I want to edit. (Building selection outlines in this way is discussed in the upcoming section "Refining your selection outline.")

At any rate, this tool goes by different names depending on the image-editing program — Freehand tool, Lasso tool, and Trace tool are among the popular labels. PhotoDeluxe opts for Trace tool. But whatever the name, you use the tool by dragging along the border of the area you want to edit. When you reach the point where you began dragging, let up on the mouse button to close the marquee.

PhotoDeluxe provides a variation of the Trace tool, known as the Polygon tool. This tool works similarly to the Trace tool, but it gives you the added ability to easily draw straight-edged selections. To draw a curved outline, drag with the tool as you would with the Trace tool. To add a straight segment, let up on the mouse button at the point where you want the segment to begin. Click at the point where you want the segment to end. PhotoDeluxe automatically creates the straight segment between the two points you click. To complete the selection outline, double-click.

You can find a similar tool in Photoshop as well as many other image editors. The specifics of drawing curved and straight sections may be different than in PhotoDeluxe, so check your program's help system for how-to's.

Selecting by the edges

If you read Chapter 10, you know that the term *edges* refers to areas where very light areas meet very dark areas, or if you want to be professional about it, areas of high contrast. Many image editors, including PhotoDeluxe, provide a selection tool that simplifies the task of drawing a selection outline along an edge.

As you drag with this tool, called the SmartSelect tool in PhotoDeluxe and the Magnetic Lasso in Photoshop 5, the tool searches for edges and lays down the selection outline along those edges. Figure 11-4 shows a close-up view of me using this tool to select a single rose petal in the rose image from Figure 11-2.

Selection point

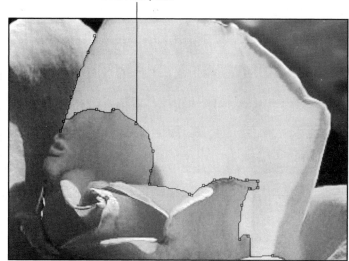

Figure 11-4:
The PhotoDeluxe SmartSelect tool detects edges and places the selection outline along those edges.

The process of using an edge-detection tool may vary slightly from program to program, but typically, it works like so: Click at the point where you want the selection to begin and then move your mouse along the border of the object you're trying to select. Note that I said *move,* not *drag* — you don't press the mouse button down as you do when dragging. As you move the mouse, the tool automatically draws the selection outline along the border between the object and the background — assuming that at least some contrast exists between the two. To finish the selection outline, place your cursor over the first point in the outline and then click.

In PhotoDeluxe, as in Photoshop, the program periodically adds tiny squares, called *selection points,* as you're creating the outline. You can see these selection points in Figure 11-4. If you're not happy with the placement of the selection outline, place your cursor over the most recent selection point and press Delete. Then drag again to redraw the segment. If you want, click to add your own selection point.

As with color-based selection tools, you can usually control the sensitivity of edge-detection tools. In PhotoDeluxe and Photoshop, for example, you can specify how much difference in contrast constitutes an edge and how far the tool should roam from the position of the mouse cursor when sniffing out edges.

To set the tool sensitivity in PhotoDeluxe, adjust the values in the SmartSelect options palette, shown in Figure 11-5. The palette appears when you select the SmartSelect tool from the Selections palette. Raise the Edge Threshold value if the tool isn't being discriminating enough — for example, if you're having trouble finding the edge between a red tablecloth and a red apple. You can enter a value from 1 to 100. The Brush Width value determines how far the tool can wander in its search for edges. Larger values tell the tool to go farther afield; smaller values keep the tool closer to home. You can enter any value from 1 to 20.

Figure 11-5:
Adjust the
sensitivity
of the
SmartSelect
tool here.

SmartSelect Options

Edge Threshold 10 pixels

Brush Width 10 pixels

Selecting (and deselecting) everything

Want to apply an edit to your entire image? Don't monkey around with the selection tools described in the preceding sections. Most programs provide a command or tool that automatically selects all pixels in your picture. In some entry-level image editors, you simply click the image with a particular selection tool, usually called a Pick tool or Arrow tool. Click once to select; click again to deselect.

Other programs provide menu commands for selecting and deselecting the entire image. Look in the Edit menu or the same menu that holds the selection tool commands for a Select All command or something similar. You can probably also find a Select None or None command that deselects the entire image — that is, removes an existing selection outline.

In PhotoDeluxe, click the All icon in the Selections palette or choose Select⇨All to select the entire image. To deselect the image, click the None icon or choose Select⇨None.

Many image editors, including PhotoDeluxe and Photoshop, enable you to use the universal shortcut for selecting everything: Ctrl+A on a PC and ⌘+A on a Mac. Some programs also provide a shortcut for deselecting everything; in PhotoDeluxe and Photoshop, press Ctrl+D on a PC and ⌘+D on a Mac.

Taking the inverse approach to selections

You can sometimes select an object more quickly if you first select the area that you *don't* want to edit and then *invert* the selection. Inverting simply reverses the selection outline so that the pixels that are currently selected become deselected, and vice versa.

Consider the left image in Figure 11-6. Suppose that you wanted to select just the buildings. Drawing a selection outline around all those spires and ornate trimmings would take forever. But with a few swift clicks of the PhotoDeluxe Color Wand, I was able to easily select the sky and then invert the selection to select the buildings. In the right image in Figure 11-6, I deleted the selection to illustrate how cleanly this technique selected the buildings.

You choose Select⇨Invert to reverse your selection outline in PhotoDeluxe. But clicking the Invert icon in the Selections palette or using the keyboard shortcut, Ctrl+I (⌘+I on the Mac), gets the job done faster.

To take the inversion train in other image editors, look for an Invert or Inverse command. The command typically hangs out in the same menu or palette that contains your other selection tools. But be careful — some programs use the name Invert for a filter that inverts the colors in your image, creating a photographic negative effect. If you find Invert or Inverse on a menu that contains mostly special effects, the command probably applies the negative effect instead of inverting the selection.

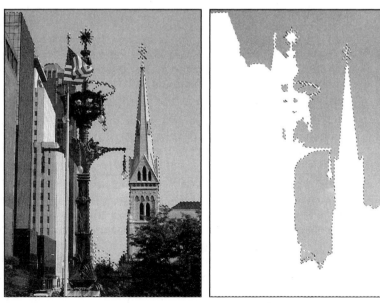

Figure 11-6: To select these ornate architectural structures (left), I selected the sky and inverted the selection. Deleting the selection (right) shows how precisely the buildings were selected.

Refining your selection outline

In theory, creating selection outlines sounds like a simple thing. In reality, getting a selection outline just right on the first try is about as rare as Republicans and Democrats agreeing on who should pay fewer taxes and who should pony up more. In other words, you should expect to refine your selection outline at least a little bit after you make your initial attempt.

All professional-level image editors and many consumer-level programs enable you to adjust your selection outline, either by adding or removing pixels or moving the selection outline to another spot in the image. Usually, you refine the outline as follows:

✔ To enlarge the selection outline, you set the selection tool to an additive mode. You can then draw a new selection outline while retaining the existing outline. To select the unselected pixels in the center of the rose in the lower-right image in Color Plate 11-1, I could simply drag around them with an oval selection tool, for example.

✔ To deselect certain pixels, you set the selection tool to a subtractive mode. The tool then works in reverse, deselecting instead of selecting pixels. For example, suppose that you select both the flower and the leaves in Color Plate 11-1. If you change your mind and decide to select the flower only, you just set your color selection tool to the subtractive mode and click on the leaves to deselect the green pixels.

✔ Methods for switching selection tools from their normal operating mode to the additive or subtractive mode vary widely from program to program. In some programs, you click a toolbar icon; in other programs, you press a key to toggle the additive and subtractive modes on and off. In Photoshop, for example, you hold down the Shift key as you drag or click with a selection tool if you want to add to the existing selection outline. You press and hold the Alt key (Option, on a Mac) if you want to subtract from the selection outline.

✔ PhotoDeluxe provides icons on its Selections palette for switching selection modes. Click the Add icon, and you can then use any selection tool to incorporate more areas of your image into the selection. If you selected too many pixels, click the Reduce icon in the Selections palette. Now when you drag or click with a selection tool, you're deselecting pixels instead of selecting them.

✔ Sometimes, you may simply want to move the selection outline rather than enlarge or reduce it. Imagine that you have a picture that includes a ball lying on a carpet. You decide that you don't want that ball in the scene, so you need to copy some of the carpet pixels to create a patch to cover up the ball. Select the ball and then move the selection outline onto the carpet. Voilà — you just selected an area of carpet that's the

exact size and shape of the ball. All you need to do now is copy and paste those carpet pixels onto the ball. (See "Creating a seamless patch," later in this chapter, for more details on this process.)

Not all image editors enable you to move the selection outline; check your manual to find out if you can perform this trick. In PhotoDeluxe, first click the Move icon in the Selections palette. Then press Ctrl and Alt as you drag with any selection tool but the Object Selection tool. Alternatively, you can nudge the selection outline into place by pressing Ctrl and Alt in conjunction with the arrow keys on your keyboard. Each press of an arrow key moves the selection outline one pixel in the direction of the arrow.

✔ In a few entry-level image editors, you adjust selection outlines a little differently. After you draw a selection, you drag on little boxes (called handles) that are sprinkled along the selection outline. These handles work like the crop-marquee handles discussed in Chapter 10. As you tug on the handles, the selection outline stretches or moves in response. You can click the outline to add more handles for more precise control.

✔ If you perform a selection-tool blunder, you can usually undo your last click or drag by choosing the Undo command, which is found in the Edit menu in most programs. See Chapter 10 for more information about undoing mistakes.

Do you need professional selection power?

Professional image-editing programs such as Adobe Photoshop and Corel PHOTO-PAINT provide you with a slew of advanced selection features in addition to the basic tools described in this chapter. For example, most professional programs enable you to save your selection outline as part of the image file so that after you create a selection outline, you can use it again and again.

You also get a broader variety of selection tools. Photoshop, for example, provides a Quick Mask mode, in which you can use painting tools to create your selection. You dab pixels with one color to select them and with another color to deselect them. In addition, you can automatically expand or contract selection outline by a specific number of pixels; select all pixels in a particular color range, regardless of where they lie in the image; and have the program search for stray pixels along the edge of the outline and then either select or deselect those pixels, depending on their position relative to the outline.

If you routinely need to create complex selections, you can speed up your image-editing work by investing in a program that offers these tools — and taking the time to become proficient at using them.

Selection Moves, Copies, and Pastes

After you select a portion of your image, you can do all sorts of things to the selected pixels. You can paint them without fear of dripping color on any unselected pixels, for example. You can apply special effects or apply color-correction commands just to the selected area, leaving reality undistorted in the rest of your image.

But one of the most common reasons for creating a selection outline is to move or copy the selected pixels to another position in the image or to another image entirely, as I did in Color Plate 11-2. I cut the rose out of the image on the left and pasted it into the image in the middle to create the image on the right.

The following sections give you all the information you need to become an expert at moving, copying, and pasting selections.

You can also copy pixels using a special editing tool known as the Clone tool. This specialized tool enables you to "paint" a portion of your image onto another portion of your image, as discussed later in this chapter, in "Cloning without DNA."

Cut, Copy, Paste: The old reliables

One way to move and copy selections from one place to another is to use those old-time computer commands: Cut, Copy, and Paste. These commands are available in most every image editor, including PhotoDeluxe.

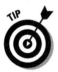

In PhotoDeluxe, as in most programs, the Cut, Copy, and Paste commands are found on the Edit menu. But you can often apply them more quickly by using the universal keyboard shortcuts: Ctrl+C for Copy; Ctrl+X for Cut; and Ctrl+V for Paste.

Here's the Cut/Copy/Paste routine in a nutshell:

- *Cut* snips the pixels out of your image and places them on the Clipboard, a temporary holding tank for data. You're left with a hole where the pixels used to be, as illustrated in the left image in Figure 11-7.
- *Copy* duplicates the pixels in the selection and places the copy on the Clipboard. Your original image is left intact.
- *Paste* glues the contents of the Clipboard onto your image.

Resize handle Rotate handle

Figure 11-7:
Cutting a
selection
to the
Clipboard
results in a
hole in your
image (left).
After
pasting the
selection,
you can
resize and
rotate it
(right).

Different programs treat pasted pixels in different fashions. In some programs, the Paste command works like super-strong epoxy — you can't move the pasted selection without ripping a hole in the image, just as when you cut a selection.

In other programs, your pasted pixels behave more like they're on a sticky note. You can "lift" them up and move them around without affecting the underlying image. After you position the pasted pixels just so, you can choose a command that affixes them permanently to the image.

PhotoDeluxe takes the second approach to pasting, as does Photoshop. Both programs place your pixels on a new *layer*. Layers are explained more fully in Chapter 12, but for now, just understand the following facts about your pasted selection:

✔ After you choose the Paste command, the selection is surrounded by rotate and resize handles, as shown in the right image in Figure 11-7, and the Object Selection tool becomes active. You can move the selection by dragging inside the selection outline. Drag one of the rotate handles (labeled in Figure 11-7) to rotate the selection.

✔ You can also resize the selection by dragging the square handles, but keep in mind that doing so can lead to image degradation. So for best results, use Size⇨Photo Size to do your major resizing *before* you copy or cut the selection to the Clipboard.

If you want your copied selection to retain its original size when placed in the other image, be sure that the image resolution is the same for both images. The software automatically changes the resolution of the selection to match that of its new home. (See the resizing information in Chapters 2, 8, and 9 for further details on resizing and resolution.)

✔ Another way to move your selection is to press Ctrl+G to select the Move tool (which is the same thing as clicking the Move icon in the Selections palette). With the Move tool selected, you can nudge your selection into place using the arrow keys on your keyboard. Each press of an arrow moves the selection one pixel in the direction of the arrow. To move the selection in 10-pixel increments, press Shift plus an arrow key. This technique is ideal when you want to move a selection precisely.

✔ When you have the pasted selection where you want it, you have two choices. You can keep the selection on its own layer, or you can merge the selection with the underlying image. If you choose the former, you can continue to manipulate the selection separately from the rest of the image. If you want to merge the selection with the underlying image, choose the Merge Layers command from the Layers palette menu. For more on working inside the Layers palette and editing multilayered images, see Chapter 12.

✔ For some reason, PhotoDeluxe doesn't enable you to undo the Paste command. To get rid of a pasted selection, delete the layer on which the selection lives. In the Layers palette, drag the layer name to the trash can icon.

If you're not using PhotoDeluxe or Photoshop, check your software help system to find out the strength of your editor's Paste command. Otherwise, you may inadvertently tear a hole in your image by trying to move pasted selections.

Dragging to move and copy

In addition to using the Cut, Copy, Paste commands described in the preceding sections, you can often *drag-and-drop* to copy and move selected pixels. You just drag the selection from one spot to another. When you release the mouse button, the program "drops" your selection into place.

Most image-editing programs support this option, but you need to check your software manual to find out what editing tool must be active in order for dragging and dropping to work. Also be sure to determine whether your dropped selection is permanently fused to the image or can be manipulated further without affecting the underlying image.

The following drag-and-drop drill relates specifically to PhotoDeluxe. In this case, the information really doesn't relate to other image editors. So if you're not using PhotoDeluxe, feel free to spend some time investigating your software's help system for information on dragging and dropping instead of reading these bullet points.

✔ To move a selection, select any tool but the Object Selection tool and click the Move icon in the Selections palette. Then drag inside the selection outline. Just as when you use the Cut command, moving a selection by dragging leaves a selection-shaped hole in your image.

✔ After you complete your drag and release the mouse button, the selection is placed on a *floating layer,* which is a temporary layer. You can find out more about layers in Chapter 12, but the short story is that your selection exists on a separate plane from the rest of the image. You can nudge your selection into place by pressing the arrow keys. Press an arrow key alone to move the selection one pixel; press Shift plus an arrow key to nudge in 10-pixel increments.

✔ Click the None icon in the Selections palette or click with any selection tool except the Object Selection tool to merge the moved pixels with the underlying image. Or if you want to keep the moved pixels on their own layer, drag the Floating Selection item in the Layers palette to the New Layer icon to turn the floating selection into a permanent independent layer. (Again, see Chapter 12 for background information on all this layer stuff.)

✔ You can select the Move tool — which is the same thing as clicking the Move icon in the Selections palette — by pressing Ctrl+G.

✔ To copy a selection to another location in the same image, choose any selection tool except the Object Selection tool and click the Move icon in the Selections palette. Then press Alt as you drag. Your copied selection ends up on a floating layer, just as described in the preceding bullet point. As long as the selection remains floating, you can nudge the selection using the arrow keys as described a few bullet points ago.

✔ To copy a selection between images, open both images and place them side by side. (Choose either Window⇨Tile or Window⇨Cascade.) Choose any selection tool except the Object Selection tool, click the Move icon in the Selections palette, and drag the selection from one image to the other. (Keep your cursor inside the selection outline as you drag.) A little plus sign should appear next to your cursor as you drag to indicate that you're indeed copying the selection, not moving it. You don't need to press Alt as you do when copying within the same image.

✔ You can't move a selection from one image to another using the drag-and-drop method. For that, you need to use Cut and Paste, as described earlier, in "Cut, Copy, Paste: The old reliables."

Saying sayonara to a selection

Deleting a selection is a cinch: In most programs, including PhotoDeluxe, you just press that old Delete key. Whichever route you choose, your selection is sent to the great pixel hunting ground in the sky. All that remains is a hole in the shape of the selection. If you're working on a layer, you see the under-lying layer through the hole. For more on layers, see Chapter 12.

Digital Cover-Ups

When I shot the image in Figure 11-8, the city of Indianapolis refused to coop-erate and relocate that darned tower thing in the background. I shot the pic-ture anyway, knowing that I could cover up the tower in the image-editing phase. The next two sections describe two methods for tackling this sort of photographic spot-removal: patching and cloning.

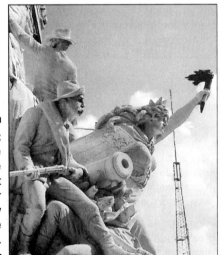

Figure 11-8: This image would be fine if it weren't for that ugly tower in the background.

Creating a seamless patch

Many image editors enable you to *feather* a selection. To feather the selection means to fuzz up the edges of the selection outline a little bit. Figure 11-9 shows the difference between a bit of black that I copied and pasted using a standard (hard-edged) selection and a feathered selection.

Figure 11-9:
A normal
selection
has hard
edges (left);
a feathered
selection
fades
gradually
into view
(right).

Feathering enables you to create less-noticeable edits because the results of your edits fade gradually into view. Without feathering, you often get abrupt transitions at the edges of the selection, making your edits very noticeable. Figure 11-10 provides an illustration. In both figures, based on the image in Figure 11-8, I got rid of the offending construction tower by copying some sky pixels and pasting them on top of the tower.

For the left image, I drew a standard selection outline around an area of sky and then copied the selection onto the tower. At the top of the tower, my patch blended fairly well with the surrounding sky because I was patching in a solid area of color. But in the bottom portion of the image, you can see distinct edges along the borders of the area I pasted because the patch has hard edges, which interrupts the natural fluffiness of the clouds.

Figure 11-10:
An
unfeathered
patch is
obvious
(left), while
a feathered
patch
blends
seamlessly
with the
original
image
(right).

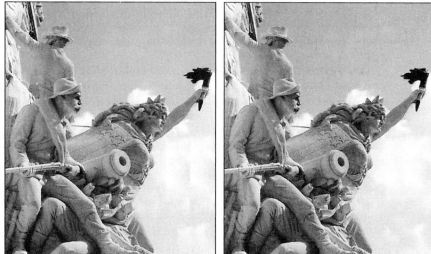

I was able to create a much less noticeable patch in the right image in the figure by selecting a portion of the sky, feathering the selection, and then pasting the feathered selection over the tower.

In many image editors, you can feather a selection after drawing the selection outline. In Photoshop, for example, you choose the Select⇨Feather command and enter a feathering value — higher values for fuzzier selection borders, lower values for less fuzzy borders. After feathering the selection, simply drag and drop it over the area you want to patch (or use the Copy and Paste commands, if you prefer).

In PhotoDeluxe, you get limited feathering capabilities. You can feather a selection, but all you can do is delete or fill either the selection or the unselected areas. That is, unless you trick the program by using the following bit of sleight of hand. Note that these steps assume that you're working on an image that has only a standard background layer and a text layer — in other words, that you haven't created any layers in addition to those you get by default.

1. **Choose View⇨Show Layers to display the Layers palette.**

 The palette is explained in Chapter 12.

2. **Copy the background layer to a new layer.**

 To do this, drag the background layer to the New Layer icon at the bottom of the Layers palette. You now have two layers, each containing the exact same image. After you create the new layer, that layer is active, which is just what you want.

3. **Select an area to serve as your patch.**

 Select pixels that are as close as possible in color and brightness to those surrounding the pixels you want to cover up. In the bottom portion of my image, for example, I selected the cloud area just to the left of the tower.

4. **Choose Effects⇨Feather.**

 The Feather dialog box, shown in Figure 11-11, appears. The Feather value determines how fuzzy your selection gets. Higher values increase the feathering effect. I used a value of 15 when creating the sky patch for Figure 11-10.

 In the bottom portion of the dialog box, click the Delete Background icon and then click OK. The selected pixels fade into nothingness, creating a nicely feathered edge for your patch. (To see what the patch looks like by itself, Alt+click on the eyeball icon to the left of the patch layer name in the Layers palette. Alt+click again to make all your image layers visible again.)

5. **Click the None icon in the Selections palette or press Ctrl+D.**

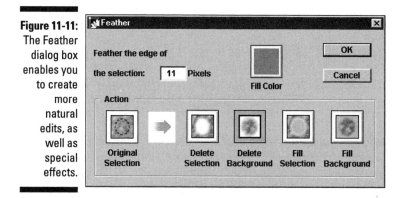

Figure 11-11:
The Feather
dialog box
enables you
to create
more
natural
edits, as
well as
special
effects.

This step is important because it gets rid of the selection outline. If you leave the selection outline intact, you wind up copying a hard-edged selection rather than that nice, soft-edged patch you just created.

6. **Select the Move tool and move the patch into place.**

 Press Ctrl+G to select the Move tool quickly. Then drag the patch into place or use the arrow keys to nudge the patch into position.

 If the patch isn't big enough to cover the entire blemish, drag the patch layer to the New Layer icon in the Layers palette to create a second patch. Then use that patch to cover up more pixels.

7. **Flatten the image.**

 When you're all finished patching, choose Merge Layers from the Layers palette menu (click on the right-pointing arrow near the top-right corner of the palette to display the menu). Your patch is now firmly glued over those unsightly pixels.

You can use this same technique to cover up just about any blemish. However, you should also investigate the alternative method for hiding image flaws, which is to use the Clone tool to paint pixels from another part of your image onto the ones you want to cover up. See the next section for a look at this tool.

Cloning without DNA

Now that humankind has successfully figured out how to clone sheep — like sheep needed our help to replicate themselves — it should come as no surprise to you that you can easily clone pixels in your image.

With the Clone tool, provided in many consumer-level image editors and all professional image editors, you can paint pixels from one image onto another image, as I did in the right half of Figure 11-12. But I usually use the Clone

tool to duplicate pixels within the same image in order to cover up blemishes and hot spots, such as the drop-out area at the top of the lemon in Color Plate 11-3.

The Clone tool has no real-life counterpart — mad scientists excepted — so you need to practice with the tool for a bit to fully understand how it works. But I guarantee that after you get acquainted with this tool, you'll use it all the time.

The following list explains how to use the PhotoDeluxe Clone tool specifically, but most clone tools work very similarly. Here's what you need to know:

✔ To select the tool, choose Tools➪Clone. When you do, you see the Clone palette, shown in Figure 11-13. In this palette, you can set the size and softness of the cloning brush tip. If you choose one of the first six options in the palette, the Clone tool paints with hard-edged strokes, like those made with a pencil. The other brush tips create strokes with fuzzier edges, like those painted with a paintbrush.

Source point cursor

Crosshair cursor

Clone tool cursor

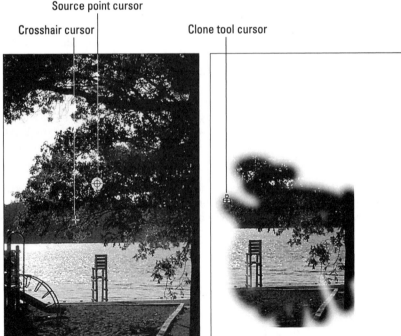

Figure 11-12:
The Clone tool enables you to paint one image (left) onto another image (right).

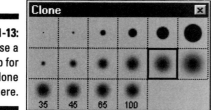

Figure 11-13:
Choose a
brush tip for
your Clone
tool here.

In the first two rows of the palettes, the icons represent the actual size of the brush tip. But the brush tips available in the bottom row of the palette are too big to show at their actual size, so PhotoDeluxe lists the size of the brush tip in pixels instead.

To select a brush tip, just click its icon in the palette.

✔ You can vary the opacity of the pixels you clone by pressing the number keys on your keyboard. Press 0 to clone at full opacity; press 1 to clone at 10 percent opacity, 2 to clone at 20 percent opacity, and so on. I often use a 60 or 70 percent opacity when using the Clone tool to blend cloned pixels with the original more naturally. But if you want your cloned pixels to completely cover the original pixels, press 0 to set the tool to full opacity.

✔ Choosing the Clone tool also displays several cursors in your image window. The round, target-like cursor represents the *source point.* This cursor indicates the initial pixels that will be cloned when you click or drag with the tool. To reposition the source point, just drag inside it.

✔ The Clone cursor indicates where the cloned pixels will be painted. (The rubber stamp icon is a carryover from Adobe Photoshop, where the Clone tool is called the Rubber Stamp.)

✔ To do your actual cloning, you can either click or drag. If you click, the pixels directly underneath the source point cursor are painted onto the pixels underneath the Clone cursor (the rubber stamp icon). How many pixels are cloned depends on the size of the brush you chose — the larger the brush, the more pixels you clone.

✔ When you drag with the Clone tool, you clone pixels along the direction and distance of your drag, relative to the source point. As soon as you begin your drag, a crosshair cursor emerges from the source point cursor to indicate what pixels you're cloning. The crosshair cursor moves in tandem with the Clone tool cursor, mirroring your every move. For example, if you drag down and to the left, you clone pixels that fall below and to the left of the source point cursor.

If that explanation sounds like gibberish, just give the tool a try. This is one of those concepts that makes perfect sense when you see it on-screen but is difficult to describe in text. (Or at least I'm certainly finding it difficult.)

✔ If you release the mouse button and start a new drag, the crosshair cursor flies home to the source point cursor, and you begin cloning from the source point all over again.

✔ Before you clone, copy the layer that contains the pixels you want to clone to a new layer. Then do your cloning work on the new layer. That way, you can easily get rid of your clones if you don't like the results — just delete the layer or use the Eraser to wipe away the offending pixels. For information on how to copy layers and work with layers, see Chapter 12.

✔ The Clone tool can't see through layers; it can clone only pixels on the active layer. So if you're working on Layer 2, for example, you can't clone pixels from Layer 1.

✔ You can however, clone between images quite easily. Just open both images side by side (choose Window⇨Tile to arrange the image windows). Click with the Clone tool in the image that has the pixels you want to clone. Drag the source point cursor into position. Then drag in the image where you want to paint the cloned pixels.

The Clone tool is the perfect answer for eliminating red-eye problems. Usually, the red glint doesn't cover the entire eye. So you can clone some of the unaffected pixels over the red ones. Be sure not to cover over any white highlights in the eye — leave those intact for a natural look.

If you don't have *any* good eye pixels to use as your clone source, you can select the red pixels and then fill them with eye-colored paint using one of the painting tools discussed in Chapter 12.

Hey Vincent, Get a Larger Canvas!

When you cut and paste pictures together, you may need to increase the size of the image *canvas*. The canvas is nothing more than an invisible backdrop that holds all the pixels in your image.

Suppose that you have two images that you want to join, placing them side by side. Perhaps image A is a picture of your boss, and image B is a picture of the boss's boss. You open image A, increase the canvas area along one side of the image, and then paste image B into the empty canvas area.

In PhotoDeluxe, choose Size⇨Canvas Size command to open the Canvas Size dialog box, shown in Figure 11-14, to adjust the canvas size. Enter the new canvas dimensions into the Width and Height option boxes. Next, use the little grid at the bottom of the dialog box to specify where you want to position the existing image on the new canvas. For example, if you want the extra canvas area to be added equally around the entire image, click in the center square.

Figure 11-14:
In PhotoDeluxe, use the Canvas Size dialog box to enlarge the image canvas.

To trim away excess canvas, reduce the Width and Height values. Again, click in the grid to specify where you want the image to be located with respect to the new canvas. Note that you can also use the Crop tool to cut away excess canvas; see Chapter 10 for information. But using the Canvas Size command is a better option if you want to trim the canvas by a precise amount — a quarter-inch on all four sides, for example.

You use the exact same procedure to change the canvas size in Adobe Photoshop, except you choose a different command: Image⇨Canvas Size. If you're using another image editor, look for information about canvas size, image background, or image size in your online help system or manual.

Chapter 12

Amazing Stuff Even You Can Do

. .

In This Chapter

▶ Painting on your image

▶ Choosing your paint colors in Windows and on a Mac

▶ Filling a selection with color

▶ Replacing one color with another

▶ Spinning the Hue wheel

▶ Using layers for added flexibility and safety

▶ Erasing your way back to a transparent state

▶ Applying special effects with filters

. .

*F*lip through any popular magazine, and you can see page after page of impressive digital art. A review of hot new computers features a photo in which lightning bolts are superimposed over a souped-up system. A car ad shows a sky that's hot pink instead of boring old blue. A laundry detergent promotion has a backdrop that looks as though it was painted by Van Gogh himself. No longer can graphic designers get away with straightforward portraits and product shots — if you want to catch the fickle eye of today's consumer, you need something with a bit more spice.

Although some techniques used to create this kind of photographic art require high-end professional editing tools — not to mention plenty of time and training — many effects are surprisingly easy to create, even with a basic image-editing program. This chapter gets you started on your creative journey by showing you a few simple tricks that can send your photographs into a whole new dimension. Use these ideas to make your marketing images more noticeable or just to have some fun exploring your creative side.

Give Your Image a Paint Job

Remember when you were in kindergarten and the teacher announced that it was time for finger painting? In a world that normally admonished you to be neat and clean, someone actually *encouraged* you to drag your hands through wet paint and make a big, colorful mess of yourself.

Image editors bring back the bliss of youth by enabling you to paint on your digital photographs. The process isn't quite as much fun and not nearly as messy as those childhood finger-painting sessions, but it's pretty cool nonetheless.

To paint in an image editor, you can drag with your mouse or other pointing device to create strokes that mimic those produced by traditional art tools, such as a paintbrush, pencil, or airbrush. Or you can choose a command that fills a whole selection with color.

Why would you want to paint on your image? Here are a few reasons that come to mind:

- You can change the color of a particular image element. Say that you shoot a picture of a green leaf to use as artwork on your Web site. You decide that you'd also like to have a red leaf and a yellow leaf, but you don't have time to wait for autumn to roll around so that you can go pick fall-colored leaves. You can use your image editor to make two copies of the green leaf and then paint one copy red and the other yellow.

- You can hide minor image flaws. Do you have a little hot spot (an area of dropout) ruining an otherwise good photo? Set your paint tool to a color matching the surrounding pixels, and dab the spot away. You can use this same technique to get rid of red-eye problems — the demonic glint caused when a camera flash reflects in the subject's eyes. Choose a color close to the natural eye color, and paint over the red pixels.

- Aside from practical purposes, paint tools enable you to express your creativity. If you enjoy painting or drawing with traditional art tools, you'll be blown away by the possibilities presented by digital painting tools. You can blend photography and hand-painted artwork to create awesome images. I wish that I could show you some of my own artwork as an example of what I mean, but unfortunately I am absolutely talentless in this area, as evidenced by Figure 12-1. So I think it's better to send you to your local bookstore or library, where you can find all the creative inspiration and guidance you need in the many available volumes on digital painting.

- And of course, painting tools provide you with one more way to adulterate photos of friends and family. Okay, you've probably already discovered this one on your own. Admit it, now — the first thing you tried with your image-editing program was painting a mustache on someone's picture, wasn't it?

Figure 12-1:
A lakeside
vista gets a
visit from
Mr. Sun,
thanks to a
paint tool.

Now that you know why you might want to pick up a paint tool, the following sections give you an introduction to some of the more common painting options. Put on your smock, grab a glass of milk and some graham crackers, and have a blast.

What's in your paint box?

The assortment of paint tools varies widely from program to program. Some programs, such as Painter, from MetaCreations, are geared toward photo painting and so provide an almost unlimited supply of painting tools and effects. You can paint with brushes that mimic the look of chalk, watercolors, pastels, and even liquid metal. Figure 12-2 provides a sampling of different paint strokes you can create in this program.

If you're skilled at drawing or painting, you can express endless creative notions using this kind of program. You may want to invest in a digital drawing tablet, which enables you to paint with a pen-like stylus, which most people find easier than using a mouse. (Be sure that the software you choose supports this function if you take the leap.) See Chapter 4 for a look at a drawing tablet if you're unfamiliar with this device.

Figure 12-2:
Painter 5 and other programs marketed toward photo artisans provide a broad range of painting tools.

To experiment with photo painting, install the demo version of Painter included on the CD at the back of this book. The CD also includes trial versions of a few other programs that provide a good assortment of painting tools.

Keep in mind that programs that emphasize painting tools usually don't offer as many image-correction or retouching options as programs such as Adobe Photoshop, which concentrate on those aspects of image editing rather than painting. On the other hand, programs that focus on retouching and correction usually don't offer a wide range of painting tools. Photoshop, for example, provides just a handful of painting tools.

PhotoDeluxe, like its older sibling Photoshop, provides only basic painting tools. Still, you can accomplish quite a bit even with these few tools. The following list provides a basic description of the PhotoDeluxe painting tools, which are similar to what you find in most other programs in the consumer category.

✔ **Brush tool:** This tool can paint hard-edged strokes, like a ballpoint pen, or soft-edged strokes, like those painted with a traditional paintbrush. To access the tool, choose Tools➪Brush. Then just drag across your image to lay down a paint stroke.

To paint a perfectly straight stroke, press Shift as you drag. Or click at the spot where you want the line to begin and then Shift+click at the point where you want the line to end.

You can change the size and softness of the brush tip by clicking an icon in the Brushes palette, shown in Figure 12-3, which appears when you select the Brush tool. The smallest brush size is just one pixel big; the largest is 100 pixels in diameter.

The first six options in the palette are hard-edged brushes, while the others are soft. Brush tips in the first two rows of the palette are shown at their actual size. The tips in the last row are too large to fit at their actual size, so a number representing the brush diameter (in pixels) appears beneath the icon.

Figure 12-3: Click an icon to change your brush tip in PhotoDeluxe.

To set the paint color, click the Color swatch in the Brushes palette, which opens the Color Picker dialog box. See "Pick a color, any color!" later in this chapter for information.

You can vary the opacity of strokes you paint with the Brush or Line tool (described next). Press 1 for 10-percent opacity, 2 for 20-percent opacity, and so on. Press 0 to create a fully opaque line. Figure 12-4 shows examples of different opacity settings. I painted inside each of the letters with white but varied the opacity for each letter.

✔ **Line tool:** The Line tool draws straight lines only. You can also draw straight lines by pressing Shift as you drag or click with the Brush tool. However, with the Brush tool, you're limited to the brush sizes available in the Brushes palette. If you want a line of a different width, select the Line tool by choosing Tools⇨Line.

The Line Tool Options palette appears, providing an option box in which you can specify the width of your line (in pixels). Click the Color swatch to open the Color Picker dialog box and change the line color. To paint your line, just drag. If you press Shift as you drag, PhotoDeluxe constrains your line to a 45-degree angle.

100% 80% 60% 40% 20%

✔ **Selection Fill command:** You can fill a selection with solid color or a pattern of color using this command, found on the Effects menu. See the upcoming section "Pouring color into a selection" for the lowdown.

✔ **Smudge tool:** This tool (choose Tools⬧Smudge) is a special purpose tool that smears the colors in your image. The effect is like dragging your finger through a wet oil painting.

When you select the Smudge tool, the Smudge tool palette appears, offering the same selection of brush tips available for the Brush and Line tools. After clicking a brush tip icon, drag to smear your pixels.

You can adjust the effect of the Smudge tool by pressing the number keys on your keyboard. Press 0 for a full-power application of the Smudge tool. Press 1 to apply the tool at 10-percent pressure, 2 for 20-percent, and so on. Set at full strength, the Smudge tool drags a color the full length of your drag. At lower strengths, the colors aren't smeared the entire distance of your drag.

To get an idea of the kind of effects you can create with the Smudge tool, see Figure 12-5. Using a variety of brush tips with the tool strength set to 70 percent, I gave my antique pottery toucan a new 'do. Who says a toucan can't have a little fun, after all? To create the effect, I just dragged upward from the crown of the bird.

Figure 12-5:
By dragging
upward
from my
toucan's
head with
the Smudge
tool, I gave
him a more
happenin'
hairstyle.

Just in case you want to try your own hand at creating hairstyles for inanimate objects, the toucan image is included on the CD in the back of this book. The filename is Toucan.jpg.

Whatever paint tool you use, if your image-editing program offers layers, I recommend that you do your painting on a separate layer so that you can easily erase your changes if you mess up. For more about erasing paint strokes, see "Editing a multilayered image," later in this chapter. Chapter 10 discusses other options for undoing mistakes.

Pick a color, any color!

Before you lay down a coat of paint, you need to choose the paint color. In most image editors, two paint cans are available at any one time. One can holds the *foreground color,* and the other holds the *background color.* Usually, the major paint tools apply the foreground color, and a few other tools paint with the background color. Check your software's online help system to figure out which tools paint in which color — or just experiment by painting with each tool.

In PhotoDeluxe, the Brush tool and the Line tool always paint in the foreground color. The background color is used only in some special effects.

Like many other aspects of image editing, the process of choosing the foreground and background colors is similar no matter what program you're using. Some programs provide a special color palette in which you click the color you

want to use. Some programs rely on the Windows or Macintosh system color pickers, while a few programs, including PhotoDeluxe, provide you with a choice between the program color picker and the system color picker.

The next three sections explain how to choose a color using the PhotoDeluxe color picker, the Windows system color picker, and the Macintosh color picker. After you read about these color pickers, you should have no trouble figuring out how to select colors in just about any image editor.

Choosing colors in PhotoDeluxe

To set your foreground and background colors, choose Effects⇨Choose Colors or click the Color icon in the Brushes or Line Tool Options palette. The Color Picker dialog box, shown in Figure 12-6, appears.

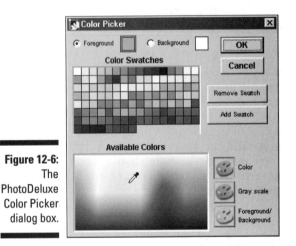

Figure 12-6:
The
PhotoDeluxe
Color Picker
dialog box.

The dialog box options work as follows:

- ✔ Click the Foreground radio button or color swatch to set the foreground color; click the Background button or swatch to set the background color.

- ✔ Select the color you want to use by clicking in the Available Colors display at the bottom of the dialog box, as shown in the figure. Alternatively, you can click a square in the Color Swatches area. (More on the Color Swatches feature in a moment.)

- ✔ You can also click a pixel in the image window to lift a color right from your image. Using this technique, you can easily match the paint color to the color of an existing pixel in your image.

- ✔ Click the icons to the right of the Available Colors display to switch the display to a different color spectrum. You can choose from a grayscale spectrum, a spectrum that fades gradually from the current foreground color to the background color, and a full-color spectrum.

✔ If you have trouble selecting just the right color, click the Foreground or Background color swatch (depending on which color you're trying to set) to open the operating-system color picker. There, you can more easily select a precise color, as outlined in the following two sections.

✔ After you select a color, you can add a swatch for the color in the Color Swatches area. That way, you can easily access the same color again in the future. Click the Add Swatch button to create your swatch. To delete a no-longer-needed swatch, click it and then click Remove Swatch.

✔ After setting your colors, click OK to close the Color Picker dialog box.

Using the Windows color picker

Many Windows image-editing programs, including PhotoDeluxe, enable you to choose colors using the Windows Color dialog box, shown in Figure 12-7. The following list explains how to use the dialog box controls.

✔ To choose one of the colors in the Basic Colors area, click its swatch.

✔ To access more colors, click the Define Custom Colors button at the bottom of the dialog box. Clicking the button displays the right half of the dialog box, as shown in Figure 12-7. (This button is grayed out in Figure 12-7 because I already clicked it.)

✔ Drag the crosshair cursor in the color field to choose the hue and saturation (intensity) of the color, and drag the Lightness slider, to the right of the color field, to adjust the amount of black and white in the color.

Figure 12-7: The Windows system color picker.

✔ As you drag the cursor or the slider, the values in the Hue, Sat, and Lum boxes change to reflect the hue, saturation, and luminosity (brightness) of the color. The Red, Green, and Blue option boxes reflect the amount of red, green, and blue in the color, according to the RGB color model. (See Chapter 2 for more about color models.)

After you create a color, you may want to record the Hue, Sat, and Lum values or RGB values for future reference. The next time you want to use the color, you can just enter the values in the option boxes instead of dragging the crosshair and slider. You're then guaranteed an exact match of the color you selected earlier.

✔ You can also add the color to the Custom Colors palette on the left side of the dialog box by clicking the Add to Custom Colors button. The palette can hold up to 16 custom colors. To use one of the custom colors, click its swatch.

✔ To replace one of the Custom Colors swatches with another color, click that swatch before clicking the Add to Custom Colors button. If all 16 swatches are already full, Windows replaces the selected swatch (the one that's surrounded by a heavy black outline). Click a different swatch to replace that swatch instead.

✔ The Color/Solid swatch beneath the color field previews the color. Technically, the swatch displays two versions of your color — the left side shows the color as you've defined it, and the right side shows the nearest solid color. See, a monitor can display only so many solid colors. The rest it creates by combining the available solid colors — a process known as *dithering*. Dithered colors have a patterned look to them and don't look as sharp on-screen as solid colors. For this reason, many Web designers limit their image color palettes to 256 solid colors or fewer.

If you're creating Web images and want to stick with solid colors, set your monitor to display a maximum of 256 colors before heading to the Color dialog box. Otherwise, you won't see any difference between the two sides of the Color/Solid swatch. After defining a color, click the right side of the swatch to select the nearest solid color.

After you choose your color, click OK to leave the dialog box. In PhotoDeluxe, you're returned to the PhotoDeluxe Color Picker dialog box, explained in the preceding section.

Using the Apple color picker

If you're editing on a Macintosh computer, your program may enable you — or require you — to select colors using the Apple color picker, shown in Figure 12-8.

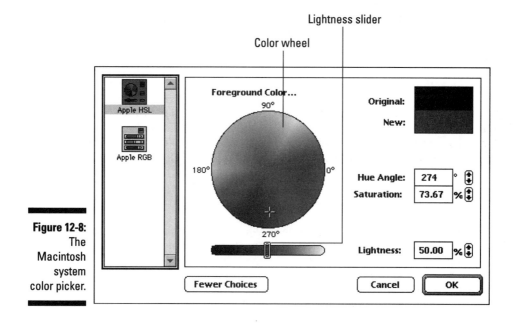

Lightness slider

Color wheel

Figure 12-8:
The
Macintosh
system
color picker.

In the Apple color picker, you can select a color using either the Apple HSL color model or the Apple RGB (Red, Green, and Blue) color model. Apple HSL (Hue, Saturation, and Lightness) is a variation of the standard HSB (Hue, Saturation, and Brightness) color model. (See Chapter 2 for background information on color models.)

Use whichever color model suits your fancy — click the Apple HSL or Apple RGB icon in the left side of the dialog box to switch between the two models.

In HSL mode, drag the crosshair in the color wheel to set the hue (color) and saturation (intensity) of the color, as shown in the figure. Drag the lightness slider bar to adjust the lightness of the color. Set the slider at the midpoint (50-percent lightness) to get the most vivid version of your color. In RGB mode, drag the R, G, and B color sliders to select your color or enter values in the Red, Green, and Blue option boxes.

Whichever color model you use, the Original and New boxes at the top of the dialog box represent the current foreground or background color and the new color you're mixing, respectively. When you're satisfied with your color, press Return or click OK.

Pouring color into a selection

Painting a large area using an ordinary brush tool can be tedious, which is why most image-editing programs provide a command that fills an entire selection with color. (For information on how to create a selection, see Chapter 11.) Most programs call this command the Fill command, but in PhotoDeluxe, the command goes by the alias Selection Fill.

I used the Selection Fill command in PhotoDeluxe to fill the apple in the upper-left corner of Color Plate 12-1 with purple. You see the results of a normal fill job in the upper-right corner of the color plate. The look is entirely unnatural because a normal fill pours solid color throughout your selection, obliterating the shadows and highlights of the original photograph.

To enable you to create more natural-looking fills, many programs offer a choice of *blend modes,* which you can use to combine the fill pixels with the original pixels in slightly different ways. I filled the apple in the lower-left corner of Color Plate 12-1 using the Color blend mode, which is available in most programs that offer blend options. Color applies the fill color while retaining the shadows and highlights of the underlying image. Now that's a purple apple you can sink your teeth into.

Programs that provide blend modes tend to offer the same assortment of modes. I could provide you with an in-depth description of how different blend modes work, but frankly, predicting how a blend mode will affect an image is difficult even if you have this background knowledge. So just play around with the available blend modes until you get an effect you like.

Your software may also offer two other fill options: You may be able to vary the opacity of the fill so that some of the underlying image pixels show through. And you may be able to fill the selection with a pattern instead of a solid color. This last option is especially useful for creating backgrounds for collages, for example.

PhotoDeluxe offers all three fill options in its Selection Fill dialog box, shown in Figure 12-9. To open the dialog box, create a selection outline and then choose Effects⇨Selection Fill. (Chapter 11 explains how to create selection outlines.)

Here's what you need to know to use the dialog box options:

- ✔ To fill the selection with a solid color, click the Color radio button. The swatch underneath the button shows the fill color. To change the color, click the swatch to select a new color as explained in "Pick a color, any color!" earlier in this chapter.

- ✔ Click the Pattern radio button to fill the selection with a pattern instead of a solid color. Click the Next and Previous buttons to see the available

patterns in the pattern preview area. When you choose the pattern as your fill, PhotoDeluxe repeats the pattern as many times as needed to fit the selection.

✔ Click the Selection icon if you want to fill the selected area; click the Background icon to fill the deselected pixels instead.

✔ The Opacity value determines whether the color or pattern you apply covers all underlying pixels. Any value less than 100 results in a semi-transparent fill, meaning that some of the underlying pixels remain visible.

✔ The Blend options control how the paint color (or fill pattern) mixes with the underlying image, as just discussed. For natural-looking color changes, try the Color and Overlay blend modes. Normal gives you a solid blob of color, as shown in the upper-right image in Color Plate 12-1.

Figure 12-9: The PhotoDeluxe Selection Fill dialog box.

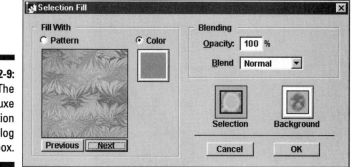

Using a Fill tool

I'm about to show you yet one more way to fill a portion of your image with color. But before I do, I want to say that I don't recommend using this method. I bring it up here only because many programs offer this option, and new users invariably gravitate toward it.

The feature in question is a special tool that is a combination of a selection tool and a fill command. PhotoDeluxe calls the tool the Color Change tool, but other programs use the name Fill tool. (This tool is often represented by a paint-bucket icon and is different from the Fill command covered in the preceding section.)

When you click in your image with the tool, the program selects an area of the image as though you had clicked with the color selection tool (explained in Chapter 11). If you click a red pixel, for example, all adjacent red pixels are selected. Then the selected area is filled with the foreground color.

So what's my problem with this tool? The results are too unpredictable. You can't tell in advance how much of your image will be filled. As an example, see Figure 12-10. The paint-bucket cursor indicates the spot I clicked; the white area is the resulting fill. Had I clicked just a few pixels to the left or right, a totally different region of the apple would have been painted white. For more accurate results, select the area you want to fill manually, using the selection tools described in Chapter 11. Then use your regular fill command or a painting tool to color the selection.

Paint-bucket cursor

Figure 12-10:
The results of clicking with the PhotoDeluxe Color Change tool using a Tolerance value of 32, 100-percent opacity, and white fill color.

I can see that you're the skeptical sort and want to try out the fill tool your-self. Here's how to do it in PhotoDeluxe: Choose Tools⇨Color Change. A little palette appears, containing a single color swatch. Click the swatch to change the foreground color and thus set a new fill color. Then click the area you want to fill.

Didn't work very well? Try adjusting the opacity of the fill by pressing a number key before you click. Press 1 for 10-percent opacity, 2 for 20-percent, and so on. You can also adjust the sensitivity of the tool by changing the Tolerance value in the Cursors dialog box. Press Ctrl+K to open the dialog box. If you use a low Tolerance value, pixels must be closer in color to the pixel you click in order to be selected and filled. In Figure 12-10, I clicked at the position of the paint-bucket cursor with the fill color set to white, the Tolerance value set to 32, and the opacity set to 100 percent.

You can keep playing around with these options all day until you arrive at the right settings if you want. But if I were you, I'd ignore this tool altogether and use one of the other methods for swapping colors described in this chapter.

Spinning Pixels around the Color Wheel

Another way to play with the colors in your image is to use the Hue command or control, if your image editor provides one.

This command takes the selected pixels on a ride around the color wheel, which is nothing more than a circular graph of available hues. Red is located at the 0-degree position on the circle, green at 120 degrees, and blue at 240 degrees. When you change the hue value, you send pixels so many degrees around the wheel. If you start with green, for example, and raise the hue value 120 degrees, your pixel becomes blue. Green is located at 120 degrees, so adding 120 degrees takes you to 240 degrees, which is where blue is located.

To change the apple color in the bottom-right image in Color Plate 12-1, I selected the apple and then lowered the hue value by 83 degrees, using the PhotoDeluxe Hue/Saturation command. At first glance, the results look similar to what I got by applying the Selection Fill command with the Color blend mode. But with the Color mode, all pixels are filled with the same hue — in the apple, for example, you get lighter and darker shades of purple, but the basic color is purple throughout. Hue shifted the red apple pixels to purple but shifted the yellowish-green areas near the center of the fruit to light pink.

PhotoDeluxe users can climb on the color wheel by choosing Quality⇨ Hue/Saturation, which opens the Hue/Saturation dialog box. Drag the Hue slider to raise or lower the hue value.

Uncovering Layers of Possibility

PhotoDeluxe, Photoshop, and many other image editors provide an extremely useful feature called *layers*. Layers sometimes go by other names, such as Objects or Lenses. But whatever the name, this feature is key to creating many of the sophisticated photographic effects you can produce in an image editor.

To understand how layers work, think of those clear sheets of acetate used to create transparencies for overhead projectors. Suppose that on the first sheet, you paint a birdhouse. On the next sheet, you draw a bird. And on the third sheet, you add some blue sky and some green grass. If you stack the sheets on top of each other, the bird, birdhouse, and scenic background appear as though they are all part of the same picture.

Layers work just like that. You place different elements of your image on different layers, and when you stack all the layers on top of each other, you see the *composite image* — the elements of all three layers merged together. Where one layer is empty, pixels from the underlying layer show through.

You gain several image-editing advantages from layers:

✔ You can shuffle the *stacking order* of layers to create different pictures from the same layers, as shown in Figure 12-11. (Stacking order is just a fancy way of referring to the arrangement of layers in your image.)

Both images contain three layers: one for the pond and trees, one for the lily, and one for a prehistoric-looking creature that I probably should be able to name but can't. The pond-and-trees scene occupies the bottom layer in both pictures. In the left image, I put the reptilian thing on the second layer and placed the lily on the top layer. Because the lily obscures most of the reptile layer, the picture appears to show nothing more menacing than a giant, mutant lily. Reversing the order of the top two layers reveals that what appeared to be the stem of the lily actually is the tail of a science experiment gone wrong.

To make the end of the tail appear to be immersed in the water, I dragged across the tail with my image-editor's eraser tool set to 50-percent opacity. You can read more about this technique in "Editing a multilayered image," later in this chapter. I also painted subtle shadows, using a soft brush and a low opacity setting, under both the scaly thing and the lily, to make the scene appear a bit more realistic.

✔ Layers also make experimenting easier. You can edit objects on one layer of your image without affecting the pixels on the other layers one whit. So you can apply the paint tools, retouching tools, and even image-correction tools to just one layer, leaving the rest of the image untouched. You can even delete an entire layer without repercussions.

Figure 12-11:
What appears to be a peaceful lily-in-a-pond image (left) becomes a far more sinister scene when the order of the top and middle image layers is reversed (right).

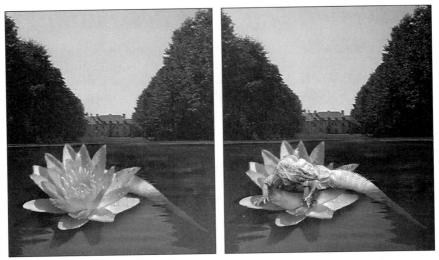

Suppose that you decide you want to get rid of the lily in Figure 12-11 so that the scaly monster appears to walk on water. If the lily, reptile, and background all existed on the same layer, deleting the lily would leave a flower-shaped hole in the image. But because the three elements are on separate layers, you can simply delete the lily layer. In place of the jettisoned flower petals, the water from the background layer appears.

✔ Layers simplify the process of creating photo collages, too. By placing each element in the collage on a different layer, you can play around with the positioning of each element to your heart's content.

As an example, see Color Plates 12-2 and 12-3. To create Color Plate 12-3, I copied the subjects of the top seven images in Color Plate 12-2 and pasted them into the bottom, brick image. I put each subject on its own layer, stacking the layers in the same order as they are shown in Color Plate 12-2.

If I pasted all seven images into one layer, I would have to get the placement of each element right on the first try. Why? Because moving an element after it's been pasted leaves a hole in your image, just as deleting an element does. But you can move individual layers around without harming the image. You just drag them back and forth, this way and that, until you arrive at a composition you like.

✔ You can vary the opacity of layers to create different effects. Figure 12-12 shows an example. Both images contain two layers: The rose is on the top layer, while the faded wood occupies the bottom layer. In the left image, I set the opacity of both layers to 100 percent. In the right image, I lowered the opacity of the rose layer to 50 percent so that the wood image is partially visible through the rose. The result is a ghostly rose that almost looks like part of the wood.

Figure 12-12: At left, the rose layer rests atop the wood layer at 100-percent opacity. At right, I set the rose layer opacity to 50 percent, turning the rose into a ghost of its former self.

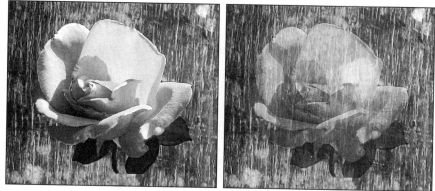

✔ You can vary how the colors in one layer merge with those in the under-lying layers by applying different blend modes. Layer blend modes determine how the pixels in two layers are mixed together, just like the fill blend modes discussed earlier in this chapter. In Color Plate 12-1, I used two different blend modes, Normal and Color, to create two differ-ent fill effects (see the top-right and bottom-left images). These same blend modes, as well as many others, are usually available for blending layers. Some blend modes create wacky, unearthly color combinations, perfect for eye-catching special effects, while others are useful for changing image colors with natural-looking results.

✔ In some programs, you can apply an assortment of automatic layer effects. Photoshop 5, for example, provides an effect that adds a drop shadow to the layer. If you move the layer, the shadow moves with it.

Not all image editors provide all these layer effects, and some entry-level pro-grams don't provide layers at all. But if your program offers layers, I urge you to spend some time getting acquainted with this feature. I promise that you will never go back to unlayered editing after you do.

Layers do have one drawback, however: Each layer increases the file size of your image and forces your computer to expend more memory to process the image. So after you're happy with your image, you should smash all the layers together to reduce the file size — a process known as *flattening* or *merging,* in image-editing parlance.

After you merge layers, though, you can no longer manipulate or edit the individual layer elements without affecting the rest of the image. So if you think you may want to play around with the image more in the future, save a copy of the image in a file format that supports layers. Check your image editor's help system for specifics on flattening and preserving layers.

For those who want some more specifics on using layers, the next sections provide some basics about layer functions in PhotoDeluxe and explain the process I used to create the collage in Color Plate 12-3.

Although the steps for taking advantage of layer functions vary from program to program, the available features tend to be similar no matter what the pro-gram. So reading through the how-to's I give for PhotoDeluxe should give you a head start on understanding your program's layering tools.

Working with PhotoDeluxe layers

To view, arrange, and otherwise manipulate the layers in PhotoDeluxe, choose View⇨Show Layers to display the Layers palette, shown in Figure 12-13. To put the palette away, choose View⇨Hide Layers.

View/hide layers

Layers palette menu

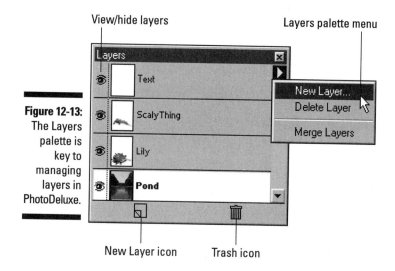

Figure 12-13:
The Layers
palette is
key to
managing
layers in
PhotoDeluxe.

New Layer icon Trash icon

As labeled in Figure 12-13, the Layers palette contains several key tools for working with layers:

✔ Each layer in the image is listed in the palette. To the left of the layer name is a thumbnail view of the elements on that layer.

✔ Only one layer at a time is *active* — that is, available for editing. The active layer is highlighted in the Layers palette. To make a different layer active, click its name.

✔ The eyeball icon indicates whether the layer is visible in the image. Click the icon to hide the eyeball and the layer. Click in the now-empty eyeball column to redisplay the layer.

✔ Click the right-pointing arrow at the top of the palette to open the Layers palette menu. The only reason to display this menu, however, is to choose the bottom command, Merge Layers. You can choose the New Layer command and Delete Layer command more quickly by clicking on the New Layer and Trash icons at the bottom of the palette. For more on adding and deleting layers, pass your eyeballs over the next section.

Adding, deleting, and flattening layers

Every PhotoDeluxe image starts life with two layers. The bottom layer holds your image pixels; the top layer is reserved for text created with the Text tool (which I don't discuss in this book because of space limitations). You can add and delete image layers as follows:

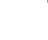

Figure 12-14:
Name your
layer and
set the
blend and
opacity
options
here.

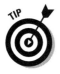

> **New Layer** ☒
>
> **Name:** | Pond | **OK**
>
> **Opacity:** | 100 | % **Blend** | None | ▼ | **Cancel**

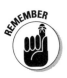

✔ To add a new layer, click the New Layer icon in the Layers palette, which displays the New Layer dialog box, shown in Figure 12-14. Here, you can give your layer a name, set the layer opacity, and choose a layer blend mode. You can change all three options later if needed; see "Editing a multilayered image," later in this chapter, for details.

✔ To copy the contents of one layer and place them on a new layer, drag the layer you want to copy onto the New Layer icon.

✔ Regardless of how you add a layer, it is positioned directly above the layer that was active when you clicked the New Layer icon.

✔ To delete a layer — and everything on it — drag the layer name to the Trash icon in the Layers palette. Or click the layer name and then click the Trash icon. You can't delete the Text layer or the background layer; every image must always contain these two layers.

✔ The more layers you add, the more you increase your image file size. So try not to overdo it on layers, and merge layers together whenever possible by choosing Merge Layers from the Layers palette menu. When you choose the command, PhotoDeluxe fuses all image layers into one, with the exception of the Text layer, which always remains separate from the rest of the image.

You can't manipulate your individual layer elements independently of the rest of the image after you merge layers. As a safety net, save a layered copy of the image using the PDD file format before you flatten the image. See Chapter 10 for information on saving files.

Editing a multilayered image

Editing multilayered images involves a few differences than editing a single-layer image does. Here's the scoop:

✔ Drag a layer name up or down in the Layers palette to rearrange the layer's order in your image.

Sadly, the Text layer never gets to travel around the Layers palette like the other layers.

✔ If you create a selection outline on one layer and then make another layer active, the selection outline is transferred to the newly active layer.

✔ To copy a selection to a new layer — for example, to place an image element on its own layer — do this: Select the element, choose Edit⇨Copy, and then choose Edit⇨Paste. PhotoDeluxe automatically creates a new layer and places the copied element on the layer.

✔ Deleting a selection on a layer cuts a hole in the layer, so the underlying pixels show through.

✔ You can also use the Eraser tool (Tools⇨Eraser) to rub a hole in a layer, as I did in Figure 12-15. In the left half of the image, I nestled my ceramic elf into a field of wildflowers, with the elf occupying the top layer in the image and the wildflowers consuming the bottom layer. The right half of the image shows me swiping away at the elf's chest and legs with the Eraser, bringing the wildflowers in the bottom layer into view.

You can find both images on the CD, by the way. The image filenames are Elf.jpg and Flowers.jpg.

You can alter the size and softness of the Eraser stroke by selecting a different brush tip from the Erasers palette, which appears when you select the Eraser tool. The palette works just like the Brushes tool palette shown in Figure 12-3 and explained earlier in this chapter, in "What's in your paint box?"

Figure 12-15: To create this image, I put the elf on the top layer of the image and the wildflowers on the bottom layer (left). Using the PhotoDeluxe Eraser tool, I rubbed away some elf pixels, revealing the underlying wildflower pixels (right).

Eraser cursor

In addition, you can adjust the opacity of the Eraser by pressing a number key. Press 1 for 10-percent opacity, 5 for 50-percent opacity, and so on, up to 0 for 100-percent opacity. At 100 percent, you swipe the pixels clean; anything less than 100 percent leaves some of your pixels behind. I used this option in Figure 12-11, earlier in this chapter. Using a soft brush and a reduced opacity setting, I erased the lower portion of the lizardy-thing's tail to make the tail appear to hang in the water.

✔ To change the translucency of an entire layer, double-click the layer name in the Layers palette to display the Layer Options dialog box and change the Opacity value. At 100 percent, any pixels on the layer completely obscure underlying pixels. (But any empty areas of the layer are completely transparent no matter what the Opacity setting.)

✔ You can also change the layer blend mode in the Layer Options dialog box. You get the same blend mode options available for the Selection Fill command, but the Normal blend mode is called None in this case. (For more about blend modes, see "Pouring color into a selection," earlier in this chapter.)

Moving, resizing, and rotating layers

To reposition or resize the contents of a layer, click the layer name and then click on any nontransparent area of the layer with the Object Selection tool. To pick up the tool, choose Select➪Selection Tools➪Object or choose the tool from the Selections palette (discussed in Chapter 11).

After you click with the Object Selection tool, a selection outline surrounds the layer contents, as shown in Figure 12-16. You can now scale, rotate, and move the layer contents as follows:

✔ Drag the square resize handles to enlarge or reduce the layer. Drag a top or bottom handle to scale the layer contents vertically; drag a side handle to scale horizontally. Drag a corner handle to retain the original proportions as you resize.

✔ Near each of the corner resize handles, you should see a round circle enclosing a curved arrow. Drag a circle, technically known as a *rotate handle*, to make the pixels kick up their heels and spin around. (You can spy the rotate handles in Figure 12-16, although they're a little difficult to see because of the dark background in the picture. On-screen, the handles appear much more visible.)

✔ To reposition the layer contents, drag inside the selection outline. Note that even if you drag so that part of the layer moves outside the boundaries of the visible canvas, the pixels beyond the canvas aren't deleted — just hidden. If you want to reveal them, just select the layer again with the Object Selection tool and drag the hidden pixels back into view.

Resize handle

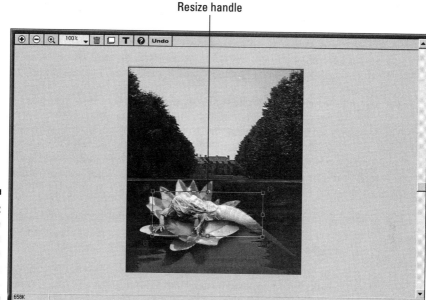

Figure 12-16:
Drag inside
the selection
outline to
reposition
a layer.

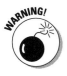

However, if you save the image in any file format other than the PhotoDeluxe format (PDD), the off-canvas elements are deleted. So you may want to save a copy of your image in the PhotoDeluxe format before saving to any other format. Hidden pixels are also lost if you crop the image using the Trim command discussed in Chapter 10.

✔ Moving the layer using the Object Selection tool can be difficult because if you click on a transparent pixel inside the selection outline, you end up moving the underlying layer instead. So for a more surefire method, press Ctrl+G to select the Move tool. Now your drag affects the active layer only. In addition, you can nudge the layer contents into position by pressing the arrow keys on your keyboard. Press an arrow key once to nudge the layer one pixel; press Shift plus an arrow key to nudge the layer ten pixels.

✔ After you finish rotating, resizing, or moving the layer contents, click outside the selection outline to complete your changes. Or if the Move tool is active, select a different tool.

✔ Remember that resizing and rotating image elements can damage your image quality. You can typically reduce your image without harm, but don't try to enlarge the image very much, and don't rotate the same layer repeatedly.

Building a multilayered collage

Layers are useful on an everyday-editing basis because they provide you with more flexibility and security. But where layers really shine is in the creation of photo collages like the one in Color Plate 12-3. I put this collage together for a marketing piece for my part-time antiques business, which focuses on the kind of small, whimsical decorating items featured in the image. I also turned this picture into a birthday card for a friend by adding the text "Happy Birthday to another oldie-but-goodie!"

To help you understand the process of creating a collage — and hopefully provide you with a little inspiration — the following list outlines the approach I took to build the collage in the color plate using PhotoDeluxe.

- ✔ I opened each of the collage images individually and did whatever color correction and touch-ups were needed to get the images in good shape. Then I saved and closed the images.

- ✔ To begin building the collage, I first opened the background brick image. This image was much larger than I needed for the final collage, so I resized it to the dimensions you see in Color Plate 12-3.

- ✔ One by one, I opened the other collage images and selected, copied, and pasted the subject into the brick image. You can find out how to select, copy, and paste in Chapter 11.

Shooting your pictures with the end use of the image in mind saves you time and trouble when you build your collage. I knew when I shot the images in Color Plate 12-2 that I would cut them out of their back-grounds. So when shooting the images, I got as close as I could so that the majority of the image pixels would be devoted to the subjects, not wasted on the background that I would be trimming away. This practice gives you the highest possible resolution for your collage subjects (see Chapter 2 for more information on resolution).

Additionally, I shot the objects against plain backgrounds, using back-ground colors that contrasted with the subjects. I then was able to use the PhotoDeluxe SmartSelect and Color Wand tools to select the back-grounds with relative ease. After selecting the background, I simply inverted the selection, which selected the object and deselected the background.

- ✔ PhotoDeluxe pastes selections on new layers, so I ended up with eight layers when I was done with all my cutting and pasting. You see the stacking order of the layers in Figure 12-17. Using the Object Selection tool, I repositioned and rotated the individual layers, playing around with different compositions until I arrived at the final image.

In a few cases, I scaled individual elements down slightly. (Remember, reducing a layer size is usually harmless; enlarging a layer very much usually does noticeable damage.) With the exception of the elf's head and the bottle stopper (that's the little guy in the bowler hat), I oriented the objects in a way that moved at least some of the original image outside the canvas area. The earlier section "Moving, resizing, and rotating layers" offers more about this subject.

✔ To make the elf's head appear partially in front of and partially behind the iron, I put the elf layer under the iron layer. Then I used the Eraser tool to wipe away the iron pixels around the elf's ears and chin.

Figure 12-17: To create the collage in Color Plate 12-3, I placed each of the objects shown in Color Plate 12-2 on its own layer, using the stacking order shown here.

✔ I saved one copy of the image in the PhotoDeluxe native format so that I could retain the layers for further editing in case the mood to do some rearranging ever hit me. Then, because I needed to turn this image over to the folks in the IDG Books production department for printing, I chose the Merge Layers command from the Layers palette menu and saved the flattened image as a TIFF file. By flattening the image, I reduced the file size. (See Chapter 10 for details on saving files; read Chapter 7 for information on file formats.)

✔ For added effect, I converted the image to a grayscale image by using the PhotoDeluxe Effects⇨Color to Black/White command. Then I created a new layer and filled that layer with a dark gold color. I set the layer blend mode to Color and set the layer opacity to 50 percent, resulting in the antique-photograph look shown in Color Plate 12-4. That old-time atmosphere is perfect for the subject of this image.

Note that if you're using an image-editing program other than PhotoDeluxe, you may need to convert your image back to the RGB color mode *after* you convert it to grayscale. Otherwise, you can't add the antique color. Because PhotoDeluxe always works in the RGB mode, this step is unnecessary in that program.

If you want to try re-creating the collage in Color Plates 12-3 and 12-4, you can find all the collage images on the CD at the back of this book. See Appendix B for more information about using these photos.

Working with multiple images and large images such as this collage can strain even the most hardy computer system. So be sure to save your collage at regular intervals so that you're protected in the case of a system breakdown.

Turning Garbage into Art

Sometimes, no amount of color correction, sharpening, or other editing can rescue an image. The top-left image in Color Plate 12-5 is an example. I shot this cityscape just past sunset, and I knew I was pushing the limits of my camera. Just as I feared, the image came out very grainy due to the low lighting conditions.

After trying all sorts of corrective edits, I decided that this image was never going to be acceptable in its "real" state. That is, I wasn't able to capture the scene with enough detail and brightness to create a decent printed or on-screen image. Still, I really liked the composition and colors of the image. So I decided to use the image as a basis for some digital creativity.

By applying different special-effects filters, I created the five other images in the color plate. For these images, I used Adobe PhotoDeluxe, but you can find similar filters — or, at least, equally entertaining filters — in other programs.

In just a few seconds, I was able to take a lousy image and turn it into an interesting composition. And the images in the color plate are just the beginning of the creative work you can do with an image such as this. You can combine different filters, play with layering and blend modes, and use any of the other editing tricks discussed throughout this chapter and the others in this part of the book to create colorful, inventive artwork.

In other words, the artistic possibilities you can achieve with digital images aren't limited to the scene you see when you look through the viewfinder. Nor are you restricted to the image that appears on your screen when you first open it in your image editor. So never give up on a rotten image — if you look hard enough, you can find art in them-there pixels.

Part V
The Part of Tens

The 5th Wave By Rich Tennant

"...and here's me with Cindy Crawford. And this is me with Madonna and Celine Dion..."

In this part . . .

Some people say that instant gratification is wrong. I say, phooey. Why put off until tomorrow what you can enjoy this minute? Heck, if you listen to some scientists, we could all get flattened by a plunging comet or some other astral body any day now, and then what will you have for all your waiting? A big fat nothing, that's what.

In the spirit of instant gratification, this part of the book is designed for those folks who want information right away. The three chapters herein present useful tips and ideas in small snippets that you can rush in and snag in seconds. Without further delay. *Now,* darn it.

Chapter 13 offers ten techniques for creating better digital images; Chapter 14 gives you ten suggestions for ways to use your images; and Chapter 15 lists ten great Internet resources for digital photographers.

If you like things quick and easy, this part of the book is for you. And if instant gratification is against your principles, you may want to . . . look up! I think that big, black ball in the sky is an asteroid, and it's headed this way!

Chapter 13

Ten Ways to Improve Your Digital Images

Digital cameras have a high "wow" factor. That is, if you walk into a room full of people and start snapping pictures with your digital camera, just about everyone in the room will say, "Wow!" and ask for a closer look. Oh sure, one guy will look unimpressed and even make a few snide remarks, but that's just because he's secretly jealous that you managed to sneak up unnoticed and kick his keister in the who's-got-the-latest-and-greatest-technology game.

Sooner or later, though, people will stop being distracted by the whiz-bang technology of your camera and start paying attention to the quality of the pictures you turn out. And if your images are poor, whether in terms of image quality or photographic composition, the initial "wows" turn to "ews," as in "Ew, that picture's *terrible.* You'd think after spending all that money on a digital camera, you could come up with something better than *that.*"

So that you don't embarrass yourself — photographically speaking, anyway — this chapter presents ten ways to create better digital images. If you pay attention to these guidelines, your audience will be as captivated by your pictures as they are by your shiny digital camera.

Remember the Resolution!

When you print digital images, the image resolution — the number of pixels per linear inch — makes a big impact on picture quality. To get the best results from most printers, you need an image resolution of about 250 to 300 pixels per inch (ppi). For on-screen pictures, you can get by with a much smaller pixel population. On average, 96 ppi is plenty for screen display.

Most cameras offer a few different capture settings, each of which delivers a certain number of pixels. Before you take a picture, consider how you want to use the image. Then select the capture setting that comes closest to generating the number of pixels you'll need for the final output.

Remember that you usually can get rid of excess pixels in an image editor without affecting picture quality, but you almost never get good results from adding pixels. In other words, better to wind up with too many pixels rather than too few.

For the complete lowdown on resolution and pixels, see Chapters 2, 8, and 9.

Don't Overcompress Your Images

Most cameras enable you to select from several *compression* settings. Compression is a technique used to shrink the size of an image file in memory.

In most cases, camera compression settings have quality-related names — Best, Better, Good, for example, or Fine and Normal. That's appropriate because compression affects image quality. Digital cameras use *lossy* compression, which means that some image data is sacrificed during the compression process.

The more compression you apply, the lower the image quality. So for the best-looking images, shoot your pictures using the setting that applies the least amount of compression. Of course, less compression means larger file sizes, so you can't fit as many images in the camera's memory as you can at a lower-quality setting.

You also need to consider the compression factor when saving your images after editing them. Some file formats, such as JPEG, apply lossy compression during the save process, while others, such as TIFF, use *lossless* compression. With lossless compression, your file size isn't reduced as much as with lossy compression, but you don't lose important image data.

To find out more about compression, check out Chapter 3; for information on JPEG, TIFF, and other file formats, flip to Chapter 7.

Look for the Unexpected Angle

As explored in Chapter 5, changing the angle from which you photograph your subject can add impact and interest to the picture. Instead of shooting a subject straight on, investigate the unexpected angle — lie on the floor and get a bug's-eye-view, for example, or perch yourself on a (sturdy) chair and capture the subject from above.

As you compose your scenes, also remember the rule of thirds — divide the frame into vertical and horizontal thirds and position the main focal point of the shot at a spot where the dividing lines intersect. And quickly scan the frame for any potentially distracting background elements before you press the shutter button.

For more tips on how to take better digital photographs, see Chapters 5 and 6.

Light 'Er Up!

When you're working with a digital camera, good lighting is essential for good pictures. The light sensitivity of most digital cameras is equivalent to the sensitivity of ISO 100 film, which means that shooting in dim lighting usually results in dark and grainy images.

If your camera has a flash, you may need to use the flash not just when shooting in dimly lit interiors, but also to bring your subjects out of the shadows when shooting outdoors. For extra flash flexibility, you can buy accessory slave flash units that work in conjunction with your camera's built-in flash. Some higher-end cameras, such as the Olympus C-2000, also have a synchronization socket for connecting an extension flash.

To shed more light on the situation, you may want to invest in some inexpensive photography lights.

For a thorough exploration of flash photography and other lighting issues, check out Chapter 5.

Use a Tripod

To capture the sharpest possible image, you must hold the camera absolutely still. Even the slightest movement can result in a blurry image.

This statement applies to shooting with film as well as when you use a digital camera, of course. But the exposure time required by the average digital camera is comparable to that required by ISO 100 film. If you're used to shooting with a film that's faster than ISO 100, remember that you need to hold your digital camera still for a slightly longer period of time than you do when taking film pictures.

For best results, use a tripod, especially when shooting in dimly lit settings. See Chapter 5 for additional shake-free shooting tricks, and check out Chapter 2 if you want some background information about film ISO ratings and image exposure.

Compose from a Digital Perspective

When you compose pictures, fill as much of the frame as possible with your subject. Try not to waste precious pixels on a background that will be cropped away in the editing process.

If you're shooting objects that you plan to use in a photo collage, set the objects against plain, contrasting backgrounds, as I did in Color Plate 12-2. That way, you can easily select the subject using image-editing tools that select pixels according to color (such as the Color Wand in Adobe PhotoDeluxe).

For more information on shooting pictures for digital compositions, see Chapter 6. To get the skinny on selecting objects in your photographs, turn to Chapter 11.

Take Advantage of Image-Correction Tools

Very few digital images emerge from the camera looking as good as they can. With some judicious use of an image editor, you can brighten up under-exposed images, correct color balance, crop out distracting background elements, and even cover up small blemishes, such as hot spots created by reflected light.

Part IV explores some basic techniques you can use to enhance your images. Some are simple to use, requiring just one click of the mouse button. Others involve a bit more effort but are still easily mastered if you put in a little time.

Being able to edit your photographs is one of the major advantages of shooting with a digital camera. So take a few minutes each day to become acquainted with your image editor's correction commands, filters, and tools. After you start using them, you'll wonder how you ever got along without them.

Print Your Images on Good Paper

As illustrated in Color Plate 8-1, the type of paper you use when printing your images can have a dramatic effect on how your pictures look. The same image that looks blurry, dark, and oversaturated when printed on cheap copy paper can look sharp, bright, and glorious when printed on special glossy photographic paper.

Check your printer's manual for information on the ideal paper to use with your model. Some printers are engineered to work with a specific brand of paper, but don't be afraid to experiment with paper from other manufacturers. Paper vendors are furiously developing new papers that are specifically designed for printing digital images on consumer-level color printers, so you just may find something that works even better than the recommended paper.

Practice, Practice, Practice!

Digital photography is no different from any other skill in that the more you do it, the better you become. So shoot as many pictures as you can, in as many different light situations as you can. As you shoot, jot down the camera settings you used and the lighting conditions at the time you snapped the image. Later, evaluate the pictures to see which settings worked the best in which situations.

If your camera stores the capture settings as metadata (explained in Chapter 4) in the image file, you don't need to bother writing down settings for each shot. Instead, you can use a special piece of software to view the capture settings for each image that you download to your computer. See Chapter 4 for more information on this option.

After you spend some time experimenting with your camera, you'll start to gain an instinctive feel for what tactics to use in different shooting scenarios, increasing the percentage of great pictures in your portfolio. As for those pictures that don't make the grade, keep them to yourself, suggests Alfred DeBat, technical editor for this book and an experienced professional photographer. "Never share your bad photos! Show your friends and family ten really outstanding pictures, and they will say, 'Wow! You really are a great photographer.' If you show them 50 great photos and 50 mediocre shots, they won't be impressed with your abilities. So bury your bad pictures if you want to build a reputation as a good photographer."

Read the Manual (Gasp!)

Remember that instruction manual that came with your camera? The one you promptly stuffed in a drawer without bothering to read? Go get it. Then sit down and spend an hour devouring every bit of information inside it.

I know, I know. Manuals are deadly boring, which is why you invested in this book, which is so dang funny you find yourself slapping your knee and snorting milk through your nose at almost every paragraph. But you aren't going to get the best pictures out of your camera unless you understand how all its controls work. I can give you general recommendations and instructions in this book, but for camera-specific information, the best resource is the manufacturer's own manual.

After your initial read-through, drag the manual out every so often and take another pass at it. You'll probably discover the answer to some problem that's been plaguing your pictures or be reminded of some option that you forgot was available. In fact, reading the manual has to be one of the easiest — and most overlooked — ways to get better performance out of your camera.

Chapter 14

Ten Great Uses for Digital Images

*W*hen I introduce most people to their first digital camera, the exchange goes something like this:

Them: "What's that?"

Me: "It's a digital camera."

Them: "Oh." (Pause.) "What can you do with it?"

Me: "You can take digital pictures."

Them: (Thoughtful nod.) "Hmm." (Another pause, this time longer.) "And then what?"

It is at this point that the conversation takes one of two tracks: If my schedule is tight, I simply discuss the most popular use for digital images — distributing them electronically via the Internet. But if I have time to kill or have ingested an excess of caffeine in the past hour, I sit the person down and launch a full-fledged discussion of all the wonderful things you can do with digital images. Around this point in the conversation, the person subtly begins looking for the closest escape route and probably starts praying that the phone will ring or some other interruption will distract me. I can be, well, overly enthusiastic when it comes to this topic.

This chapter enables you to enjoy the long version of my "what you can do with digital images" speech in the safety of your own home or office. Feel free to leave at any time — I'll be here with more ideas when you come back. But before you go, could you order some more coffee? I have a feeling that someone else might pass by soon and ask me about this funny-looking camera, and I want to be ready.

Creating a More Exciting Web Site

Perhaps the most popular use for digital images is to spice up World Wide Web sites. You can include pictures of your company's product, headquarters, or staff on your Web site to help potential customers get a better idea of who you are and what you're selling.

Don't have a business to promote? That doesn't mean you can't experience the fun of participating in the Web community. Create a personal Web page for yourself or your family. Many Internet service providers make a limited amount of free space available for those who want to publish personal Web pages. And with today's Web-page creation software, the process of designing, creating, and maintaining a Web page isn't all that difficult.

For information on how to prepare your images for use on a Web page, check out Chapter 9.

E-Mailing Pictures to Friends and Family

By attaching an image to an e-mail message, you can share pictures with friends, family, and colleagues around the world in a matter of minutes. No more waiting for the film lab to develop and print your pictures. No more hunting for the right size envelope to mail those pictures, and no more waiting in line at the post office to find out how many stamps you need to slap on that envelope. Just snap the picture, download it to your computer, and click the Send button in your e-mail program.

Whether you want to send a favorite aunt a picture of your new baby or send a client an image of your latest product design, the ability to communicate visual information quickly is one of the best reasons to own a digital camera. For more about attaching images to e-mail messages, turn to Chapter 9.

Adding Impact to Sales Materials

Using a desktop publishing program such as Adobe PageMaker or Microsoft Publisher, you can easily add your digital images to brochures, fliers, newsletters, and other marketing materials. You can also import your images into multimedia presentations created in Microsoft PowerPoint or Corel Presentations.

For best results, size your images to the desired dimensions and resolution in your image editor before you export them. For information about preparing images for use in on-screen presentations, see Chapter 9. Chapter 8 contains details on preparing images for print use.

Putting Your Mug on a Mug

If you own one of the new color printers designed expressly for printing digital images, the printer may come with accessories that enable you to put your images on mugs, T-shirts, and other objects. Many of the consumer-level image-editing programs also provide tools that make it a snap to prepare your images for use in this fashion.

Being a bit of a jaded person, I expected to get rather cheesy results from these kinds of print projects. But after I created my first set of mugs using the Fargo FotoFUN! printer, I was hooked. I chose four different images featuring my parents, my sisters, and my nieces and nephews and placed each image on a different mug. The process was quick — with this particular printer and mug-accessory kit, you print the image, tape it to the mug, place a special clamp around the mug, and then bake the mug in an oven for 15 minutes. And the results were extremely professional-looking.

Call me sentimental, but I can envision these mugs being around for generations (assuming nobody breaks one, that is) to serve as a reminder of how we twentieth-century Kings once looked. Hey, 100 years ago, nobody thought that old tintype photographs would be considered heirlooms, right? So who's to say that my photographic mugs won't be treasured tomorrow? In the meantime, the family members who have laid claim to the mugs I created seem to be treasuring them today.

Creating Custom Calendars and Greeting Cards

Many consumer-level image-editing programs include templates that enable you to create customized calendars featuring your images. The only decision you need to make is which picture to put on December's page and which one to use on July's. You can also find templates for designing personalized greeting cards and stationery.

If your image editor doesn't include such templates, check the software that came with your printer. Many printers now ship with software for creating calendars and similar projects.

When you want more than a handful of copies of your creation, you may want to have the piece professionally reproduced instead of printing each copy one by one on your own printer. You can take the job to a quick-copy shop or to a commercial service bureau or printer.

Don't forget that the paper you use to print your stationery or cards plays a large role in how professional the finished product appears. If you're printing the piece yourself, invest in some high-quality paper or special greeting-card stock, available as an accessory for many color printers. If you're having your piece professionally printed, ask your printer for advice on which paper stock will generate the results you want.

Adding Visual Information to Databases and Spreadsheets

Digital images can be easily added to company databases and spreadsheets, giving you a way to provide employees with visual as well as text information. For example, if you work in human resources, you can insert employee pictures into your employee database. Or if you're a small-business owner and maintain a product inventory in a spreadsheet program, you can insert pictures of individual products to help you remember which items go with which order numbers. Figure 1-4 in Chapter 1 shows an example of a spreadsheet that I created in Microsoft Excel to track the inventory in my antique shop.

Merging text and pictures in this fashion isn't just for business purposes, though. You can take the same approach to create a household inventory for your personal insurance records, for example.

Putting a Name with the Face

You can put digital pictures on business cards, employee badges, and nametags for guests at a conference or other large gathering. I love getting business cards that include the person's face, for example, because I'm one of those people who never forgets a face but almost always has trouble remembering the name.

Several companies now offer special, adhesive-backed sticker paper for inkjet printers. This paper is perfect for creating badges or nametags. After printing the image, you simply stick it onto your preprinted badge or nametag.

Exchanging a Picture for a Thousand Words

Don't forget the power of a photograph to convey an idea or describe a scene. Did your roof suffer damage in last night's windstorm? Take pictures of the damage and e-mail them to your insurance agent and roofing contractor. Looking for a bookcase that will fit in with your existing office decor? Take a picture of your office to the furniture outlet, and ask the designer for suggestions.

Written descriptions can be easily misunderstood and also take a lot longer to produce than shooting and printing a digital image. So don't tell people what you want or need — show 'em!

Wallpapering Your Computer Screen

If you're tired of looking at the same old computer screen day after day, you can replace the standard-issue desktop wallpaper with one of your favorite images. Chapter 9 gives you the how-to's.

You can also create a personalized screen saver featuring a whole batch of images. Many consumer-level image-editing programs provide a wizard that makes designing a screen saver a piece of cake, and you can also find inexpensive stand-alone programs that provide the same sort of screen-saver assistance.

Creating a New Masterpiece for Your Wall

Many of the ideas discussed in this chapter capitalize on the special capabilities that going digital offers you — the ability to display images on-screen, incorporate them into desktop publishing projects, and so on. But you can also take a more traditional approach and simply print and frame your favorite images.

For the best-looking pictures, print your image on a dye-sub printer or on a high-quality inkjet using glossy photo paper. If you don't own such a printer, you can take the image file to a commercial printer for output. Some commercial photo labs also offer this service. (For more on printer types and printing options, read Chapter 8.)

Keep in mind that prints from dye-sub and inkjet printers do fade when exposed to sunlight, so for those really important pictures, you may want to invest in a frame that has UV-protective glass. Also, hang your picture in a spot where it won't get pummeled with strong light on a regular basis, and be sure to keep a copy of the original image file so that you can reprint the image if it fades too badly.

Chapter 15

Ten Great Resources for Digital Photographers

*1*t's 2 a.m. You're aching for inspiration. You're yearning for answers. Where do you turn? No, not to the refrigerator. Well, okay, maybe just to get a little snack — some cold pizza or leftover chicken wings would be good — but then it's off to the computer for you. Whether you need solutions to difficult problems or just want to share experiences with like-minded people around the world, the Internet is the place to turn. At least, it is for issues related to digital photography. For anything else, talk to your spiritual leader, psychic hotline, Magic 8-Ball, or whatever source you usually consult.

This chapter points you toward ten of my favorite online digital photography resources. New sites are springing up every day, so you can no doubt uncover more great pages to explore by doing a Web search on the words "digital photography" or "digital cameras."

Note that the site descriptions provided in this chapter are current as of press time. But because Web sites are always evolving, some of the specific features mentioned may be updated or replaced by the time you visit a particular site.

www.kodak.com

As one of the companies at the forefront of the digital photography movement, the Eastman Kodak Company is making a major effort to help consumers understand this new technology. In addition to marketing information about Kodak products, the Kodak site offers a wealth of basic information that's extremely useful to anyone wanting to learn more about digital photography.

From the Kodak home page, click the Digital Cameras and Technology link to access the digital-imaging information. Click the Digital Learning Center link for reference material that will help you get a firmer grasp on the science behind digital cameras and other digital photography hardware. Click the Discussion Forums link to share opinions, ideas, and solutions with other digital photographers.

You can find samples of the kind of material found at the Digital Learning Center on the CD at the back of this book. The CD contains two learning modules from the site: One provides you with an in-depth look at color theory, while the other opens up a digital camera and enables you to peer at all the components inside.

www.photopoint.com

Looking for a convenient way to share pictures over the Internet? Log onto PhotoPoint. After e-mailing your pictures to the site, you can arrange them into online photo albums. When people come to the PhotoPoint site, they enter your e-mail address to view pictures in your album. If you're worried about security, you can establish a password that site visitors must enter in order to access your images. The service is easy to use and, best of all, free.

In addition to this cool feature, the PhotoPoint site offers forums for discussing photography, information about buying and using digital cameras, and content from digital photography and traditional photography publications.

www.pcphotoreview.com

Whether you're shopping for your first digital camera or looking for accessories to enhance your digital photography fun, this site helps you make the right choices. You'll find camera reviews, details about current money-saving promotions from hardware and equipment vendors, and discussion groups where you can share information with other users. A glossary of digital photography terms and explanations of camera features make this site even more useful to people just getting started in digital photography.

www.imaging-resource.com

Click here for a wealth of buying advice and digital photography news. One especially helpful section of the site offers thorough, easy-to-understand answers to frequently asked questions about choosing and using digital cameras. Product reviews and discussion forums related to digital photography round out this well-designed site.

www.digitalphoto.com.nf

Travel to this Web address to explore the latest issues of *Digital Photography & Imaging,* an online journal about digital photography and imaging. You can read reviews of digital-imaging hardware and software, view images from photographic exhibitions at galleries all over the world, find creative inspiration, and get recommendations for other interesting sites to visit.

www.zonezero.com

Head to this site for a look at another great online magazine, *ZoneZero.* This magazine discusses both traditional and digital photography and is one of the most beautifully designed sites I've had the pleasure of exploring. The site has a definite international flavor, with contributors from all points of the globe. Photo essays from leading photographers, thoughtful editorials on the history and future of photography, and technical information are included. Real-time chats and discussion boards provide yet another reason to click your way to this site.

www.hyperzine.com

This online magazine covers traditional photography, still digital photography, and digital video. You'll find lots of product reviews and technical information, as well as ideas and tips for creating better pictures. The site also maintains an excellent glossary of photographic terms and is home to several discussion groups related to different aspects of photography.

rec.photo.digital

For help with specific technical questions as well as an interesting exchange of ideas about different equipment and approaches to digital photography, subscribe to the rec.photo.digital newsgroup. (For the uninitiated, a *newsgroup*, also called a *discussion group*, is simply a bunch of folks with similar interests who send messages back and forth about a particular topic.) Many of the people who participate in this newsgroup have been working with digital imaging for years, while others are brand new to the game. Don't be shy about asking beginner-level questions, though, because the experts are happy to share what they know.

comp.periphs.printers

Shopping for a new photo printer? Having trouble making your existing printer work correctly? Subscribe to this newsgroup, which deals specifically with issues related to printing. Newsgroup members debate the pros and cons of different printer models, share troubleshooting tips, and discuss ways to get the best possible output from their machines.

www.manufacturer'snamegoeshere.com

In addition to the site operated by Kodak (see the first listing in this chapter), you can find Web sites for just about every manufacturer of digital-imaging hardware and software. Typically, sites are geared to marketing the company's products, but they also serve as a service resource for existing customers. Many manufacturers publish a list of answers to frequently asked questions (FAQs, for the non-Webbies in the crowd). In most cases, you can also e-mail the company's technical support staff for assistance with a specific problem.

Many vendors also make updates to software available through their Web sites. For example, you may be able to download an updated printer driver or a patch that fixes a bug in your image-editing program. I recommend that you get in the practice of checking your manufacturer's Web site routinely — say, once a month or so — to make sure that you're working with the most current version of the product software.

Part VI
Appendixes

The 5th Wave By Rich Tennant

Principal

"I found these two in the multimedia lab morphing faculty members into farm animals."

In this part . . .

You're reading along in this or some other digital photography tome, and you stumble across an unfamiliar term. Don't be proud and pretend to know what's going on — check out Appendix A, which defines digital photography terms in plain English.

When you've had enough of deciphering strange computer acronyms and are ready for something a bit more fun, pop the CD that's attached to the back of this book into your computer. The CD includes full, working versions and demo versions of a bunch of cool programs to use in your digital photography studio, including image editors, catalog programs, and other goodies. And just in case you don't have any of your own images to use as you try out the software, I've included a few sample images on the CD as well.

To make sure that everything goes smoothly, read Appendix B, which describes all the freebies provided on the CD and outlines the process for accessing and installing them.

Appendix A

Digital Photography Glossary

• •

Can't remember the difference between a pixel and a bit? Resolution and resampling? Turn here for a quick refresher on that digital photography term that's stuck somewhere in the dark recesses of your brain and refuses to come out and play.

8-bit image: An image containing 256 or fewer colors.

16-bit image: An image containing roughly 32,000 colors.

24-bit image: An image containing approximately 64 million colors.

aliasing: A digital-image defect that gives the picture a jagged look, usually due to a too-low image resolution. *See* jaggies.

artifact: Noise, an unwanted pattern, or some other image defect caused by an image capture or processing problem.

bit: Stands for *binary digit.* It is the basic unit of digital information. Eight bits equals one *byte.*

BMP: The Windows bitmap graphics format. Reserved today for images that will be used as system resources on PCs, such as screen savers or desktop wallpaper.

burst mode: A special capture setting, offered on some digital cameras, that records several images in rapid succession with one press of the shutter button.

byte: Eight bits. *See* bit.

CCD: Short for *charge-coupled device.* One of two types of computer chips used to capture images in digital cameras.

CIE: A color model developed by the Commission International de l'Eclairange. Used mostly by higher-end digital imaging professionals.

cloning: The process of painting one portion of an image onto another image or another part of the same image.

CMOS: Pronounced *see-moss*. A much easier way to say *complementary metal-oxide semiconductor*. A type of computer chip used to capture images in digital cameras; used less often than CCD chips.

CMYK: The print color model, in which cyan, magenta, yellow, and black inks are mixed to produce colors.

color correction: The process of adjusting the amount of different primary colors in an image (for example, lowering the amount of red in an RGB image).

color model: A way of defining colors. In the RGB color model, for example, all colors are created by blending red, green, and blue light. In the CMYK model, colors are defined by mixing cyan, magenta, yellow, and black.

color temperature: Refers to the amount of red, green, and blue light emitted by a particular light source.

CompactFlash: A type of removable memory card used in many digital cameras. A miniature version of a PC Card — about the size and thickness of a matchbook.

compositing: Combining two or more images in an image editor.

compression: A process that reduces the size of the image file by eliminating some image data.

downloading: Transferring data from one computer device to another.

dpi: Short for *dots per inch*. A measurement of how many dots of color a printer can create per linear inch. Higher dpi means better print quality on some types of printers, but on other printers, dpi is not as crucial to quality.

dye-sub: Short for *dye-sublimation*. A type of printer that produces excellent digital prints.

edges: Areas where neighboring image pixels are significantly different in color; in other words, areas of high contrast.

EV compensation: A control that slightly increases or decreases the exposure chosen by the camera's autoexposure mechanism. EV stands for exposure value; EV settings typically appear as EV 1.0, EV 0.0, EV−1.0, and so on.

file format: A way of storing image data in a file. Popular image formats include TIFF, JPEG, and GIF.

FlashPix: A new image file format developed to facilitate the editing and online viewing of digital images. Currently supported by only a handful of software programs.

gamut: Say it *gamm-ut*. The range of colors that a monitor, printer, or other device can produce. Colors that a device can't create are said to be *out of gamut*.

GIF: Pronounced *gif,* with a hard g. GIF stands for *graphics interchange format*. One of the two image file formats used for images on the World Wide Web. Supports 256-color images only.

gigabyte: Approximately 1,000 megabytes, or 1 billion bytes. In other words, a really big collection of bytes. Abbreviated as GB.

grayscale: An image consisting solely of shades of gray, from white to black.

HSB: A color model based on hue (color), saturation (purity or intensity of color), and brightness.

HSL: A variation of HSB, this color model is based on hue, saturation, and lightness.

jaggies: A hipper term for aliasing. Refers to the jagged appearance of images that have been printed or displayed at too low a resolution.

JPEG: Pronounced *jay-peg*. One of two formats used for images on the World Wide Web and also used for storing images on many digital cameras. Uses *lossy compression,* which sometimes damages image quality.

Kelvin: A scale for measuring the color temperature of light. Abbreviated as *K*, as in 5000°K. (But in computerland, the initial *K* more often refers to kilobytes, as described next.)

kilobyte: One thousand bytes. Abbreviated as *K*, as in 64K.

LCD: Stands for *liquid crystal display*. Often used to refer to the display screen included on some digital cameras.

lossless compression: A file-compression scheme that doesn't sacrifice any vital image data in the compression process. Lossless compression tosses only redundant data, so image quality is unaffected.

lossy compression: A compression scheme that eliminates important image data in the name of achieving smaller file sizes. High amounts of lossy compression damage image quality.

marquee: The dotted outline that results when you select a portion of your image. Also sometimes used as a verb, as in "I'm in the mood to marquee something."

megabyte: One million bytes. Abbreviated as MB. *See* bit.

megapixel: Refers to digital cameras that can capture high-resolution images; technically reserved for cameras that can capture 1 million pixels or more.

Memory Stick: a memory card used by several Sony digital cameras and peripheral devices. About the size of a stick of chewing gum.

metadata: Extra data that gets stored along with the primary image data in an image file. Metadata often includes information such as aperture, shutter speed, and EV setting used to capture the film, and can be viewed using special software.

metering mode: Refers to the way a camera's autoexposure mechanism reads the light in a scene. Common modes include spot metering, which bases exposure on light in the center of the frame only; center-weighted metering, which reads the entire scene but gives more emphasis to the subject in the center of the frame; and matrix or multizone metering, which calculates exposure based on the entire frame.

noise: Graininess in an image, caused by too little light or a defect in the electrical signal generated during the image-capture process.

NTSC: A video format used by televisions and VCRs in North America. Many digital cameras can send picture signals to a TV or VCR in this format.

PAL: The video format common in Europe and several other countries. Few digital cameras sold in North America can output pictures in this video format (*see also* NTSC).

PCMCIA Card: A type of removable memory card used in some models of digital cameras. Now often referred to simply as PC Cards. (PCMCIA stands for *Personal Computer Memory Card International Association.*)

Photo CD: A special image format used for writing images to a CD.

PICT: The standard format for Macintosh system images. The equivalent of BMP on the Windows platform, PICT is most widely used when creating images for use as system resources, such as startup screens.

pixel: Short for *picture element.* The basic building block of every image.

platform: A fancy way of saying "type of computer system." Most folks work either on the PC platform or the Macintosh platform.

ppi: Stands for *pixels per inch.* Used to state image resolution. Measured in terms of the number of pixels per linear inch. A higher ppi translates to better-looking printed images.

resampling: Adding or deleting image pixels. A large amount of resampling degrades images.

resolution: The number of pixels per linear inch (ppi) in an image. Generally speaking, higher resolution means better images. Also used to describe printer, screen, or scanner capabilities.

RGB: The standard color model for digital images; all colors are created by mixing red, green, and blue light.

sharpening: Applying an image-correction filter inside an image editor to create the appearance of sharper focus.

SmartMedia: A thin, matchbook-sized, removable memory card used in some digital cameras.

TIFF: Pronounced *tiff,* as in little quarrel. Stands for *tagged image file format.* A popular image format supported by most Macintosh and Windows programs.

TWAIN: Say it *twain,* as in "never the twain shall meet." A special software interface that enables image-editing programs to access images captured by digital cameras and scanners.

unsharp masking: The process of using the Unsharp Mask filter, found in many image-editing programs, to create the appearance of a more focused image. The same thing as *sharpening* an image, only more impressive sounding.

uploading: The same as downloading; the process of transferring data between two computer devices.

USB: Stands for *Universal Serial Bus.* A type of new, high-speed port included on the latest computers. USB ports permit easier connection of USB-compatible peripheral devices such as digital cameras, printers, and memory-card readers.

white balancing: Adjusting the camera to compensate for the type of light hitting the photographic subject. Eliminates unwanted color casts produced by some light sources, such as fluorescent office lighting.

Appendix B

What's on the CD

● ●

*G*lued to the inside back cover of this book is a little plastic envelope containing a CD-ROM. The CD contains a treasure trove of goodies, including:

- Full working version of Kodak Pictures Now and freeware version of MediaCenter (from PictureWorks Technology)
- Demo and trial versions of other image-editing programs
- Demo and trial versions of image-catalog and browser programs
- A sampling of the original digital images used to create the figures in this book
- Supplemental reference information from the Kodak Digital Learning Center

For a brief description of each program included on the CD, see the section "What You'll Find," later in this appendix.

System Requirements

Make sure your computer meets the minimum system requirements listed below. If your computer doesn't match up to most of these requirements, you may have problems using the contents of the CD.

- **A PC with a 486 or faster processor, or a Mac OS computer with a 68030 or faster processor.** Keep in mind that, with these minimum processor requirements, opening and editing large images may be very slow.
- **Microsoft Windows 95 or later, or Mac OS System software 7.5 or later.**
- **At least 16MB of total RAM installed on your computer.** For best performance, I recommend 32MB RAM.
- **At least 630MB (for Windows) or 140MB (for Macs) of hard drive space available to install all the software from this CD.** (You'll need less space if you don't install every program.)

✔ **A CD-ROM drive — double-speed (2x) or faster.**

✔ **A sound card for PCs.** (Mac OS computers have built-in sound support.)

✔ **A monitor capable of displaying at least 256 colors.**

How to Use the CD Using Microsoft Windows

To install the items from the CD on your hard drive, follow these steps:

1. **Insert the CD into your computer's CD-ROM drive and close the drive door.**

2. **Click the Start button and then click Run.**

3. **In the dialog box that appears, type** D:\SETUP.EXE.

 This instruction assumes that your CD-ROM drive is set up as drive D. Substitute the proper drive letter if your CD-ROM drive uses a different letter.

4. **Click OK.**

 A License Agreement window appears.

5. **Read through the license agreement, nod your head, and then click the Accept button.**

 After you click Accept, you'll never be bothered by the License Agreement window again.

 From here, the CD interface appears. The CD interface lets you install the programs on the CD without typing cryptic commands or using yet another finger-twisting hot key in Windows.

 The software on the interface is divided into categories whose names you see on the screen.

6. **To view the items within a category, just click the category's name.**

 A list of programs in the category appears.

 Note that the Images folder does not contain software, but rather sample images that you can open and edit from inside an image-editing program. So the remaining steps in this section don't apply to anything inside the Images folder.

7. **For more information about a program, click the program's name.**

 Be sure to read the information that's displayed. Sometimes a program may require you to do a few tricks on your computer first, and this screen will tell you where to go for that information, if necessary.

8. **To install the program, click the appropriate Install button.**

If you don't want to install the program, click the Go Back button to return to the previous category screen.

After you click an Install button, the CD interface drops to the background while the CD begins installation of the program you chose.

When installation is finished, the interface usually reappears in front of other opened windows. Sometimes the installation confuses Windows and leaves the interface in the background. To bring the interface forward, just click once anywhere in the interface's window, or use whatever keystroke or mouse move that your version of Windows uses to switch between programs (the Alt+Tab key, and so on).

9. **To install other items, repeat Steps 6 through 8.**

10. **When you finish installing programs, click the Quit button to close the interface.**

You can eject the CD now. Place it back in the plastic jacket of the book for safekeeping.

To run some of the programs, you may need to keep the CD inside your CD-ROM drive. Otherwise, the installed program would have required you to install a very large chunk of the program to your hard drive space, which would have kept you from installing other software.

How to Use the CD Using a Mac OS Computer

To install the items from the CD to your hard drive, follow these steps:

1. **Insert the CD into your computer's CD-ROM drive and close the drive door.**

In a moment, an icon representing the CD you just inserted appears on your Mac desktop. Chances are, the icon looks like a CD-ROM.

2. **Double-click the License Agreement icon.**

This is the End-User License that you are agreeing to by using the CD. After you've looked it over, you can close the file and get on to the good stuff.

3. **Double-click the Read Me First icon.**

This text file contains information about the CD's programs and any last-minute instructions you need to know about installing the programs on the CD that I don't cover in this appendix.

4. **Double-click the CD icon to show the CD's contents.**

5. **To install most programs, just drag the program's folder from the CD window and drop it on your hard drive icon.**

6. **To install other, larger programs, open the program's folder on the CD, and double-click the icon with the words "Install" or "Installer."**

After you install the programs that you want, you can eject the CD. Carefully place it back in the plastic jacket of the book for safekeeping.

What You'll Find

Here's a summary of the programs and other freebies included on this CD. If you use Windows, the CD interface helps you install software easily. (If you have no idea what I'm talking about when I say "CD interface," flip back a page or two to find the section, "How to Use the CD Using Microsoft Windows.")

If you use a Mac OS computer, you can enjoy the ease of the Mac interface to quickly install the programs.

Kodak Digital Learning Center modules

Kodak provides a terrific reference library at its Web site, www.kodak.com. Called the Digital Learning Center (DLC), the library includes all sorts of reference materials to help novice digital photographers get acquainted with the basics of the technology. The DLC also includes higher-end materials for advanced photographers who want to know more about the science behind the art of digital photography.

Kodak has contributed two DLC modules to the CD. One module contains an in-depth discussion of color theory to expand on the fundamental information contained in Chapter 2. The second module shows you what's inside a digital camera — literally. The folks at Kodak popped the case off one of their cameras and took some pictures of the chips, circuit boards, and other components inside, saving curious minds from the trouble (and possible electrical shock) of cracking open their own cameras. (Just in case that last sentence sounded a little too lighthearted, let me emphasize that I do *not* recommend that you even *try* opening up your camera in this fashion.)

To view the DLC modules, just open your Web browser (Windows or Macintosh) and click File➪Open (or Open Page or whatever option your browser gives you). Type the path to the Index.htm file on the CD for the module you are interested in. For the DLC module on Color Theory, the path is D:\EXTRAS\KODAK\COLORTHY.HTM. To take a look at the inside of a digital camera, enter the path D:\EXTRAS\KODAK\Inside.HTM. Of course, if your CD-ROM drive is not D, be sure to use the correct letter for your computer.

After viewing the modules on the CD, be sure to visit the Kodak Web site to check out other DLC modules that may interest you. From the Kodak home page, click the Digital Cameras and Technology link and then click the Digital Learning Center link.

If you are using Windows, you can find this information in the Extras section of the CD interface.

Image-editing software

If you're in the market for new image-editing software or just want to see whether another program serves your needs better than your current software, take a look at these popular offerings. If you'd like more information about a program, point your Web browser to the address listed.

- **MGI PhotoSuite III, from MGI Software:** Offering an easy-to-navigate interface, this suite of image-editing tools provides just about anything the novice digital photographer could want. Along with basic image-correction tools, the suite includes a stitching utility, image-cataloging tools, and a feature that enables you to create a "photo tapestry" out of multiple images. Demo version for Windows — www.mgisoft.com.

- **Painter 5.5 Web Edition, from MetaCreations Corporation:** Explore your artistic side with this terrific photo-artistry program, which provides you with tons of painting tools and other creative features. Demo version for Windows and Macintosh — www.metacreations.com.

- **Paint Shop Pro, from JASC, Inc.:** Designed for more-advanced users, this popular program has a good selection of editing tools and special effects. Evaluation version for Windows — www.jasc.com.

- **PhotoExpress, from Ulead Systems:** The Ulead entry in the consumer image-editing market, PhotoExpress provides a nice assortment of tools and special effects in an easy-to-understand interface. Trial version for Windows — www.ulead.com.

- **PhotoImpact, from Ulead Systems:** PhotoImpact offers professional-level image editing with an emphasis on tools for creating Web images and graphics. Trial version for Windows — www.ulead.com.

- **Photoshop, from Adobe Systems, Inc.:** An outstanding set of retouching and editing tools in a clean, elegant interface keep Photoshop at the top of the list for users who need professional power. Tryout version for Windows and Macintosh — www.adobe.com.

Specialty software

In addition to the image-editing programs listed in the preceding section, the CD also includes the following special-purpose digital photography programs:

- ✓ **BrainsBreaker, from Juan Trujillo Tarradas:** Turn your favorite photo into a virtual jigsaw puzzle! The program breaks your image into puzzle pieces, and you can then solve the puzzle on-screen. Shareware version for Windows — www.jtrujillo.pair.com.

- ✓ **Face Factory, from Ulead Systems:** With this family-fun program, you can blend two photos of your head into a realistic 3-D model. After sending your head into the third dimension, you can apply distortion and lighting effects. Trial version for Windows — www.ulead.com.

- ✓ **Jigsaw Deluxe, from Captain's Software, Inc.:** With this program, Macintosh users can get in on the puzzle fun. Like BrainsBreaker, Jigsaw Deluxe enables you to create and solve digital jigsaw puzzles featuring your images. Demo version for Macintosh — www.unboxed.com/ MoreInfo/CaptainsSoftware/JigsawDeluxe.html.

- ✓ **Looney Tunes Photo Print Studio, from MGI Software:** Kids will love this program, which provides templates for making cards, banners, calendars, and more featuring their favorite photos and Warner Brothers cartoon characters. Trial version for Windows — www.mgisoft.com.

- ✓ **MediaCenter, from PictureWorks Technology:** Part image-editing program and part Web browser, MediaCenter provides basic image-correction tools, cataloging tools, a built-in Web browser, and utilities for acquiring and sharing images via the Internet. One fun feature enables you to send e-mail postcards featuring your favorite picture and audio clips. A full, working freeware version for Windows is provided — www.pictureworks.com.

- ✓ **Picture Information Extractor, from hoju.Soft:** If your camera records capture settings as metadata, you can use this nifty program to view the information. See Chapter 4 for more information about metadata. Fifteen-day trial version for Windows — www.hoju.de.

- ✓ **Pictures Now, from Kodak:** For photographers who just want a quick way to print their pictures, Pictures Now offers an easy-to-use solution. You just drag and drop images into printing templates to output photos in standard sizes (wallet, 5 x 7, and so on). The CD includes a fully functional version of the program. For Windows — www.kodak.com.

- ✓ **Live Picture PhotoVista and Live Picture Viewer, from MGI Software:** Join two or more images into a panorama or a 360-degree movie with PhotoVista; use the Live Picture Viewer to explore PhotoVista panoramas in your Web browser. The CD includes a demo version of PhotoVista and a full working version of the viewer. For Windows and Macintosh — www.mgisoft.com.

✔ **Photoshop/PhotoDeluxe plug-ins, Ulead Systems:** *Plug-ins* are special utilities that extend the functions of other programs. Ulead Systems (www.ulead.com) offers a number of excellent plug-ins that work with Adobe Photoshop and PhotoDeluxe, as well as many other image-editing programs. The CD includes trial versions of the following plug-ins, all available for Windows only.

- **Type.Plugin:** Create special text effects in a flash.

- **Particle.Plugin:** Add fire, bubbles, clouds, stars, smoke, and other interesting effects to your images.

- **ArtTexture.Plugin:** Fill a selection with sample patterns or your own custom-made patterns.

- **FantasyWarp.Plugin:** Warp a selection to create kaleidoscope image designs.

Cataloging and album programs

After you shoot all those digital pictures, you need a way to organize them. The following programs provide you with different approaches to keeping track of your photos:

✔ **PhotoRecall Deluxe, from G&A Imaging Ltd.:** Get image clutter under control by organizing your images in a digital photo album. The program enables you to tag images with keywords and other data to make finding a specific image easier. Thirty-day trial version for Windows — www.photorecall.com.

✔ **PolyView, from Polybytes:** Browse through thumbnails of your images using an interface that mimics the Windows Explorer interface. You can also do some basic image editing in this program. Shareware for Windows — www.polybytes.com.

Shareware means that you can try the program out for free for as long as you like. But you're honor-bound to pay the registration fee if you like the program enough to keep it.

✔ **Extensis Portfolio, from Extensis:** Catalog and organize images, sound files, movie files, and regular document files using Portfolio. Then track down specific images by searching for keywords or other file data. Demo version for Windows and Macintosh — www.extensis.com.

✔ **Presto! PhotoAlbum, from NewSoft:** Create a digital version of a traditional photo album. After adding your images to an album page, apply special backgrounds, frames, shadows, and clip-art graphics. Fifteen-day trial version for Windows — www.newsoftinc.com.

✔ **ThumbsPlus, from Cerious Software, Inc.:** This popular shareware program enables you to browse image thumbnails using a Windows Explorer–style interface. You can also organize movie files, fonts, and other multimedia files. Evaluation version for Windows — www.thumbsplus.com.

Images on the CD

I've included an assortment of the original images that I used to create some of the figures and color plates in this book. Figure B-1 provides thumbnail views of the images available.

Figure B-1:
You can find these pictures in the Images folder on the CD at the back of the book.

You can open any of the images inside an image editor or view the image inside a browser by using the same procedure you would to open or view any other file. Just crack open the Images folder on the CD. All images are stored in the JPEG format. If you're working in Windows, the files have the file extension .JPG.

Feel free to use these images in whatever manner you see fit. They're copyright free — my little thank-you gift to you for buying this book. I know, it's not much, but the store didn't have any "I ♥ Julie!" T-shirts in your size. Of course, if you happen to win some big prize or cash award as a result of using one of my images, I expect to go halfsies with you.

Web links page

Here's a tool to help you connect quickly to some of my favorite Web sites. The great folks at IDG who developed the CD for this book have created a Web page containing all the links mentioned in Chapter 15, as well as links to software companies included in this appendix. To use the page, connect to the Internet and start your browser; then choose File⇨Open and open the Web page file (D:\Links.htm if your CD drive is D). You can then just click a link to jump to the corresponding Web site. Cool!

If you are using Windows, you can find this information in the Other Cool Things section of the CD interface.

And one last thing. . . .

 ✔ **Acrobat Reader 4.0, from Adobe Systems, Inc.:** Acrobat Reader is a free program that lets you view and print Portable Document Format, or PDF files. Some of the programs on this CD include manuals in PDF format. Freeware for Windows and Mac — www.adobe.com.

 If you are using Windows, you can find the Adobe Acrobat Reader in the Other Cool Things section of the CD interface.

If You've Got Problems (Of the CD Kind)

I tried my best to compile programs that work on most computers with the minimum system requirements. Alas, your computer may differ, and some programs may not work properly for some reason.

The two likeliest problems are that you don't have enough memory (RAM) for the programs you want to use, or you have other programs running that are affecting installation or running of a program. If you get error messages saying that your computer's out of memory or the Setup program can't continue, try one or more of these methods and then try using the software again:

- ✔ **Turn off any antivirus software that you have on your computer.** Installers sometimes mimic virus activity and may make your computer incorrectly believe that it is being infected by a virus.

- ✔ **Close all running programs.** The more programs you're running, the less memory is available to other programs. Installers also typically update files and programs. So if you keep other programs running, installation may not work properly.

- ✔ **In Windows, close the CD interface and run demos or installations directly from Windows Explorer.** The interface itself can tie up system memory or even conflict with certain kinds of interactive demos. Use Windows Explorer to browse the files on the CD and launch installers or demos.

- ✔ **Have your local computer store add more RAM to your computer.** This is, admittedly, a drastic and somewhat expensive step. However, adding more memory can really help the speed of your computer and allow more programs to run at the same time.

If you still have trouble installing the items from the CD, please call the IDG Books Worldwide Customer Service phone number: 800-762-2974 (outside the U.S.: 317-596-5261).

Index

IDG Books Worldwide, Inc., End-User License Agreement

READ THIS. You should carefully read these terms and conditions before opening the software packet(s) included with this book ("Book"). This is a license agreement ("Agreement") between you and IDG Books Worldwide, Inc. ("IDGB"). By opening the accompanying software packet(s), you acknowledge that you have read and accept the following terms and conditions. If you do not agree and do not want to be bound by such terms and conditions, promptly return the Book and the unopened software packet(s) to the place you obtained them for a full refund.

1. **License Grant.** IDGB grants to you (either an individual or entity) a nonexclusive license to use one copy of the enclosed software program(s) (collectively, the "Software") solely for your own personal or business purposes on a single computer (whether a standard computer or a workstation component of a multiuser network). The Software is in use on a computer when it is loaded into temporary memory (RAM) or installed into permanent memory (hard disk, CD-ROM, or other storage device). IDGB reserves all rights not expressly granted herein.

2. **Ownership.** IDGB is the owner of all right, title, and interest, including copyright, in and to the compilation of the Software recorded on the disk(s) or CD-ROM ("Software Media"). Copyright to the individual programs recorded on the Software Media is owned by the author or other authorized copyright owner of each program. Ownership of the Software and all proprietary rights relating thereto remain with IDGB and its licensers.

3. **Restrictions on Use and Transfer.**

 (a) You may only (i) make one copy of the Software for backup or archival purposes, or (ii) transfer the Software to a single hard disk, provided that you keep the original for backup or archival purposes. You may not (i) rent or lease the Software, (ii) copy or reproduce the Software through a LAN or other network system or through any computer subscriber system or bulletin-board system, or (iii) modify, adapt, or create derivative works based on the Software.

 (b) You may not reverse engineer, decompile, or disassemble the Software. You may transfer the Software and user documentation on a permanent basis, provided that the transferee agrees to accept the terms and conditions of this Agreement and you retain no copies. If the Software is an update or has been updated, any transfer must include the most recent update and all prior versions.

4. **Restrictions on Use of Individual Programs.** You must follow the individual requirements and restrictions detailed for each individual program in Appendix B of this Book. These limitations are also contained in the individual license agreements recorded on the Software Media. These limitations may include a requirement that after using the program for a specified period of time, the user must pay a registration fee or discontinue use. By opening the Software packet(s), you will be agreeing to abide by the licenses and restrictions for these individual programs that are detailed in Appendix B of this book and on the Software Media. None of the material on this Software Media or listed in this Book may ever be redistributed, in original or modified form, for commercial purposes.

5. Limited Warranty.

(a) IDGB warrants that the Software and Software Media are free from defects in materials and workmanship under normal use for a period of sixty (60) days from the date of purchase of this Book. If IDGB receives notification within the warranty period of defects in materials or workmanship, IDGB will replace the defective Software Media.

(b) IDGB AND THE AUTHOR OF THE BOOK DISCLAIM ALL OTHER WARRANTIES, EXPRESS OR IMPLIED, INCLUDING WITHOUT LIMITATION IMPLIED WARRANTIES OF MERCHANTABILITY AND FITNESS FOR A PARTICULAR PURPOSE, WITH RESPECT TO THE SOFTWARE, THE PROGRAMS, THE SOURCE CODE CONTAINED THEREIN, AND/OR THE TECHNIQUES DESCRIBED IN THIS BOOK. IDGB DOES NOT WARRANT THAT THE FUNCTIONS CONTAINED IN THE SOFTWARE WILL MEET YOUR REQUIRE-MENTS OR THAT THE OPERATION OF THE SOFTWARE WILL BE ERROR FREE.

(c) This limited warranty gives you specific legal rights, and you may have other rights that vary from jurisdiction to jurisdiction.

6. Remedies.

(a) IDGB's entire liability and your exclusive remedy for defects in materials and workmanship shall be limited to replacement of the Software Media, which may be returned to IDGB with a copy of your receipt at the following address: Software Media Fulfillment Department, Attn.: *Digital Photography For Dummies,* 3rd Edition, IDG Books Worldwide, Inc., 7260 Shadeland Station, Ste. 100, Indianapolis, IN 46256, or call 800-762-2974. Please allow three to four weeks for delivery. This Limited Warranty is void if failure of the Software Media has resulted from accident, abuse, or misapplication. Any replacement Software Media will be warranted for the remainder of the original warranty period or thirty (30) days, whichever is longer.

(b) In no event shall IDGB or the author be liable for any damages whatsoever (including without limitation damages for loss of business profits, business interruption, loss of business information, or any other pecuniary loss) arising from the use of or inability to use the Book or the Software, even if IDGB has been advised of the possibility of such damages.

(c) Because some jurisdictions do not allow the exclusion or limitation of liability for consequential or incidental damages, the above limitation or exclusion may not apply to you.

7. U.S. Government Restricted Rights.
Use, duplication, or disclosure of the Software by the U.S. Government is subject to restrictions stated in paragraph (c)(1)(ii) of the Rights in Technical Data and Computer Software clause of DFARS 252.227-7013, and in subparagraphs (a) through (d) of the Commercial Computer–Restricted Rights clause at FAR 52.227-19, and in similar clauses in the NASA FAR supplement, when applicable.

8. General.
This Agreement constitutes the entire understanding of the parties and revokes and supersedes all prior agreements, oral or written, between them and may not be modified or amended except in a writing signed by both parties hereto that specifically refers to this Agreement. This Agreement shall take precedence over any other documents that may be in conflict herewith. If any one or more provisions contained in this Agreement are held by any court or tribunal to be invalid, illegal, or otherwise unenforceable, each and every other provision shall remain in full force and effect.

IDG BOOKS WORLDWIDE BOOK REGISTRATION

We want to hear from you!

Visit **http://my2cents.dummies.com** to register this book and tell us how you liked it!

- Get entered in our monthly prize giveaway.

- Give us feedback about this book — tell us what you like best, what you like least, or maybe what you'd like to ask the author and us to change!

- Let us know any other *...For Dummies*® topics that interest you.

Your feedback helps us determine what books to publish, tells us what coverage to add as we revise our books, and lets us know whether we're meeting your needs as a *...For Dummies* reader. You're our most valuable resource, and what you have to say is important to us!

Not on the Web yet? It's easy to get started with *Dummies 101*®: *The Internet For Windows*® *98* or *The Internet For Dummies*®, 6th Edition, at local retailers everywhere.

Or let us know what you think by sending us a letter at the following address:

...For Dummies Book Registration
Dummies Press
7260 Shadeland Station, Suite 100
Indianapolis, IN 46256-3917
Fax 317-596-5498

BESTSELLING BOOK SERIES

Installation Instructions

Here is the bare-bones information you need to see the stuff on the CD. For more detailed information, see Appendix B.

For Microsoft Windows Users

1. Insert the CD into your computer's CD-ROM drive and close the drive door.

2. Click the Start button and then click Run.

3. In the dialog box that appears, type D:\SETUP.EXE (assuming that D is your CD-ROM drive).

4. Click OK.

5. Read through the license agreement, nod your head, and then click the Accept button.

6. To view the items within a category, just click the category's name.

7. For more information about a program, click the program's name.

For Mac OS Users

1. Insert the CD into your computer's CD-ROM drive and close the drive door.

2. Double-click the License Agreement icon and check it out.

3. Double-click the Read Me First icon and give it a read-through.

4. Double-click the CD icon to show the CD's contents.

5. To install most programs, just drag the program's folder from the CD window and drop it on your hard drive icon.

6. To install other, larger programs, open the program's folder on the CD, and double-click the icon with the words "Install" or "Installer."